Red City, Blue Period

The publisher gratefully acknowledges the contribution provided by the Art Book Fund of the Associates of the University of California Press, which is supported by a major gift from the Ahmanson Foundation.

Red City,
Blue Period

Social Movements
in Picasso's Barcelona

Temma Kaplan

UNIVERSITY OF CALIFORNIA PRESS

Berkeley / Los Angeles / Oxford

The author gratefully acknowledges the University of Chicago Press for permission to reincorporate material first used in "Female Consciousness and Collective Action: The Case of Barcelona, 1910–1918," *Signs* 7, no. 3 (Spring 1982): 545–566; and Cambridge University Press for permission to recast material from "Civic Rituals and Patterns of Resistance in Barcelona, 1890–1930," in *The Power of the Past: Essays for Eric J. Hobsbawm,* edited by Pat Thane, Geoffrey Crossick, and Roderick Floud (1984).

University of California Press
Berkeley and Los Angeles, California

University of California Press, Ltd.
London, England

Library of Congress Cataloging-in-Publication Data

Kaplan, Temma, 1942–
 Red city, blue period: social movements in Picasso's Barcelona / Temma Kaplan.
 p. cm.
 Includes bibliographical references and index.
 ISBN 978-0-520-08440-7
 1. Social movements—Spain—Barcelona—History. 2. Barcelona (Spain)—Social conditions. 3. Women—Spain—Barcelona—Social conditions. 4. Barcelona (Spain)—Intellectual life. 5. Picasso, Pablo, 1881–1973. 6. Spain—History—Alfonso XIII, 1886–1931. 7. Spain—History—Republic, 1931–1939. I. Title.
HN590.B3K37 1992
303.48′4′094672—dc20 91–4686

Printed in the United States of America

16 15 14 13 12 11 10 09 08
10 9 8 7 6 5 4 3 2

For Jean Millar and in memory of
Teresa Claramunt and Jane Teller

Contents

Illustrations

Acknowledgments

This study of the triumph of the spirit despite constant political repression in Barcelona is a deeply felt personal work. Research on it began with a paper on "The Making of the Barcelona Working Class" I wrote in 1964, just after reading E. P. Thompson's *The Making of the English Working Class* while in Spain for the first time. Fifteen years later, Dotty and Edward Thompson became my friends, and I am happy to acknowledge that by their example as historians and as political activists they have shaped this book's political views and sense of purpose more than they might imagine.

The historical research I have carried out on Barcelona would not have been possible without the early tutoring I received from Josep Fontana, who more than anyone was my teacher. Even when he has not agreed with my focus on women or with my unwillingness to engage in academic debates, he has helped me tell my own story by suggesting sources and by permitting me to work in his personal library, one of the outstanding private collections in Spain. Scholars whose deep and rich work on other subjects has enabled me to focus on broad issues of Barcelona's cultural politics include José Álvarez Junco, James Amlang, Albert Balcells, Jonathan Beecher, Manuel Castells, Herschel B. Chipp, William Christian, Jr., T. J. Clark, Natalie Davis, Victoria de Grazia, Stuart Hall, Eric J. Hobsbawm, Lynn Hunt, Gabriel Jackson, David Kertzer, Claudia Koonz, Marilyn McCully, Robert Moeller, Mary Nash, Linda Nochlin, Ellen Ross, Joan W. Scott, Carl Schorske, Richard Sennett, Josep Termes, Dorothy Thompson, E. P. Thompson, Joan Connelly Ullman, Pierre Vilar, Raymond Williams, Eric R. Wolf, and John Womack, Jr.

What I know about Barcelona and its history comes less from books than from people, of whom the following have shared their experiences, knowledge, and opinions. James Amlang, Jordi Argente, Angels Carabi, Montserrat Condominas, Josep Fontana, Mary Nash, Susana Tavera, Madrona Torrets, and Mercé Vilanova have put up with my endless questions, accompanied me to festivals, located for me puppet theaters and votive curio shops from their youth, sent me books, found me pictures, and taught me how to cook Catalan food.

The younger generation of Catalans and Catalanists has justified my enthusiasm for the culture and history of Barcelona. As colleagues, students, research assistants, and friends, they have helped me explore new areas in order to tell my story. Foremost among them are Joan Casanovas, Eliza Martí López, Mary Ann Newman, and María Leonora Sesén. Though new to Catalan studies, my mapmaker, Bonne Wagner, shared my delight in Barcelona's physical landscape and the urban reforms that kept changing the face of the city.

Librarians and archivists have done more than orient me to their particular collections; they have helped resolve many of the difficulties involved in bringing a book such as this to completion. I am grateful to Montserrat Condominas, formerly the librarian of the Institut Municipal d'Història, Casa l'Ardiaca, who over more than twenty-five years has guided my work, introduced me to people who could advise me, and throughout the late sixties and early seventies helped me gain access to material that was hidden until the death of Franco in 1975. People like Montserrat should be considered part of an intellectual underground who preserved Barcelona's history and culture during the long, dark days of the Franco Regime. Rudolph de Jong, director of the Spanish and Latin American Section of the Institute for Social History, Amsterdam, and Thea Duijker, the assistant director, have been indefatigable sources of information about anarcho-syndicalists and their lives in Barcelona. At the Museu Picasso, Barcelona, Margarita Ferrer and María Teresa Ocaña, the director, have made the job of gathering visual evidence about Barcelona a constant pleasure. Angela Kitty Chibnik of Avery Memorial Architectural Library, Columbia University, Montserrat Blanch at the Arxiu Mas, Barcelona, and the staffs of the Institut del Teatre and the Biblioteca de Catalunya have provided me with the direction I needed at crucial junctures.

A book that has been gestating for twenty-five years has a lot of time to account for. During the past eight years while I have directed the Barnard Center for Research on Women my work has been accom-

plished largely during vacations, evenings, and weekends. Before that time, I received a grant in 1977–1978 from the National Endowment for the Humanities for an earlier version of this book and in 1982–1983 from the Rockefeller Foundation for several chapters of this work. Academic Senate Research Grants from UCLA during the period 1969–1983, when I was a professor there, enabled me to write my earlier book *Anarchists of Andalusia, 1868–1903* and then, after 1977, to live and work in Barcelona over long periods of time. A Spivack Grant from Barnard College in 1985 helped me return to Barcelona at an important point in my research.

Behind this book is a community of people whose commitments to human decency make the prejudices and preconceptions about resistance to oppression expressed here seem less farfetched. I am indebted to the following people for the range of human contacts they have provided for me over the many years I have been writing this book. Ellen Ross and Dick Glendon took me into their lives and allowed me to be Zachy's aunt for his seven brief years, for which I will always be grateful. Amy Ansara; Danilo and Margaret Bach; Ruth Bloch; Leah Chodorow; Louise DeSalvo; Ellen, Tom, Abra, and Teddy Edwards; Ruth Farmer; Lucy, Billy, Tanya, Ezra, Gideon, and Sam Friedman; Mary Gordon; Charles and Susan Halpren; Claudia Koonz; Honor Moore; Deborah L. Rhode; Debora L. Silverman; Kathryn Sklar; Ann Snitow; Meredith Tax; Jane Teller; Debora Valenze; and Mary Yeager were always there when I needed them. Jean Millar taught me how to roll with the punches and keep fighting.

Individual chapters, sections, and earlier manuscripts of this book have benefited from the advice of different people. Chief among them are Victoria de Grazia and Robert Moeller, who have given unstintingly of their time, intellect, and affection. Whether or not I have taken their advice or heeded their warnings, I have also appreciated the thought-provoking comments of Louise Bernikow, William Christian, Jr., Louise DeSalvo, Susan Harding, Natalie Kampen, Eunice Lipton, Linda Nochlin, Rosalind Petchesky, Pamela Radcliff, Ellen Ross, Meredith Tax, and Joan Connelly Ullman.

I have been fortunate in receiving help from three editors. Helena Franklin provided me with the invaluable responses of someone with a probing mind and a playful spirit. By unraveling ideas that are strongly felt but were not always clearly expressed, she helped to translate enthusiastic prose into a coherent narrative. At the University of California Press, Sheila Levine immediately understood how cultural resistance

can have a significant political impact and why explaining it demanded a new kind of cultural history. For taking a chance on me and my work and for bringing this project to fruition, Sheila Levine will always have my gratitude. Rose Vekony's moral support and serenity and Anne Geissman Canright's copyediting skills turned the production process into a creative act—and a pleasant one at that.

Abby Sims, my stepdaughter, has never known me when I was not working on this book, but in many ways she has made it worth writing. By her outrage over the bombing of Guernica almost forty years before she was born, and by her feminism, she has reassured me about the value of writing history and the values of her generation. Bennett Sims, an inveterate reader of history, has urged me to break my academic chains and tell you the story of cultural resistance in Barcelona with all the passion and commitment that I feel. Most of all, my thanks go to the people of Barcelona, who have often promoted art and freedom and have frequently been willing to fight for them.

Introduction:
The Symbolic Landscape

The task I have undertaken in this book is to account for the peculiar sense of solidarity that the citizens of Barcelona developed between 1888 and 1939, and to explain why shared experiences of civic culture and pageantry were sometimes sufficient to galvanize resistance to national authoritarian governments but not always enough to overcome internecine struggles based on class and gender in the city itself. Most of all, I am concerned here with the process by which principles of regional freedom and economic equity developed and changed in a city long known for its commitment to human dignity and artistic achievement.

Women occupy a central place in this study of the creation and transformation of civic culture as a forum for political struggle. The grassroots politics in which activist women overwhelmingly participated has often been overlooked in studies of political life in Barcelona at this time. Yet because this study regards streets and cafés as political arenas, women's activities in them and in the movements that emanated from them assume a pivotal position in the arguments that follow.

From 1888 to 1939 the politics of region, class, and gender expressed themselves in terms of assorted communal manifestations of Barcelona's civic culture. Festivals and other street gatherings were prominent, providing a means to vent officially repressed aspirations as well as officially sanctioned sentiments. The same festivals or public events could serve divergent purposes at different times. They could express or encourage either local solidarity or internal struggle, celebra-

1

tion or opposition. Thus, civic forms could and did evolve over time, providing a rich and flexible political language that, in turn, gave rise to new strains of thought and new political options. This process both influenced and was reflected in the works of artists like Pablo Picasso, who came of age in Barcelona during this period.

Urban Landscape

This history of urban life and politics in Barcelona is closely tied to the local landscape. The old city seemed to fan out from the Mediterranean. Running between the seaport, which was marked by a forty-foot monument to Columbus, and the Plaza of Catalunya, on the northwestern outskirts of the medieval town, was the promenade known as the Rambla (see Appendix, map 1). This oasis of plane trees within the tumult of the industrial city was often crowded with people strolling. There they were shielded from the pollution that belched from the smokestacks of the factories, factories that provided elite textile barons with the source of their wealth and gave work to the city's many mill hands—120,000 of them in 1905, of whom over 81,000 were unskilled women and children.[1]

The Rambla was divided into sections. About two-thirds inland from the sea was the flower market. Here female flower vendors set up stands, making this part of the promenade into an urban garden. Across from the Rambla of Flowers, the Boqueria Market (officially known as Saint Joseph Market) provided a daily meeting place for housewives in the downtown area. So did the fountains up and down the rest of the promenade, where working women and servants of the wealthy drew daily supplies of water for cooking and cleaning. Down from the market stood the Lyceum Theater, Barcelona's opera house, a center of elite culture and a gathering place for the rulers of the city.[2] Running along the harbor perpendicular to the Rambla was the Plaza of the Palace, where the Madrid-appointed civil governor ruled over the region of Catalunya, of which Barcelona was the capital city. Just behind the government center stood the Basilica of the Virgin of Mercy, Barcelona's patron. Pablo Picasso, who came to the city at age fourteen in 1895, lived with his family near the sanctuary on Mercy Street.

At the other end of the Rambla, in what in 1888 resembled an empty field, stood the Plaza of Catalunya, filled with a few scattered palm trees.

The square remained unfinished until 1926, when large statues and planters were added and paths laid out. No administrative building stood in the square, nor did it have any strategic importance; but it was the symbolic center of the city, the place where all demonstrations began and where news of the day was exchanged. Since it served as the downtown terminal for trollies and buses, it was also the transportation and information center of the city.

Beyond the Plaza of Catalunya, at the northwestern end of the basin in which the city was set, loomed Tibidabo Mountain, on whose slopes the town of Vallvidrera was nestled. To the southwest, Montjuich dominated the city's skyline. Following an uprising of the Catalans in the seventeenth century, the triumphant Castilians took over the Castle of Montjuich—the Catalan Bastille—which cast its shadow over the people below. Along the ridge of Montjuich, exhibition halls and a model Spanish village, featuring artifacts from throughout Spain, were constructed for the 1929 Barcelona International Exposition. And in 1934, the great Museum of Catalan Art, which houses medieval wall murals removed from provincial monasteries, first opened its doors in Montjuich.

Along the eastern face of Montjuich and running down to the Rambla was the hilly section known as Pueblo Seco, or Dry Town. Clustered together there in six- to seven-story tenements lived a sizable proportion of the 230,000 people who populated Barcelona in 1888. Preparing for the 1888 Universal Exposition, one of the great world's fairs that were a feature of late-nineteenth-century Europe and the United States, the city had undertaken massive public building projects near the harbor. One part not completed until 1894 was the construction of a new street, Marquis of Duero Avenue, that ran from the harbor to Main Street (Gran Vía or Avenida Corts Catalans), dividing Dry Town. Although named for the marquis of Duero, the street (and the neighborhood around it) was popularly called "the Parallel," allegedly after a local tavern owned by a geographer who noted that a parallel of latitude ran through the street. Here was the center of leisure activities, the scene of popular entertainments of all kinds. Like Paris's Montmartre, the Parallel provided living space for the city's laborers and studio space for artists like Pablo Picasso.

The Parallel was the center of night life in Barcelona. The nightclubs, burlesque theaters, music halls, and houses of prostitution that gave the Parallel its reputation for excitement made it a gathering place for people of all classes. Alongside circuses and night spots were wax mu-

seums and casinos. By the end of the century, the Nap movie theater introduced working people in the district to the delights of the screen for an admission fee of fifteen cents. Outdoor electric lighting, installed for the 1888 exposition, lit up the Parallel, causing people to call Barcelona "the Paris of the south."[3]

Across from the Parallel on the northeastern side of the Rambla, the narrow and twisting cobblestone streets of the city's oldest district, the Gothic Quarter, wended their way toward the harbor. They connected the cathedral and the numerous churches that marked Barcelona as a highly clerical city. Most of the larger churches and monasteries had their own burial grounds, but one after another these were turned into plazas as cholera, typhoid, yellow fever, typhus, and tuberculosis swept through the city, making hygiene an important urban concern and burials in churches and convents suspect as ostensible breeding grounds for disease. Around 1900 in Barcelona, typhus caused the deaths of 2,500 people a year, of whom 1,600 were female pieceworkers who labored in damp and dark hovels in the Gothic Quarter.[4] Between 1908 and 1911 the city cut through a major street, Laietana Way, from Urquinaona Plaza to the harbor, in order to lay new sewers and to open up the streets near the harbor to light and air. In the process, numerous houses and squares were destroyed, and the old Gothic Quarter was divided in two.

Between Laietana Way and the Rambla lay the main cathedral, the old Jewish ghetto, or *call,* which had housed the Jewish population until the fourteenth-century pogroms, and fetid housing that stretched down to the harbor. This section was relieved only by the open space of the Plaza of Saint James, in which the City Hall faced the gothic Catalan government building, or Generalitat. When laws affecting Catalunya and its relations to the Spanish government were passed or when regional holidays took place, the square filled with celebrants. Around the turn of the century, as today, the streets leading from the square to the harbor sheltered one of Europe's most famous red light districts, whose prostitutes blended in with other poor women during the day.

To the northwest of these downtown districts of the city, fanning out from north to south, lay the towns of Barceloneta, Saint Martin of Provence, Saint Andrew, Gracia, Sarriá, and Sans. By 1897, all these towns (except Sarriá) had been incorporated as boroughs of Barcelona, raising the total population of the city to 533,000 by 1900, to nearly 596,000 by 1910, and to 710,335 by 1920.[5] The towns retained their

distinctive characters. Saint Martin and Saint Andrew were industrial suburbs peopled by factory workers in textile and metallurgical plants. They lacked city centers and the numerous taverns, cafés, and markets that made life bearable in downtown Barcelona. Gracia, in contrast, with its wrought-iron street lamps and its narrow streets, housed artisanal workshops, print shops, artist's studios, and night schools. Along with Sarriá and Sans, it retained the sense of being a village, a hillside town above the bustling city center of Barcelona.

Between the Plaza of Catalunya and the incorporated towns lay a great plain that was the center of a distinctive real estate development. From 1863 on, in successive periods of urban renovation, the streets between the old city and the outlying towns became the axes of a new kind of city. The streets were laid out in a grid pattern bisected by the elegant Gracia Pass, running from the Plaza of Catalunya to Gracia. At each intersection, a tree-lined hexagonal plaza was formed by cutting diagonal lines across each corner. This new area, known as the Extension (Ensanche), provided elegant villas and apartment houses for the city's wealthiest people and commissions for talented art nouveau architects.[6]

Local architects like Antoni Gaudí and Josep Puig i Cadafalch, both of whom constructed buildings along Gracia Pass and other areas of the Extension, were known as modernists *(modernistas)*, and it was they and their colleagues who transformed the district into a virtual museum of art nouveau architecture. Here, buildings with iron framework were covered with concrete or Portland cement manufactured by the Güell family, who, in turn, commissioned palaces, garden cities, and company towns. The architects either reproduced natural forms, swirling their wrought-iron and stucco leaves, flowers, and mushrooms over doorways and windows, or chose historic designs from the backgrounds of medieval Catalan paintings.[7] Gaudí's Milá House, an apartment building of concrete over molded iron, looked from a distance like a butte high on Gracia Pass, leading people in Barcelona to nickname it "the quarry." His Church of the Holy Family, on Mayorca and Provence streets, begun in 1885 and left unfinished at his death in 1926, resembles a sand castle made of dribbled concrete, with bits of folk art recalling Christmas manger figures set over the main portal.[8]

These buildings were fitting symbols of the confidence and wealth of a regional elite, which was determined to regain autonomy over its own section of the country. Catalunya, Charlemagne's Spanish marches, had governed itself throughout the Middle Ages. It had its

own ruler and parliament, the Corts, inaugurated at the time of the Magna Carta; a standing committee of the parliament (and the building, both called the Generalitat) dates from the thirteenth century. Catalunya was as proud as England of its democratic legal system, even though it began to lose its autonomy after its ruler Ferdinand of Aragon married Isabella of Castile in 1469.

As a result of the marriage, Catalunya lost its regional government and parliament. Despite separatist rebellions in the seventeenth and eighteenth centuries, it remained a part of Spain ruled by the Spanish monarchy. That monarchy underwent a transformation in the period between 1868 and 1874. When Queen Isabella II lost the support of her army and was forced to flee on September 17, 1868, a constitutional monarchy was established with an Italian prince, Amadeo of Savoy, as king. After he in turn fled the country, becoming, as Friedrich Engels put it, the first king in history to go on strike, Spain became a federal republic on February 11, 1873.[9] Josep Pi i Margall, a Catalan republican, was chosen as president.

Then, in January 1874, a military coup ended the First Republic, and the military recalled Alfonso XII, the son of the departed Isabella II, to rule Spain in a constitutional monarchy alongside a weak Cortes, or Parliament. The king died in 1885, whereupon the queen became regent until his posthumous child, Alfonso XIII, could take over the kingdom in 1902. The architect of the Restoration, Antonio Cánovas del Castillo, set up a system of government by which prime ministers were chosen from two basically conservative political parties that alternated power. Until Cánovas's assassination in 1897—the direct result of governmental repression of the anarchist workers' movement, particularly in Andalusia and Barcelona—the Spanish government ruled autocratically and relatively successfully over a highly centralized state in which cities like Barcelona lacked any decision-making rights over collecting taxes, hiring police, organizing museums, or building schools.

Every Spanish province such as Barcelona had both a civil governor, appointed by the prime minister, and a captain general, appointed by the minister of the interior. Under normal conditions, laws governing the locality emanated from Madrid in the form of statutes and legislation passed by the Cortes or decrees pronounced by the king or the prime minister. The civil governors carried out the law in the different regions of Spain. But when social order was threatened, martial law was quickly imposed, and then all civil and military power came to rest with

the captains general. It was their job to preserve the peace through the use of the army and Civil Guard (Guardia Civil).

Originally organized to wipe out bandits, the Civil Guard was an armed force occupying every district of the country. Those stationed in Catalunya spoke different languages and had different customs from the Catalans. Not only were they outsiders, but they were trained to stay that way. It was they who became the captain generals' crack troops in the war against urban workers. The Spanish army, made up of conscripts, was, except for its forays to Cuba, the Philippines, Puerto Rico, and Morocco, used to back up the Civil Guard in ruling over the Spanish people. Thus everything about Barcelona's economic, social, and political life was decided by the government in Madrid through an appointed civil governor until a semblance of autonomy emerged in the cultural realm in the late nineteenth century.

Texture of the City

In Barcelona, as in many European cities in the late 1800s, population growth was due largely to migration from the countryside. Rural immigrants, pushed off their land because of the wine blight known as phylloxera and because of crop failures, flocked to the city seeking work.

At first the peasants who arrived from outside Barcelona came from the Catalan provinces of Lleída, Girona, or Tarragona; in 1900, nearly 73 percent of Barcelona's population of 533,000 had been born in some part of Catalunya. Moreover, of the 55,000 men and 58,000 women born outside the province, almost all came from Zaragoza, Huesca, Valencia, Alicante, and Castellón—Catalunya's neighboring provinces. By 1910, however, the proportion of Catalans had fallen to barely 66 percent, and the numbers diminished even further when Barcelona's industries expanded during the First World War.[10]

Barcelona was a bustling industrial city with a reputation for hardworking people. Of the approximately 156,000 people with regular employment outside domestic service in Barcelona in 1905, 139,000 people—of whom 93,000 were women and children—worked in clothing manufacturing and the textile mills. Men also found jobs in transport and at the docks, in construction, and in metallurgical plants,

and they worked as day laborers, artisans, small shopkeepers, and small manufacturers.[11] Even though Barcelona was one of the major industrial centers of Spain, plants tended to be small. There were 742 textile factories in the city at the beginning of the twentieth century, and even industrial workers generally worked in shops with fewer than twenty-five employees.[12]

Barcelona's streets and squares formed a kind of civic stage during the roughly fifty years from 1888 to 1939 covered in this book. In that period, the city became a testing ground for a variety of "isms," among them, anarcho-syndicalism, Catalan nationalism, and artistic *modernismo*. The heady mix sometimes exploded into urban civil war and at other times gelled into a sense of solidarity against the usually repressive central government of Spain.

The actors in this pageant were legion. They included Catalan nationalists and federalist republicans, Catholic reformers and anticlericals, anarcho-syndicalists and Socialists. Sharing the stage were artists like Pablo Picasso and Joan Miró; the cellist Pablo Casals; playwright Santiago Russinyol; the engineer, puppeteer, and promoter of medieval and folk arts Miquel Utrillo; the anarcho-syndicalists Salvador Seguí, Ángel Pestaña, and Teresa Claramunt; and women engaged in grass-roots politics like Amàlia Alegre and Josefa Prieto. These and others shaped the culture of Barcelona politically and artistically. On many occasions campaigns were waged and alliances struck by the full range of Catalan society against the national government of Spain. At other times, the lines were drawn between Catalan nationalist industrialists, supported by the police, and members of the popular community, frequently led by the anarcho-syndicalists.

Between 1888 and 1939, a period extending from the Barcelona Universal Exposition in 1888; through the general strikes of 1902, 1909, 1917, and 1919; to urban insurgency against the Spanish dictator Miguel Primo de Rivera in the twenties; to events that attracted worldwide attention in 1936 and 1937 during the first year of the Spanish Civil War, Barcelona developed a unique identity.

The Shape of Cultural Politics

In the pages that follow, the argument will be presented in a series of snapshots highlighting cultural battles that traditional po-

litical, social, or economic history often overlook. Because struggles between Spain and Catalunya and between the Castilian and Catalan languages lie at the core of this study, most proper names used here have either been Anglicized from the Catalan or translated into English. Although this will annoy some readers, it is symbolic of the commitment of this book, which is to write from a Catalan perspective.

Chapter 1 considers how, at the end of the nineteenth century, festivals became performances through which opposing forces in Barcelona acted out their parts. Local citizens, whatever their religious convictions, enjoyed the frequent Catholic holiday celebrations and spectacles often associated with the change of the seasons and key dates in the religious calendar. Celebrants often lost sight of the specific Madonna or saint being celebrated: for the vast majority of the population, religious holidays merely provided opportunities for revelry. Whatever meaning church and civic authorities imputed to them, the ceremonies and processions could in fact mean anything and everything the audience desired—one reason competing groups often adopted the same or similar forms for their celebrations and demonstrations. For those who opposed the authorities who repressed unions and tortured labor militants, celebrations provided a means for registering their outrage or promoting an alternative vision. By organizing pageants of their own in which to attack military or civic leaders, they symbolically contended with those in power for control of the city. Celebrations at this time provided a way to express solidarity as Catalans against the government in Madrid.

With popular spectacles and folk art constantly before their eyes, Barcelona's artists sought to create their own alternative community, which is the subject of Chapter 2. In the 1890s, Santiago Russinyol used his vast wealth to promote modern, "decadent" art by turning his villa just south of Barcelona into a museum and a retreat. There, through theatrical galas and artistic processions reminiscent of religious festivals, he put forward the idea that art should be worshiped. Not content to retreat to the country, Russinyol, the artist Ramón Casas, and the entrepreneur Pere Romeu founded the Barcelona café known as the Four Cats. Modeled on the Chat Noir in Montmartre, the Four Cats was a beer hall, art gallery, and puppet theater where the French avant-garde of postimpressionism was promoted along with Catalan folk arts like puppetry. There people of all classes found companionship, and Pablo Picasso, who arrived in the city in 1895 and remained until 1904, acquired his first group of admirers.

No form of cultural life could always contain class antagonisms. At times, as in the general strike of 1902, the city became a war zone. Later that same year, however, attempts were made to use a week-long Virgin of Mercy celebration to repair the damage. The events covered in Chapter 3 thus represent both sides of the civic coin, internecine struggle and community unity, and in turn raise issues about solidarity and local antagonisms that resonated as late as the Spanish Civil War of 1936 to 1939. Moreover, while the 1902 general strike presented the embryo of a future egalitarian society, the Virgin of Mercy festival suggested the possibilities of commercializing existing culture in Barcelona. Despite the danger of violent political clashes, festival life, with effigies, banners, anthems, and folk figures, drew even outsiders to Barcelona. These symbols were apparently manipulated by successive city governments in the hopes of encouraging tourism.

Chapter 4 explores the many valences of women in Barcelona and the ways in which differing perceptions of women reflected the cultural conflicts in the city in the early twentieth century. Patron saints like the Virgin of Mercy, nuns, upper-class women, prostitutes, and the working-class women of Barcelona were all cramped in certain stereotypic roles. Yet these stereotypes were exploded during the period 1905 to 1909 as women participated prominently in civic rituals and civic conflict.

Chapter 5 investigates how grass-roots movements led by women helped to shape political culture in Barcelona. Women whose lives intersected with those of men of all classes could play a variety of roles on the civic stage, from victim to sexual activist to political revolutionary. Victimized women abounded, but so did activists. Women textile workers led a strike in their own way in 1913, breaking with the male leaders who claimed to speak for all the workers of the city. In 1918, women again called on one another as neighbors and as citizens to take matters into their own hands when a freezing winter, fuel shortages, and speculators violated the system of rights by which they thought the city should be ordered.

Meanwhile, during the height of the First World War, leftists and Catalan nationalists were seeking to forge new systems of political culture, as Chapter 6 reveals. In the summer of 1917, regionalist challenges to the Spanish monarchy and the threat of a leftist general strike undermined the stability of the national government. This year of crisis for the central government in Madrid permitted divergent forces in Barcelona to assert specific political agendas for the city and the region. Car-

nival, revived in 1917 after many years, provided a fitting vehicle for the confrontation with authorities that was taking place at all levels of society. Pablo Picasso, who returned to Barcelona for several long visits in 1917, may have reaffirmed his connections to the city by using carnivalesque images in his sets and costumes for the ballet *Parade,* introduced in Paris and then performed in Barcelona in the late spring and early winter of 1917. At this time, Picasso also produced a number of drawings that focused on a theme rooted in his years in Barcelona and his recent experiences there: the violence of the bullfight. The image of the wounded horse, which figured prominently in these works, would reappear during the Civil War in his masterpiece, *Guernica.*

With the brutal repression of the workers' movement in 1919 and the virtual civil war that reigned between employers and syndicalists until 1923, cultural and political Catalan nationalism became the primary vehicle for resistance—the subject of Chapter 7. The dictator Miguel Primo de Rivera, who ruled Spain from 1923 to 1930, repressed the Catalan language, holidays, and dance, but that only enhanced their underground appeal. Violations of Catalan culture welded disparate forces, from the clergy to anarcho-syndicalists, into a united movement for Catalan freedom.

The contradictions between the political culture of working men and women and the goals of regional autonomy reemerged forcefully with the creation of the Second Spanish Republic in 1931, the period at which Chapter 8 begins. When the anarcho-syndicalists of Barcelona crushed a right-wing army-led insurrection against the legally elected republican government on July 18, 1936, the revolution in community consciousness that had long been dreamed of in certain circles came to fruition. Although half the country fell to the army and its promotion of the right-wing Nationalist cause, Barcelona was transformed into a commune, a collectivist, self-consciously revolutionary city. But by May 1937 the dream had turned sour as Communists, aided by republicans and Socialists, attacked the anarcho-syndicalists, who had become the dominant force in the city. Barcelona experienced a civil war within the Civil War in late April and early May 1937, a conflict that manifested the kind of hostility so often found in places where solidarity has been greatest. Picasso, whose mother, sister, nephews, and old friends were still living in the city, knew about events transpiring there. Commissioned by the Spanish government to paint a mural for the Paris Exposition of 1937, he may have drawn on his past experiences as a citizen of and visitor to the city and on his consequent awareness of what frat-

ricidal struggle could mean in Barcelona. The result was the celebrated
Guernica.

The title of this book requires some explanation. From
the vantage point of art history, the years 1900 to 1904 constitute Pi-
casso's "blue period." Because Picasso, as a young man living in Barce-
lona between 1895 and 1904, participated in some of the festivals, pag-
eants, and alternative artistic communities that contributed to the
popular culture of that time, his images often provide visual informa-
tion about the city. Blue itself has had a variety of uses in twentieth-
century Spain. Thanks to the production in Germany of Rickett's blue,
a by-product of manufacturing steel, blue became the color of the
cheapest dyes and paints. Like denim today, the blue cloth that Spanish
workers wore from the late nineteenth century up through the 1960s
was durable and cheap. The paint made from the pigment, too, though
not very durable, was inexpensive, which is one reason Picasso used it
so much in the early twentieth century. This book uses "blue period" to
define the time span from 1888 to 1939, when popular culture in Bar-
celona was shaped and reshaped by groups of people including the
workers and artists for whom blue was so important.

"Red and black city" would be the appropriate designation for Bar-
celona if this book were a study of anarcho-syndicalism, and "red and
yellow" if the focus were on the Catalan nationalists. But since this book
is really about how republicans, regionalists, and workers, including
women, forged a shared culture, red is an appropriate color to represent
them all.

1

Resistance and Ritual, 1888–1896

My generation of Americans hardly ever used the word *ritual* without the adjective *empty*. For us, "rituals" meant obsessive habits, neurotic quirks designed to control one's life. We scorned the pomp of Nixon's imperial presidency and ignored the playing of "The Star-spangled Banner" at baseball games. But when Roseanne Barr, a popular television comic, made a mockery of the ceremonial singing of the anthem, the fans in the stadium booed and newspapers analyzed her heresy for weeks afterward. The self-righteous media underscored the fact that rituals are filled with symbolic meaning, and counterrituals are deadly serious, even in contemporary America.

No one in late-nineteenth-century Barcelona would have questioned the importance of rituals and pageants. Apart from the Sunday bullfights in season, there were several religious celebrations a month, and all political groups had their own festivals as well. But what did these various communal events mean, and why did the city spend so much money on them? Before radio and television, street rituals were, in fact, the main medium for communicating ideas. Processions of one political coloration or another provided visual tableaux of different perspectives on the social order and were at least as persuasive as any other form of debate. Mass demonstrations signaled a community of shared values. They reassured participants of their own strengths and intimidated opponents. Sometimes rituals also provided opportunities for antagonists to register their opposition to the community celebrating itself in public.[1]

Between 1888 and 1896, rituals played an extraordinarily important role in the urban politics of Barcelona. For one thing, industrialists and the city government used civic rites to assert the city's prominence and to demonstrate their strength. At the time, the anarchist labor movement was in disarray because of the fall of their national confederation and the police repression that increasingly haunted organized labor after 1888.[2] Lacking the power to control the police and army, who routinely arrested and tortured labor militants, disaffected individuals still could and did attack authorities during public rites in the nineties.

Competing for prominence in the city's streets and society were not only the city's establishment and its political antagonists but also, among others, Catholic Catalan nationalists and clergy, secular republicans of all stripes, and workers, including artisans and housewives as well as anarchists and Socialists. Often they opposed one another; sometimes they united to confront the government in Madrid. All of this activity was reflected in the city's festivals and pageants.

Six episodes in the history of Barcelona between 1888 and 1896 help to explain how some rituals created a sense of shared identity and others produced a battleground in the city. A few of these ceremonies resemble the celebrations of the centennial of the Statue of Liberty or the U.S. bicentennial; others evoke American political campaigns, with their gatherings of the faithful and political speeches. The six episodes in question include the coronation of the Virgin of Mercy as the patron saint of Barcelona in October 1888; the republican commemoration of the twentieth anniversary of the First Spanish Republic in September 1888; the first May Day in 1890; the bombing of the Virgin of Mercy celebration in 1893; and, in 1896, the Corpus Christi Day bombing, followed by the public funeral of the victims.

The Virgin of Mercy

"Ritual plays an important political role in bringing about solidarity where consensus is lacking," according to anthropologist David I. Kertzer.[3] The influx of rural immigrants into Barcelona in the 1880s certainly threatened to intensify social conflict there. Those responsible for maintaining social order—the Catholic church, the city government, and the industrial leaders—thus sponsored a series of pageants to project a particular image of social solidarity. As a result, rituals

themselves became an area of contention. Competing forces among secular republicans and leftists organized their own ceremonies, and both sides attacked or sought to repress one another at play.

The four hundredth anniversary of Columbus's embarkation from Barcelona in 1488 on the trip that would bring him to America in 1492 provided an occasion for Barcelona to proclaim its centrality to the modern world at the end of the nineteenth century. To commemorate the trip, Catalan nationalist businessmen, jurists, architects, and city officials participated in the city-financed 1888 Universal Exposition and undertook widespread urban renewal of the city. Designed to display the achievements of Catalan industry, which was undergoing a recession, the exposition provided a form of economic relief. Construction work boomed, and tourists flocked to the city during the six months of the fair.[4]

The culmination of the exposition, which began on May 27, 1888, was the October 24 crowning of the Virgin of Mercy as patron of Barcelona. The Virgin of Mercy had long been identified with the city, with one particular representation of her, the fourteenth-century carved and painted wooden image known as Santa María of Cervalló, being especially revered. Accordingly, from among the various statues of the Virgin of Mercy in the city, this was the one used in the civic ceremonies dedicated to her. Her day was traditionally celebrated between the third week in September and the second week in October. In 1888, however, it was deemed fitting to end the exposition with the Virgin's celebration on October 24.

Like the unveiling of the restored Statue of Liberty in New York in 1986, the coronation of the Virgin of Mercy worked on many psychological levels. One emotion evoked was love of country, or, in Barcelona's case, Catalunya.

Ever since it lost its autonomy in 1469 upon the marriage of Ferdinand and Isabella, Catalunya had been merely a source of draftees and revenues for Castile in its imperial pursuits in the Netherlands and the Americas. Catalunya rebelled in 1640 and lost.[5] Again during the War of the Spanish Succession, from 1700 to 1715, Catalunya and other northern provinces, led by Barcelona, attempted to regain their independence from Spain. This effort, too, failed, and the victorious Bourbon monarchy reduced Catalunya to a captive nation, forbidding use of its language in official documents and abolishing many remains of common law. Intellectuals could publish their works only in Castilian; the uneducated people, though, continued to speak only Catalan. Shortly

after the 1715 treaty that ended the war, the Bourbons built a citadel at the harbor to house eight thousand soldiers who were responsible for preventing future uprisings.

The activities of 1888 were designed in part to wipe the Bourbon stain from the face of Barcelona. Razing the citadel, the city created a fairground and Citadel Park to house the Universal Exposition. Within the park, the Provincial Museum of Antiquities showed medieval Catalan religious art never before displayed in a secular setting.[6] Outside the gates of the park, an arch of triumph signaled the rebirth of Catalan culture. Nearby at the harbor, the city erected a colossal statue of Columbus pointing from Barcelona out to the New World.

Rituals honoring powerful local emblems—whether the Statue of Liberty or the Virgin of Mercy—evoke strong feelings of loyalty, solidarity, and national purpose.[7] The 1888 ceremony built on earlier precedents that likewise were dedicated overtly to the Madonna but served as well to celebrate and revive Catalunya's cultural heritage. In medieval times, the Madonna had been venerated as guardian of captives lost at sea and was known as the Virgin of Redemption. During the Napoleonic Wars, she assumed her modern role as protector of Barcelona. At that time, Catalans traditionally celebrated the Day of the Ascension of the Virgin Mary on May 25 by honoring the Black Madonna at the Montserrat Abbey (Catalunya's Westminster), some twenty miles northwest of Barcelona. Because Napoleon's armies virtually leveled the monastery, however, in 1808 the celebrations were moved to Barcelona, whose monasteries, though closed, were still standing. The French, claiming that it was a center of sedition, had turned the Mercedarian monastery and the basilica that housed the Virgin of Mercy into an army barracks.[8] The wooden statue had been hidden in the city's cathedral, but that year the monks gained permission to restore it to its altar.

Repression of a nation through its principal religion often backfires, as the Soviets learned in Poland in the 1980s. In Catalunya, identification with the church only intensified under French occupation. The Mercedarian monks organized a mass meeting in May 1808 to pray for Barcelona's protection and succeeded in holding a procession through the streets to carry the devotional object back to its sanctuary in the basilica. Reluctant to provoke the population any more than they had to, the French permitted the restoration of the image, thus in effect permitting the civic community of Barcelona to reassert its identity.

That pageant became a model for subsequent rites of revitalization. At the head of the procession was a banner of Saint Eulalia, the gooseherd. She, too, is a patron saint of Barcelona, and her statue tops the

city's cathedral. Behind the banner, men followed bearing the cross from the cathedral. Then came representatives of the major guilds, followed by other city notables. The Mercedarian chorus marched after them singing the Virgin's hymn. The richly adorned wooden body of the image came next, surrounded by the household of the duke of Medinacelli and six Mercedarian monks. Following them were the general of the Order of Mercedarians, the rest of the monks, and then the clergy from the cathedral and other notables.[9]

From the cathedral the parade moved slowly down the Street of the Inquisition, the main route through the Gothic Quarter, past the Plaza of the King and the chapel where the remains of Saint Agatha had once been housed, under the Gothic bridge, past the old prison, and through the Plaza of the Angel (see Appendix, map 2). From there it went down Boria, Corders, and Montcada streets, then on to Vidriera Street and the Plaza of the Palace, the scene of so many subsequent political gatherings. Finally, it turned the corner and approached the monastery of the Mercedarians. On the wall of the basilica, emblematic of the relationship between the city and the Madonna, was a relief of the Virgin sheltering the masses. After 1808 Ascension Day celebrations returned to the monastery of Montserrat, though they still occurred periodically, but on a smaller scale, in Barcelona.

Beginning in 1859 another ritual took hold in Barcelona. In that year, people committed to preserving Catalan traditions revived a late-medieval poetry and history pageant called the Floral Games (Jocs Florals). Poets, historians, writers, and members of the public assembled in the Salon of the Council of One Hundred, the great hall where the medieval city council of Barcelona had met, to listen to odes extolling the ancient achievements of Catalans and poetry proclaiming the marvelous powers of different Madonnas. The presiding officer of the games sat on a throne before a banner emblazoned with the ubiquitous image of the Virgin of Mercy, the emblem of the festivities.[10] It was his job to award a gold flower or medal to the winners, just as the king had done in the High Middle Ages. The winning submissions in poetry and history were then published in a journal also called Jocs florals. The pageant took place annually until 1936 on the first Sunday in May, except in 1888, when the opening of the Universal Exposition caused it to be postponed until the end of the month.[11] A cultural spring rite comparable to Easter, the games, dedicated to different Madonnas, signaled the rebirth of Catalunya as a cultural entity.

Given the precedent of associating Madonnas with the Catalan nation, the desire of Catalan nationalists to wed the city to the powerful

Virgin of Mercy in 1888 is not odd. In 1887, in fact, Catalan national-
ists had sought and eventually won Pope Leo XIII's permission to
crown the Virgin of Mercy as Barcelona's patron. Explaining the
crowning of the Madonna del Carmine in New York's Harlem, histo-
rian Robert Anthony Orsi notes that "the process of crowning a partic-
ular statue of the Virgin and elevating a shrine to the officially recog-
nized dignity of a sanctuary is a formal ecclesiastical procedure with
specific rules and requirements. . . . The priests and people of Italian
Harlem . . . desired the dignity and legitimation that such official rec-
ognition and blessing would convey." [12] So did the Catalans. At first the
pope was fearful that approving the coronation of the Virgin of Mercy
might politicize the faith, pitting Catalan regionalism against Spanish
nationalism and contributing toward a separatist political movement.
But Catalans convinced him that their goals were cultural, not political,
and would enhance the faith.[13] Since the church had already shown it-
self to be accommodating to regional expressions of faith, the corona-
tion did not seem like a radical departure from tradition. Until the re-
forms of the twentieth century, the Catholic church permitted the use
of the vernacular instead of Latin in catechism and in recitation of the
Rosary and the Pater Nostre in only one place on earth: Catalunya.[14]

The October 21, 1888, coronation of the Virgin of Mercy was the
symbolic crescendo of the Universal Exposition. Since believers and
atheists were equally familiar with Catholic rituals such as processions,
these became the template for all other ceremonies. Thus, even when
the message was entirely secular, religious patterns shaped civic be-
havior.

The festivities of the Virgin began on October 18 with a parade.
Daily events led up to the actual coronation of the effigy by Barcelona's
Bishop Jaume Catalá on the morning of October 21, 1888. Following
that, a Te Deum was sung, and the crowned Virgin was returned to the
basilica.[15]

Like the Virgin of Mercy, who is represented nestling the faithful in
her robes, the coronation procession enveloped the city. The parade
route covered the old quarter of the city and the wealthy Catalan nation-
alist wards of the Extension (Ensanche). From the cathedral, in the
heart of the Gothic Quarter, the procession moved to the New Plaza
and then along Arch Street to Plaza of Saint Anne (see map 2). From
there it passed down Fivaller Street, up the sumptuous Gracia Pass,
along Main Street (the Street of the Corts of Catalunya), down the
Rambla of Catalunya, to the Plaza of Catalunya. Then it moved down

the Rambla itself, where more than fifteen thousand people thronged the parade route. Next, the procession passed to the Basilica of the Virgin of Mercy by way of Saint Francis and Narrow streets. Another enthusiastic crowd cheered at Mercy Plaza in front of the basilica, welcoming the effigy back to the neighborhood.[16]

At one level, the procession was a motion picture of history, religion, and society as Catalan nationalists viewed it. The church brought its banners, including those of the cathedral of Barcelona, the main parishes, and the remaining guilds. Among the participants in the parade were Catalunya's leading prelates, workers from the Barcelona Catholic Workers' Circle, girls dressed in white who sang hymns to the Virgin, students from the Catholic schools, the city council, and the mayor of Barcelona. When the procession reached the sanctuary, the ceremonial leader of the city, the mayor, kissed the hand of the effigy as it was replaced on the main altar.[17]

The identification of Catholicism with Catalan nationalism, already so pronounced at the festival, was intensified at the mass held the next morning, Monday, October 22. The archbishop of Urgel addressed the crowds in Catalan, proclaiming that he, like all Catalans, had learned to worship God and the Virgin in his "mother language," taught to him literally at his mother's knee. He could not separate his pride in Catalunya from his deep religious faith.[18]

The great Catalan nationalist poet Jacint Verdaguer, a Franciscan friar, published a poem honoring the Virgin of Mercy following her coronation in 1888. He dedicated the poem to a friend, Bishop Catalá, but he explicitly linked the religious ceremony to the secular celebration of Catalan industry taking place at the 1888 exposition. He wrote:

In the time of the great Universal Exposition
Our City was the center of Europe:
To her palaces came all the kings,
To her ports, all the ships.
And they crowned Her Queen of the Sea and gave
Her scepter and crown.
The scepter was a trident and she rejoiced in it.
The diadem was of gold and it was beautiful.
Barcelona was entrusted to her as patron:
I kneel to my Queen, the divine Virgin of Mercy,
Redeemer of all prisoners.[19]

Even ostensibly religious celebrations in Barcelona, however, resembled Mardi Gras in New Orleans. At the head of the October 21

procession were the folk figures known as *gegants,* or giants, men on stilts who wore papier-mâché heads and beautiful costumes fashioned by leading artists and local dress designers. Dating back to the late Middle Ages, when they provided a carnivalesque accompaniment to Corpus Christi Day celebrations each June, different *gegants*—including Solomon and the queen of Sheba, Queen Esther, and a Moorish king—belonged to the churches of Pi, Saint Mary of the Sea, the House of Charity, and the cathedral (figure 1).[20] Around the *gegants* gathered grotesques called "kids" (*nans*), who frequently performed lewd dances, and men dressed as eagles, dragons, bulls, and lions, possibly representing the emblems of Saints John the Apostle, Michael the Archangel, Luke, and Mark, respectively.[21] Along with the menagerie came the *tinbaleros,* equestrian drummers dressed in medieval-style clothes.[22] Given the unorthodox elements included in the procession, the clergy could hardly protest when, in 1893, the captain general appointed by the minister of the interior joined the parade with his soldiers.

During celebrations like the annual Virgin of Mercy Day festivities, the city streets became a theater for marchers and their audience. As art historian John Berger observes, pageants, like "mass demonstration[s,] can be interpreted as the symbolic capturing of a capital. . . . The demonstrators interrupt the regular life of the streets they march through or the open spaces they fill. They 'cut off' these areas, and . . . they transform them into a temporary stage on which they dramatise the[ir] power."[23]

In Barcelona, the physical act of moving through the city marked the plazas and streets with cultural significance and bonded the people who participated. Even those who joined in as audience, viewing the urban ceremony from the sidelines, became familiar with the content of the "arguments" proclaimed. In the case of the Virgin of Mercy celebration, the message was that the people of Barcelona—regardless of religious commitment to the institutional church—were under the protection of their own special urban Madonna.

Republican Rituals

Obviously, there were those who rejected this identification with the Madonna. In fact, although people from all walks of life enjoyed the festivals, many republican and anarchist leaders wanted

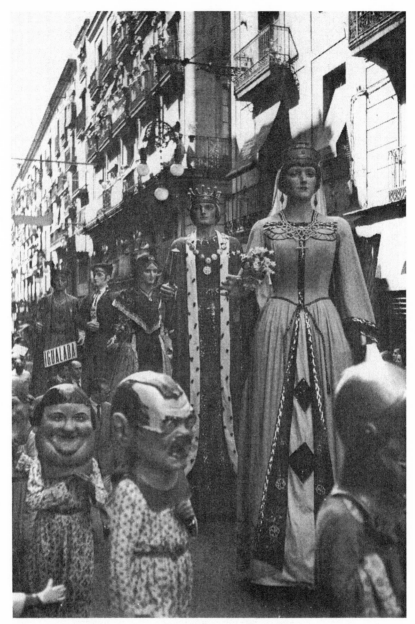

Fig. 1. *Gegants* and *nans* used in folk festivals in Barcelona.
Courtesy of Arxiu Mas, Barcelona.

strict separation of church and state and viewed parades led by the church and paid for by the municipality as unwarranted incursions of religion into secular society.[24] Republicans and leftists repeatedly urged the church to keep their statues and crosses behind closed doors, and they successfully barred civic payment for religious ceremonies in 1899 (when there was a republican mayor), even though the city had picked up the bill for all street celebrations and urban fairs at least as far back as the early nineteenth century.[25] The idea that religion had anything to do with Catalunya's distinct democratic tradition was generally repugnant to secular republicans. They looked back longingly to the Corts and the Generalitat, among other democratic institutions of the past, and favored the creation of a republic. While they may have differed as to specifics, essentially they agreed that Catalunya should have a measure of political autonomy, including a regional legislature, judiciary, and executive structured along the lines of the Swiss or U.S. government.

As a means for projecting their own view of Catalan history and thus their own hopes for the future, republicans themselves commemorated historical events with ritualized festivities—even though many republicans opposed street celebrations. By 1888 republicans were holding ceremonies to observe several holidays: July 14, Bastille Day; March 18, the anniversary of the 1871 Paris Commune; September 11, the day in 1714 when Catalunya lost its autonomy because it failed to back the victorious French in the War of the Spanish Succession; September 17, the date when in 1868 Spain's Glorious Revolution (la Gloriosa) began with the flight of Isabella II from the nation; and February 11, the day of the founding of the First Republic in Spain in 1873 when, after a series of constitutional governments, the brief monarchy of Amadeo of Savoy gave way to a republic with the Catalan Josep Pi i Margall as president. Thus, September 17 and February 11 became two of the most significant holidays in the Catalan republican calendar.

On the twentieth anniversary of the revolution of 1868, fourteen years after the restoration of the Bourbon monarchy in 1874, Pi i Margall returned to Catalunya. In Barcelona proper, religious Catalan nationalists were preparing for the coronation of the Virgin of Mercy a month hence; meanwhile, in the town of Vallvidrera (now a borough of Barcelona), a very different kind of festival was under way. Eight thousand people from the city below proceeded up the mountain of Tibidabo that September 17 to join the festivities. Paradoxically, the republican celebration took place at the Royal Pavilion of Tibidabo.[26]

Banners were as prevalent in this ceremony as in any religious one,

only here they were predominantly red, blue, and purple, for the Barcelona republican club, and red, white, and blue, in honor of the French republic (as well as the American one). Secular schools sponsored by republican groups also had their own flags. "The colors of the Spanish flag [that is, of the reinstated Bourbon monarchy that ruled Spain in 1888] were scarce, however."[27] Throughout the crowd were scattered French republican bonnets, the red stocking caps traditionally worn by Catalan and French peasants alike.

Pi i Margall's carriage wended its way through Barcelona along Gracia Pass, up San Jeronimo, and across Tibidabo Mountain, reaching the heights of Barcelona's borders. He arrived to choruses of the "Marseillaise" and applause and cheers. After the old man rested, he answered questions with the help of his son Pi y Arzuaga. Students from the republican schools recited poetry. Pi i Margall then denounced the monarchy as an anachronism and called for a democratic republic.[28]

Rituals are symbolic processes whose significance is never fully conveyed by their overt content. Pi, like the Virgin of Mercy, stood for a self-identified community. And his parade, like hers, traced a map of the city on which his group put their stamp.

Because with their rituals republicans engaged in political combat against the city authorities and against the monarchy, such demonstrations would frequently be repressed as they grew in political significance after 1888. This one was not. Concern with tourism at the 1888 exposition, as well as the fact that the festival took place in Vallvidrera rather than downtown Barcelona, may explain why the police did not disrupt what they might have considered an incendiary meeting. This time at least, so long as it did not interfere with the exposition, the authorities were willing to tolerate a republican demonstration.

The Creation of Leftist Traditions

What determined whether a demonstration would be regarded as seditious or not had little to do with its actual content and everything to do with the political situation at the time. As a broad leftist movement, growing from the embryo of Catalan republicanism but increasingly independent of it, gradually took shape in 1890s Barcelona, the police became more wary.

At least as far back as the mid-nineteenth century, small groups of

workers and crafts people in Barcelona had formed associations to improve their working conditions. Like unions elsewhere in Europe, however, those in Barcelona lacked the strength of a movement, which meant that these attempts were largely unsuccessful.

To meet the growing need to coordinate workers and political activists in order to transform social and economic conditions, Mikhail Bakunin, the anarchist, and Karl Marx, the socialist, along with trade unionists from Europe and America, had founded the International Workingmen's Association in 1864. Unlike Marx, who tried to provide scientific explanations for the development of capitalism and the way workers' relationship to the means of production would govern their ability to act, Bakunin stressed the importance of revolution based on community struggles. Drawing insights from movements already taking place in Russia, Italy, and Spain by the 1860s, Bakuninists argued that political oppression, not economic exploitation, would galvanize action among disparate groups of people living in the same place. In Barcelona, the Bakuninist brand of politics appealed to groups as diverse as printers, metallurgists, and neighborhood women.

Guiseppe Fanelli, an emissary of Bakunin's, came to the city in 1868 to win a following for the International Workingmen's Association. While there, he met with an assortment of political activists in an artist's studio on Casanova Street. Many of those who first heard Fanelli (who spoke to them in Italian) were printers, journalists, and illustrators, not factory workers. Many, too, had already been drawn to republicanism, but they were increasingly concerned about the plight of the working classes.

Affiliates of the First International Workingmen's Association in Barcelona—whose members were given the name *anarchists*—promoted ideas about cooperatives and labor unions that would enable workers to keep what they had earned. Coeducational grade schools, night schools, burial societies, newspapers, and journals were also part of anarchist life in Barcelona by the 1890s.[29]

The anarchists and their rivals, the Socialist Workers Party of Spain, which was founded in Barcelona in August 1888, often spoke for a laboring community that neither truly led. On the job, workers continued to improve their working conditions, but they had rarely made themselves visible as citizens with views on how society might be more equitably organized. It was only a matter of time before leftists in general demonstrated their social views and hopes for the future through their own sets of symbols and practices. The opportunity came on May 1,

1890, when socialists throughout Europe and the Americas planned a symbolic general strike.

European socialist political and labor leaders had met in Paris on Bastille Day, July 14, 1889, to form the Second International Workingmen's Association. Among those assembled were August Bebel of Germany, Eleanor Marx of Great Britain, and Pablo Iglesias of Spain. They called for coordinated popular demonstrations worldwide on the first of May, 1890. The symbolic meeting on Europe's most sacred republican holiday, Bastille Day, thus gave birth to Europe's major leftist celebration, May Day. The ceremony that leftists envisioned would publicize working-class determination to win an eight-hour workday and regulation of female and child labor.

The leftists who initiated May Day in Paris wanted it to be a militant demonstration, not a festival. But many leftists, from republicans to anarchists, were afraid they would not be able to maintain any meaningful distinction between demonstrations and celebrations. Even the idea of a symbolic, one-day strike prompted one Catalan republican to complain about this "new celebration that seems rather like the days that plague the calendar: [due to] tradition and the celebration of festivals."[30] But street festivals are fun even for atheists, and the joy of public display and pageantry is not so easily abandoned. The working class in Barcelona unconsciously imitated patterns set by the church in commemorating their own achievements and in demonstrating their hopes for the future.

May Day 1890 became a revolutionary international holiday, complete with anthems, globes enveloped with palms of peace, red carnations, red flags, and, in Barcelona, yellow triangular ribbons emblazoned with slogans calling for the eight-hour day. The demonstration in Barcelona started with a mass meeting at the Tívoli Theater on Gracia Pass, close to the Plaza of Catalunya. The audience heard speakers call for the eight-hour day, an end to child labor altogether for children under fourteen, and a six-hour day for those between the ages of fourteen and eighteen. They demanded abolition of most night work and prohibition of female employment in mines. They called for consecutive thirty-six-hour rest periods every weekend or for a half-day on Saturday. And they demanded that the government regulate jobs dangerous to the health of workers.

About twenty-five thousand people joined in the demonstration, among them marble cutters, shoemakers, tailors, sugar refiners, candy and cake manufacturers, copper smelters, cabinet makers, fabric print-

ers, and members of various republican clubs, artist societies, and trade unions.[31] They marched from the Tívoli Theater down the Rambla to Columbus Pass, then along the harbor to the civil governor's office on the Plaza of the Palace (see map 2). People in balconies above the closed shops on the Rambla cheered the festive demonstrators, who obviously did not appear threatening even to conservative onlookers. The presence in the crowd of so many women and children dressed in holiday finery made the demonstration seem like an ordinary festival. When the parade reached the governor's offices, a delegation was sent up to present their petition for the eight-hour day. The ritual aspects of the procedure were deferential: peaceful supplicants stood below as the governor appeared on the balcony to bestow the political version of a blessing on the crowd. They responded by applauding him. The parallels to religious holidays were obvious to contemporary observers. One journalist compared the first May Day to Holy Thursday before Easter.[32]

Socialists and unaffiliated artisans were willing to accept the symbolic and festive elements of May Day from that first celebration in 1890 on. Anarchist workers, however, remained suspicious about festivals: to them, militant struggle was more appropriate. Several groups among the male anarchists insisted that May Day 1890 should be not a holiday but a general strike. They boycotted the Tívoli Theater meeting and the peaceful march to the governor's offices. Instead they met at Tetuan Plaza at the center of the northeastern workers' section of Barcelona and vowed to strike until they won the eight-hour day. Waving sticks, they marched down Workshop Street to the Rambla and headed toward the harbor, where police stopped them near the Atarazanas Barracks (see map 1). Another group gathered close to the harbor, near the governor's palace.[33]

On Friday, May 2, the shops and the Boqueria Market (Saint Joseph Market) along the Rambla were open as "servant girls, although in reduced numbers, went to market to secure provisions."[34] But anarchists struck the cotton and metallurgical factories in the neighborhoods of Saint Martin of Provence and Sans and attempted to hold another militant strike meeting in Tetuan Plaza. Angry workers filled the downtown area, setting fire to garbage in the Plaza of Catalunya and throwing stones. The governor felt menaced by so many mobilized workers and poised for action in the city center.[35] Captain General Ramón Blanco y Arenas (who a few years later instigated Spain's scorched-earth policy in the war with Cuba), needlessly fearful that there might be an insur-

rection in Barcelona, declared a state of war, thus placing the city under martial law and under his own direct command.

Soldiers took up positions at the Plaza of Catalunya, the Rambla, the Plaza of Saint James, between city hall and the provincial government building, at Tetuan Plaza, and at Saint John's Pass, which workers from Saint Martin had to traverse on their way downtown. But fires blazed nonetheless in the Plaza of Catalunya, and workers walked off their jobs on the railroad and at the docks.[36]

The militant anarchists agreed to assemble again at 9:00 A.M. on Saturday, May 3. From the Tetuan Plaza they moved across the boulevards that ringed the downtown working-class neighborhoods; as they proceeded down the Rambla they shouted for a general strike. When workers on Pelayo Street threw stones at police, the cavalry of the Civil Guard charged, driving everyone out of the Plaza of Catalunya.[37] Troops stationed along the Rambla stopped the march, and shouts rang out in the Plaza of Catalunya. The Civil Guard apparently had orders to shoot if necessary to seal off escape routes and contain the demonstrators in the center of the city, away from the captain general's headquarters.[38]

The militants must have won the support of people who had participated in the peaceful demonstration on Thursday, for an estimated twenty thousand workers congregated in central Barcelona on Sunday, May 4. They filled the downtown areas of the Plaza of Catalunya and the Rambla, where people of all ages, sexes, and classes usually teemed. On this Sunday, though, the female flower vendors, like most women, had withdrawn from the downtown area, afraid of fighting in the streets. On Monday morning, a rumor circulated that the guns of Montjuich would be turned on the streets below. Servants and working women quickly did their shopping and scurried back to their houses.[39] But by Monday afternoon, women had returned in force to Gracia Pass and to the Rambla and the old city, having decided that there would be no more violence.[40]

In the poor people's suburbs, the strike continued. Workers stayed out of the factories in Sans and Saint Martin of Provence through May 11, vowing to stay on strike until they won the eight-hour day, double pay for overtime and holidays, and union membership as a requirement for hiring.[41] Shoemakers, cooks, hatters, and waiters joined the strike, airing their own grievances. The waiters and cooks, who may have belonged to a clandestine union known as the Progressive Society, called

for a full day off every fifteen days. They wanted restaurant owners to pay for cleaning white uniforms, and the waiters demanded that they be allowed to keep their tips (not share them with owners).[42]

May Day became emblazoned on the consciousness of the working population of Barcelona, which after 1890 continued to celebrate the day as a festival whenever it was permitted. The way this new civic ritual established itself in 1890 indicates how political struggles become part of traditional ceremonies. The mass meetings and the march through the city, which were part of a wholly peaceful demonstration, came to assume ritual form in later May Day celebrations.

Of course, many elements of the first May Day, especially the political processions, are so common in any demonstration that their meaning is often blurred. Yet a peaceful communal march, such as the one that started at the Tívoli Theater, can have greater impact than a more violent one in which women and children are not present. Although many anarchists criticized the notion of a "festival of labor," which May Day increasingly became after 1890, the repetitive symbolic seizure of the city by working women as well as men ritually represented a world in which their concerns might jointly prevail.[43] Laboring groups were creating their own alternative community on May Day, one in which "work will not be the object of iniquitous exploitation but an endeavor whose fruits will be equally divided."[44]

The Virgin of Mercy Bombing

When masses of people gathered in central areas of the city, they were legitimated as spokespeople for a self-identified community, which is one reason why the police repressed militant workers. The organizers of any festival had first crack at determining the meaning of the celebration. But others could interrupt the celebration, effectively acting out alternative meanings for a largely illiterate audience.

In 1892 and 1893, social disorder rocked Barcelona as bombings and assassinations, often touched off by police and government repression, plagued public life. The violent antagonism of Captain General Arsenio Martínez Campos to the growing union movement led to intensified persecution of leftist political organizations in Barcelona at this time, when throughout Spain the government was increasingly cracking down on the labor movement. With associational life threatened, expe-

rienced leaders jailed, and real or suspected activists subject to torture by army officers and the police, individuals who thought they were acting in the interests of a self-defined community took matters into their own hands. Downtown Barcelona became a political theater, a war zone.

It was in the streets that the city's political struggles were played out. Even though officials traveled everywhere without guards and so could easily be assassinated, terrorists used the streets as their forum, making their political points in ritualized ways. Militants sought out and attacked repressive leaders in front of an audience, the better to argue for the power of the people to resist.

On February 9, 1892, four alleged anarchists blamed for an insurrection in faraway Jerez de la Frontera were executed. This event launched the cycle of repression and terrorism that tore Barcelona apart that year and the next, culminating in an assassination attempt at the Virgin of Mercy Day celebration of 1893.

First, in February, someone in Barcelona set off a bomb at the Royal Plaza just off the Rambla (presumably in retaliation for the executions), killing one and injuring three.[45] Throughout the spring and summer of 1892, the violence escalated. In March, a bomb exploded in the Boqueria Market. Later that month and again in May, bombs went off at the electric company near the Plaza of Catalunya. In May, too, another bomb failed to detonate on Jaume Giralt Street. July saw the dynamiting of the home of the director of the Association of Wool Manufacturers.[46] All this activity was believed to emanate from the left.

Strike waves and bombings ended with the imposition of martial law throughout Barcelona in July 1893. The police then ransacked the working-class neighborhoods. An anarchist paper reported: "The police have detained some of us in our homes, others in the street, and others in working-class centers for no other reason than our ideas about justice and emancipation or because we belong to legally constituted workers' associations."[47] Demonstrations and police attacks persisted, and the army moved in to carry out roundups of labor militants. In the spring of 1893, authorities seized Teresa Claramunt, leader of the textile workers' union, and her companion, Jaume Prats. Because the province was under martial law, they were placed before a war tribunal and charged as rebels; they were later released.

It appears that the government opposed any and all glimmerings of communal solidarity among Barcelona's citizens. Officials were no more happy with regionalists than they were with the far more threatening

leftist workers and those who retaliated against the government on their behalf. At the May 1893 Floral Games, a guest speaker from Galicia induced the crowd to burst into cheers for Galicia and Catalunya, much to the disgust of Captain General Arsenio Martínez Campos. A career officer, he had led the coup that overthrew the First Republic in 1874. In spearheading the attack on leftists in Barcelona, he was equally obsessed with overcoming regionalism: federalism, in his view, was the political equivalent of anarchism. He thus responded angrily to the crowd's cheers for autonomy, claiming that he would have remained at home and sent his troops instead had he known that such seditious activities would be taking place.[48]

Given this political setting, the Virgin of Mercy Day celebration scheduled for September 24, 1893, must have aroused public fear. Later, the well-known Catalan poet and playwright Augustí Calvet (called Gaziel) recalled attending the parade as a boy of six. An inappropriate military display had been added to the festivities that year, surely to intimidate people outraged by widespread political repression. Although many adults were angry about the addition of a military review to the usual parade, the little boy was enchanted: "The soldiers . . . were tall men with beards, like the *gegants* in processions."[49]

As the troops approached the reviewing site at the corner of Muntaner and Main streets, in a working-class enclave west of the Plaza of Catalunya, a single man, Paulino Pallás, carrying a bomb in each hand, approached the place where Martínez Campos waited on his horse. Pallás tossed the bombs at the assembled officers. At first smoke obscured the damage. When the air cleared, the captain general was on the ground and another general, Luis de Castellví, was apparently seriously wounded in the right arm and knee. The bomb had also injured Generals Molins and Bustos. It turned out that Martínez Campos was merely scratched; but a nearby member of the Civil Guard, Jaime Tous, had his legs blown off and died half an hour later in the hospital, and an unknown peasant was trampled to death by the horses. As Gaziel remembered the scene following the bombing:

Two deep and vague explosions resonated as the troops drew to order. They came like a strange vibration of the air, but nothing at first alarming. All at once, with nothing more occurring, we began rocking and everything went crazy— surprisingly and furiously crazy. A terrible sound broke out, punctuated by small hysterics, with the sound of troops rattling and a sound of horns such as might sound the end of the world. Some of the soldiers remained immobile and stupefied. Others broke formation as if they were ready to run. Others, here and there, as if ripped by panic, pointed their rifles at the people. With that, the

crowd began to flee; perhaps the soldiers were attacking and beating them with their sabers. I closed my eyes and when I opened them, we three remained alone, in the middle of a fleeing multitude.[50]

The street was covered with hats and batons as people fled. Observers later wrote that the Civil Guard panicked, shot into the crowd, and wounded numerous women and children who were trying to escape.[51]

After his attempt to kill Martínez, Pallás went home and quietly waited to be arrested. At his house, the police found anarchist literature and photographs of the alleged Haymarket bombers of Chicago, the anarchist leaders who were railroaded to their deaths because of another police riot in 1886. The police claimed that Pallás had in his possession letters from France telling him how to carry on a social revolution.

Paulino Pallás, born in 1862 in the village of Cambuls in the Catalan countryside, had migrated to Argentina and Brazil along with countless others looking for work. A printer by trade, he had had to find other jobs after long periods of unemployment. At the time of his arrest, he worked at home with his wife and three young children, doing garment piecework on two sewing machines. On the morning of the attack he had left the house at 7:00, saying to his wife that he would not return until that night. On September 28, four days later, he was tried before a military court. The next week, in the courtyard of the Castle of Montjuich, on the heights above the city, the executioner garroted him. Avengers would certainly respond.[52]

The subsequent detonation of a bomb in the Church of Saint Just and Pastor, one of Barcelona's oldest chapels, located a few hundred feet from City Hall and the provincial government building in the Plaza of Saint James, led to further arrests. Suspecting a conspiracy centered on the Catalan Café, where Pallás was a regular customer, police flooded the café with informers. The roundups led to increasingly violent rhetoric in anarchist newspapers. Cooler heads could not always prevail, especially since the police and army had rounded up most of those anarchists and socialists with any experience in leading strikes and other organized activities. More violence was bound to occur because of the repression, and it did.[53]

The Corpus Christi Bombing

Since every ritual is a symbolic performance, opponents sometimes attack a whole system of ideas when they attack a ritual. Cor-

pus Christi Day, a particularly enjoyable folkloric holiday in Barcelona, was one of the first rites the city ever celebrated. Like Venice and Constantinople, Barcelona claimed to have acquired a fragment of the true cross in the late Middle Ages. From the fifteenth century on, the city thus had a pretext for a late spring procession in which people from all classes marched.

When the procession was bombed on June 7, 1896, with five killed, the attack was widely treated as if it had sullied everyone in the city. No one knows who was responsible for the bombing. The police took three months to fabricate a case, meanwhile arresting and torturing numerous people who had been engaged in union struggles throughout the nineties. But whoever did it, the city was outraged.

Beautiful, stately, lewd, and raucous, Corpus Christi Day took in a wide range of the elements that Catalans so enjoyed in their public life.[54] As in the Virgin of Mercy festival, the procession included *gegants;* but because Corpus Christi celebrations were not citywide but involved individual churches, competition for the most elegant *gegant* added an edge to the merrymaking. The *gegants'* hair and beards were modified annually and changed completely every five years for the day. Dressed in the latest fashion, the female *gegants* set the standard for women's spring styles, keeping Barcelona's dressmakers working at a ferocious pace the week before Corpus—and further taxing the vision of poor seamstresses (figure 2).[55]

The easy acceptance of the grotesques among the participants in the pageant reveals the many layers on which Corpus Christi Day worked as a civic rite. Ideally, the celebration provided a place for adherents of traditional religion as well as for celebrants unattached to a religious community. The authorities, who recognized that the carnivalesque side of the festivities offered opportunities for sedition, had canceled observance of Corpus Christi Day during the unstable period from the revolution of 1868 through the years of the First Republic, 1873–1874.

Corpus Christi Day processions left from different churches. City and national officials stationed in Barcelona joined the parade that since the fourteenth century had wended its way from the cathedral to Saint Mary of the Sea. The priests, the bishop, his retinue, and representatives of the historic guilds of the city—the dyers, bleachers, shoemakers, tailors, and ironworkers—marched up front.[56] Behind them came men carrying the relic of the cross and the host. Following them, but still ahead of the little children celebrating their first communion and the rest of the common people, marched the military, who did not appear in the parades from the other churches.[57]

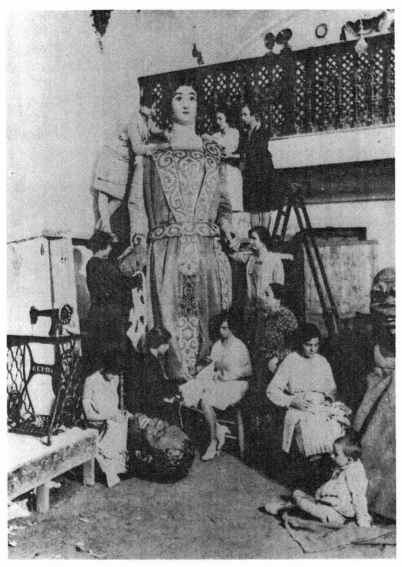

Fig. 2. Seamstresses repairing a *geganta*. Courtesy of Arxiu
Mas, Barcelona.

From the exit in front of the cathedral where the procession began, the marchers, led by the *gegants,* passed through the Plaza of the Angel to Boria, Wool Plaza, and the square in front of the Chapel of Marcus; it then proceeded down Montcada Street to Born Plaza, Street of the Glassmakers, and through Old and New Transit (streets which disappeared with the urban renewal of 1908 to 1911) to the old mercantile aristocracy's church of Saint Mary of the Sea (see map 2).

At 8:40 on the evening of June 7, 1896, just as the host was entering the church and the end of the procession had reached the alley known as New Transit (Camvis Nous), bombs exploded. Two bombs, thought to be meant for the captain general or the leading church officials in Barcelona (who had entered the church ahead of the host), killed five people on contact, including two children, a boy and a girl. The explosion also fatally wounded a music student, who died at home. Another forty people at the rear of the procession were severely hurt.[58]

The common funeral—organized by the city—provided a foretaste of other cleansing rituals that communities would perform in Barcelona for the next forty years. If civic rituals cemented the bonds of unity, attacks on defenseless people enjoying urban theater were perceived as a sacrilege of communal life, a violation of the rules of public behavior. Thus, the funeral rite had to attempt to restore what had been destroyed. A procession led by the municipal guard, the Almansa army regiment band, and the clergy of Holy Cross Hospital proceeded from the hospital, which had served as the mortuary for those killed. The two white funeral coaches of the murdered boy and girl, covered in white flowers donated by the women flower vendors of the Rambla, followed the military band. Next came four black coaches, the final transport for the working-class housewife, journalist, shopkeeper, and music student killed in the blast. After them marched the bishop, captain general, civil governor, acting mayor, chief judge, president of the provincial government, and the entire city council.[59]

The cortege, followed by two hundred thousand mourners, went down Carmen Street to the Rambla, passed the flower market, and moved down to Columbus Pass. All stores were closed, their lights lit to proclaim sympathy with the mourners. Except for the bands, and despite the crowd, silence hovered over the route. In an eerie touch, at 5:45 P.M. the Provincial Charity House paid its own tribute to the dead as its house band, *gegants, nans,* and equestrian drummers in troubadour garb solemnly performed for the victims just then going past.[60]

The government then proceeded according to another ritual familiar

in Barcelona: the captain general declared a state of war, thus suspending constitutional guarantees and giving the army a free hand. Soldiers and police arrested over four hundred dissidents, including people who lived in common-law marriages and women who refused to baptize their children. It took the whole summer and widespread use of torture before the police came up with suspects and a purported plot. According to the official story, five anarchists who frequented the Bisbal Bar in the Parallel had planned the bombing and won support from workers and lecturers at the Jupi Street teamsters' night school and community center. No motive was ever alleged. Despite a popular campaign both in Spain and abroad protesting against the institution of a new Spanish Inquisition, five men were executed in the courtyard of Montjuich Castle in November 1896, and hundreds of others remained in Spanish prisons for more than a year.[61]

Conclusion

For the predominantly illiterate population of Barcelona at the turn of the century, street life was a way of knowing and a way of being. Civic rituals helped to socialize peasant immigrants by teaching them how to participate in an urban community. But which community, and in pursuit of what goals? There is no question that street spectacles presented a pleasant alternative to the grim life that working-class people led in factories, shops, and dank apartments. Most people probably attended most parades: the sense of shared relaxation that this form of civic culture provided could, after all, result equally from spectacles organized by anarchists and socialists in their May Day demonstrations, from holidays initiated by republicans, or from civic and religious rites sponsored by Catalan nationalists or the church. Viewing and participating in public celebrations were a staple of life in the red city.

Terrorist attempts to assassinate the governor general of Catalunya during the celebration of Virgin of Mercy Day in 1893 and the bombing of the Corpus Christi procession in 1896 represented rituals of desecration; poor people were injured and died as a result, and leftists were persecuted. In fact, the systematic roundups and imprisonment of political activists, as well as the widely publicized executions of terrorists like Pallás and the five anarchists accused of the Corpus Christi bombing, constituted yet another civic ritual in late-nineteenth-century Barcelona.

This one, however, was organized by the state to intimidate unionized laborers, whether terrorists or not.

Rituals embodied a sense of community and solidarity for the left, the right, and the entire town. Some rituals provoked counterrituals; hence, rituals could express or give rise to struggle as well as solidarity. Some ceremonies celebrated the status quo, and others argued for an alternative culture. But of course, rituals, like culture, are constantly changing.

Before radio and television, street rituals provided common people with visual statements about what was going on in their communities and where political lines were drawn. In the streets, the "common people" and the elite defined themselves in opposition to one another. Those familiar with this kind of politics would understand that the rituals themselves were part of the struggle. Marching down certain streets, reaching certain plazas to hold demonstrations, represented an assertion of community and solidarity that words alone could not convey.

2

Popular Art and Rituals

Leaving a feminist conference in Barcelona in October 1988, I stepped right into a parade going down the Rambla. Representations of President Ronald Reagan and Spanish President Felipe González looked like *nans* I knew from Corpus Christi and Virgin of Mercy Day celebrations. The crosses of Corpus Christi had become missiles, and the traditional eagles and bulls had become warships. There were signs that proclaimed opposition to NATO. And one demanded, "Make Art, Not War!"

Such a slogan was particularly appropriate in Barcelona, a city that for a hundred years has prided itself on its artistic traditions. Despite the many artists and artistic movements that Catalunya has produced since the Middle Ages (including its claim to have nurtured Picasso), the regional cult of art and pride in indigenous traditions really dates to the turn of the century, when so many other forms of local awareness also emerged.

Just as one who arrives in the middle of a performance may or may not understand the play, the young Picasso, who came to Barcelona in 1895, may or may not have understood that he was witnessing a community in the making. The particular new community with which Picasso would be most intimately involved had its beginnings in the Four Cats Café and Art Gallery, open from 1897 to 1903.[1] Financed by Santiago Russinyol i Prats and managed by Pere Romeu and Miquel Utrillo, the café became a kind of secular shrine, filled with objects of devotion peculiar to its own religion. There, where artists mixed with

artisans, and where Pablo Picasso had his first exhibit in 1900, the same artists who introduced avant-garde art from Paris resurrected forgotten artists like El Greco and promoted interest in ancient regional crafts such as ceramics. Popular local pastimes such as puppet shows became aesthetic rites. Not just a bastion of lost arts, the Four Cats functioned as a clearing house where budding artists like Picasso learned about the artistic trends of the time in a community free of snobbism about artistic hierarchies. Breaking with Western traditions in which the aristocracy, the high clergy, and the wealthy determined value in arts and decoration, Barcelona's new artistic movement was based on the union of bohemians and artisans and on their recognition both of the merits of past artistic styles and of crafts and entertainments popular among common people but never before considered art.

The official art of late-nineteenth-century Spain was dominated by academic and romantic historical painting. Its bastion was the Llotja Art School, where Picasso's father was a professor. Forced to matriculate, Picasso stayed only a few months before he succeeded in escaping in late 1897. For more than a decade before his quick retreat, other local artists, with an inkling that something exciting was going on abroad, had been traveling to London and Paris. They returned bearing news about art nouveau, impressionism, postimpressionism, and symbolist art. In appropriating new styles, they also developed sympathy for non-Western arts. But long before Picasso became familiar with Iberian sculpture and African masks in the early twentieth century, he and other artists throughout Europe were fascinated by the primitive within—earlier art forms and folk art from the countryside around them.[2] The exhibit of Gothic painting and sculpture at the 1888 Universal Exposition in Barcelona had already effectively challenged academic art by introducing the Catalan public to medieval religious painting and sculpture, never before treated as art.[3]

A distinction among "high," "popular," and "folk" arts had not yet come into being in turn-of-the-century Barcelona, for the latter two were not considered "art" at all. Popular entertainments such as shadow and hand puppets were certainly never regarded as art until Miquel Utrillo and Pere Romeu, fresh from Paris, reexamined puppet shows in a new light. Folk arts, including wooden carvings for churches or votive paintings produced by artisan painters to commemorate escapes from disaster, came to be considered art only after critics like Russinyol proclaimed their ability to meet his definition of the word, which was that they transform consciousness. For Santiago Russinyol, Miquel Utrillo,

and Pere Romeu, art, whatever its physical nature, had to provide a means for overcoming the lack of spirituality and the commercialism they associated with modern life in the industrial city of Barcelona.

While civic rituals imitated and transformed Catholic pageantry in the streets, artistic rituals were, as we shall see, doing the same at Russinyol's villa at Sitges, as well as creating at the Four Cats Café a new artistic community, one that Russinyol perceived in quasi-religious terms. Using art to try to direct life in Barcelona toward more spiritual goals, Russinyol attempted to establish it as the secular equivalent of religion, with artists as the high priests. To him, being an artist meant practicing "the religion of art and truth, crystallizing aspirations in work, dominating the base and profane world, and demonstrating an ideal by finding divinity in human beings."[4] Given to depression, Russinyol frequently altered his own consciousness through the use of morphine. He sought to change popular consciousness as well—through painting, through the establishment of the Four Cats Café, and, increasingly, through his work as a playwright.

Santiago Russinyol

Had Russinyol been a character in one of his own plays he could not have been any more colorful. Born in 1861 into a wealthy family of textile manufacturers, he was orphaned in youth and raised by his grandparents. Whereas his brother, Albert Russinyol, took over the family business, exploited his workers, initiated a major labor struggle in 1909, and helped to found the Catalan nationalist Regionalist League, Santiago was an entirely different type.[5] A maverick, he outraged his grandparents by deciding to become a painter. To their consternation, he took painting lessons from Tomás Moragas, Barcelona's leading watercolorist, and then, in 1878, moved to Paris with his lifelong friend Ramón Casas.[6]

Two prosperous young men, Russinyol and Casas were always eager for artistic adventures of all kinds. They had traveled through Catalunya by wagon in the 1870s, and it was probably during these trips that Russinyol first became seriously acquainted with popular village entertainments and indigenous artists. Now the artistic revolution going on in Paris drew them irresistibly. They attended the Gervex Academy, and Russinyol worked with Puvis de Chavannes and Eugène Carrière. They

shared a room above the Moulin de la Galette, the bohemian nightclub in Montmartre that was a Mecca for the young avant-garde of Paris. By mingling with painters and musicians like Henri de Toulouse-Lautrec, James Abbott McNeill Whistler, and Erik Satie, Russinyol and Casas absorbed the most radical ideas of the new French artistic pioneers.[7] Russinyol, moreover, became Catalunya's prophet of the new art by reporting on creative developments for various Barcelona newspapers. Together, too, he and Casas, by returning for a joint exhibit at the Parés Gallery in 1890, helped to carry the message of avant-garde art back to Barcelona. Constantly expanding his own artistic skills, Russinyol began writing monologues in 1890, and by 1891 he was turning out full plays. Even more than painting, the theater may have provided Russinyol with the sense of community that he seemed to crave. In every endeavor, he was a showman.

Russinyol inherited a large part of his wealth in the nineties, and he commissioned the Catalan nationalist architect Josep Puig i Cadafalch to build him a villa at Sitges, about twenty miles south of Barcelona. In the eighties, Russinyol had begun buying up Catalan antiques, among them wrought-iron Visigothic crowns, keys, candlesticks, and iron work from church grilles, appreciating their rough, earthy, raw quality. Unlike Castilian blacksmiths, who worked iron in the same intricate patterns as silversmiths and goldsmiths, Catalan artisans liked and respected the material's own particular character. Russinyol did too, and he built the Sitges house to serve as a reliquary for these craftspeople's work.[8] Nicknamed the House of Iron, the villa became an emblem of the kind of artistic community that Russinyol hoped to create.

In 1892, 1893, and 1894, Russinyol periodically drew the cream of Barcelona's artistic community to what he called "modernist" festivals in Sitges. The first Modernist Festival, in 1892, included a folk opera commissioned by Russinyol for the occasion, to demonstrate that peasant life was a suitable subject for art. The next year saw the performance of a Catalan translation of Maurice Maeterlinck's first play, *L'intruse*.[9]

Then, on November 9, 1894, Russinyol adapted ritual practices from Barcelona's holiday celebrations to what one journalist called a "spectacle of civic religion" honoring art.[10] The villagers in Sitges prepared for the event as they would for a Catholic festival. Along the route of the planned procession, people decorated their balconies and windows. The parade itself began at the Sitges station, where Barcelona's leading artists were greeted by a receiving committee with Lluís Lambarta and Pere Romeu on horseback in the lead, holding a Catalan flag

aloft. The artists then joined the quasi-religious procession, made up of Russinyol, the city officials, and the two mounted escorts.[11]

It was common in religious processions for people to carry effigies or relics, and the same was true of the artistic pageant at Sitges, in which avant-garde artists Ricard Canals, Ramón Casas, Joaquim Mir, and others known for their agnosticism or outright anticlericalism carried two tabernacles containing El Greco paintings, one of Saint Mary Magdalene, the other of Saint Peter. Catalan interest in El Greco dated to Santiago Russinyol's purchase of two works by the painter from a junk shop in Paris, discovered by his friend the artist Ignacio Zuloaga.[12] Russinyol's delighted response to the El Grecos, with their metallic colors and elongated bodies, reflected his appreciation for what was distinctive in popular folk art. Underrated and neglected for over three hundred years, El Greco's style was as new to Russinyol and his friends in Barcelona as that of Paul Gauguin and other avant-garde artists they had learned to appreciate in Paris. In fact, the local people in Sitges seem to have thought for a long time that El Greco was a contemporary artist whom Russinyol was trying to help.[13]

After the El Grecos were paraded through the street on that November 9, the 150 writers and artists invited from Barcelona lunched under tents on the beach. Following the meal, they retired to the main hall, where Russinyol himself launched a series of lectures and poetry readings. Outlining his religion of aesthetics, he railed against modern life, which, he said, offers "everything for the miserable flesh and nothing for the noble spirit." He attacked the old aristocracy, "which ruled through force," and modern society, which "exalts science and material life," has destroyed religion, and "will destroy artistic sensibility unless artists and writers take up the challenge and substitute the worship of art for religion and science."[14] "Balanced between sentiment and childish energy," in the words of a local journalist, Russinyol became the leader of the "party of religion and art" in Barcelona.[15]

The Four Cats Café

Sitges was too far from the city to serve as the main cathedral of the new religion of art. For that purpose, Russinyol, Casas, and Utrillo created the Four Cats Café, hiring Pere Romeu to assist Utrillo in managing it. Close to the Plaza of Catalunya, the café, art gallery,

puppet theater, and beer hall occupied the ground floor of a small apart-
ment building designed by Puig i Cadafalch (see map 1). On the sign at
the entrance to the café was a picture of some mischievous cats attrib-
uted to the young Picasso.[16] The name Four Cats had two sources. One
was a Catalan saying, "No one's here but us four cats"—meaning a
gang. The other source was undoubtedly the Chat Noir, the famous
Parisian café where Miquel Utrillo and Pere Romeu had begun their
artistic careers manipulating shadow puppets.

 Although shadow puppetry now seems exotic, it was a popular enter-
tainment in late-nineteenth-century Paris and Barcelona. More than any
other popular art, it represented a blend of sound and illusion, much in
the vein of movies and music videos today. Shadow puppet theater re-
sembled cinema in other ways as well. Sometimes lewd, puppetry was
not considered cultivated—though, like film, it could be arty. Unlike
stage plays, shadow puppet acts were seen on a white screen in a dark-
ened room, thus promoting the dreamlike state that morphine users
like Russinyol sought, a sense of totality. Then, too, the experience of
drifting into a fantasy world structured by images projected onto a
screen was shared with a larger public—another parallel with the
movies.[17]

 From the early nineteenth century on, shadow puppetry had been
popular in Barcelona.[18] The screen, slicked down with oil or water to
make it translucent, was usually set up in a large apartment or loft. The
"actors" were heavy cardboard figures mounted on wooden bases. Wire
strings attached to movable heads and joints enabled the jumping-jack
characters to engage in swordplay, coy manipulations of fans or hand-
kerchiefs, or broad head movements. More refined action was inhibited
by the fact that the audience was seeing everything in silhouette.[19] Lan-
terns in which lime was burned provided illumination (limelight) until
finally, at the end of the nineteenth century in places like the Four Cats,
electricity could provide the steady stream of light that brought scenery
and characters into sharp relief.[20]

 The plays varied. At first, little comedies focused on dramatic mo-
ments like lion hunts and falling bridges, but the audiences tired of such
scenes, and so, gradually, narratives emerged.[21] Romantic stories of love
and death based on popular legends appeared in shadow puppet plays
performed in Catalan in the 1830s; then farces with their bawdy over-
tones—so popular in legitimate Castilian-language theater—entered
the repertoire, as well as presentations of such popular entertainments

as bullfighting (prefiguring Picasso's ink-blot toreadors of almost one hundred years later).[22]

Pere Romeu and Miquel Utrillo brought to life Russinyol's dream of using aesthetic experiences to create a sense of artistic community. Pere Romeu—puppeteer, auto mechanic, roller-skating rink operator, gym owner, cabaret proprietor, and sportsman—was just the kind of artistic entrepreneur Russinyol was looking for to guide the project. Lincolnesque in both height and homeliness, he was also short-tempered and brusque.[23] He looked like a habitué of the Parisian Latin Quarter; according to the visiting Nicaraguan poet Rubén Darío, "he had a long face surrounded by stringy black hair, below which was a huge tie that trumpeted its loud colors to shock the bourgeoisie."[24] He was a late-nineteenth-century bohemian who believed that his life was an attack on bourgeois materialist values and that he was born to make art.

Romeu seems to have come alive in Paris when he was in his early twenties. He took Toulouse-Lautrec's friend and subject, the cabaret manager Aristide Bruant, as a model for the role he hoped to play in promoting artistic entertainment, bringing together avant-garde craftspeople and artists and providing an atmosphere where art could flourish amid popular entertainments.[25] In the meantime, he found work in cafés, where he developed his skills as a puppeteer. In the mid-eighties in Paris, he met Miquel Utrillo at the Chat Noir. Utrillo, one of the few avant-garde Catalan artists actually born in Barcelona, was a lifelong folklorist. He sometimes performed Catalan dances like the *cirici* in Parisian cafés, seeking to acquaint audiences with folk dances that he found both beautiful and strange. More of a student and scholar than Romeu, Utrillo had been trained as an engineer, and he went to Paris to work at the Institut National Agronomique. But his heart was in cabarets. He worked with Théophile-Alexandre Steinlen, the socialist illustrator who contributed drawings to the *Chat noir,* the journal published by the cabaret. It was through a job as correspondent for the Barcelona newspaper *Vanguardia,* however, that Utrillo managed to support himself in Paris between 1889 and 1893. He had an affair during this time with artist Suzanne Valandon and may have fathered her son, the painter Maurice Utrillo, to whom he gave his name.

Utrillo's technological skills and his artistic interests drew him to shadow puppetry, with which he must have been familiar from his childhood. In 1891, he enticed the composer Erik Satie into providing

music for a puppet show he was producing in the basement of the nightclub Auberge du Clou.[26] As a trained engineer, Utrillo was an expert at special effects. He knew "how to bring together art and science as brothers, to obtain rare contrasts of color with changing effects of light," Russinyol reported.[27]

Utrillo and Romeu traveled with Léon-Charles Marot's Théâtre des Ombres Parisiennes to the 1893 Columbia Exposition in Chicago, where the shadow puppet plays "Le virtuose" and "Une page d'amour" by Steinlen and "La conquête de la lune" by Miquel Utrillo were scheduled.[28] When the fair closed, Utrillo went on to Cuba and then New York, where he again worked on puppet shows for a while before his return to Barcelona in 1895. Romeu, for his part, traveled to New York and San Francisco, making contacts with puppeteers along the way. He returned to Barcelona and participated in the Modernist Festival that Russinyol organized in Sitges in 1894.[29] Three years later, in 1897, he and Utrillo helped to found the Four Cats, where they almost immediately launched shadow puppet performances.

The people whom Pere Romeu attracted to the café were bohemian artists, a few of them independently wealthy but most lower middle class. They came largely from artisanal families ranging from noodle and button makers, who lived above their shops, to jewelers and ironmongers. There was the tailor Benet Soler Vidal, nicknamed "Scraps," who traded suits and pants to young dandies like Picasso in exchange for individual and family portraits. Juli González, whose whole family were wrought-iron workers responsible for balconies, door knockers, lamp posts, and gates patterned on ancient motifs, also frequented the Four Cats, as did the jeweler Lluís Bonnin. González moved to Paris and became a sculptor; Bonnin, who tried his hand as an illustrator and a painter, moved to Nice in 1900, where he remained a jeweler. Other habitués were Julià Pi and his father, Juli, who doubled as a messenger for the borough of Gracia when he was not creating the plays for hand puppets that he and his son performed together at theaters and cafés.[30]

Utrillo, Romeu, and Russinyol promoted the integration of avant-garde Parisian art with popular art at the Four Cats and to that end launched a shadow puppet theater there in December 1897. The first performance of the *sombras artísticas,* artistic shadow theater, used sets designed by Utrillo and Ramón Pitxot. Two more programs were presented before April 1898, when the shadow plays were discontinued.[31] Although shadow puppets, as Utrillo and Romeu conceived them, created a total theater of the senses, blending music, movement, and paint-

ing, they proved no match for silent films, which began to open in Barcelona in the late 1890s.

Hand Puppets

Far more popular than shadow puppets were realistic hand puppets, a popular entertainment of peasants and working-class people throughout Catalunya. Introduced to the Four Cats in 1898, they played a significant role in keeping the café open until 1903. With different, more ribald and bawdy roots in the folk culture of the countryside than shadow puppets, hand puppets appealed to a much larger, less sophisticated audience. In fact, puppet theaters permeated the working-class district near Citadel Park, especially along Princess Street at the edge of the Gothic Quarter. There were many theaters near the Rambla of Catalunya, near the Plaza of Catalunya, on Sadurni Street, and on Robador Street, in the old political and cultural centers of Barcelona.

Besides the theaters devoted entirely to hand puppet productions, intended for the whole family and performed with music in the Catalan language, some cafés presented puppet plays as well. The puppet café district centered on Robador Street and Saint John's Flats, a block away from the Four Cats—which, to a certain extent, vied for attention with its more plebeian competitors.

The Four Cats played an important role in reintroducing artists to the popular art of hand puppetry. Rubén Darío, understanding no Catalan, had plenty of time to reflect on the ambience around the puppet show at the Four Cats when, in 1898, he visited the café at Russinyol's invitation:

The bocks of beer circulated to the high-pitched sound of the puppets. Naturally, puppets at the Four Cats spoke in Catalan, and I could hardly understand what was going on in the play. The story was of local interest, and it must have been swell considering how hard the audience was laughing. I couldn't understand what the characters were saying, but they carried sticks as in Molière's plays, and the military was subjected to ridicule. The set designs were truly beautiful. It is clear that whoever designed the miniature theater did so with love and care.[32]

The puppet theater was like a civic rite in a small space and became a metaphor for the community that the founders of the Four Cats hoped

to create. Many artists, Ramón Casas chief among them, contributed to the impression that the Four Cats was a magical world in which everyday life was transformed into something beautiful and sublime, in part by means of puppetry. Dissolving the distinction between reality and illusion, Casas and Utrillo depicted Romeu as a puppet actor on the ceramic decorations they designed for their *modernista*-style puppet stage in 1898. These show a modern woman striding through a field of iris, being greeted by familiar characters from Catalan hand puppet shows. Among the spirited denizens of this world are the Devil, a member of the Civil Guard, and Pere Romeu himself, decked out in the *anima*, or inner glove, that serves as the puppet's body under its outer layers of costumes.[33] Here, then, Casas and Utrillo were using the traditional Catalan craft of ceramics to express modern themes in a *modernista* style.

As Casas's 1898 poster for the puppet theater indicates, the puppets became the emblem of the Four Cats (plate 1). In the ad, Casas showed himself to be a master of the Japanese-style, flattened patterns characteristic of prints then being produced in France. Another source for the flattening may have been the folk paintings that hung on church altars all over Barcelona. The poster casts Pere Romeu in his role as puppeteer. Against a gray background like those that Whistler was making famous in Paris, he is portrayed with his hair worn long in bohemian fashion, falling from beneath his broad-brimmed hat. As puppet master, Romeu has turned into a dark puppet with fixed hands. In the lower right triangle of the poster is depicted the chief puppet used in the shows that puppeteer Juli Pi gave from 1898 until the café closed in 1903. With his regular features, short hair, and red blouse, the painted puppet is representative of the sort of realistic hand puppet used in late-nineteenth-century Barcelona. Above the figures at the top of the poster are the words *Puchinell-lis,* which strictly speaking means marionettes, though these were hand puppets.

The avant-garde artists of Barcelona associated with the Four Cats viewed the puppeteers as pure showmen who were rooted in folk culture. And they were right. At country fairs, it was common for the traveling puppeteer simply to throw a cape over his head, lift his arms, and perform his puppet show wherever the crowds gathered (figure 3). In the city of Barcelona, puppet shows had by the 1860s become a popular family entertainment enjoyed by the city's new immigrants and people of all classes. They were beloved theatrical events that, for the price of a cup of coffee, anyone could enjoy.[34]

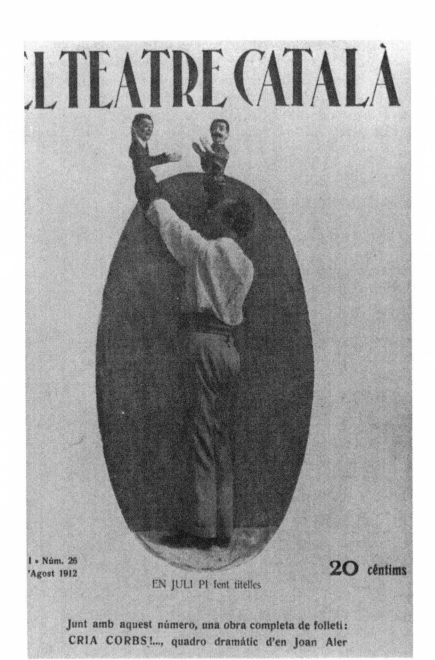

Fig. 3. Puppeteer Juli Pi demonstrating his technique. Courtesy of the Institut Municipal d'Història, Casa de l'Ardiaca, Barcelona.

Puppet shows, like street pageants, were communal rituals that reaffirmed shared traditions. Audiences in turn-of-the-century Barcelona knew the plots and characters of most of the puppet plays and probably derived pleasure and reassurance from their predictability, much as they did from the constancy of civic and religious rituals. The ubiquitous protagonists, Tofol and Titella, both had long histories in European theater dating back to the sixteenth-century commedia dell'arte. That earlier improvised comedy's Christofi Pulcinella became Punch in England, Hanswurst in Germany, Cristoval Polchinella in Spain, and Cristofol or Tofol in Catalunya.[35]

Like so many of Barcelona's immigrants, Tofol was a peasant, a classic bumpkin, natural and naive rather than stupid. He was also the classic sly peasant, always sensitive to matters concerning his own world. Tofol bore up under all his misfortunes and usually outsmarted his enemies, as often through his witlessness as through guile. Tofol "[suffered] all injuries, even those meant for others. . . . If the Devil [tried] to land a blow on Titella, you [could] be sure that Tofol [would] arrive just in time to receive it. He [could be identified] by his short black beard and the vacant expression on his face."[36]

Titella, the other male lead in Catalan puppet shows, was not as feisty or violent as his counterparts Guignol in Lyon or Kaspar in Germany.[37] Titella often had a boyish, ruffian quality immediately recognizable in Barcelona's newspaper boys and in the kids who collected trolley tickets. Tough on the outside, Titella was basically a good soul and, despite mishaps, frequently came out on top.[38] He usually outsmarted those around him by his humor and fast talk. It is culturally significant that, like many of the new immigrants, he spoke Catalan mixed with Castilianisms.[39]

As in myths and children's stories, the plots of the puppet plays were both repetitive and infinitely various. Titles point to numerous categories: there were the sentimental stories "Rose the Blind Girl" or "The Lost Daughter"; for bawdy comedy, "The Cave of the Moorish King" or "The Soldier and the Servant Maid" would do; for straight comedy, there was "The Servant with the Beret" or "Braying for the Lost Donkey"; and the political twist could be had with "The Incendiaries."[40] Because puppet shows reflected popular consciousness, the repertoire was quite sexist. Two recurrent female characters were featured. One was Marieta, a Judy figure, who was always tired owing to her difficult life. Her condition did not warrant viewers' sympathy, however, since part of her trouble came from deceiving her husband or some other

male who depended on her.[41] She frequently interacted with an older woman called La Cascarria—who could be anyone from her mother-in-law to the maid. This character sometimes assumed the aspect of the menacing, witchlike Celestina, the traditional Spanish figure of the uncontrollable postmenopausal woman.[42] Puppet shows mirrored political culture in Barcelona; in some ways, then, they were radical, but in others reactionary—just as the city itself was.

In that puppet plays helped to cement the artistic community, it comes as no surprise that Russinyol actively promoted puppet shows and other traditional arts. In his 1911 play *The Prodigious Puppet*, a comic melodrama about Tofol's marriage to a countess who betrayed him, human actors assumed the stereotyped roles of puppets. But since Tofol always triumphs despite his troubles, it was certain from the beginning—as in any melodrama—that the story would have a happy ending of the kind poor people could not necessarily expect in their own lives.[43] Even though puppet theater, unlike the lives of common people, was rather predictable, the indomitability of puppet heroes and heroines as they repeatedly battled the same forces gave their real-life counterparts courage in facing their own misfortunes.

Puppets and Culture

Puppeteers served as archetypes for liberated artists living outside society and free from its constraints. Retaining the aura of traveling players who were at liberty to say and do as they pleased, they seemed to be magicians who could manipulate reality.[44] And because hand puppets appeared under bright lights, the lilliputian "actors" with their naturalistic faces seemed to represent an alternative reality, an illusion that Catalan puppeteers' skills only enhanced. Their tricks were legion. In "The Police Search," a play taken from the theater, a leading character was a knife grinder, who actually used his trundle and so made the familiar noise associated with the knife grinders found on Barcelona's streets. Catalan puppets also got out of bed and put on shoes, or rode horses that they dismounted on stage. One of the puppets in the Theater Museum in Barcelona is a *picador* from the bullfight, complete with mount.[45]

Puppeteers like Juli Pi and his son Julià were craftspeople, playwrights, actors, and impresarios. Although Pi earned his living as a mes-

senger, he was the author of more than one hundred puppet plays and creator of over 150 puppets. In keeping with his place as a theatrical personality, "he wore wide and puffy pants, pointy shoes, and a musketeer's beard"—the bohemian actor's costume.[46] With the aid only of his son, Pi was able to mount full plays. When he needed additional support he used hired hands, including those of Picasso's lifelong friend the sculptor Manuel Martínez Hugué, known as Manolo.[47]

Juli Pi learned the craft of puppetry when as a youth he started attending the puppet shows on Carmen Street presented by Joaquim Saez. By the time Pi was fifteen, in 1867, he already had a concession to perform his own shows in a café on Migdia Street.[48] He and another puppeteer, Isidro Busquets, followed in the footsteps of the distinguished puppeteer Federicu, who had changed the repertoire by adding representations of popular novels like *The Count of Monte Cristo* to the farces that had previously dominated the puppet theater.[49]

Busquets and Pi then went further. Instead of using the primitive puppets that consisted of wooden heads and cloth bodies, they commissioned new puppets with wooden heads, shoulders, and midriffs carved from a single piece of wood. Cardboard arms passed through holes in the wood, ending in wooden hands. The puppeteer's three middle fingers would be slipped inside the torso and head, while the thumb and pinky moved the arms. Attached to the torso was an inner glove known as the *anima* that enabled the puppeteer to create the illusion of a moving body under the outer garment. The puppets were given glass eyes and real hair for their mustaches, beards, and hairdos.[50]

At least subliminally, the hand puppets of Barcelona resembled religious statues, for they were made by the same artisans.[51] Breaking with the commedia dell'arte tradition of giving puppets exaggeratedly caricatured faces, artisans fashioned their Catalan puppets with the same realistic expressions they gave to both devotional objects and *gegants*.[52] As we have seen, civic rites, religious celebrations, and artistic rituals borrowed characters and performances from one another. The consequent repetition of familiar patterns undoubtedly contributed to a sense of continuity and tradition in religion, social relations, and art.

Just as people called on the saints whether they were believers or not, they also turned to the puppet plays for insights into their own lives. Throughout history, puppet plays reflected and commented on psychological dilemmas. In the late Middle Ages, Dominican friars put on puppet shows to promote fears of Judgment. Chief among their actors

were the Devil and Death, and as late as the turn of the century, the Devil and Death always made ritual appearances at the end of every Catalan puppet play.[53] After the requisite happy ending, when Titella and others were celebrating, in came Death and the Devil.[54] Rather than being allies, however, the two were antagonists. Audiences usually favored Death, who spoke Catalan, over the Devil, who used Castilian.[55]

Fights, the resolution of misunderstandings, and the triumph of good over evil after violent interludes were part of the excitement and dynamic force in traditional puppet theater. Before the resolution, violence must cleanse the scene. Thus, in puppet theater as in terrorist attacks on public celebrations, violence plays a ritualized part. The symbolism of puppet theater, moreover, leaves little doubt about puppet politics. Two stock sets of figures in turn-of-the-century puppet theater were members of the Civil Guard and the municipal police, known as the *urbanas*. Like the Devil, the *urbanas* wore red capes and spoke Castilian. Also like the Devil, the urban guards and police often wielded sticks. But neither the Devil nor the authorities ever defeated Titella, the Catalan hero. At the end of a typical late-nineteenth-century show, either the puppets sang or a musical instrument played the "Dance of Tururut," a word meaning roughly, "That's All, Folks." It went as follows:

> In the dance of tururut
> He who squeals, he who squeals;
> In the dance of tururut,
> He who squeals has been hit.[56]

Vicariously sharing the experiences of the puppets, viewers became a community of Tofols. But ties in and around the artistic community were as fragile as political unity in the city. The personal experience of Pere Romeu is reason enough to question how successful the Four Cats was in completing its mission of overcoming materialism and especially material need.

Romeu seems to have been a tragicomical character, though it is unclear whether he made himself an object of derision simply to attract attention. At any rate, as the clown in his own café spectacle, he set the tone of irreverence that was to characterize the modern community he and Russinyol were trying to create. Artists like Casas and Picasso, who both prepared postcards, ads, handbills, and posters for the Four Cats, often used Romeu's features, just as Toulouse-Lautrec abstracted the

hats and scarves of Aristide Bruant. According to Russinyol, Romeu "dreamed of castles in the sky." When the Four Cats closed in 1903, he managed a roller-skating rink and then a garage. Despite his enthusiasm for bikes and automobiles, he could not have been happy so far away from the entertainment business. When Romeu died of natural causes in 1908 Russinyol commented that, "accustomed to drinking the happy wine of the inn," Romeu had "had to turn to gas at the garage—and it killed him!"[57]

Utrillo fared much better. After the Four Cats closed, he earned his living as a journalist, art critic, and folklorist. Anything but academic art interested him. In 1907, he published the first study of El Greco written in modern times. From 1921 to 1929, he was involved in the creation of the Spanish Village on Montjuich. A showcase for folk art and regional architecture from all over Spain, the village housed votive paintings and puppets as well as other popular artifacts. This museum-fairground at the top of the city was a highlight of the Barcelona Exposition of 1929 and remains to this day a testament to Utrillo's interest in popular and folk traditions. Just before his death in 1934, Utrillo helped launch the Museum of Catalan Art and showed Picasso around the new museum. Here, examples of Catalan paintings, sculpture, and decorative arts dating back to ancient times were gathered together for the first time under one roof. The Museum of Catalan Art was virtually next door to the Spanish Village, and together they transformed Montjuich into a mountain of Catalan culture (see map 1).

Miracle Paintings

Russinyol, who was delighted by all but academic art, frequently drew the public's attention to popular customs and folk arts. Some of the few remaining accounts of traditional artistic life in Barcelona at the turn of the century appear in Russinyol's plays and essays. His gift was in showing that common crafts could be highly creative and that creativity was not the exclusive province of a few artists who signed their paintings. His respect for craftspeople (though tinged with irony) and his love for the ritual magic of everyday life came through in a variety of his plays.

One figure to whom he called attention in his comic play *The Painter*

of Miracles was the frequently anonymous craftsman who made objects of devotion and votive art, including "miracle paintings." In real life, when political, social, and personal disasters befell local people, they had long turned to these skilled artisans, who would depict scenes that buyers described. The resultant paintings, which were to be hung on church altars, served as tokens of thanks to a Madonna or saint presumed to have intervened to assure that a bad situation did not become worse.[58]

Russinyol's *Painter of Miracles* portrays the lives of a votive painter named Bartomeu and his moralistic friend Peipoc. Bartomeu, father of six children under the age of nine, paints on commission for his living. Peipoc claims that Bartomeu dabbles in magic. A notary asks Bartomeu to paint a picture to help prevent the discovery of his bigamy. Another customer, a policeman, does not like the painting he has ordered. A fish bone had lodged in his throat; a miracle had saved him, and he wanted to acknowledge it. His wife thought the circumstances were not sufficiently heroic and commissioned instead a painting that portrays him under attack by bandits. Enter Alcibiades, an atheist. An electromagnetic belt cured his ailment; not wishing to leave the medical miracle unacknowledged, he wants a painting to donate to his Masonic lodge, about which he is quite mysterious. The notary comes into an unexpected inheritance, shares it with Bartomeu, and helps save the children from starvation. Bartomeu thinks the windfall is due to a miracle and plans to commemorate it with a painting.[59]

Alcibiades probably reflects Russinyol's own ironic skepticism toward the magical religious aspects of votive painting, along with his appreciation of the importance of these works. This appreciation was evidently shared by C. Gumá, a popular republican writer who composed a ditty entitled "The Sculptor of Saints." In it, the sculptor says: "How wonderful to be a sculptor of saints! The glory of poets and painters is very fleeting, the number of people who see them minimal. . . . Their chief works may be applauded and celebrated, but our creations are treated better: They are adored."[60]

Before Vatican II forbade the use of votive paintings and objects as a superstitious practice for which there was no basis in doctrine, churches throughout Barcelona were laden with miracle paintings and wax or metal body parts. Jumbled together without apparent design, the objects and paintings transformed altars into precursors of abstract, even cubist, sculpture. The mixture of naive religious votive paintings, de-

votional objects, and signed paintings provided a visual metaphor for the blend of high and popular art that Russinyol helped shape in Barcelona.

In the miracle paintings, anonymous artists recorded the collective fears and experiences of common people and transformed them into popular art.[61] Commissioning the paintings was something of a communal ritual, and the miracle paintings really were collaborative works between the artist and purchaser. Like medieval patrons of the arts who demanded that their portraits appear in religious paintings they were donating to churches, those who commissioned miracle paintings dictated how they wanted themselves or an incident portrayed. They described objects that had to be included and the saints to be thanked or implored for good results.

Like Persian miniatures, the miracle paintings showed a series of events all taking place in the same frame. Whatever had happened to inspire their commissioning, the paintings are quite literal. A person might lie ill in one room while, in another room, someone else kneels in prayer. The saint or Madonna to whom prayers are addressed might appear in a corner or on a cloud above a representation of the accident or illness he or she has helped to overcome. Although many of the paintings were merely cartoons in which a scene was roughly outlined and colors were minimal, others were impressive abstract primitive paintings with people and objects schematized into brightly colored patterns. Still others, with their shading and use of perspective, recalled the work of trained artists.

Up to the end of the nineteenth century, miracle paintings frequently portrayed collective experiences. When the Madrid government bombed Barcelona's harbor in 1842 in a tax dispute, residents who lived nearby but escaped unscathed collectively purchased a painting for the Madonna of the Narrow Wall and for Saint Tecla, a local saint. The Madonna they honored was the patron of the nearby rural area of Selva del Camp, while Saint Tecla had great prominence in Tarragona Province to the south, one of the places in Catalunya from which migrants to Barcelona came.[62]

Sanctuaries on the edge of the city, in what are now Barcelona subway stops, gradually replaced far-off hermitages as points of attraction for urban workers. Job opportunities for artisan painters increased as people sought them out for miracle paintings to place in these local shrines. The shrines of Our Lady of Coll and the Virgin of Bonanova became the two leading urban pilgrimage sites at the turn of the cen-

tury. In 1903, when people living on the lower part of the Horta and Sagrera roads in the industrial section of Saint Martin of Provence escaped injury after a trolley jumped its tracks and ran down the street, the neighborhood took up a collection for a painting to give in gratitude to the sanctuary of the Mother of God at Coll.[63]

The urban saint to whom immigrants to the city most often gave their allegiance was the Virgin of Bonanova, whose shrine stood on a northwestern peak of Barcelona. When a fire struck a piano factory on Ponent Street, neighbors organized a bucket brigade until the fire engines came and saved the factory. The owner, thankful for their help, for the lack of damage, and for the fact that no one was hurt, commissioned a miracle painting for the Virgin of Bonanova (plate 2).[64] This Madonna also won the gratitude of a man who was not injured when a cauldron exploded in the machine shop in which he was working on Amalia Street. The man could have been killed but did not die, a mercy he thought he owed to the Virgin of Bonanova, to whom he had a picture dedicated.[65]

Urban life had other perils for which miracle painters could provide solace. For example, when a female servant on New Street ate some poisoned cheese meant for a rat, she did not die—an occasion that inspired a miracle painting in which a rat loomed large. A sausage fiend on Robador Street ate as much sausage as he could, which earned him the nickname Miguel of the *botifarra* (Catalan-style sausage). He always ate the hottest sausages he could find and finally developed a stomach ailment blamed on his excesses. He vowed to the Virgin of Bonanova that if she cured him, he would change his eating habits. He did indeed recover, and in gratitude he had a miracle painting made for her with a *botifarra* sausage on it. But alas, his passion for sausages returned, and despite pleas for the intercession of the Madonna, he died of his stomach ailment.[66]

Personal life in the city could be more insecure than in the countryside; miracle painters were thus partly therapists who listened to people's problems and gave them relief from their pain through art. For example, one Barcelona woman, whose lover promised to marry her as soon as he returned from America, was disappointed when he disappeared without a trace. She went to a painter, explained her problem, and secured an offering to the Madonna of Bonanova to speed his return. Another woman was luckier. When her husband gave up his mistress, stopped having affairs, and agreed to return to her, she commissioned a painting in celebration. A woman whose son was passionately

involved with a young woman she did not trust ordered a painting for the Virgin of Bonanova to assure that the son's girlfriend keep her promise to marry him.[67]

Even Picasso painted at least one miracle painting while he was in Barcelona, and he may have drawn on their sense of whimsy and their haphazard composition later in life. When Miquel Utrillo escaped injury in a road accident in 1899 or 1900, Picasso spoofed a miracle painting for his friend (plate 3). Following the typical pattern, it consists of a narrative of the accident with the image of a generic Madonna (possibly the Virgin of Mercy) in the upper left-hand corner.

Conclusion

Russinyol and the artists around him, though benefiting from industrial development in Barcelona, blamed technology and science for the shallowness of cultural life in the city. Enriching culture by highlighting a variety of artistic forms from Visigothic ironwork, to medieval Catalan painting and El Greco's works, to French avant-garde art, puppets, and miracle paintings, they helped to create new forms of communal identity. Through the construction of civic rites, following a strategy similar to that unconsciously pursued by Catalan nationalists and leftists, the artists of the Four Cats divorced popular religious arts and entertainments from organized religion, all the while treating them as devotional objects or rituals in themselves: in short, they borrowed the popular religious forms to suit new functions. Even if the instructions for the set design of Russinyol's play *The Prodigious Puppet* had not compared its colors to those in votive paintings, there would be no question that Russinyol was attempting to use puppet spectacles as aesthetic substitutes for religious practices.

With their immediacy and vitality, puppet shows and miracle paintings captured the imagination of the late-nineteenth-century artistic vanguard in Barcelona. The founders of the Four Cats were relatively self-conscious in their use of theatrical rituals to persuade people in Barcelona—and in Sitges—of the existence and importance of a common religion of art. The Modernist Festivals and puppet theater were only two means by which they chose to accomplish this.

As political groups increasingly used Catholic-style pageants to win over the city's population, some Four Cats artists attempted to recast

old popular cultural forms in order to create a community of people who noticed and valued art of all kinds. In the process, they educated participants about the richness of folk culture, providing a source of images and patterns that contemporary urban artists could use. Picasso's humorous miracle painting recounting Miquel Utrillo's auto accident is just one instance, demonstrating the artist's sensitivity to popular forms and his unwillingness to separate himself from artisanal traditions.

Reviving lost artistic forms and using them to express modern themes was a specialty of those who frequented the Four Cats. Of course, without knowledge of the French avant-garde, they would have had no context into which to fit popular forms. At the same time, without heightened sensitivity to the works of El Greco, votive paintings, and crafts that were alternatives to official art, they would have been unable to draw on the genius of traditional arts and entertainments. By bringing public attention to folk arts and practices and by developing a view of art that excluded aesthetic hierarchies, the Four Cats, which lasted only five years, left its mark on culture in Barcelona up through the Spanish Civil War of 1936–1939.

3

Community Celebrations
and Communal Strikes,
1902

Anyone visiting New York in the fall has probably at-
tended the street fair of San Gennaro in Little Italy. A reminder of the
time when an immigrant community was creating and celebrating its
neighborhood traditions, San Gennaro is now mostly a tourist attrac-
tion—except among the old people. They recall coming together to en-
joy their own sense of identity, citizens of Little Italy rejoicing in their
community.

Picasso and his friends in Barcelona participated in similar festivals.
One, most notable for its costumes, floats, and folk figures, was the
weeklong fair of the Virgin of Mercy held in the fall of 1902. Despite a
general strike (really an urban insurrection) the previous February, fol-
lowed by a period of martial law, poor and rich alike joined in the rev-
elry for Barcelona's patron Madonna. The people on New Street, where
Picasso had his studio and where barricades had gone up during the
general strike, decorated their street in the style of the late Middle Ages.
Although the city government promoted the festival to secure tourist
money, Picasso's neighbors jumped right in to impose on the proceed-
ings their own ideas about their community. Picasso himself com-
memorated festival life and his view of the poor with a newspaper car-
toon.

The year 1902 was a pivotal one in Barcelona, when the city govern-
ment and the working population competed for control of the streets.
Each of the two forces attempted to determine how the city would be
run and who would run it. Each demonstrated in its slogans, demands,

and practices what their vision was. In alliance with the church and Catalan nationalists, the city government promoted the idea that the elite had always governed, had done so benignly, and such a state of affairs should therefore serve as the model for the future. Promotion of this so-called tradition was as much a new political program as the ones laborers were attempting to popularize. Working men and women, for their part, were attempting to win a reduction in the workday and to emphasize collective identity in their neighborhoods. During both the general strike and the Virgin of Mercy festival, both constituencies proclaimed the different meanings they attached to community.[1]

In the absence of a more powerful system of symbols, the artists at the Four Cats Café, Catalan nationalists, leftists, and working women's groups all drew on and transformed Catholic images and practices to create solidarity around their own values. Religious processions had frequently claimed portions of the city as "sacred space," and the left did something analogous in 1902. By symbolically seizing certain city streets, they contended with police and soldiers for the right to territory they were not yet powerful enough to seize outright.

As we have seen, the city's artistic community had been rediscovering religious art and viewing it in secular, artistic terms—not so much to deprive the art of its religious significance as to present as art paintings and sculpture previously viewed simply as religious paraphernalia. The removal of religious art from churches to public exhibition halls during the 1902 Virgin of Mercy festival took this process a step further. Moreover, once the festival became a completely commercial civic endeavor, designed to place badly needed tourist revenues in the city coffers, the transformation of folk figures associated with Catholic rites into an element of popular culture became nearly complete. By legitimating folk and religious artifacts as art, Catalan nationalists and artists had inadvertently initiated their removal from church control. As the images and practices that had united a Catholic community became more and more part of secular popular culture, urban culture was transformed. In adapting those folk figures, in other words, Pablo Picasso and other artists unconsciously entered a forum in which the very meaning of popular culture and community was being debated.

One reason for increasing contentiousness in the cultural realm in Barcelona was rapid population growth, which was due in part to agrarian crises that drove masses of peasants off the land and into the mechanized textile industry. By 1900, the population of the city stood at 533,000, of whom about 93,000 were rural Catalans and 121,000 were

not Catalans at all. The contest over who would socialize these peasants reached a crescendo in 1902.[2]

Despite the efforts of Catalan nationalists, anarchists, artists, and the government to shape the rapidly growing population into one group united by shared identity and culture, the migrants represented a special threat to the established community. Largely unskilled, immigrants from the countryside and small towns were not as familiar with the labor movement as people from urbanized Barcelona Province, where, as we have seen, unions called resistance societies had flourished since the middle of the nineteenth century. Constituting a vast pool of labor and adding to the number of potential strike breakers who could be called on to reduce labor solidarity during work stoppages, the immigrants were often viewed with hostility by organized workers. Referred to derogatorily as Murcianos (though they came mostly from Valencia and Aragon), they presented a time bomb that organized labor had to defuse.

The largely anarchist union movement in Barcelona faced new challenges apart from demographic changes. Spain's loss of colonies in Cuba, Puerto Rico, and the Philippines in the Spanish-American War of 1898 deprived Barcelona of the captive markets on which its industrial prosperity had depended. Forced to mechanize the textile industry, the industrialists sought to intensify the use of labor by replacing skilled, unionized factory workers with unskilled immigrant men, women, and children.

To regroup, organized workers in Barcelona embarked on two somewhat contradictory strategies. First, they promoted general strikes, in an effort to unite the entire working population, regardless of their place in the economy, into a single movement of opposition. Second, they urged participation in a new labor confederation, the Spanish Federation of Workers' Resistance Societies (FSORE). In October 1900, under the auspices of Madrid's organized construction workers, about sixty-five delegates claiming to represent fifty-two thousand anarchists throughout Spain had met and formed the FSORE as a national organization to coordinate local anarchist unions. Facing constant harassment, the group managed to survive for two years, with offices first in Girona and then in Barcelona[3]—for even though unions had been legal in Spain since 1897, they were still viewed as seditious.

Preeminent among Barcelona's FSORE members were textile and metal workers.[4] It was these workers who, pressing for civic and class

solidarity, led the largely unorganized working people of Barcelona in the general strike of 1902.

The 1902 General Strike

What became the 1902 general strike began as a simple work stoppage. The metal workers' union set out in the last days of 1901 to assert labor's right to unionize and to alleviate widespread unemployment. Within a few weeks, the strike had spread not just to other unions, but to the working population as a whole. It became Barcelona's first general strike, engaging a variety of women and men who hoped to improve the quality of their lives.

People who have experienced a general strike understand that it is an urban uprising in which everyone must choose sides. General strikes, which usually begin with a single union, spread to the larger population, including not only workers but poor women and others with grievances about their living conditions. Unlike an economic strike, which addresses issues limited to wages and working conditions on the job, a general strike raises fundamental questions about the quality of life of the vast majority of the people. And because its locus of activities is neither a factory nor even an entire industry, but a city or a region, it resembles a guerrilla war. In 1902, the general strike in Barcelona whirled through poor neighborhoods, sweeping up housewives, domestic workers, and even prostitutes. Once the strike became generalized in this way, people whose grievances against society could not be pinpointed in demands to employers were galvanized into action.

Because of massive migrations from the countryside to cities throughout Europe at the turn of the century, organized labor in each country faced similar problems of forging new alliances and winning the new, largely unskilled workers to its side. Whether to strengthen unions or to win political rights, workers from Belgium to Russia and from Sweden to Spain engaged in general strikes. The most significant gains were made in Belgium. There, general strikes in 1893, 1903, and 1913 finally won male—but not female—workers the right to vote.[5] A relatively new phenomenon at the turn of the century, general strikes captured the interest of French theorists like Fernand Pelloutier and Georges Sorel and of the German Marxist Rosa Luxemburg. Writing in

1906 about the 1905 general strike in Russia, Luxemburg viewed what had happened as a "spontaneous" event that showed that democratic socialism could constantly renew itself.[6] She recognized that a general or mass strike was not a single event but a step in the creation of a revolutionary tradition that might one day transform existing unions, women's informal neighborhood associations, and cultural groups into a new revolutionary society.[7] She thought the directing agent would be a political party; anarchists, in contrast, thought the new society would be administered by unions or syndicates, and so they called themselves "anarcho-syndicalists."[8]

Members of the anarcho-syndicalist metal workers' union in Barcelona launched their first strike in December 1901 to win recognition of their right to unionize, to reduce the workday, and to spread work opportunities among more people. The initial demand for a nine-hour day was designed to alleviate unemployment as well as to improve the living conditions of the jobless. Employers, many of whom belonged to the Catalan nationalist Regional League, adamantly resisted any effort by workers to influence the work process and were equally opposed to national labor legislation interfering with their right to run factories any way they saw fit.

The metallurgical workers' strike had gone on for nine weeks before a public meeting was held on February 16 at the Spanish Circus Theater. Although Barcelona's different unions had their own meeting places (some, such as the painters, carpenters, shoemakers, and ironworkers, even shared premises at New Saint Francis Street), no large spaces other than circuses and bullrings could accommodate mass meetings. As a result, at least subliminally, activists must have come to associate popular entertainments and sports with their efforts to transform their lives.

Among the speakers who sparked reaction from the crowds on Sunday night, February 16, was Teresa Claramunt, one of the early twentieth century's foremost anarcho-syndicalist leaders. A textile worker from the nearby industrial city of Sabadell, she had begun her political work fighting alongside weavers and spinners on the shop floor. Gradually, her speaking ability and skills as an organizer catapulted her to leadership of the textile unions of Catalunya. She became an anarchist in the late eighties and was arrested and then forced into exile in France and England during the wave of repression following the Corpus Christi bombing of 1896. One of the founders in 1901 of the anarchist newspaper the *Productor* (Producer), she used it and her powers as an

orator to draw the various regional groups of anarcho-syndicalists to-
gether. She seemed to be everywhere. From Catalunya in the northeast
to Andalusia in the southwest of Spain, she overcame local differences,
building solidarity among anarcho-syndicalists whose strength really lay
in local and regional councils. She had the capacity to speak to a crowd
as if she were talking to friends in a café, and reached equally the male
and female working class. A natural teacher, she understood and could
explain how particular struggles fit into larger campaigns. Called the
Spanish Louise Michel, she was one of those mythical organizers who
wound up convincing her jailers of her cause. When, a few years after
1902, she was exiled to Zaragoza, then a political backwater, she almost
single-handedly created an anarcho-syndicalist movement in Aragon.
She began to hit full stride at the Spanish Circus Theater meeting that
began the 1902 general strike.[9]

On a foggy Monday morning, February 17, following the mass
meeting at the Spanish Circus Theater the day before, most factories
opened. But the general strike began in the streets as two to three thou-
sand people prevented trolleys from leaving the Parallel district.[10] Al-
though public transport had run (albeit sparsely) enough to get people
to work, by nine that morning hardly a bus or trolley was to be seen in
the streets. Metallurgical plants in Saint Martin stayed closed that day,
as they had for nine weeks. Metalworkers visited other plants through-
out the city, informing workers about the general strike meeting the day
before and urging them to come out into the streets and join the
strike.[11] By ten o'clock, most of the factories in the city had shut down
because workers, either willingly or under duress, had left their jobs. By
the same hour, the shops and cafés in downtown Barcelona had closed
their doors. The city, which was usually bustling with people cleaning
up and preparing for the day, appeared to have undergone some tragic
transformation.

The captain general declared a state of war, placing the citizens under
martial law and depriving them of their normal civil rights. The various
branches of the armed forces moved into position in the already familiar
theater of revolution where everyone knew his role. The hated Civil
Guard, the Spanish cossacks, with their tricorner, patent leather hats,
began to patrol the streets on horseback along with the army cavalry.
The infantry took up positions in the major squares and on the streets
that were the arteries of the poor neighborhoods. One of the main bar-
ricades went up across New Street of the Rambla, a narrow street on
one side of which stood the Güell Palace (now the Theater Museum),

designed by architect Antoni Gaudí for the Catalan nationalist industrialist Eusebi Güell. Despite the villa, New Street was really a honky-tonk neighborhood. Across from the palace was the Eden Concert, a sumptuous nightclub that housed a famous bordello upstairs. (See map 1.) Right next door were cheap lofts suitable for studios that young artists, Pablo Picasso among them, rented. And around the corner was the Barcelona Circus, where a nightly vaudeville review featured animal acts.

Clearly, the workers could swim in their own protected sea in a setting like the Parallel. Nothing needed to be rehearsed; everyone knew that there would be fighting, and everyone knew where it was likely to take place. The streets had symbolic political and military significance: as the heart of laboring Barcelona, the Parallel was important to both sides. By eleven that morning men and women had begun to fill the Plaza of Catalunya, the top part of the Rambla, and the surrounding streets. They threw stones and wielded sticks, forcing the troops, overwhelmed by the huge crowd, to withdraw. Fighting broke out on the boulevards that formed a pentagon-shaped ring around downtown. Red Cross cars were the only vehicles seen in the streets—and their services were needed, since the numbers of wounded began to mount as the troops opened fire on the strikers.

The army and police foolishly thought they could end the general strike by finding its "leaders" and arresting them. By 8:00 P.M., February 17, they had closed all workers' centers and had instituted searches for the known trade union and leftist political leaders, including Teresa Claramunt.[12] But in a general strike as in a guerrilla war, the local units that generate their own male and female leaders help to sustain the movement, whether or not the so-called leaders have been jailed.

In the course of the general strike, protesters tried to seize control of train stations. Not far from where Pablo Picasso lived with his family on Mercy Street, the terminus for trains to France was the scene of a pitched battle on Tuesday morning, February 18. When a group of men refused to let the train pull out of the station, they were attacked by the cavalry. One man was killed and another critically wounded. A skirmish in Saint Martin of Provence that same day resulted in three dead and three injured.

The day's biggest battle occurred in the Parallel, amid the cafés and nightclubs frequented by artists and workers. Troops and members of the popular resistance fought in the street as night approached. People shot from their balconies and from the upper floors of buildings. Gunfire swept the air for over an hour. When the battle was finished, the Red Cross removed the bodies of the dead and wounded. These bodies

were taken to Holy Cross Hospital, about ten blocks away. Including the victims of the Parallel battle and those who had been hurt further up the Rambla and at the Plaza of Catalunya, about nine people were killed and over thirty injured in the fighting that evening.

On Wednesday morning, February 19, the only sound heard in the streets was the muffled clop of horses' hooves. Among the few stores that remained open were some pharmacies, where the injured who were well enough to avoid the hospitals cared for their wounds. Avoiding punishment for participating in the strike meant avoiding the hospital. In any case, only the most severely wounded could get treatment at the downtown Holy Cross Hospital, since it had begun to overflow with all those caught in cross fire.

The biggest battle on Wednesday occurred in the morning near the Columbus monument at the end of the Rambla. The Civil Guard cavalry, armed with rifles, attacked the populace, who were armed only with knives, revolvers, and hunting guns.[13] The situation was reminiscent of the one Francisco Goya had painted in 1808, when common people resisted the Napoleonic troops stationed in Madrid. As in Madrid nearly one hundred years before, the sheer numbers of insurrectionaries in Barcelona in 1902 meant that large numbers of soldiers were wounded and killed, despite their superior arms.

By Wednesday, local authorities had to worry about food supplies as well as public order. Because the trains were not running, food was not getting to the city. With carts, buses, and trolleys commandeered by soldiers to carry food unable to get through the barricades to the markets, and supplies for bread becoming scarce, authorities feared a run on bakeries. Grocery stores could open only under armed guard. The army attempted to guide what food did reach the city to central markets, where it could be sold in an orderly fashion, while some meat, vegetables, and bread were delivered to stores under armed guard. Poor women, who had suffered from the high cost of living even before the general strike, were suspicious of the guardians of public order and took matters into their own hands. Having heard about hoarding and speculating, they attacked merchants at the stores that opened to sell food, and crowds marched to the municipal slaughterhouse to try to secure meat. Yet even despite the shortages, there was very little looting.[14]

By midday, women of the popular classes had gathered at the Rambla of Flowers, across from the Boqueria (Saint Joseph) Market. From there, armed with sticks, they marched through the district, forcing transport to stop, pulling people off buses and trolleys, and compelling stores to shut down, thus ensuring that business as usual could not be

carried on in Barcelona. Women carrying banners marched to the streets between Princess and Saint Mary of the Sea, breaking the windows of those merchants who refused to close their shops. From there they poured to Columbus Pass, past Mercy Street, again stopping all vehicles and forcing passengers to get out and walk.[15]

The city shut down—or was shut down. Not only did shops, factories, and transport cease to function, but cafés and other recreational centers closed their doors as well. An eyewitness tells how he found himself at five in the afternoon on Workshop Street, where the first nineteenth-century cotton factories in Barcelona had stood. A crowd, pursued by the army cavalry and civil guards, fled past him. Apparently soldiers had attempted to drag certain strikers to the nearby military barracks of Buensuceso Street, but they were cut off by a large crowd at Ramalleras Street. There, alongside the cafés frequented by puppeteers and miracle painters and beneath the windows of the Maternity Hospital and nearby houses of prostitution, the crowd liberated the people the soldiers had just captured.[16]

By 6:30 that evening, close by on the Parallel, another battle swept innumerable workers into the path of mounted soldiers. Armed only with stones and knives, the strikers nevertheless were able to inflict severe damage on the soldiers by virtue of their sheer numbers. Afterward, it took over two hours for the ambulances to remove the five dead and the more than twenty wounded. Soon all the criminal and military jails in the city overflowed with union members arrested by the authorities in an attempt to end the hostilities.[17]

On Thursday morning, February 20, a thick winter fog had fallen over the city; rain made the streets slippery. Troops gathered to guard Balmes and Aribau streets, through which the train to the town of Sarrià passed above ground, and in Saint Martin on Provence Street, in the bus and trolley garages. At around ten, heavy rains began to fall as the trolleys resumed service under the watchful eyes of heavily armed guards. Further skirmishes broke out at the Buensuceso Barracks in the afternoon, but the heavy rains of the evening brought a deathly silence to the city. Again the hoofbeats of the horses ridden by civil guards and soldiers patrolling the city were the only sound to be heard. Reinforcements had augmented the force of troops already in Barcelona, who were exhausted after half a week on duty.[18]

On Friday, huge crowds of people surrounded the slaughterhouse near Provence Street, at the heart of Saint Martin of Provence. They attacked the meat carts as they moved out, probably believing that the food was not destined for sale in the popular markets and knowing that

people did not have enough cash to purchase the meat anyway. Once again, as in other urban guerrilla skirmishes that week, people attacked the armed guards with knives and stones. Only their overwhelming numbers permitted them to go on against the superior weapons of the forces of order. Just as it appeared that the people were winning, another squadron of cavalry that had been guarding the buses came to reinforce the soldiers at the slaughterhouse. One dead with several wounded was the popular toll of that battle. The meat carts now rolled, accompanied by the armed guards.[19]

Private and public vehicles began to circulate in the downtown streets. The apparent tranquility was short-lived, however. A man was shot on Saint Rafael Street. Authorities intensified their search for known political leaders such as the anarcho-syndicalist textile workers Teresa Claramunt and López Montenegro. By nightfall, buses, trolleys, and the train to suburban Sarrià had stopped moving. After eight o'clock, police and soldiers tightened their grip in an attempt to apprehend any possible leader. The next day, as the roundups continued, there were shootouts in outlying districts of Barcelona. By Sunday it looked as if people would return to work on Monday, and indeed they did. Yet the laborers went back to a ten-hour day; and fifteen hundred metalworkers found themselves blacklisted.[20]

When the general strike of 1902 ended, the victims included some sixty to one hundred dead and hundreds wounded, most of them poor people. About five hundred wound up in prison.[21] Contemporaries of various political persuasions agreed that about one hundred thousand people had participated in the uprising, a number far in excess of the approximately forty-five thousand workers, or one-third of Barcelona's working class, said to have belonged to some union when the general strike erupted.[22]

What transpired when the plazas and avenues of downtown Barcelona became battlegrounds left its mark on the urban landscape. Bullet holes filled the walls between which barricades had been built. Yet the symbolic meaning of the streets remained open to debate. The Mardi Gras spirit associated with a great celebration could snap the population back into a sense of community despite deep antagonisms.

The Festival of the Virgin of Mercy

Between September 23 and October 5, 1902, the city of Barcelona celebrated Virgin of Mercy Day as a carnival with fireworks,

parades, bullfights, and an art exhibit of Romanesque and Gothic religious art. One hundred sixty-five thousand people from Barcelona and outlying districts attended the five-day celebration, apparently quite happily. Some social critics of both the left and right, however, were dismayed by the festivities. One outraged republican journalist compared Barcelona to a prostitute who, unconscious of her degradation and slavery, "runs into the street to sing, perform, and undress for anyone who'll look."[23]

The church, accepting the fact that for years the celebration had owed more to popular holidays like carnival than to the more solemn 1888 crowning of the Virgin of Mercy as patron of Barcelona, nevertheless held a mass in her honor. In the Basilica of the Virgin of Mercy, Cardinal Casañas delivered the benediction. Apparently delighted by the way a religious celebration had seeped into the cultural life of the city as a whole, the cardinal reminded his audience of the 1888 celebration and claimed that only "republicans and Carlists" (reactionaries critical of the modern church and the crown as too lenient and unorthodox) opposed making the Virgin of Mercy Barcelona's patron.[24]

The church was also quite content to have ancient religious paintings and statues removed from churches and abbeys and shown in a museum at the fair. From churches in Vic and Girona, as well as the province of Barcelona, religious art was brought to the Palace of Fine Arts, newly renovated and reopened as the Museum of Decorative Arts. The exhibit, the most ample display of Romanesque and Gothic art in Barcelona, regaled the public with religious paintings, crosses, and murals presented as art. The one high cultural event on the festival program, it reached a larger audience and included more artifacts than the gallery at the 1888 Universal Exposition had done.

Although the church made no official pronouncement on the exhibition, it implied by its silence that it did not object to the way the art was presented. In fact, leading prelates had begun to promote religious art, and individual ecclesiastics had already emerged as patrons of the arts. Barcelona's one-time bishop Josep Morgades, now the bishop of Vic, had founded that city's Episcopal Museum, bringing to light many treasures of medieval Catalan religious art. To the consternation of not a few republican secularists, Morgades was widely praised by Santiago Russinyol, who was ecumenical in his enjoyment of art and, beneath all his cosmopolitanism, strongly Catalan nationalist.[25]

The one view the church seems to have shared with such secularists

was that by introducing religious imagery into secular rituals, the church promoted religion and ecclesiastical power in civic affairs. The church, therefore, was perfectly happy to have religious figures and celebrations become identified with civic pride, even though that meant the clergy relinquished some control over the uses to which religious symbolism would be put. The danger of the imagery becoming too secularized, of its being used in irreverent ways, was never great in any case. Indeed, the religious architect Josep Puig i Cadafalch, one of the guiding lights of the Catalan nationalist Scholars' Center, assisted in organizing the exhibition of Romanesque and Gothic art.[26]

Still, the exhibit served two diametrically opposed purposes. On the one hand, it permitted religious symbols to saturate the secular realm of art, thus pleasing the clergy. On the other, by emphasizing the formal, artistic attributes of religious works and not their subjects, it granted secularists dominion over art previously revered for its sacred meanings rather than for aesthetic—or regional—significance. Many republicans and secularists might rail against the infiltration of civic life by church art; but for secular artists such as Santiago Russinyol, Miquel Utrillo, and the young Picasso, Romanesque art was a refreshing antidote to traditional post-Renaissance European art.

The fine arts, however, played a relatively minor role for the majority of people attending the 1902 fair. Folk art, in contrast, played a very important role indeed. That year's festival of the Virgin of Mercy was primarily a costly but successful public relations event organized by the Barcelona civic government.[27] Everywhere there were street fairs sponsored by the city. Each street was decorated according to a theme, ranging from Polynesian, which one street in the Parallel selected, to Gothic, adopted on New Street of the Rambla.[28] Even though the mood was festive, few inhabitants would have forgotten that eight months earlier a barricade had stood at the latter spot. Some people opposed spending so lavishly on public display, but the editors of the Catalan nationalist paper *Veu de Catalunya* (Voice of Catalunya) justified the costs by claiming that such festivals, in creating a sense of "union and solidarity," assured that "other victories [would] follow."[29] Creating civic pride and overcoming political antagonisms following a year of turmoil had to be part of what the *Veu* and the city government sought to achieve. But a citywide celebration in Barcelona always presented the threat of insurgency. Undoubtedly, many of the 165,000 people who attended the festival had been among the approximately 100,000 who, only eight months before, had participated in the general strike. Festivals had been

sabotaged before, and the civil governor, if not the city government, must have feared further attacks on this pageant. If so, their fears proved unmerited.

So many engaging events were held that the city could easily bury its anxieties in balls, theatrical performances, gymnastics, bicycle races, bullfights, fireworks, and performances of the *sardana*, the traditional Catalan circle dance performed to the wistful sound of bassoons, clarinets, and flutes. From all over Catalunya, assemblies of *xiquets de valls* arrived; these groups of men made human pyramids, an acrobatic feat customarily performed at festivals of all kinds, including Corpus Christi. Artisans set up their wares throughout the city, giving the entire urban landscape the air of a country fair.

The central event, however, was to be a parade of *gegants* brought in from all over Catalunya and of floats honoring blacksmiths', bakers', and confectioners' societies.[30] Among the historical floats was one of Hannibal and his elephant (figure 4). *Gegants* coming from outside the city, meanwhile, marched toward Citadel Park, the site of the 1888 exposition, like a jocular invading army: the dragon from La Bisbal; "La Patum," a big bird, from Berga (figure 5); and a whole assortment of other *gegants* dressed as traditional Catalan peasants and royalty. At the park the visiting creatures found shelter until the day of the parade.[31]

In the meantime, local *gegants* were being prepared. Those of Saint Mary of the Sea, for example, were completely redone for the festival. Following the design of Josep Puig i Cadafalch and under the direction of Dr. Diones Renat, an army of seamstresses revamped their clothing, hair, and makeup; one *gegant* ended up dressed as a fifteenth-century Barcelona city councilman (figure 6).[32]

The parade, whose route covered the old city and the Extension, was scheduled to set off from Citadel Park at 4:00 P.M. on September 25 and travel up Saint John's Pass toward Tetuan Plaza, across Main Street to Gracia Pass and the Plaza of Catalunya, and then down the Rambla, across Columbus Pass, and back into the park (see map 2). An added celebration was to be held as a children's day on September 26, when the floats and monsters were to circle the park.[33] Because of rain, however (another tradition of the Virgin of Mercy celebrations), the parade on September 25 had to be canceled.

When the cavalcade finally took place on Monday, September 29, it was well worth the wait. The judges who awarded prizes for the best *gegant* and *nan* costumes included Miquel Utrillo and Josep Puig i Cadafalch. Honorable mention went to *gegants* of the parish of Our Lady

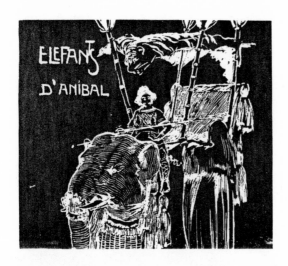

ELEFANTS D'ANÍBAL

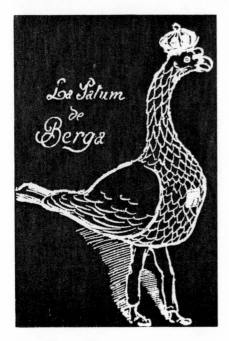

La Patum de Berga

Fig. 4. Float of Hannibal and elephant from the 1902 Virgin of Mercy parade. Drawing from *Veude Catalunya*. Courtesy of the Institut Municipal d'Història, Casa de l'Ardiaca, Barcelona.

Fig. 5. "La Patum": Folk figure from the 1902 Virgin of Mercy Parade. Drawing from *Veu de Catalunya*. Courtesy of the Institut Municipal d'Història, Casa de l'Ardiaca, Barcelona.

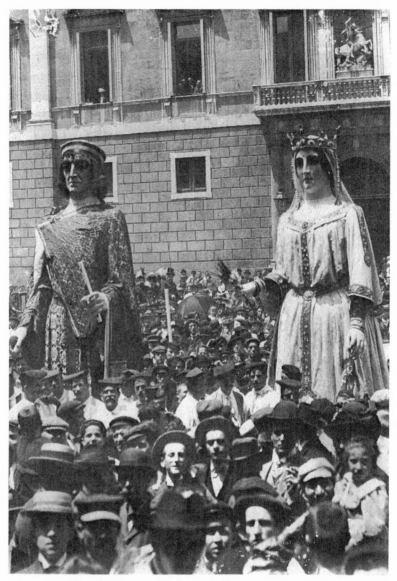

Fig. 6. *Gegants* in 1902 dressed as a queen and a fifteenth-century Barcelona city councilman. Courtesy of the Arxiu Mas, Barcelona.

of Bonanova and of Saint Mary of the Sea, though the grand prize winners were outsiders: the "Wolf's Head" of Vic and the "Lliga Moscas" of Olot.[34]

While no violence occurred during the Virgin of Mercy celebrations, no festival or any other public rite in Barcelona could remain free of politics, and this one proved no exception. Even children's events raised political issues. Spanish imperialism in Latin America, which ended only with the loss of Cuba and Puerto Rico in 1898, and support for expeditions in Spanish Morocco had been popular causes with all classes in Barcelona—until, that is, colonialism entailed the loss of the lives of numerous Catalans. In 1902, as the struggles among France, Spain, Germany, and Great Britain were heating up in Africa, imperialism still seemed like a heroic enterprise to some Catalans. For children's day during the festival, on September 26, boys were dressed up as African Volunteers to recall the original Spanish conquest of Morocco in the mid–nineteenth century. Under the command of a lilliputian version of the real General Prim, the children's army, wearing blue uniforms, leather boots, and yellow hats, restaged the battle right on Columbus Pass, where they could salute the military forces housed near the governor's palace. They then marched to the Plaza of Saint James to pay their respects to the city and provincial officials, and then on down Ferdinand Street, across the Rambla, and down New Street to the tune of trumpets and the "Royal March" (chosen by the city government).[35] Playing a monarchist tune was a gesture almost certainly designed to free the festival of any Catalan nationalist or republican political coloration. The festival as a whole, of course, celebrated the status quo and created the fantasy of a community in which class and regional differences held no importance.

However, because labor insurgency outside Barcelona soon afterward aroused fears that local workers might use the festival to revive their own struggles, a children's day scheduled for Citadel Park on October 5 was canceled. It is worth noting that the strikes that had swept Barcelona in late 1901 and early 1902 were in part responses to worsening economic conditions and intensifying unrest all over Spain. Now, in the autumn of 1902, in Cádiz Province, in the towns of La Linea, Cádiz, and Jerez de la Frontera, agricultural and wine workers were attempting to win improved working conditions.[36] Teresa Claramunt, on a speaking campaign in the south, was arrested in Cádiz in early October 1902, and the government feared that workers in Barcelona might rise to her defense by attacking the government.[37] Not trusting even the

children, the captain general of Catalunya forbade their October 5 parade, claiming that such a large assembly now posed a threat to public order.[38] With this decision, he asserted his will over both the city government of Barcelona and the church. Once again, representatives of the Spanish monarchy took precedence over even conservative leaders in Barcelona.

Pablo Picasso

In the largely unconscious struggle taking place at this time over regional symbols, artists, including Picasso and others at the Four Cats Café, played their part. The avant-garde artists of Barcelona viewed themselves as liberals in that they were open to a range of ideas and images and opposed most orthodoxies. Among the regular participants in activities at the Four Cats were four artists—Isidre Nonell, Ricard Canals, Joaquim Mir, and Ramón Pitxot—whose work at the turn of the century focused on the industrial suburb of Saint Martin of Provence.[39] One of the poor neighborhoods ringing Barcelona, filled with laborers employed in the metallurgical and textile plants, Saint Martin offered a militant population that the painters might have chosen to represent. But the group known as the Circle of Saint Martin depicted only poverty and oppression, not activism. During a period when newspapers were publicizing the talents working people displayed in their decorated apartment blocks and their floats for the Virgin of Mercy festival, these socially conscious artists portrayed only victims.[40]

Nonell had outraged the religious middle classes of Barcelona in 1892 with his anticlerical drawing *Annunciation in the Slums*. By setting an angel sarcastically proclaiming "Glory to God in the Highest" amid the desolate factories and the downtrodden people of Saint Martin of Provence, Nonell lashed out at the church for ignoring poverty. Yet he himself overlooked the area's dyers, printers, spinners, weavers, and metalworkers in favor of beggars and gypsies. Even though the workers created the wealth of Catalunya and their actions at the workplace and in their neighborhoods had begun to create an alternative community in Barcelona, marking it as a militant red city, they were evidently not attractive artistic subjects.

Picasso, like his friends in the Circle of Saint Martin, frequently documented poverty but cast it in purely romanticized terms. With his

home located near the railroad station to France, where so much fighting had gone on during the general strike, and his studio located at 10 New Street of the Rambla, where a large barricade had been erected, Picasso must have noticed that working people were capable of acting in their own defense.[41] Yet when he did his cover for the October 5, 1902, issue of the *Liberal*, he portrayed only the victimization of the poor, not their courage (figure 7).

In that drawing, *gegants* and the Hannibal float, complete with elephants, provide a festive background to the celebration of the Virgin of Mercy; in the middle ground, well-dressed middle-class people take part in the festivities. The foreground, however, is occupied by a poor woman and child of the kind Picasso often portrayed in his blue period (1900–1904). Two such figures appear in a painting called *The Soup* (sometimes dated to 1902), in which a child and a Madonna-like woman stoop over a bowl from which steam rises like a halo (plate 4). The child, whose posture is echoed in the *Liberal* drawing, reaches up, lifting her right leg to emphasize how she must stretch to take the soup. From this period also date various depictions of crumpled women hovering in doorsteps and oppressed mothers and children walking along desolate beaches.[42]

Except to say that she is a poor woman, it would be impossible to classify the central figure in Picasso's drawing for the *Liberal*. She certainly has no particular political role to play. Yet she is an important marker, an indicator that all is not entirely well in Barcelona. Since Picasso could draw what he wanted for the cover of the newspaper owned by his friend Carles Junyer-Vidal, his drawing indicates that his natural response to the city's troubles was relatively apolitical.[43]

His symbolizing the laboring woman as a poor mother weighed down by her responsibilities is particularly ironic because the most visible labor leader of Spain at the time was the hale and hearty Teresa Claramunt, who had so recently been arrested in Cádiz. Although memoirs of the period frequently refer to her as a strong and attractive woman, a heroine who could transform a crowd into a revolutionary army, she was seldom if ever caricatured, let alone painted.[44] She could never have been the model for the mother in Picasso's drawing.

In contrast, the sentimental personification of the laboring classes as a poor woman unconsciously neutralized the power of the much more menacing anarcho-syndicalist movement in Barcelona. Picasso's woman, like so many portrayed by Nonell, Mir, Pitxot, and Canals, was not at all threatening. She could pull on the heart strings, assuage the

Fig. 7. Pablo Picasso, Drawing of the Virgin of Mercy cele-
bration, with *gegants* and the Hannibal float. Published in *Li-
beral*, October 5, 1902. Courtesy of the Institut Municipal
d'Història, Casa de l'Ardiaca, Barcelona. Copyright 1991
ARS N.Y. / SPADEM.

guilt of socially conscious artists and their audience, and yet not demand that they openly take sides.

Among all the avant-garde artists in Barcelona, Ramón Casas, Santiago Russinyol's close friend, best evoked images of struggle between authorities and the working population. Known for his portraits of local celebrities, Casas also painted pictures that served as the social and political conscience of the liberal middle class. In his 1899 painting *The Charge,* he showed an unequal battle between well-armed Civil Guards and brave but defenseless workers (plate 5). The central figure, a member of the mounted Civil Guard, rides forward, sword held over his right shoulder as he attacks. His mustache repeats the lines of his Napoleonic-style two-cornered hat; his high collar forms an ominous red mask over his lips and chin. As his horse rears to our left, ready to trample a fallen worker, the man grasps at the ground with his elongated fingers. His left leg, flung upward before the hooves of the horse, emphasizes his vulnerability. Behind the two central figures are three more mounted civil guards. The two on the right appear to be breaking up a group of workers. A shadowy guardsman in the left rear has his sword drawn as he and his horse gallop through a tightly packed group of workers.

Only the red collars of the Civil Guard and the white jodhpurs on the central figure, his horse's spats, and the white horse of the guardsman on the right stand out in the largely gray and black painting. Emblematic of the frequent cavalry attacks on workers' demonstrations in Barcelona, Casas's painting conveys a sense of the 1902 general strike, with its undertones of class war. Although *The Charge* was painted in 1899, it was redated 1902—a fact that only accentuates its symbolic importance.

Conclusion

Two sides—laborers and the middle-class rulers of the city—fought over control of the streets of Barcelona in 1902, in a struggle that partly concerned the symbols by which the city would be represented. One set of civic symbols—those engendered by the laboring class—showed courageous people fighting against their oppressors, as in the painting by Casas. Another set of civic symbols, rooted in Catholic imagery and traditional folk culture, had already emerged in

Barcelona before the 1902 celebration of the Virgin of Mercy, but they achieved new currency because of the festival. The fact that church rites were associated with the pageant and that religious art was acclaimed for its aesthetic merit established that religious imagery could transcend the purposes for which it was crafted and speak for universalist values. Although the church thus lost some control over the meaning of religious figures, it gained by having that imagery seep into the city's consciousness of art and aesthetics as a whole.

By promoting the Virgin of Mercy as a secular symbol of Barcelona, the city portrayed her as a representative of all citizens, whatever their social rank. As the workers increasingly organized themselves in their own resistance societies, their own neighborhoods, and their own leisure activities, the danger of Barcelona's being divided effectively into two cities—one controlled by the city government, the other by the anarcho-syndicalists—increased. The Virgin of Mercy celebration was in part an attempt to mute the fury that underlay relations between the rulers and the laboring class. The rulers incorporated their own symbols—from military reviews to nationalist songs—into the festival and treated it as a manifestation of solidarity and continuity. Workers and artisans, meanwhile, in street decorations and in floats, demonstrated that they could contend for power even on turf occupied by the church and the city government. They proved that they could compete with the pageant organizers to establish their own meaning for the Virgin of Mercy and her celebration.

Picasso and the artists of the Circle of Saint Martin were secondary players in the 1902 battle over the meaning of civic symbols. Russinyol upheld art for art's sake and yet applauded Catalan nationalist clerics who protected religious art. Picasso seems to have enjoyed and appreciated the folk figures of the *gegants* and the talent that went into constructing the floats. However, he and Nonell could also shame the middle classes of Barcelona by highlighting the poverty the government hoped to mask with its festivals. All the same, even though they recognized social differences, the two artists neutralized their potential political impact by making laborers appear pathetic. Certainly neither man was driven to make common cause with workers who attempted to help themselves through their unions and the general strike. Casas, the society painter, perhaps because of his personal commitment to painting what he saw, was the only contemporary artist who captured the mounting antagonism between the government and the anarcho-syndicalists.

4

Women Out of Control

Powerful women—from the Virgin of Mercy to Teresa Claramunt—wielded various kinds of influence in early-twentieth-century Barcelona. Yet in a society in which apparitions of the Virgin Mary were worshiped, powerful women not under the control of men were generally suspect. It is hardly surprising, then, that prostitutes, who sometimes became leaders of resistance, and nuns, who ran almost all social service institutions in Barcelona, were much disparaged by adversaries. The virginity of the nuns and the sexuality of the prostitutes were equally problematic. Prostitutes who were not perceived as pliantly sensual came across as pathetic, and nuns who were not perceived as nobly selfless and self-effacing appeared malevolent: the popular range of female stereotypes allowed no other options.

While views of nuns and prostitutes might vary from one community to another, there was a remarkable consensus among men of all classes about poor, working women. An innocent female victim was, they agreed, an object of pity, especially if she was a virgin or a dedicated mother. But what about the woman who seemed to have chosen the streets over the sweatshops, or the one who struck back at her exploiter?

Although the cultural ideal among men, whatever their social rank, seems to have been the docile and submissive wife, daughter, or nun— or the sort of sexually submissive women Picasso often drew at this time—in fact, early-twentieth-century Barcelona was filled with remarkably strong, self-reliant women from all walks of life. There were the vendors at the flower market and the fruit peddlers; there were the

barmaids and the factory workers, the domestic servants, and the wealthy women who managed charities; there were the mothers superior who ran schools, prisons, and orphanages. And there were, as we shall see, the women of the poor neighborhoods who banded together to take matters into their own hands when their community was threatened by war. Flesh-and-blood women, ranging from nuns to procurers and prostitutes, made their own history, often in opposition to other women. The spectrum of possible female behavior in Barcelona circa 1900 was far more ample than the common representations of women would imply.

The left was no different from the elite or the avant-garde when it came to myopia about the range of women's activities: leftists were equally preoccupied with the image of poor women as victims whom men had to protect. For labor leaders, the symbol of the young virgin victimized by poverty helped legitimate the struggle for social justice. Leftist male culture in early-twentieth-century Barcelona never ceased to idealize purity, casting the dishonored female worker or the suffering poor mother as the secular equivalent of the Madonna.

The republican and leftist press frequently recounted stories about employers' victimization of working-class women. In 1908, for example, a radical newspaper printed an account of a sexually exploited working woman who lived with her mother and two brothers. At one point, during a strike, the family was suffering financial troubles; in the same time interval, the employer molested the woman and then offered her money. To avenge their sister's honor, the brothers murdered the employer.[1] How the strike figured in the relationship between the woman and her employer, how the men came to find out that their sister had been abused, and what the woman herself did are not considered important to the story and are not reported. The moral of the story seems to be as much about poor men's family honor as about social justice or sexual harassment.

Bombing the Rambla of Flowers

In the city whose patron was the Virgin of Mercy, violence against citizens could be seen in sexual terms, especially if the victims were young, seemingly pure working women. If the maidenhood of the body politic was assaulted, it had to be ritually purified.[2]

The whole city of Barcelona responded to an outrageous attack on September 3, 1905, when a bomb went off at the flower market along the Rambla at 1:20 that Sunday afternoon. Pedestrians filled the narrow promenade as female flower sellers pursued their most active trade of the week. The bomb, which evidence suggests was set by a police provocateur, exploded in an outdoor urinal behind Petxina Street just off the Rambla. People fell over one another in confusion, and blood ran in front of the Trillo watch shop, whose large sign, a local landmark, had shattered along with the store's windows. Among those gravely injured were the wife of an army colonel and his two daughters, several flower vendors, and other young women.[3] The explosion wounded sixty and killed four.

The brutal attack on the most beautiful and widely frequented section of the city on a Sunday afternoon, when crowds were teeming in the streets, had a special pathos for the public because it caused the death of two poor, young, unmarried women—sisters out for a stroll with their cousin, who was wounded. Rosita Rafa, age nineteen, had lived with her sixteen-year-old sister, Josefa, and their mother in poverty in the Gothic Quarter. The mother, who went to the morgue to mourn one daughter, discovered there that the other was also dead.

The bombing was a direct result of the 1902 general strike and its repressive aftermath, even though it occurred three years later. Once forced underground, the labor movement had become increasingly infiltrated by police agents. In the spring and summer of 1905, bombs had been discovered before they exploded at the Palace of Justice and on fashionable Ferdinand Street, not far from the flower market. The police blamed "anarchists," although their failure to name specific suspects lent credence to rumors that they themselves or one of their informers was responsible. Anarcho-syndicalists charged that police and "shameless separatists" again seemed to be fanning the flames of terrorism in order to round up dissidents.

At the time, conflict between the anarcho-syndicalists and the Catalan nationalists was clearly on the rise. Supported by many leading industrialists, Catalan nationalism was gaining ground as a political movement in the early twentieth century. Blaming the anarcho-syndicalists for bombings dating back to the nineties, these nationalists wanted more police; but in the highly centralized Spanish monarchy, Barcelona lacked power to determine the size of the force. Viewing social disorder as the result of the monarchy's neglect (or even its active encouragement of terrorism, which would divide the Catalan people), Catalan nation-

alists argued that a measure of autonomy—at least the power to rule in their own area—would reduce the violence.[4] Although there is no evidence that they themselves were promoting social disorder as a way of winning local and regional self-government from the monarchy, labor militants thought them suspect.

In the early years of the twentieth century, Catalan nationalists, led by the tall, frail Enric Prat de la Riba, were attempting to unite all local citizens, regardless of status, against the state centered in Madrid. In 1886, when Prat was a young man studying law, he and other students (among them Josep Puig i Cadafalch) had organized the Catalanist Scholars Center. A year later, in 1887, they broke with cultural Catalan nationalists and founded a group known as the Catalan League (Lliga de Catalunya), whose task was to wage political propaganda campaigns in support of Catalan political rights. This became the Catalan Union, which Prat directed. In 1897, the Catalan cultural magazine *Renaixença* (Renaissance, founded in 1881) collapsed, and two years later Prat participated in founding the influential Catalan nationalist newspaper *Veu de Catalunya* (Voice of Catalunya).[5] He also helped organize the Regionalist League political party (Lliga Regionalista) in 1901, becoming one of its deputies to the Cortes. In 1907, he was elected president of the Regional Government of Barcelona, a largely ceremonial position, since the civil governor appointed by Madrid actually ruled the region.[6]

The fear of civil unrest and the elite's sense that they could maintain control only if they could make their own laws, collect taxes regionally, and establish their own police force contributed to growing antagonism between the wealthiest industrialists and the national government, which otherwise they might have loved to support.[7] In the words of historian Jordi Solé-Tura, Prat and his colleagues "were a basically reactionary class that played a revolutionary role in the Spanish context; a conservative and corporatist class that proposed to Europeanize, modernize, and liberalize the country."[8] Although few in the working classes bought into the image of Catalan nationalists as protectors, the sense of violation that the nationalists felt because of the bombings quickly spread to the population of Barcelona as a whole.

Prat responded to the 1905 bombing on the Rambla as one would expect. Proclaiming Catalan nationalist leaders the "fathers" and rightful overseers of Barcelona, he argued that the Spanish state was deliberately promoting violence in the city. By limiting the number of police when Prat and other regionalists wanted the force increased above its

current manpower of 170, Madrid was, Prat claimed, nurturing the "criminal population."[9]

Collective mourning at political funerals is a civic ritual that unites a community, enables it to reclaim sacred spaces, and permits it to cleanse itself of death. In Barcelona, pageants of mourning dated back at least to the bombing of Corpus Christi Day in 1896. During these funerals (which of course drew on the imagery of religious processions, such as the coronation of the Virgin of Mercy as patron of the city), contending forces attempted to place their own imprint on the civic community. In the case of the Rafa sisters' funeral, city officials controlled the overt political message; yet the female flower sellers presented their own views through a ceremonial act as well.

The funeral was arranged by officials of the municipality, acting in their roles as "city fathers." First they notified male relatives (not the mother) of the two slain girls that the city would organize and pay for the final rites. Then they turned the ceremony into a civic pageant, one that symbolically cleansed death from the city streets with the live bodies of demonstrators.

The cortege started from the morgue on Hospital Street, just behind the Rambla, and moved down the Rambla to the Columbus monument before proceeding back through the Parallel to the cemetery on the west side of Montjuich (see Appendix, map 3).[10] Civic leaders led the procession, thus proclaiming that the city itself was the chief mourner. There was a mounted escort for the luxurious hearses that carried the girls, who had previously lain in state and on view at the hospital. Their heads crowned with flowers, they resembled Madonnas as they rested on fine white satin of the kind they had probably never even touched in life. The city officials and the girls' uncles followed the hearse; after them came the captain general and three other generals. The procession curled onto the Rambla, attracting crowds of poorly dressed, weeping women. The swelling cortege passed the black-draped stalls of the flower vendors, who had lined up as an honor guard for their slain sisters (figure 8). In so doing, they informally replicated a ritual the captain general had introduced into the 1893 Virgin of Mercy celebration and the 1896 Corpus Christi procession; thus the flower sellers reclaimed their space along the Rambla. Balconies above the street displayed black crepe, and closed shops bore signs such as one that said: "Closed due to the death of the innocent victims of a repugnant attack on the Rambla of Flowers. The city of Barcelona protests."[11]

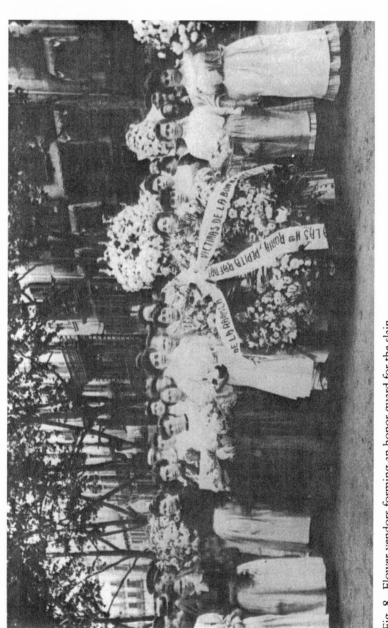

Fig. 8. Flower vendors forming an honor guard for the slain Rafa sisters, 1905. Courtesy of the Institut Municipal d'Història, Casa de l'Ardiaca, Barcelona.

Like the funeral after the 1896 Corpus Christi Day bombing, this one united the entire community, but it also had a specifically gendered meaning. If the women killed had been union activists and had died in a bombing, authorities might have held them responsible for their own deaths. If the young women had had known lovers, it is unlikely that they would have received the civic burial they did. Their deaths certainly would not have caused the same degree of outrage had they been prostitutes. Politically and sexually, the women had to be "innocent" victims. The wretchedness of the Rafa sisters' lives, together with their presumed virginity, made them appropriate symbols of transgression against the city; the authorities took advantage of this situation, Teresa Claramunt maintained, to justify a reign of terror against the anarcho-syndicalists.[12]

Prostitutes and Barcelona's Working-Class Community

In fact, the bombing victims could easily have been prostitutes, since the Rambla, Ferdinand Street, and the Royal Plaza near the flower market were frequented by such women. Early-twentieth-century Barcelona had a reputation as one of Europe's major centers of vice.[13] It teemed with streetwalkers and had more than its fair share of brothels, patronized by sailors from around the world. In 1912, 95 percent of Barcelona's prostitutes were from poor families, and 70 percent were under twenty-one. Judging by the number of prostitutes alone—some 10,000, out of a total population of 560,000 in 1912—one might expect that they would play a large role in any insurrectionary movement in downtown Barcelona—as they certainly did in 1909, in what would be called Tragic Week.[14]

To be sure, most working women were often only a few weeks' wages away from prostitution, which was the only social security they had when joblessness hit. Many women became occasional, clandestine prostitutes: they neither registered (as all prostitutes were legally required to do), nor did they work exclusively in the profession. Among working women, domestic servants were particularly vulnerable, not only to fate as a prostitute, but also to sexual mistreatment. Maids discovered to have been raped or seduced by the men of the employer's family were often dismissed. Looking for work under such circum-

stances, they had few choices: they could move one step down and become servants in boarding houses or hotels, or they could join brothels.[15]

When a woman employed in a factory or sweatshop was dismissed during the slack season, she, too, frequently turned to prostitution. As one late-nineteenth-century physician and social reformer described the situation: "The woman who is accustomed to earning her living by doing paid labor is proud to be able to support her aged father or her younger brother. . . . Then the workshop or factory in which she works closes down because there is too little work, striking her a mortal blow. At first she hopes to find work elsewhere. She may even have a little savings. But a week passes without work. Her savings disappear. She has one hope: she pawns the good clothes she has for special occasions." When that failed, he added, she became a prostitute.[16]

Even if a working woman kept her job, an illness in the family generally meant that the household income—which was normally insufficient to meet all the family's needs anyway—would not stretch far enough. The recourse for a poor woman, again, was prostitution, and the opportunities were endless.

Grown women were not the only ones who suffered these cruel choices. Barcelona shared with Shanghai and Algiers the dubious distinction of having child prostitutes widely available in brothels and on the streets. Many surely came from the ranks of the girls under fourteen who worked in the textile and clothing industries—11,408 in 1905.[17] Layoffs were frequent owing to overproduction and the loss of markets for textiles in Cuba, Spain's former colony.

The reality was that working girls and women shared the responsibility for supporting their households. And with women earning one-quarter to one-third of male workers' already low wages for an average twelve-hour-day, it is no wonder that a relatively large number of women engaged in prostitution at some time in their lives.[18] Some enterprising women, forced to choose between one form of exploitation and another, probably chose to be prostitutes of their own free will. "Teresa, or the Daughter of District V," a woman described by the journalist Paco Madrid, is drawn to the streets and to cabarets such as the Eden Concert. She becomes a kept woman but then, bored with her lover, takes up with a student who gives her a more exciting life. Betrayed by him just after giving birth to his child, she returns to the cabarets to earn a living.[19]

Knowing how few options working women had, one might think

that prostitution would have been less stigmatized among socially con-
scious workers than it was. But even the left required that a prostitute
redeem herself in some way before she could be welcomed back to the
fold. In *School of Rebellion*, a novel by the anarcho-syndicalist leader Sal-
vador Seguí, a former barmaid and prostitute named María Rosa forms
a monogamous relationship with a labor union militant. A woman with
a past that includes a long-term masochistic relationship with a violent
lover, she distinguishes herself from other women with tarnished repu-
tations by "her discretion, her natural elegance, her delicate and aristo-
cratic air."[20] The couple is very poor, but they manage to get along un-
til, true to melodramatic form, she becomes ill and dies. During their
life together, because she is repentant, she is accepted as his "wife" by
all of their friends.

Prostitutes fell into at least three different categories, depending on
where they worked. The women who earned the least were the street-
walkers. They catered to dock workers, sailors, and farmers who
brought their produce to the town markets. Standing near the markets
or the harbor, they gestured to the men, who would follow them to
cheap rooms the women rented by the hour. Because all working
women spent a certain amount of time away from home every day
going to market or drawing water from fountains, these women could
easily pass as simple housewives. Women who plied their trade at night,
however, made more money than the day workers because their clien-
tele was larger. In 1899, Pablo Picasso painted one such streetwalker,
known as "Pug Nose." Dressed in the long skirt and shawl of any poor
woman in the neighborhood, she marked herself as a prostitute by dan-
gling a cigarette from her lips (plate 6).[21]

Another group of prostitutes and their female procurers worked in
the cabarets. Cafés were the subject of harangues by those who disap-
proved of modern life in Barcelona: "once fountains of culture," one
social critic wrote, "[they] have turned into dens of prostitution."[22]
Here, as in Paris, poor women bought cheap drinks and sat and waited
for customers—as two of them do in Picasso's 1902 painting *Cocottes in
the Bar*.[23]

It was widely believed that all the waitresses and barmaids at cafés
and bars such as the Excelsior, Palace, and Alcázar served their custom-
ers sexually.[24] One sentimental story in the workers' press underscored
how difficult it was for women who worked in bars to avoid their cus-
tomers' sexual advances. Adelina, orphaned at fourteen, went to work
in a tavern owned by her aunt. The family relationship did not protect

Adelina from rough treatment by male customers, however. When she became pregnant at eighteen, her family rejected her. To earn a living, she became a prostitute in a bordello; ultimately, she wound up in a hospital with a venereal disease.[25]

Streetwalkers and bar prostitutes worked outside brothels and so needed help finding rooms and protection from violent clients. For this purpose, some women kept pimps (*ganchos*), who were frequently gamblers. True to stereotype, they found the prostitutes rooms and took a portion of their earnings, often abusing them in the bargain.[26] Other prostitutes kept their independence and used the services of enterprising older women like Carlota Valdivia, whom Picasso portrayed as *The Procuress* or *The Celestina* in 1904 (plate 7); living above the Eden Concert, she undoubtedly rented out rooms.

The third type of prostitute worked in brothels that were scattered throughout downtown Barcelona.[27] Among the best known were the houses on Robador and Ramalleras streets, across from the maternity hospital; the one on El Cid Street; and the one on Avinyo Street, later immortalized by its French name in the *Demoiselles d'Avignon;* the houses on the small, dark, winding alleyways that ran from Ferdinand Street to the harbor; and the elegant brothel on New Street of the Rambla, at number 12, above the Eden Concert, which served a better clientele than those who frequented Carlota Valdivia's rooms (see map 1). Men from stevedores to bohemian artists to long-married patriarchs spent considerable time and money among prostitutes in brothels that became their homes away from home.[28] Although some brothels cultivated exotic images, many provided middle-class comfort. The proper madam of one particularly wholesome house was appalled by the drunken raucousness of journalists whose offices were next door and tried to get them to modify their behavior. Amused, the newspapermen scornfully referred to their neighbors as "homecooking whores" (*putes d'escudella i carn d'olla*).[29]

Even the poorest houses of prostitution afforded the men comforts such as couches or divans from which they could look over the prostitutes.[30] Depending on the customs of the house, the women joined the client either fully clothed or seminaked. In *The Divan* of 1901, Picasso depicts one such encounter (plate 8). Beneath a painting of a nude woman, a fully clothed man and woman fondle each other as their legs, visible under a table on which a bottle and a pipe rest, begin to intertwine. The woman's left hand stretches out, away from her side and beyond the man's view, holding an object that may be a wallet she has

picked or may be a sum he has paid her. The man wears the navy blue smocked-style jacket of a worker. Hovering in the background is the squat figure of a witchlike crone. Whether or not she is the madam, the woman would be recognizable to most local people as the Celestina.

Born in the High Middle Ages as a character in Fernando de Rojas's *Tragi-Comedy of Calisto and Melibea,* Celestina, like Don Quijote, had, as we saw in our discussion of puppets, become a cultural archetype. The Celestina can be depicted as the procurer, the woman responsible for birth control, the abortionist, or the madam. Because she is post-menopausal, her powers over the sexual activity of others and potential for sexual rebellion can be viewed as even more potent than those of the woman of childbearing age. Because she is an independent woman, whom presumably men do not desire, the Celestina or procurer adds an ominous note to any sexual scene of which she is a part.

Whatever the image of the procurer or madam, prostitutes them-selves were of course in the business of selling sexual pleasure, as Picas-so's 1902 comic drawing of the painter Isidre Nonell engaged in oral sex demonstrates (figure 9). In the lower part of the drawing, the torso of a woman appears in profile with her right breast exposed. She wears the topknot hairdo made famous in Toulouse-Lautrec's drawings. The top two-thirds of the line drawing shows the smiling, well-groomed Nonell, wearing a floppy bow tie above his tight collar. He holds his hands at his sides against his neatly pressed jacket. The prostitute, kneel-ing before him, sucks his penis. A bawdy drawing like this seems to be Picasso's visual equivalent of the verbal witticisms for which the sharp-tongued Nonell was famous.

Group visits to brothels often continued men's social intercourse in the cafés, and seem to have been nearly as public an activity. Picasso and his friends often went from the Four Cats or the Eden Concert to share prostitutes. In 1901 and 1902, in fact, Picasso caricatured his friends at sexual play in a series of erotic drawings. In one, which shows a sex scene, the artist Ángel de Soto, dapper in a dress suit with a long jacket, with two shocks of dark hair over eyebrows and eyes, holds a long pipe in his mouth (figure 10). A nude woman, with striped stockings up to her thigh, black shoes, and a thin body with big breasts, holds an upraised champagne glass in her left hand. De Soto spreads his hand under her upraised left leg, his finger tickling her clitoris. At the center of the drawing is his erect penis, encircled by her right hand.

A group sex scene is seen in Picasso's drawing of the two de Soto brothers and a woman called Anita (figure 11). Ángel de Soto, now

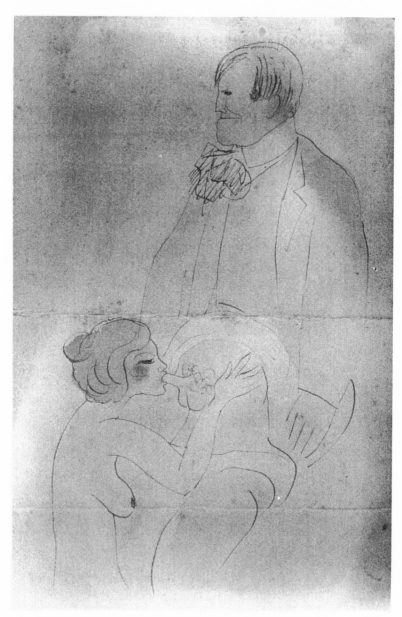

Fig. 9. Pablo Picasso, *Isidre Nonell and a Woman*, 1902–1903.
Courtesy of the Museu Picasso, Barcelona. Copyright 1991
ARS N.Y. / SPADEM.

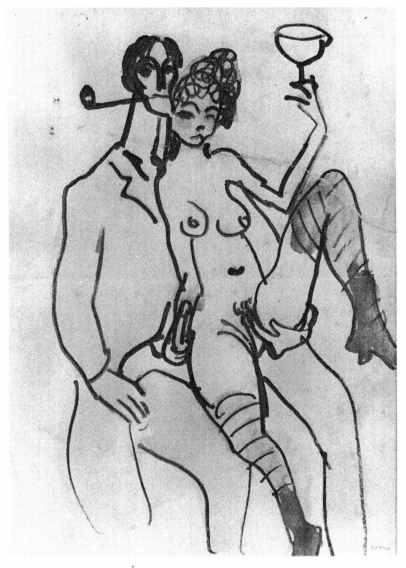

Fig. 10. Pablo Picasso, *Ángel de Soto and a Woman*, 1902–1903. Courtesy of the Museu Picasso, Barcelona. Copyright 1991 ARS N.Y. / SPADEM.

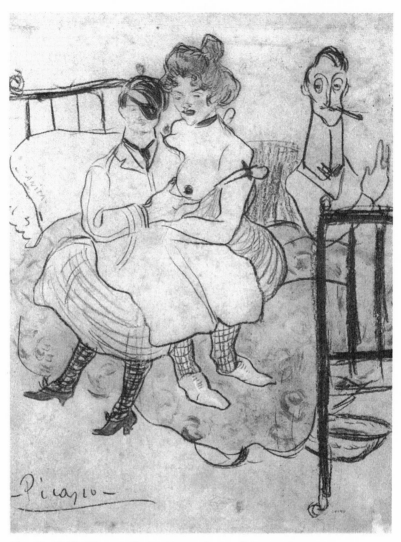

Fig. 11. Pablo Picasso, *The De Soto Brothers and Anita*, 1902–1903. Courtesy of the Museu Picasso, Barcelona. Copyright 1991 ARS N.Y. / SPADEM.

with his hair combed to the side and his eyes wide open over an elongated, giraffelike neck sits on an iron four-poster bed, under which a wash basin or bedpan is clearly visible. In this quickly sketched drawing, a dwarflike Mateu de Soto takes his place on the lap of a woman whose bare left breast he fondles. He wears an eye patch and a long overcoat, while she is fully dressed except for the bare breast. Although Anita's name appears on the drawing, there is no sense of who she is, nothing to acknowledge her personality like the bow tie, pipe, long neck, or overcoat Picasso uses as affectionate details to highlight the identities of the men in his drawings.

If Picasso's sexually active women lack character, they are still not pathetic like the poor mothers or absinthe drinkers he depicted at around the same time. Occasionally a woman is abused, as in the drawing he called *The Virgin,* which depicts a woman clearly in pain as she is mounted from behind.[31] In general, however, he presents prostitutes as sexual confections available for their clients' pleasure. When they are not pliant and docile, they are as terrifying as the prostitutes in his *Demoiselles d'Avignon* of 1907. Despite his avid interest in prostitutes, then, Picasso resonated the fear of sexually active, independent women that was so widespread in the society.

Prostitutes' lives and attitudes were far more varied than those who portrayed them apparently imagined. This fact is most evident when we look at their leadership role in what became known as Tragic Week.

Tragic Week

In the spring and summer of 1909, as labor antagonism in Barcelona mounted, so did pacifism. Spain's disastrous defeat in the Spanish-American War in 1898 had hammered deeper the wedge between rich and poor in the city. Among the most hated of the city's rich businessmen were the marquis of Comillas and his son-in-law, the count of Güell, who commissioned many buildings from Antoni Gaudí. Comillas and Güell each had large shares in the iron mines of the Rif in Spanish Morocco. Before the war, their holdings had also included the Transatlantic Steamship Company, the General Tobacco Company of the Philippines, and the Spanish Northern Railroad Company, which were managed through the Hispano-Colonial Bank. With the loss of Spanish colonies in Puerto Rico, Cuba, and the Philippines in the war,

however, Güell and Comillas had readjusted their empire and placed a large measure of their holdings in the Hispano-African Society, centered on the Moroccan port of Melillas.[32]

When guerrillas in the Rif attacked the railroad leading from the lead mines to the port on July 5, 1909, killing four workers, the Spanish government retaliated by sending a column of soldiers to pursue the guerrillas and by reinforcing positions on nearby Mount Atalayon. The Spanish soldiers suffered enormous losses, and the minister of war decided to augment the troops with six more battalions, made up mostly of reservists from Barcelona. The embarkations of Catalan soldiers began on July 9 from Barcelona; by July 25, twenty-four thousand ill-trained Spanish troops were facing about eight thousand guerrillas from the Rif.[33] The conflict became known in Barcelona as the Bankers' War. Such an unpopular military engagement, especially one that called primarily on poor married men, was bound to lead to strong opposition. The embarkations from Barcelona that July, in ships belonging to the marquis of Comillas—who also, it should be noted, administered the finances of the Jesuit Order in Spain—could not have been better calculated to outrage the city's working-class population, particularly the women seeing off their male relatives.[34]

Ever since the institution in 1885 of a rule that permitted an annual indemnity to be paid in lieu of military service, most prosperous people had managed to save their sons from the draft. The fee was 1,500 *pesetas*—roughly three years' salary for a worker. The reason Picasso, for example, could come and go in early-twentieth-century Spain without doing military service was that his uncle in Málaga had paid a bounty for his freedom.

On Sunday, July 18, at 4:30 P.M., as the local people of downtown Barcelona awoke from siesta to stroll in the cooler hours of the evening, Catalan reservists marched through the central part of the city, down the Rambla to the harbor, where they were scheduled to embark. There the troops broke ranks to join their families in one last embrace. Police, massed along the way, tried to break up the emotional partings, while wealthy Catholic matrons—whose own sons and husbands had paid the bounties and so did not need to go—distributed religious medals and cigarettes to the departing troops.[35]

This misguided bit of charity was the last straw. Many soldiers grabbed the medals and threw them into the water as crowds began to chant, "Throw down your arms." "If the rich don't go, no one goes." "Let the priests go." "Send Comillas." The transport ship *Catalunya*,

owned by Comillas, was ordered to pull out as the guards shot into the air to prevent the crowd from stopping its departure. The crowds swelled, circulating down the Rambla and throughout the downtown area protesting against the war the next day. In ever-increasing numbers, the multitude gathered before the palace of the marquis of Comillas on the Rambla to shout, "Long live Spain and death to Comillas." The protesters then moved to the offices of the *Poble català*, the Radical party newspaper. The journal, one of the leading republican publications in Barcelona, defined anticlericalism in the city. Its staff came to the windows to applaud the demonstrators, who moved on to the plaza in front of the university. There the police held the line and arrested eight youths. This pattern continued night after night until July 23.[36]

In an effort to reduce the animosity, King Alfonso XIII issued a royal decree granting a wage of fifty *céntimos* a day to the families of reservists fighting in Morocco. Otherwise they received no combat pay.[37] Yet that sum was clearly far from adequate: a family of four in Barcelona required at least 3.50 *pesetas* daily to get by. Moreover, the families of reservists killed in action became eligible for a pension only when another royal decree was issued on August 6—too late for many.[38]

Acts of largesse by elite women only exacerbated popular distress. On July 22, the president of the Chamber of Commerce, Industry, and Navigation urged his colleagues to continue paying the salaries of those workers who were among the reserve troops fighting in Morocco. The conservative Catalan nationalist political party, the Regionalist League, had already urged the government to call the Cortes to discuss the problem of the Catalan troops and related matters. On the evening of the twenty-second, the marquise of Castellflorite, an aristocratic Catholic philanthropist, who had initiated the distribution of religious ornaments and cigarettes at the pier, gathered local civic and cultural leaders to discuss raising private money to pay the salaries of those in active service.[39] None of these efforts were of any avail.

A general strike, scheduled to last one day, was called for Monday, July 26, with the support of Socialists, anarcho-syndicalists, and Radicals. In Barcelona, where the Socialists had only a small following and the anarchists opposed political action in favor of either organizing labor syndicates or associating in cultural and educational organizations, many working people gave their political allegiance to the republican Radical party, directed by the journalist and orator Alejandro Lerroux. The party drew workers through its system of community centers,

known as Houses of the People, where people gathered to socialize and gain skills; the centers also offered cheap food, health and old age insurance, night school, and frequent theatrical entertainments.[40]

As historian Joan Connelly Ullman shows in her now classic study *The Tragic Week*, which appeared just as the new women's movement emerged in the United States in 1968, women played a crucial role in every aspect of the insurrection that erupted on July 26, 1909.[41] Like other general strikes, Tragic Week was an assertion of community solidarity as well as of labor grievances, one in which poor women took an active part. Women joined men at 4:00 A.M. on the roads to the factories to urge all workers to stay home. Although many did report for work, women, wearing white bows symbolizing the strike, urged them to walk out. The factory owners, fearing violence, told workers to go home, thus assuring the success of the strike.[42]

At the Plaza of Catalunya at 6:00 that morning, a woman named Mercedes Monje Alcázar called on the men to prevent the drafted troops from leaving for Morocco. The Civil Guard intervened and arrested her, despite the large number of people around. By 10:00 other women, joined by young men, were demanding that merchants close their shops. All kinds of women joined the fray. Some had already participated in Radical party politics as the Red or Radical Women (Damas Rojas or Radicales). Others were active in street politics. Among these was "Forty Cents," the nickname given María Llopis Berges, a prostitute: she led a group that strong-armed shopkeepers along the Parallel, forcing them to close in support of the general strike or face destruction of their windows and furniture. Some two hundred men and women attacked the police station on New Street of the Rambla, where they liberated a woman who had just been arrested.[43] From there they fled to Union and then Ferdinand streets, where the mounted Civil Guard charged the crowd and dispersed it.[44]

By noon, men and women from New Town, east of Citadel Park, arrived downtown. Wearing white bows and sashes emblazoned with the phrase "Down with War," the women led an attack on the trolleys. Thirty-four streetcars were damaged and two totally destroyed when the crowds stoned, overturned, and set fire to them and tore up the tracks.

A Radical woman, Carmen Alauch Jerida, launched an assault on the police station in Clot–Saint Martin between 3:00 and 4:00 P.M. Two civil guardsmen and seven security guards were wounded, and two men and two women demonstrators killed in the onslaught. With women

and children proclaiming the Radical slogan "Down with War" in the lead, a group from New Town marched down the Rambla to Columbus Pass and the captain general's headquarters. In hopes that the soldiers would ally with them, the demonstrators hailed the army but attacked the war in Morocco. Between three and fifteen people died when the security guards shot into the crowd.[45] General Germán Brandeis ordered his troops to fire on dockworkers supporting the demonstrators. And when the workers called, "Don't fire, companions; we are fighting for you," the possibility that the soldiers might mutiny seemed real.[46]

By 11:00 the next morning, the general strike had become an insurrection. The narrow cobblestone streets of the Parallel district, with its slums, factories, music halls, brothels, and the port, provided the ideal place for barricades, as well as the population to serve on them. Local men and women used manhole covers and the streets' cobbles to construct barriers against the troops, who were certain to attack and did.[47]

During the night of Monday, July 26, and all day Tuesday, religious institutions burned throughout the city, especially in areas of Radical strength, with the convents especially hard hit. A long tradition of anticlericalism followed by nine years of anticlerical agitation by the Radicals and their demagogic leader Alejandro Lerroux had succeeded in focusing popular distress and wrath on the religious orders.[48] The violence of Lerroux's rhetoric and its way of attacking the church by attacking nuns contributed to the climate that turned the general strike into an anticlerical rebellion. The most famous example of Lerroux's style comes from a speech he gave in 1906:

Young barbarians of today, enter and sack the decadent civilization of this unhappy country; destroy its temples, finish off its gods, tear the veil from its novices and raise them to be mothers to civilize the species. Break into the records of property and make bonfires of its papers that fire may purify the infamous social organization. Enter its humble hearths and raise the legions of proletarians that the world may tremble before their awakened judges. Do not be stopped by altars nor by tombs. . . . Fight, kill, die.[49]

Downtown, the first church to go was the Romanesque Saint Paul in the Fields, right in the middle of the Parallel district. A barricade designed to protect the demonstrators attacking the church had been leveled Tuesday morning. When the Civil Guard mysteriously withdrew at noon, the barricades immediately went up again. Under the direction of Adela Anglada and Rafael Fernández, nicknamed "Son of the Wind," the crowd of locals burned the building; they then left for the Hierony-

mite convent known as the Royal Monastery of Saint Matthew.[50] The twenty-eight cloistered and reputedly wealthy nuns of this order fled out the back, where their poor neighbors stood jeering at them. The nuns escaped to the home of a wealthy industrialist and, wearing borrowed clothes, found refuge in the homes of sympathetic Catholics throughout the city. Charges that the nuns hoarded their money rather than distributing it to the poor seemed to be substantiated when the crowds uncovered enormous wealth, which the nuns claimed to be guarding for the faithful.[51]

Evidence supporting additional popular grievances against nuns surfaced when the crowds invaded other convents. Working women who sewed garments and linen at home had long complained that the convent labor of nuns and their orphan and student wards undercut piece rates.[52] (There must have been some merit to the charges; a few years later, devoutly Catholic women established a boycott of goods prepared by religious institutions, in order to steady and raise the wages of poor women who worked at home.) The Franciscan Sisters of the Immaculate Conception faced such charges when their poor female neighbors around the Parallel attacked the convent at 2:00 Tuesday afternoon and uncovered fifty heavily embroidered communion dresses. Denying that these had been produced for sale, the mother superior claimed that wealthy patrons had donated them for the use of poor girls.[53] As the nuns attempted to flee the convent, a man tried to rip the habit off one, saying he intended to search her for hidden guns. The crowd then destroyed the building.[54] Later that night, a nun hiding stocks and bonds escaped to Gracia, where a crowd led by a woman named Francisca Norat forced her to remove her clothes, thereby revealing the documents. Norat proceeded to drive the nun down the street in her underwear as people around shouted insults.[55]

The cloistered Augustinian nuns of the Convent of Santa Magdalena, on Saint John's Ravine just behind the Four Cats Café, had also attracted neighborhood suspicion. They now faced angry women neighbors, who forced them to leave the convent at 6:00 P.M. on Tuesday, July 27. The neighbors then "discovered" torture chambers in the basement, including a "martyrdom room" with a metal bed made up of tubes connected to a gas pipe. The prioress later tried to explain that an insane nun, Sister Teresa Bonsom, was kept in that room; after spending three years in the insane asylum of the Holy Cross in Saint Andrew of Palomar, she had returned to the convent and, it was claimed, suffered a relapse. The neighbors and the nuns disagreed about whether she had

been the victim of sadistic treatment at the hands of her secretive co-religionists.[56]

Another mystery surfaced at Our Lady of Charity. Despite public health regulations forbidding the practice, it was still common for monks and nuns to be buried in the walls of their cloisters. In ransacking the tombs of that convent, the neighborhood women were shocked to find bodies bound hand and foot with scourges by their sides. No one could explain, moreover, why male and children's bodies were also found in the crypt.[57]

Events at the Plaza of Padró on Wednesday, July 28, further revealed the depth of antagonism popularly felt toward the convents (see map 1). The small square, deep in the downtown section west of the Rambla where the first textile factories had grown up in the nineteenth century, was a symbolic center of old Barcelona, once the point of origin of many of Barcelona's festivals. Until hygienic reforms led to the construction of the glass-covered Saint Anthony Market in 1886, it had been one of the city's central marketplaces. At the turn of the century, women still frequently gathered in the Plaza of Padró, near the central stylus topped by a statue of Saint Eulalia, the gooseherd, to gossip and discuss events of the day. On July 28, a large number of local women assembled when an excited neighbor claimed that her sister, a nun in the nearby Hieronymite convent, "had been tortured" for being more attractive than the other nuns.[58] The crowd swelled as it drew close to the convent. Once there, it proceeded down to the crypt, lifted the marble that covered the tombs, and exhumed twenty-five to thirty mummies.[59]

The women were outraged by the unhygienic convent burials. It was poor people who died of typhus, spread by a flea carrying bacteria believed to live on cadavers and other damp organisms, and of cholera, caused by the bacteria in waste products, including decomposing bodies. Furthermore, the crowd was horrified to find that the mummies' hands and feet were bound. Taking matters into their own hands, the women dragged the bodies to the Plaza of Padró, where they were displayed. Then a macabre demonstration began as they dragged the mummies to various places in the city (figure 12). One cadaver was propped up like a prostitute with a cigarette in her mouth in front of the Church of Saint Mary of the Pine Tree. Two more were left as calling cards before the Güell Palace on New Street of the Rambla. Eight mummies were carried by young boys to City Hall and deposited in front of the troops there. The procession was headed by a large white sign with black letters that read: "Martyred Nuns."[60] A few women took on the

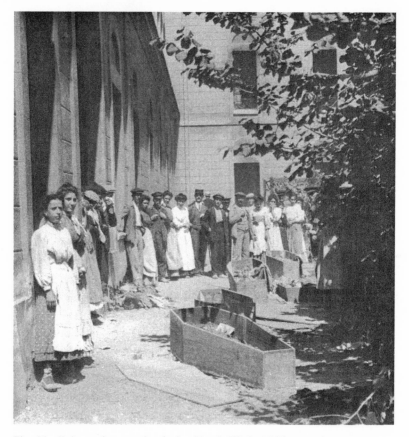

Fig. 12. Exhumed mummies during Tragic Week, 1909.
Courtesy of the Institut Municipal d'Història, Casa de
l'Ardiaca, Barcelona.

task of exposing the cadavers to a broader public. They dragged them
to the barricade on Carmen and Roig streets, and from there men trans-
ported a few more to the Güell Palace. Clearly the crowds thought they
had proved their point about the cloistered nuns' evil deeds.

It is worth noting here that digging up corpses is not uncommon in
cultures in which death—particularly a good death, as in a bullfight—
and its ceremonies are so much part of civic and religious life. In a soci-
ety in which bodies of heroes are kept in glass showcases and saintly
purity might be alleged when a body "miraculously" failed to decom-
pose, one finds a legacy of fascination with the condition of bodies. In
fact, just before Tragic Week, in June 1909, local heroes who had re-

sisted the Napoleonic invasion of Barcelona in 1808 were exhumed and reburied following a mass in the cathedral.[61]

The last act of Tragic Week could have been a Mardi Gras rite. Toward the end of carnival in Barcelona, the mock king, symbolizing authority, sickens and dies despite the best efforts of physicians and clergy. Then the king, who in health is a harlequin, in death becomes a straw man, a dove, or a sardine, which is ritually buried.[62] By parodying the Crucifixion and Resurrection, the burial affords the crowd a chance to ridicule death itself. During Tragic Week, a retarded twenty-two-year-old coal tender, Ramón Clemente García, unconsciously imitated this carnival ceremony. He carried one of the mummies exhumed from the Hieronymite convent along the Rambla to the house of the marquis of Comillas, where the tattered youth, covered in the soot of his trade, committed an act of sacrilege: as the crowd cheered, he danced with the cadaver—an act that would cost him his life when he became one of five people executed in connection with the insurrection.[63]

Carnival week was a period when "the cheerful vulgarity of the powerless [was] used as a weapon against the pretence and hypocrisy of the powerful." The way Clemente García played to the crowd provided them with a sense of community. Thanks to his sacrilege, he and those around him were able to attack "class hierarchy, political manipulation, sexual repression, dogmatism and paranoia. . . . [This act] of creative disrespect [showed] a radical opposition to the illegitimately powerful"—to use the words of R. Stamm regarding carnival rituals.[64] But, in Barcelona, carnival was always followed by the reimposition of authority.

By Monday, August 2, the insurrection had petered out as more and more troops moved into the city. Before the task of mopping up could begin, working women of Clot–Saint Martin demanded the release of all prisoners taken as a result of the insurrection. But despite the women's threats to keep the factories closed until the amnesty was complete, workers returned to their jobs on Monday morning. Barcelona remained under martial law until November.[65]

During the unrest of 1909, local women showed a strong sense of being neighborhood guerrillas, guardians of their communities. Enriqueta Sabater, for instance, known as "the Big One," cut down electric poles and telephone lines in the Parallel after directing the construction of barricades. One military leader, the Valencian Rosa Esteller, waved her revolver as she toured the neighborhood making sure doors were open so that resistance fighters could get to the roofs to attack police.

In nearby Clot–Saint Martin, Carmen Alauch, a fishmonger, who the day before had led an attack on the police station, recruited teenage boys to fight alongside her.[66] Back in downtown Barcelona, Teresona, a woman who sold fruit and vegetables illegally in the street near the convent on Saint Anthony Street, upheld the neighborhood honor. When a gang entered the convent, they found the nuns kneeling in the chapel with their arms crossed over their chests. One nun screamed: "Kill us! Kill us! But don't violate us! We are ready to die! . . . We are ready to be martyrs!" Teresona intervened to defend the nuns. She entered the convent and berated the sisters for losing control: "What kind of martyrdom are you talking about? Don't you see that these boys, our kids, aren't capable of killing a fly? Quiet down. Come with me and nothing bad will happen." Then she, with the help of other neighborhood women, led the nuns to safety.[67]

Local prostitutes played a role as leaders of the poor community. None was more remarkable than Josefa Prieto, "the Woman from Bilbao." She supervised the battle in the harbor area, aided by her lover, the Radical Domingo Ruíz; her lieutenant, Encarnación Avellaneda, "the Castiza"; and "Boy of the Wind," who had headed the first convent burning on Monday night. A born leader, Prieto ran one of the biggest brothels in the red light district. In and out of jail for defending herself against the police, even before Tragic Week she had a neighborhood reputation for toughness. Once the rebellion was quashed she was exiled to Perpignan, where she joined the Committee for the Defense of Expatriated Spanish Citizens and won an amnesty for herself and other political exiles.[68]

In terms of military prowess, the neighborhood women sometimes met their match in the mothers superior. Mother Sacred Heart of Jesus of the Order of Handmaids, Adorers of the Blessed Sacrament and of Charity, presided over a wealthy order. Situated on the corner of Casanova and the Council of One Hundred streets in the Extension, it devoted itself to educating poor children and rehabilitating girls from the slums, many of whom probably engaged in occasional prostitution. The word *charity* might appear in its title, but the order evidently was best known for its stern discipline, which won it the neighborhood nickname "the girls' Bastille." The mother superior clearly accepted the role of general when she organized her students and all the nuns under her command to defend themselves against arson at 5:00 P.M. on July 27. When everyone was forced to leave the convent, many of the girls ran away from the nuns. The mother superior then won the support of the

captain general himself, who ordered soldiers to protect this particular convent all week. All but eight of the escaped girls, having no place else to go, returned "voluntarily" after the insurrection was suppressed. Yet as late as October 1910 a newspaper published an account of a girl's attempted escape from the convent.[69]

Nuns, Prostitutes, and Rebellion

One of the most clerical cities in Spain, Barcelona was home to 4,117 nuns in 348 convents—compared to 187 convents in Madrid and 153 in Valencia.[70] Most of the poor in Barcelona had at least a passing acquaintance with nuns and the convents that dotted the urban landscape. In orphanages, public hospitals, and schools for poor children, nuns were the principal educators and caretakers. According to statistics published in the Catholic press following the insurrection, Barcelona's nuns operated 200 hospitals, 20 insane asylums, 40 foundling hospitals, and 248 homes for children and the aged in 1909, and they taught 56,000 nursery school children, 15,591 elementary school children (whom they educated free of charge), and 880 adults in night school. They also served as nurses and jailers in military hospitals and in prisons.[71] Clearly, they were among the city's most powerful women.

Hidden from view, the religious rituals of cloistered nuns were mysterious and therefore terrifying to many of the poor men and women over whose families the nuns wielded so much power. The nuns themselves, because they were perceived as powerful and secretive, were feared as well. Popular literature in all the Catholic countries capitalized on fascination with convents and their inhabitants. A play entitled *The Nun Buried Alive; or, The Secret of That Convent,* by Jaume Piquet, was repeatedly staged in Barcelona.[72] Referring specifically to the nuns of the Hieronymite Order, who were widely believed to scourge themselves, the play appeared first in 1886 at the popular Odeon Theater and continued to be revived through the twenties.[73] Titillating, semipornographic stories about nuns torturing others in their orders helped to set off exaggerated fears of these elite virgins, who lived largely under the direct rule of a mother superior rather than any male authority.

There is no doubt that the power and sometimes the self-righteousness of nuns in turn-of-the-century Barcelona were resented by many of those who benefited from their work. It was primarily in the

schools that many of the poor actually suffered at the hands of nuns. Working parents—often single mothers—who were forced to place their children with the sisters may well have been uncomfortable with their patronizing attitudes and the authority they wielded over children and parents alike. In the aftermath of the insurrection, story upon story appeared in newspapers about how the mothers who had to place their children in orphanages because of poverty attacked the nuns, charging wanton neglect.[74] Certainly, the class system continued within the convents.

The participation of prostitutes in many of the attacks on authorities, including their leadership of the working population, has a certain logic. Prostitutes were part of the everyday life of poor neighborhoods, and local people included them in the community.[75] It thus stands to reason that prostitutes would take the side of the insurrectionaries, as the women of the brothel on Robador Street did, cheering on the fighters below them in the street.[76] Because prostitutes were knowledgeable about the police and their operations, they also made skilled protest leaders. It is of course common for authorities to challenge the purity of all women who engage in rebellion; yet in uprisings from the seizure of the Bastille to the Commune in Paris to Tragic Week in Barcelona, fierce women who happened to be prostitutes in fact did come to lead urban rebellions.[77]

It is revealing that within a decade after the Paris Commune of 1871, the French government made prostitution a crime.[78] Part of a European-wide policy of controlling the spread of venereal disease, laws governing prostitutes always claimed to be concerned with public health, not morality or politics. By becoming involved in political struggle, however, prostitutes were elevated to the role of revolutionaries who threatened the political public health.[79] In 1911, a far-reaching proposal was introduced by Barcelona's Academy of Public Health to increase medical control over the lives of prostitutes, a plan that, at least unconsciously, may have been an effort to cleanse the city after Tragic Week.[80] This recommendation is yet another indication that female sexuality, whether suppressed by the women in question, as in the case of nuns; sold, as in the case of prostitutes; or managed, as in the case of procuresses, could be, and often was, perceived as a threat.

Both real and presumed rebels against authority in Barcelona were persecuted in the aftermath of Tragic Week. Four participants and one scapegoat—the libertarian and libertine educator Francisco Ferrer, who

happened to be outside the city during the uprising—were executed, some within weeks of the uprising, Ferrer in November 1909. The roundup that followed was an effort to reassert control through a "purification" process designed to bring unruly men and women under control and therefore channel the energies of the entire working community. Anarchists and free thinkers bore the brunt of the punishment meted out after Tragic Week. Despite the continued efforts to portray good poor women simply as victims, Tragic Week revealed that they— and especially the prostitutes among them—could be something far more terrifying. In one week, they had become people who just might take matters into their own hands.

5

Female Consciousness and Community Struggle, 1910–1918

Working women played a key role in certain aspects of political street life in early-twentieth-century Barcelona because they felt they had special responsibilities and so demanded special rights to protect their families and communities against extinction. A belief in this unwritten sense of privilege, which I will call "female consciousness," was frequently acknowledged by members of all political groups and even by authorities, who were reluctant to order troops to shoot at poor women.[1]

The civic world of poor women in turn-of-the-century Barcelona was more localist than that of men, concerned as women in particular were with such issues as hygienic conditions in the neighborhood and prices at the markets. It was at the same time more global as well, in that poor women arrogated to themselves the right to defend all humanity and define human decency. Male politics generally aimed somewhere in between—at the level of unions, cities, regions, or nations.

When women left their households to protest against certain indignities or demand changes in their own and their families' lives, they presented themselves not as political actors, but as the very conscience of the community. One contemporary commentator in Barcelona put it this way: "Men make the laws, [but] women make the customs."[2] Prominent among such customs was the habit of acting as if survival took precedence over law. By mobilizing themselves around what they believed was a common female obligation to ensure that scarce re-

sources were distributed equitably, they were asserting a special image of citizenship for themselves as women.

Women's daily work in community settings, of course, brought them into contact with one another, which in turn influenced what and how they thought. Physical proximity in plazas, wash houses, markets, churches, beauty parlors, and even female jails contributed to the power of female community. The loose networks that resulted facilitated the formation of tight bonds, the strength of which was revealed in times of collective action.

Whether a woman was a factory worker, a laborer in a sweatshop, or a poor housewife employed at home in the garment trade, she was more likely to ally politically with other women than with men. The reason lies in part in the fact that a woman's employment was apt to vary with her age and marital status, whereas her relations with neighbors and friends remained relatively constant. When young, she was most likely to find work as a domestic servant, factory worker, or waitress; once she had children, she would instead probably engage in garment piecework at home or obtain employment as a laundress or clothes presser. And of course, all working women might potentially be forced into prostitution when unemployment or insufferably low wages made it impossible to make ends meet. Thus, consciousness of the entire social condition of their families and neighbors, rather than work conditions alone, governed the alliances poor women made in the second decade of the twentieth century.

During waves of strikes and rebellions that began with the 1902 general strike, the women's networks in the popular quarters of Barcelona acquired a political character. Networks devoted to preserving life by providing food, clothing, and medical care to households became instruments to transform social life. An examination of female collective action in 1910 following a case of child molestation, in 1913 during the Constancy textile strike, and in 1918 in Barcelona's "women's war" demonstrates how women came to respond to broader political issues in their defense of rights they considered their due on the basis of "female consciousness."

Collective Action: Barcelona, 1910

In Barcelona, female community solidarity formed most readily in opposition to forces that violated what local women consid-

ered to be their customary rights. Shared antagonisms, more than shared values, welded poor women together in the second decade of the twentieth century.

A scandal that gripped Barcelona's poor female community in October 1910, when the city was in the midst of another long metallurgist and machinist strike, provides a case in point. Male workers were again fighting for the nine-hour day and against forced layoffs and unemployment. These were obviously matters of importance for their female relatives and for the relatively few females who shared their particular trades as well. But a sexual division of concern seems to have arisen: while male workers preoccupied themselves with the labor situation, women were busy demonstrating their outrage at a case of child molestation.

The widow of a police inspector and mother of six children, all of whom were ill, had placed the two youngest girls, aged seven and four, in an orphanage run by nuns, as poor single parents sometimes did in this city, where children were frequently abandoned and teenage boys lived in street gangs.[3] Recently, the events of Tragic Week had brought to the fore suspicions about convents and the presumably perverse sexuality they fostered. Then, on October 10, 1910, the woman received a letter from the mother superior telling her that her seven-year-old, Montserrat Iñíguez, had severe indigestion and should return home. The child was suffering excruciating pain, so the next day the mother took her to a local clinic. There the doctor discovered that she had lesions in her vagina and anus. He sent her to another clinic where it was discovered that the child had a venereal disease.[4]

The case was taken up in the republican newspaper *Diluvio*, which ran almost daily reports throughout October on the child's condition, the responses of the nuns to accusations that the child had been molested while under their care, and the actions of the authorities. The city prosecutor, ordering a formal inquiry, investigated the allegations of rape.

The child claimed a strange man had come to where she had been isolated from the other girls in the dormitory. He gagged her, said he was going to bathe her, then raped and sodomized her.[5] The nuns denied her story but kept changing their own. They admitted that they had sent for the mother but claimed that the child had not been molested inside the convent. Spreading rumors about the mother and the two older sisters who were factory workers, the church authorities intimated that they were prostitutes who had arranged the child's rape.[6]

The female community of Barcelona claimed the victim as their own. Throughout the marketplaces women talked of nothing else. Female neighbors lamented with the mother as it gradually became clear that the child had been sexually molested. Despite publicity in the *Diluvio* and demonstrations by anticlerical men throughout the city, women did not participate in demonstrations outside their own neighborhood, the physical embodiment of their sense of community. They cemented their bonds as women, as mothers, and as neighbors through talk, moral support, and small financial contributions to the impoverished family of the victim. Then on October 17, the day of a local festival, large numbers of humble women, including the market women from the Born and Barceloneta markets of the old city, gathered in front of the little girl's house to show solidarity with the mother and her sick child, calling on Saint Luke, the patron saint of healers, to cure the girl.[7]

As the official inquiry proceeded and more and more doctors were appointed to examine the girl, local women continued to take action on their own. Large groups of women visited the mother every day and contributed money to help her and her family. Although the doctors tried to keep people away from the girl, women continued to congregate before the house where she lived.

An increasing consciousness that officials, not they, would determine how the victim and her family were treated outraged the women. The officials' investigation, with its numerous doctors, amounted to a violation of what they considered their right to protect children and each other from violence and sexual harassment, acts that openly challenged women's collective sexuality.

Community women planned a females-only demonstration at Citadel Park in the victim's neighborhood for October 30. The civil governor, undoubtedly fearing a repetition of women's activities during Tragic Week, banned the meeting, arguing that times were not propitious for street demonstrations. He also took the precaution of forbidding unions from discussing Montserrat Iñiguez's case.[8] It became clear that when women attempted to unite as women, they could seriously alarm the government.

City authorities removed the other children from the convent where Iñiguez had been molested, thus effectively closing down the orphanage, but still the case dragged on. The *Diluvio,* carrying out its own trial by press, ascertained that no man except the chaplain delivering last rites or a doctor, accompanied by a nun, was ever permitted within the convent walls at night.[9] No one ever learned how the child was molested.

The Birth of the CNT

Almost exactly a year after the scandal, an unrelated event of enormous consequence for male workers occurred. The Catalan regional labor confederation known as Workers' Solidarity (Solidaridad Obrera), founded in 1907, organized a historic meeting in Barcelona. Anarcho-syndicalists from all over Spain gathered at the Barcelona Palace of Fine Arts from October 30 to November 1, 1911, to form the National Confederation of Labor, or CNT.

At its initial meeting, the CNT set down its principles and goals. The assembled anarcho-syndicalists called for shorter hours and better wages, and they sought to democratize society through the decentralization of power and thus the enhancement of local autonomy. As the anarchist Anselmo Lorenzo told the assembled gathering:

You, whom they call the lowest social group, . . . are especially capable of the great human labor of reorganizing society on the basis of universal participation in the economy, each contributing to production and to the rational distribution of wealth. If every man's treasure is his heart, you, who exploit and deceive no one, who victimize no one, who gain nothing from exploiting differences among people, and who practice association to achieve social good, you are the ones to establish the basis for a just society.[10]

As early as 1900, Lorenzo had lectured about the need to protect women and children factory workers. The issue of the victimization of women and children in the workplace was very much on the minds of the *cenetistas,* as members of the CNT were called.[11]

The subject of women came up during the group's initial discussions about the society of the future.[12] In fact, the CNT called for equal pay for equal work, condemned the double burden of home and job that women workers carried, disparaged the way even the working man became "a new bourgeois" at home, and resolved to raise women's consciousness through education, although the participants were divided over whether pregnant women and mothers of young children ought to be excluded entirely from the work force.[13] The CNT's progressive views about relations between the sexes were remarkable for the time, especially given that few if any women were members during the first few years of the confederation's existence, when it was frequently outlawed.

Collective Action: Barcelona, 1913

During the 1913 Constancy textile strike, about which the clandestine CNT remained quiet, political consciousness among women again emerged as a factor to be reckoned with. In that massive collective action, women of the popular classes took their grievances to the civil governor in order to promote the goals of working women.

The fortunes of and working conditions in the textile industry affected almost all Barcelona's working women, since most textile workers were female. In 1913, 16 to 18 percent of women over fourteen who lived in and immediately around Barcelona labored in textile factories and related industries (omitted from these figures are their sisters, mothers, and neighbors who worked at home sewing clothing for piece rates). Female factory workers put in eleven- or twelve-hour days, although male textile workers (employed as printers and dyers) usually worked only ten hours. In 1913, the average male wage was between 3.85 and 4 *pesetas* a day; the average female wage was between 1.75 and 2.50 *pesetas*. Few women, however, earned more than 2 *pesetas* a day. In the ready-made clothing industry, which grew up in response to the expansion of textile production, a shirtmaker working at home earned about 2.50 *pesetas* for a dozen men's shirts, which took her twelve hours to complete.[14] In 1913, the minimum daily cost of living for a family of four was 5.75 *pesetas;* this sum rose to 8.50 *pesetas* in 1917, and to 9.45 *pesetas* in 1919.[15]

Conditions of life for poor women and their families were often desperate in the first part of the twentieth century in Barcelona. Many mothers watched their children die: of fourteen thousand deaths in the city in 1900, four thousand were children under four years of age. According to historian Albert Balcells, "Between 1905 and 1909, one-quarter of the infants born in the city of Barcelona died before they were two years old—15.5 percent of them before they were one. And this infant mortality represented one-quarter of all the deaths in the city, a very high proportion."[16] Dead fetuses and foundlings near starvation were left on the streets of the working-class districts almost every day in the winter and spring of 1913. During that year, a typical working-class family of four, eating three meals a day, consumed coffee and bread in the morning, salt cod and rice at midday, and potatoes and salt pork at night. This cost, on average, 1.54 *pesetas* a day, of which 76 *céntimos*

went for bread alone (owing to bad grain harvests throughout the world between 1904 and 1912). With ever-increasing immigration of peasants to the city, rents in the poorest districts of Barcelona had sky-rocketed. The cost of an apartment in these districts was 50 *céntimos* a day or 14 *pesetas* a month. In 1910, clothing, blankets, and soap came to 25 *céntimos* a day, and fuel accounted for another 20 *céntimos*.[17] The intensification of Spain's war against Morocco during this period helped to push the cost of living upward. Wages, however, failed to keep pace with these new and rising costs, thus exacerbating the poverty of urban workers in Barcelona.

To survive under such conditions, women banded together and formed tight affinity groups made up of neighbors who knew each other simply by sight. Significantly, women organized primarily by neighborhood, not by trade. For the anonymous women who worked at home manufacturing shirts, blouses, corsets, linen, umbrellas, shoes, and other apparel, only a community-based strike offered the opportunity to attack the exploitive system that kept ready-made clothing costs down.[18]

Of course, in Spain as elsewhere housewives had sometimes joined political groups such as the anarchists. Male leftists had long recognized that women, through the neighborhood organization of laundries, clinics, and food kitchens, supported men during strikes. But only symbolically—by calling for an end to female and child labor—had anarcho-syndicalists or Socialists even tried to win better wages for female workers. Before the CNT, leftists had hoped instead to raise male wages so that women would not have to do paid work.

In October 1912, the Constancy Union was formed to organize un-skilled men, women, and children in the textile industry. When organizers called a general meeting on February 17, 1913, two thousand people, mostly women, showed up. Those who shared the platform and chaired the meeting were primarily union activists, among whom was only one woman, a textile worker and Socialist from Madrid named María García. Speakers from the floor included anarcho-syndicalists and some Socialists from a variety of trades, few of them women. Although the speakers discussed the need to end the unbearable workdays that women suffered in factories, they never discussed piecework or life in the neighborhoods: the Constancy Union was slow to recognize that improving living conditions at home was an important aspect of what women workers hoped to achieve.

As summer approached, the cost of living continued its steady rise.

Women, whether they worked outside the home or not, found it diffi-
cult to put food on the table. Despite widespread unemployment in the
region (an estimated eighty thousand people were out of work), women
throughout the community pushed for a strike in the textile industry.[19]
Finally the organizers of Constancy agreed to strike against the biggest
companies in the districts of Sans, Saint Andrew, Clot–Saint Martin,
and New Town—working-class suburbs contiguous to the factories and
to the old city. Apart from demands for a nine-hour day and an eight-
hour night shift, the union called for pay increases of 40 percent in piece
rates and 25 percent in day wages.

In an open Constancy meeting in Saint Martin, women from
throughout the city discussed strategies for spreading their demands
and organizing demonstrations to win adherents. They decided to send
representatives to all the major food markets to talk with the women
who gathered there daily. Many of the people at this meeting had un-
doubtedly been involved in the anti–Moroccan War demonstrations of
mid-June 1913, which had led to the arrest of Socialist leaders; amnesty
for the demonstrators thus became part of their cause.

On the night of July 27, people from throughout the popular neigh-
borhoods of Barcelona and the surrounding textile towns gathered at
one of the Radical party community centers (known as Houses of the
People), the main one on Aragon Street in the Clot district, to discuss
employers' unwillingness to negotiate with them. More than one thou-
sand women attended the meeting, but there was no way to tell who
belonged to Constancy.

On July 30, almost twenty thousand workers in Barcelona, of whom
thirteen thousand were women and children, went out on strike.
Countless others, including home garment workers, seem to have
joined them in street demonstrations. As a liberal journalist explained,
"The spirit of the women has spoken with enough eloquence to launch
the entire working population and, as in other campaigns for social jus-
tice, the women excite the exaltation. It will be necessary to negotiate
with them, because they will never accept a settlement short of their
goals."[20]

Mass mobilizations centered on the Sans area, on the southwest edge
of the old city, and on the Clot–Saint Martin, Saint Andrew, and New
Town areas in the industrialized north and east. Sans, a village absorbed
into Barcelona along with Saint Martin, Gracia, and Saint Andrew in
1897, had its own district plazas and daily markets. All these "new"
districts were linked to the downtown area of Barcelona by coach and

trolley lines, so that by the time the outlying towns officially joined the city, there was already considerable traffic between "old" and "new" parts of town. Many women from the center city went at least once a week to one of the new markets. Since many of the new spinning mills of the late nineteenth century grew up in Sans just twenty blocks away from the Saint Anthony Market in old Barcelona, and since the young women and children of old Barcelona and Sans provided the labor for these mills throughout the twentieth century, many working women were familiar with public places in both the old, settled working-class districts of Sans and downtown Barcelona. It was these squares and markets that became rallying centers during the Constancy demonstrations.[21] And it was women like those described above, who understood how the neighborhoods were connected, who were particularly suited to lead the struggle.

On July 30, 1913, the women of the Sans textile factories demanded that a 1900 law banning night work for women be enforced. Because of overproduction, employers were happy to expel their workers: they locked the women out. Four to five hundred women, the workers along with their female neighbors, began to gather daily at the Plaza of Catalunya, the city's civic center.

On August 5, women began what was to become a daily civic ritual. Instead of gathering at the Boqueria (Saint Joseph) Market along the Rambla, they marched from the Plaza of Catalunya, down the Rambla, across Columbus Pass, and on to the civil governor's office at the Plaza of the Palace (figure 13).[22] It is significant that the female community went to the governor rather than to factory owners to voice their general grievances. They seem to have been conscious more of communal than of trade union goals—as well they might have been, since their number included women who shared life situations but not a workplace in the factories.[23] The fact that the women were not exclusively factory workers aroused some comment. Whereas authorities viewed strikes merely as an economic strategy of withholding labor to resolve grievances at the factory, these women were clearly participating in a social movement.

For five days, the women—who were difficult to distinguish from other poor women, including prostitutes—carried on the fifteen-minute-long demonstrations, marching at three o'clock in the afternoon just as the usual crowds swelled the Rambla during the lunch break. A comic element was added to the scene as the number of undercover police increased; clearly, the government was growing nervous about

abril. - La manifestación femenina del lunes

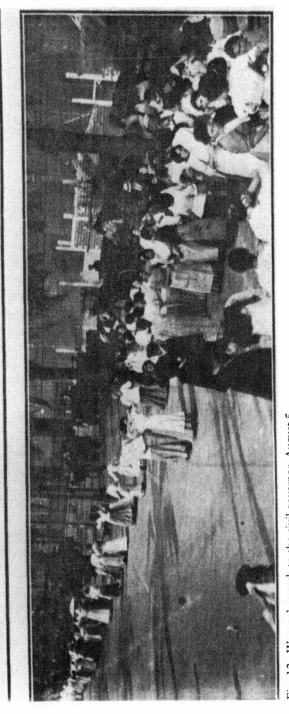

Fig. 13. Women's march to the civil governor, August 5, 1913. Courtesy of the Institut Municipal d'Història, Casa de l'Ardiaca, Barcelona.

street agitation. On August 8, when the women began their daily march, police stopped them and ordered them to disperse. To avoid violence, the small groups of men who sometimes accompanied the women disappeared once the police came on the scene. Confrontations with poor women (but not poor men) can make police and soldiers uncomfortable, for armed forces frequently agree with women about their right to defy the law when the economic survival of their families is at stake. Indeed, the fact that neither side ever knows whether the police and soldiers will obey orders to attack a crowd of women often gives the protesters leverage. In 1913 Barcelona, women tried to outsmart the police by regrouping on their predetermined path. Although approximately two hundred women reached the civil governor's office, the police prevented them from entering. The governor then sent word that he had already presented their union representatives with proposals to end the strike. The strike committee had one day to consider his plan.[24]

Constancy called an assembly to discuss the proposals, scheduling the meeting for 7:00 the next evening, August 10, at a downtown theater. Instead of meeting in the Plaza of Catalunya, as was their custom, the demonstrators—among them women from all over the city—gathered at the theater at three o'clock that afternoon, where they remained until the night meeting began. Luis Serra, acting as chair, announced that the gathering was an assembly of the community, not just a union meeting; all were welcome and could speak as equals. Debate about the governor's proposals for a settlement ensued, but all those assembled voted overwhelmingly to continue the strike. Railroad workers who attended the meeting said they would suggest calling a sympathy strike. Foundry workers in the city had been agitating since mid-July, and their strike was still going on. By the night of the tenth, then, it looked as if a general strike was brewing.[25]

Through their street demonstrations, the women had been activating as well as acting on their "female consciousness," their beliefs about the relationship between social life and economic reforms. When, at the August 10 meeting, some male leaders of Constancy begged them to stop their street action, the women answered with catcalls. The next afternoon, a massive demonstration of about 1,500 women and 800 men gathered in the Plaza of Catalunya and marched down the Rambla and Columbus Pass to the civil governor's offices. As they approached the Plaza of the Palace, a sixteen-woman committee went ahead to meet the governor and explain that they would not return to work. They then

retraced their steps up Columbus Pass. Once they reached the Gate of Peace, below the statue of Columbus at the mouth of the Rambla, the police charged in an attempt to disperse them. Some strikers broke through to the Rambla of Saint Monica and regrouped, while others fought the police; then they all reassembled at the Plaza of Catalunya.[26]

On August 12, the women began their march from the Plaza of Catalunya an hour earlier than usual, at 2:00 P.M. The police had orders to stop them. The women retreated through the neighboring streets, spreading out to Pelayo, the Plaza of the University, and Urquinaona Plaza in order to approach the Rambla by back streets (see map 3). Most headed down toward the Royal Plaza, where mounted police drove them off. The police, having some experience in riot control, then blocked all streets that opened onto the Rambla and drove the women into the nearest back streets. The women and police spent the afternoon battling for control of the Rambla. Meanwhile the railroad workers, who met nearby, voted three to one to join the battle.[27]

Throughout the strike—which did not end until September 15—the women continued to hold their demonstrations every day on the Rambla. They also carried out daily meetings in the streets and markets downtown and in Sans, Saint Andrew, Clot–Saint Martin, and New Town. The main focus of the women's demonstrations shifted to the Plaza of Spain, where the old city meets Sans. But the working class was by no means united.

The women and the new strike committee, elected at the August 10 assembly, were not cordial. Even the militant labor leaders disapproved of the "unruly" women's demonstrations. They opposed, for example, the women's tactic of shaming female scabs by cutting off their hair to mark them as traitors. (The strikers warned the scabs to think of their beauty rather than their stomachs next time, and they suggested selling the hair to wig makers to raise money for the food kitchens.) Constancy repeatedly denounced the women as a mob and tried to convince them to stop demonstrating. Not only did the men and women protest in different ways, then, but the men disapproved of the women. Nevertheless, the women assembled at the western foot of Montjuich on August 20 and attempted to march from there across the Parallel.

At the civil governor's offices near the harbor, they hoped to explain that they would not abide by agreements made by the strike committee. However, the police persuaded them not to march. Instead the women went to the strike committee offices at 12 Vista Alegre, in the heart of the Parallel, where they informed the male leaders that they and not the

strike leadership spoke for the community, and that it was they with whom the governor had to negotiate.[28]

The civil governor announced a new royal decree: it unilaterally settled the strike by mandating a sixty-hour week, or a maximum of three thousand hours of work per year in the textile industry. Women could arrange their hours, so long as they managed to work sixty hours a week. The flexibility was meant to permit them to work only five hours on Saturdays so that they could catch up with their housework.[29] As far-reaching as the decree was, in the end it accomplished nothing for the strikers, since employers refused to abide by a law that interfered with their right to run their factories as they chose.

The strike ended on September 15 because the workers could no longer survive without their wages. Nevertheless, the overall action had important positive consequences for the women of the city. The street demonstrations, especially those that proceeded down the Rambla to the governor's office, gave physical evidence of a distinct women's political culture and of the political presence of women in city affairs. As in a May Day demonstration, the women's protest marches of 1913 identified participants as a self-conscious entity, a civic community. By revealing women as more than background figures, the demonstrations also showed that society depended on working women. Communal strikes invariably affect living conditions, for privatized "women's work" becomes a public responsibility once restaurants and cafés are forced to close. This strike was no exception: feeding people became the responsibility of more than individual women, and in turn, the networks that working women customarily maintained were transformed into politicized bodies. The relationship of working women to the preservation of the community became obvious in 1913; it grew even clearer during the disruptions in Barcelona's civic life during the First World War.

Collective Action: Barcelona, 1918

Subsistence issues again provoked public displays of "female consciousness" during World War I, when Spain was a nonbelligerent nation. Inflation and war shortages afflicted civilian populations in Barcelona in 1917 and 1918 and exacerbated the normal difficulties working women had providing food, fuel, and shelter for their com-

munities. By the summer of 1917, the cost of living for a working family of four had risen 23–29 percent relative to October 1911.[30] After long shifts in the factories, workers faced high food and rent costs, a situation that made a mockery of the harsh life they led and their hopes for the future. The Spanish authorities' failure to regulate the provision of necessities caused women to resort to direct action, and the provincial governments to lose women's loyalty. In the course of their effort to preserve life, then, the women created a definition of civic identity that included working women and excluded the authorities who had let them down.

Under normal circumstances, working women used their networks to obtain essential provisions; when shortages prevailed, they had to secure satisfaction from the state. During the war, food and fuel, which otherwise would have been distributed locally, were shipped out from Spain to belligerents and to Latin American markets cut off from their usual suppliers. Without government controls, speculation ran rampant. Shortages and inflation were the result.

As long as authorities regulate supplies, rents, and fuel fairly during times of scarcity or when prices rise above the limitations of normal budgets, women will accept hardships. As long as distribution is equitable, women will generally go along. But hoarding, speculating, and profiteering mock poor women's sacrifices and often provoke their anger.[31]

That is what happened in Barcelona. The women's uprising began there in January 1918, during one of the coldest winters on record. Lack of gas and electric power due to coal shortages had forced more than ten thousand workers out of the factories. Bread prices had been inching upward since October 1917, and rumors circulated in early January that they would rise another 5 céntimos. The city established a price board to investigate fuel and food prices. Bakers claimed that they needed price hikes to break even, while coal merchants complained that they could not stay in business if they sold coal at the prices the board suggested. The shortage of coal for heating houses and its high price were, most immediately, what caused the movement in Barcelona.

On January 9, over five hundred women began to attack coal trucks in the five major districts of Barcelona. About a thousand women took over a big coal retail depot on Parliament Street near the downtown area and proceeded to auction off the coal at the lowest price stipulated by the board.[32] The second phase of the growing movement started on January 10, when a crowd of about two hundred housewives from Bar-

celoneta circulated through the city to the textile factories (see map 3). They called on women workers to walk out. One hundred women from the knitwear factory on Arc of the Theater Street near the harbor did so, soon followed by other female factory workers. As they paraded through the streets, the marchers carried signs that read: "Down with the high cost of living!" "Throw out the speculators!" "Women into the streets to defend ourselves against hunger!" "Right the wrongs!" "In the name of humanity, all women take to the streets!"[33] They lined up in front of coal dealers, wandered from coal yard to coal yard to gather supporters, and then moved to the Saint Joseph, Saint Catharine, Saint Anthony, Sans, Gracia, and Clot markets, where they discussed the subsistence crisis and urged women to take action.

Gathering their forces, housewives and female workers marched to the governor's offices at the Plaza of the Palace. A delegation of six young women, led by Amàlia Alegre and Amparo Montolíu, mounted the steps to present a list of the women's grievances to the governor. They asked that coal prices be regulated, along with the prices of bread, olive oil, meat, and potatoes.[34] Amàlia Alegre explained:

We are hungry; there is no coal; we cannot afford to clothe ourselves. Our children are cold and there is no food. The situation cannot go on this way. . . . Before we see our children die of hunger and cold, [we will take action]. . . . Today we are a bunch of women from the Atarazanas neighborhood; tomorrow it will be the whole district; then, all the women of Barcelona; and, if our demands are not met, we will close down the factories and request solidarity not only from the women of Barcelona but from all those whose lives are made impossible by present conditions.[35]

Elsewhere in the city, women continued to attack coal yards, and the mayor dispatched police to guard coal transports. In Gracia, with its well-developed radical political culture, women marched on the slaughterhouse and tried to auction off meat. Near Tetuan Plaza, close to the metallurgical factories, women urged men to go on strike.[36]

Women sent informal delegates from one neighborhood to another to share information about what was happening and to report whether officials had responded. On January 11, two separate women's delegations, one of older women led by Lola Barrios and one of younger women led by Amàlia Alegre, visited the exasperated governor.[37] The latter group told him that they hoped "to stop all work of women in Barcelona until the authorities roll back prices on all primary necessities."[38] As the refrain of a popular ballad at this time put it:

One Amàlia Alegre, in a very bad mood,
Sent a message one day saying to the governor:
"We want cheap food, and if we don't get it,
Someone will pay through the teeth."
Ai . . . Ai . . . Ai . . .
For the women are going to give you a hard time
Marching through the street all week crying,
Ai! . . . Ai! . . . Ai! . . . [39]

That night, apparently in an effort to reduce fuel consumption, women from the harbor districts marched on the local music halls. Up and down the streets of pleasure in the Parallel they went, stopping at the Pompey, the Pay-Pay, and the Follies. Women wielding sticks broke down doors, smashed mirrors, and called on female bar attendants and cabaret dancers (usually assumed to be prostitutes) to join them. In some cases, as at the Eden Concert, the Marinica Café, and the Spanish Alcázar, women protesters and owners fought physically over whether female employees could leave to join the women's demonstrations. That same evening, the police arrested seven women who were going from place to place talking to women in the Parallel. Before the police could drag them away, a crowd of some two hundred women surrounded them and tried to free the detainees. Two protesters were wounded by police officers. That night the Civil Guard went on patrol.[40]

Crowds of women intensified their efforts to make themselves and their needs known. Two thousand gathered at the Royal Plaza, just off the Rambla, at 6:00 A.M. on Monday, January 14. From there they marched through downtown, northwest to the Extension, and west to Sans, to big textile mills like Industrial Spain, calling all women who worked in the factories out to join them. By the afternoon, thousands of women had gathered below Montjuich. They continued on to the Plaza of Catalunya and down the Rambla to the Royal Plaza, sweeping up still more female supporters along the way. After speaking to the mayor in the Plaza of Saint James, they doubled back to the Plaza of the Palace to demand that the governor prohibit the movement of food and fuel out of the province of Barcelona.[41]

At 6:00 that evening, another women's delegation went to the civil governor and called for a rollback on all prices to prewar levels. Moderate, older women from that group, demurring, visited the governor's office separately; they claimed that they would be satisfied simply with reductions of food and fuel costs, but demanded to know when the prices would come down.[42] The governor claimed to be doing every-

thing possible, refused to make any promises, and complained that with all the visits from women's delegations he was unable to get any work done. Among the crowd at the Plaza of the Palace was a group of a thousand militant younger women who had marched all over the city that day, including to the governor's office. When these women heard about his exasperated comment, they grew angry. They attempted to storm the stairs, but the police cut them off; panicked, the officers shot nineteen of the women, gravely wounding two.[43]

The shooting in the stairwell seems to have marked the governor's decision to repress rather than receive delegations of women. When women attempted to hold an afternoon demonstration on January 15, in the Plaza of Catalunya, the police dissolved the meeting by shooting into the air as women congregated in the nearby Rambla. The police also cordoned off the Royal Plaza, another public area that had become a regular gathering place for female dissidents. The women grew angry and began to whistle and jeer. One journalist remarked, "Repressive action of the police exacerbated the women's rebellious spirit."[44]

"Female consciousness," which may lack doctrine and structure, tends to develop quickly when rulers resort to force, and that was the case here. Women's networks had by now assumed leadership of a social struggle that they were pursuing in the name of the entire female community, one uniting housewives in the working-class districts with female factory workers.

From January 15 on, most women workers, joined by some 1,700 male laborers, went on strike and forced shops to close.[45] Women of the popular classes continued to interrupt the operation of business as usual. They marched up the Rambla to El Siglo (The Century), Barcelona's first department store, where they called on saleswomen to join their demonstration. Citywide attacks on grocery stores containing food, soap, or olive oil increased, as did periodic attempts by police to repress them through the use of armed force.

Despite official opposition, thousands of Barcelona's women gathered at the Globe Theater on January 17 for a public meeting. A female weaver presided. The women called for prices of all basic commodities to be rolled back to prewar levels; they demanded rent reductions and lower freight costs, which they believed were a major element in the general increase in the cost of living; and they demanded that six thousand male railroad workers be rehired. A significant number of those present participated in the general discussion.[46]

Women continued to attack commercial property in an effort to win

control over the distribution of goods. For example, they stopped a wagon carrying six hundred pounds of salt cod down New Street of the Rambla, protesting that the driver had no right to take the fish, which would only be stored in a warehouse until its price rose still higher.[47] On January 23, the women fanned out over the Rambla of Catalunya, going door to door in apartment blocks, attempting to bring all women into the streets. By 2:00 P.M. about four thousand women had gathered close to the northern bullring near Tetuan Plaza for an open-air meeting presided over by Lola Ferré. She proposed that they march the next day to Montjuich, where the military barracks were. Three pairs of civil guardsmen, swords drawn, and three pairs of security guards then converged on the women, wounding several.[48]

Fearing civil war, the authorities in Madrid recalled the governor. By January 24, there was no food to be found in Saint Martin, New Town, or Gracia. The huge crowd of women gathered in the Fountain of the Cat, a café in Montjuich, to discuss what to do, but their meeting was dispersed by police who shot at them. Reconvening down the hill at the Plaza of Spain, they were again attacked by the police. Elsewhere in the city, crowds of women attacked warehouses, claiming that food was being stockpiled. Groups near Saint Anthony Market accosted coal suppliers, forcing the owners to sell them heating coal at what the women considered fair prices.[49]

On January 25, the captain general declared a state of war and suspended civil rights, including the right of assembly. Nevertheless, the women continued to march on stores whose owners they believed were speculating. Strikes in the textile industry continued until February. Despite military repression, women refused to acquiesce to the greed of speculators and the irregularities of the market: at 7:00 every morning, they gathered at the markets to fight with the vendors about prices. They refused to go to work in the factories, causing plants that employed mostly women to close down. Since the problem of hunger was severe and prices so high, it is a tribute to women's solidarity (though this solidarity was often supported by shaming techniques) that the female population held firm. On January 27, the captain general called in twenty-five thousand troops to protect Barcelona's markets against angry female citizens.[50] As late as February 15, price increases on salt cod at the Gracia Market were still inspiring political mobilizations.[51]

"Female consciousness" had become apparent in the patterns of activation that Barcelona's women chose and the way they defined their movement. Throughout the six-week-long mobilization, women devel-

oped a female urban network. Marches followed the processional routes of pageants and May Day demonstrations, for these paths were ingrained on the consciousness of all citizens from thirty years of civic culture. The markets substituted for shrines and religious sanctuaries; and instead of bands playing, women shouted their slogans.

Naming things, including oneself, promotes consciousness, and the term *vecindaria* became current for describing activist women in Barcelona in 1918. The masculine *vecino* simultaneously means "inhabitant," "head of household," and "citizen." Before 1918 in Barcelona, the feminine correlate was *hembra*, or simply "female." *Vecindaria* was a village term, denoting a woman who is a member of a close-knit community. Translating roughly as "female comrade" or "sister," it was as close to a kinship term as the contemporary language could muster for a woman's civic identity. The constant use of the word during the 1918 uprising and subsequent movements of women reflects the sense of female self-awareness and solidarity that grew throughout January and February 1918.

Conclusion

The capacity of local women to mobilize to express their sense of unique citizenship became increasingly apparent in the early twentieth century as women moved ever further away from their own neighborhoods and into the centers of government and commerce. During the funeral of the Rafa sisters in 1905, poor women joined the procession just where the female flower vendors had set up their honor guard in front of the flower stalls on the Rambla. During Tragic Week in 1909, women at first went where they pleased; but the mass arrests and executions cowed them until necessity forced them to organize outside their neighborhoods again. By 1913, what appeared to be a labor struggle became a ritualized battle over social policy between the popular community, led by women, and the authorities. The street became the stage for this conflict, proof that "female consciousness" was moving Barcelona's women to take radical action proclaiming a uniquely female sense of civic responsibility.

Women's collective action in early-twentieth-century Barcelona demonstrates their belief that because their and working class men's social roles were different, they had different political rights and obligations as

well. But even as they defended the notion of separate rights based on separate activities, Barcelona's women violated that selfsame principle. In beseeching and then confronting government officials in the urban plazas and offices that were symbolic of the political and commercial power men wielded, in taking collective action to preserve their routines, women disrupted what was left of orderly life in their neighborhoods and, in the process, shocked police and authorities.

Just as working men, republicans, and Catalan nationalists all shaped their own distinctive versions of civic culture, working women incorporated into their own views of citizenship their particular notions of "female consciousness." Their attempts to act according to the notions of their community and time about women's roles sometimes led them to contradictory positions. They saw themselves as especially life-conserving, and they wanted to maintain their special status as women. Yet in going beyond images of women as victims and martyrs to win their goals through direct action, they were radical. The activism they demonstrated in their attacks on speculators and government officials challenged the stereotype of women as docile victims. Indeed, working women had earned a reputation for bravery that led anarcho-syndicalists like Adolfo Bueso to remark that women, "whether because of greater courage or ignorance, or confidence in the respect owed to their sex, certainly were always more decisive than men."[52] In the course of struggling to do what those of their gender, society, and class were expected to do, working women in Barcelona became outlaws between 1910 and 1918. To fulfill what they saw as women's special obligations, they rebelled against the men of their community and against the state. Their double duty as defenders of community rights and as law-abiding citizens became a double bind, which they forcibly ruptured through direct action.

6

Democratic Promises in 1917

The history of Barcelona in the first decades of the twentieth century tells two competing stories. One is the story of rich versus poor; the other is the story of all against all, or of Barcelona against the government of Madrid. Both conflicts raised questions about the political system that governed Spain. And they intensified during World War I, when Spain remained neutral but sold food and uniforms to both sides in the European conflict.

The war brought the entire political system of Spain into question. According to the constitution of 1875, which had restored the Bourbon monarchy to the throne of Spain, the king was supposed to govern alongside an elected, if relatively weak, Cortes. King Alfonso XIII, who gained the throne in 1902, increasingly ruled alone with the support of the army. As one observer wrote, "All public power is in the hands of the monarch, [and] although there is a parliament, in reality it is nothing more than a fiction or the mask on an autocratic regime."[1]

Two movements for democracy centered in Barcelona reached fever pitch in the summer of 1917. Parliamentary delegates from throughout Spain met secretly in the city in July 1917 to draft a constitution making Spain into a true constitutional monarchy. At the same time, anarcho-syndicalists and Socialists from all over the nation made common cause in an effort to win both reduced hours and wages that could keep pace with inflation.

The movement for popular democracy was already well under way when the crisis reached a head that summer. The CNT, the anarcho-

syndicalist National Confederation of Labor founded in 1910, had increasingly assumed the leadership of an effort to overcome capitalism and to transform the state. As we have seen, anarcho-syndicalists, who opposed parliamentary government, favoring instead a system of local democracy in which syndicates organized around trades and professions would administer society, depended on the general strike to win power and substitute the rule of the unions for the rule of state and local officials. But not all general strikes are revolutionary attempts to overthrow capitalism and the state. In fact, frequently a general strike means merely that a variety of unions are striking at the same time. Nevertheless, for anarcho-syndicalists, the strike was an expression of the democratic control of workers over their own labor as much as it was a withholding of labor to achieve certain specific ends. Direct democracy by which people controlled their own affairs without delegating authority was a linchpin of CNT political doctrine, and the general strike was one way to express it.

It is hardly surprising, then, that a main instigator of democratic struggles in Barcelona that summer were the anarcho-syndicalists. Their early leaders, Salvador Seguí and Ángel Pestaña, came of age in the 1917 movement. Pestaña was the intellectual, though he would never have accepted that designation. Born in León to a railroad construction worker and his wife, Pestaña had worked in the Basque mines, in factories, and as a set painter in the theater before traveling to Algeria and to France, where he learned to be a watchmaker. In 1914, he settled down in Barcelona with María Expres, a twenty-eight-year-old woman from Zaragoza, who became his lifelong companion.[2] With his Mephistophelian air, he was the pragmatist among the anarcho-syndicalists, and from 1916 on, he edited *Workers' Solidarity* (*Solidaridad obrera*), the organization's newspaper.

Despite initial antagonism, Seguí and Pestaña became inseparable friends. Seguí, a painter by trade, went on in 1919 to direct the Construction, Woodworking, and Metallurgical Workers Union. He was the great orator, the moral conscience, the tribune of the people, and the greatest leader of the anarcho-syndicalists in Catalunya. Widely known as "Sugar Boy" because of his legendary sweet tooth, he was a popular local figure.

As a child in the early 1900s, Seguí had worked alongside his mother selling candy as she sold flowers in the lobbies of local theaters. An immigrant to Barcelona from the Catalan-speaking section of Aragon, he had initially been attracted to the Radical party youth group known as

the Young Barbarians. He participated avidly in the Radical party's Workers Center on Mercader Street, for which he wrote a play entitled *Social Astronomy, or an Inhabitant of the Moon* to help raise money for imprisoned workers. But his real avocation was studying the history of the French Revolution and the social transformations that followed it.[3]

An energetic participant in the general strike during Tragic Week, afterward Seguí increasingly turned to cultural and political activities among the anarcho-syndicalists. In the period 1909–1918, Catalan nationalism of a republican and federalist stripe had become a frequent topic of debate for Seguí and other members of Barcelona's popular intelligentsia.[4] Although neither Seguí nor other workers were drawn to the movement for Catalan regionalism, which was dominated by their employers, as *cenetistas* they were generally in favor of decentralizing political authority; specifically, they advocated placing it in the hands of local labor unions, which could be confederated to allow coordination.

An incidental witness to the changes that took place in Barcelona during the 1910s was Pablo Picasso. Like many bystanders, he was not overtly concerned with struggles for democracy. Lonely and depressed in Paris because his friends Georges Braque and Guillaume Apollinaire had left to serve in the French army, in 1916 and 1917 he visited Barcelona in search of solace. Since moving to Paris in 1904, Picasso had returned to Catalunya only during summers. During Tragic Week in 1909, he was vacationing in the Catalan village of Horta del Ebro, where a church was burned. He returned to Barcelona in the late spring of 1913 upon his father's death. Then he did not visit again until the Christmas–New Year season of 1916–1917, a time when the celebration of carnival was revived after many years of neglect. By the time he next returned, in June 1917, competing democratic movements in Barcelona had assumed new importance.[5] Even though Picasso was not outwardly political, as a citizen of Barcelona he had learned the symbols and rituals of local politics, some of which may have found their way into his art then and later.

The Impact of the First World War

Class and regionalist struggles intensified with the dislocations of World War I, which turned Barcelona into a boomtown for

speculators, merchants, and industrialists even as it impoverished many workers. The city also became a center of espionage, much as Casablanca would in World War II. To monitor shipping, German and French spies spread over the town. Factories expanded and drew workers from throughout the country to meet the belligerents' demand for everything Spain and Barcelona could produce. This growth in production led to high wages, but, as we have seen, the cost of living climbed even more rapidly. Between 1914 and 1920, the buying power of a working family in Barcelona diminished by 17 percent.[6]

Local forces regrouped, each trying to gain some control over social conditions. With war-related social problems so pressing, political questions about the impact of international issues on local concerns came to the fore. Ángel Pestaña, as editor of *Worker's Solidarity*, revealed the graft and espionage that characterized the behavior of police and industrialists in Barcelona during the war: for instance, he broke the news that Barcelona's repressive chief of police, Bravo Portillo, was making a fortune informing the Germans about Spanish ships bound for Allied ports.[7] In an unrelated case, the CNT reported that although a German submarine found in Barcelona's harbor had been seized and disabled (its navigation equipment was supposedly removed) according to international laws governing neutrality, it simply disappeared one night.[8] Pestaña did not have to stretch popular imagination to show that local politicians and authorities were on the take; no tradition of liberal politics existed in Barcelona to be discredited.

A constant irritant to local authorities, the CNT was outlawed for most of the period 1910–1914. But legal or illegal, it flourished, for its main centers were cafés, which were the living rooms of the poor. Café life absorbed immigrants and longtime city residents, police and syndicalists, men and women. Foreign observers even disparaged cafés because so many women sat around gossiping with friends.[9] Women's visibility (albeit at separate tables) in fact provided yet another instance of how well cafés served as microcosms of social life broadly construed. Given the frequency with which states of war were imposed and union halls closed down in Barcelona during this period, cafés assumed added importance as political clearinghouses and hotbeds of social thought.

A place like the Spanish Café, part terrace, part cavernous interior, was really an extension of the street. One of the first such establishments in the Parallel, it burned down and was rebuilt in 1909. It served as a meeting place for political groups and immigrant clubs. People from Aragon, for example, gathered there to sing the music for their regional

dance the *jota*.[10] Such topics as workers' emancipation and how to win it were vociferously discussed in cafés and cabarets by the city's popular intelligentsia.[11] Describing the Spanish Café in 1917, the anarchist novelist Victor Serge claimed: "The café—crowded at every hour of the day, has tables which are—in a manner of speaking—reserved. The [syndicalists] occupy one section of the terrace, a double row of tables inside, under the dazzling mirrors. The police informers . . . with straining ears and prying eyes, form a familiar circle—not far off—at a round table."[12] The authorities obviously knew that CNT members met frequently, but they could not close down all of Barcelona's cafés. Thus, whenever the authorities softened their perennial repression, the CNT was ready to emerge with a vast following. In 1917, for example, when they had been legalized for about three years, they incorporated roughly 25 percent of the working people.[13]

Picasso in Barcelona

During his brief return to Barcelona's cafés, streets, and theaters in late March and early April 1913 and during his longer stays in 1916 and 1917, Picasso may have absorbed some of the flavor of what was going on around him. He remained in close contact with his parents and his married sister, Lola Vilató. He had also started spending vacations in nearby Céret, in French Catalunya on the other side of the Pyrenees, where he shared a house with his old friend, the Catalan sculptor and former puppeteer Manolo Martínez Hugué. In late March 1913, he had already taken up his summer residence in Céret when he was called to Barcelona for his father's funeral.

Although as an adolescent Picasso had rejected his ineffectual father, the art professor who hung up his own brushes when faced with his young son's conspicuous talent, on his return to Barcelona for the funeral the thirty-two-year-old artist could not have helped being catapulted back to thoughts of his earlier life there and the political turbulence he had witnessed at the time. Such turbulence was of course very much a feature of the city's present as well, as Picasso surely realized.

Picasso's father, José Ruiz, had had a number of republican friends, although he was not politically active himself. When he died in early spring 1913, the Constancy textile union had just been founded, and it

was clear that a massive textile strike would follow—which, of course, it did. While in Barcelona, Picasso probably read the *Diluvio,* the republican, Castilian-language newspaper, clippings of which he would later use in a collage. Accused of focusing on details of the ordinary life of common people rather than pursuing the so-called larger issues, the *Diluvio* provided information about everyday life and grass-roots movements in Barcelona. Widely popular, it could be purchased at restaurants and cafés, and from vendors at factory gates.[14]

No overt social concerns are evident in *Guitar,* a cubist work that Picasso created immediately upon his return to France from the funeral, but it resonates with influences from his recent stay in Barcelona.[15] Against a blue background (paler than the blues of the blue period, but nevertheless blue), the artist sketched a set of musical notes in the lower right hand corner of the drawing (plate 9). The guitar itself, held vertically just as the true flamenco guitarists from Ruiz's native Málaga would do, dominates the left side of the drawing. The center of the guitar's bowl is a round newspaper cutout, and half the bowl consists of a simulated pattern of Jacquard silk—the kind of cloth that some of the striking female workers of Barcelona made in their factories in 1913. To the right of the sketched-in bowl is another sheet of Jacquard, behind which is a black vertical band. This motif, which Picasso used in later works to commemorate the death of close friends, commonly appeared in newspaper obituaries.

Picasso seems to have stayed away from Barcelona from 1913 to 1916, but he did return twice during the long insurrectionary year of 1917. Although Christmas and New Year 1916–1917 were not propitious times to be in the city (the working classes carried out a one-day general strike on December 16), Barcelona was far less depressing for Picasso than Paris. So he came home to neutral Barcelona for the holidays, possibly remaining there until mid-February. Under the eye of his mother and his old friends, Picasso champed at the bit. On January 16, 1917, he wrote to Apollinaire: "I feel too sick of everything. Of finding myself still here. I don't know when I will be returning, but I am working. Don't be angry if I don't write to you, but you are always in my thoughts. Write to me if you want to make me happy. I met Picabia at the bullfight on Sunday."[16]

Bullfights had played a special role in Picasso's life; indeed, his earliest extant drawing, done when he was nine, is of a *picador.* He had frequently attended bullfights with his father as a child, and he often went

with his friends as a youth. But unlike the population of Picasso's native Málaga, the working people of Barcelona had shown relatively little interest in the spectacle until the period after Tragic Week.

Enthusiasm for bullfighting came with new immigrants, who between 1911 and 1920 filed into Catalunya at the rate of 22,500 a year. They so reconstituted the population that by 1920, 40 percent of Barcelona's inhabitants were from outside the city, and 21 percent were from outside Catalunya. The city grew to eight hundred thousand by 1920, and to one million by 1930.[17] The vast majority of those migrating to Barcelona from outside the Catalan provinces of Barcelona, Girona, Tarragona, and Lleída were from nearby Aragon and Valencia.[18]

By March 1913, when Picasso clipped the *Diluvio* for his collage, the republican newspaper was running periodic histories of the greatest bullfights back to 1886.[19] Such a series would have been unheard of a decade before, when republicans and anarchists denounced bullfighting as the violent and decadent sport of conservative southern landowners. In 1917, however, militants, including *cenetistas,* were increasingly interested in attending the *corrida*. Bullfighting fans, who memorized statistics and competed over who perceived the finer points of the spectacle, had begun to sweep the city, where the *toros* were always discussed in Castilian, even among Catalans.

The French writer Paul Morand remarked on the importance of the bullfight in Barcelona, as did the Russian anarchist novelist Victor Serge, whose fictional syndicalists indulge in the spectator sport even during revolutionary periods. For instance: "A precious Sunday was lost because Benito had to kill his bull that day. The thin sword in the hand of this ex-cowherd from Andalusia seemed to be parrying the death blow aimed at the monarchy. . . . 'He kills like an angel,' wrote the newspapers. 'Let's go watch Benito!' cried Eusebio, 'we'll fight better afterwards!' "[20]

Bullfighting was not the only public pastime that Picasso enjoyed during his visits to Barcelona. He also went back to the music halls that had been among his early haunts. In 1917, a flamenco dancer and cabaret singer, Blanquita Suárez, was a sensation in the city—much to her own regret. Suárez had agreed to do a full performance in Barcelona's Tívoli Theater, but when she was offered a job as an opening act in Madrid—the fulfillment of her life's ambition—she tried to cut short her stay in Barcelona; the management, however, held her to her contract. This, of course, enabled Picasso to see and immortalize her in a painting (figure 14).[21]

Fig. 14. Pablo Picasso, *Blanquita Suárez*, 1917. Courtesy of
the Museu Picasso, Barcelona. Copyright 1991 ARS N.Y. /
SPADEM.

The preparations for Barcelona's carnival in late January and precarnival festivities in early February undoubtedly pleased Picasso during his 1916–1917 visit. An opportunity for excess available to people of all classes, the week-long celebration included the parades and floats and charity balls for which the city was famous.[22] Masked balls, held at different theaters, allowed amateur and professional entertainers to appear in fancy dress. The Novelty Theater, decked out as an eighteenth-century garden complete with allegorical figures, offered a contest for the best costume. Santiago Russinyol, a judge, awarded fourth prize to Blanquita Suárez, arrayed in a flamenco dancer's costume complete with *mantilla* and fan—as Picasso would paint her.[23] Professionals and amateurs created new costumes, but perennial themes appeared year after year. Bullfighters and Spanish *señoritas* (typical of Andalusia rather than Barcelona) dominated the masquerades, along with such stock characters as an American girl, a Chinese conjurer, satyrs, and Harlequins, who had figured in Barcelona's carnival festivities as far back as the 1860s.

On his return to Paris in February 1917, Picasso focused his energies on what was for him a rather unusual project. The preceding August he had accepted the poet Jean Cocteau's invitation to work on the sets and costumes for a ballet called *Parade* for Serge Diaghilev's famous Ballets Russes. This new extravaganza, based on a story by Cocteau with music by Erik Satie and choreography by Leonide Massine, would premiere in Paris in May and be performed in Barcelona in November.[24] After Picasso's stay in Barcelona that winter, where he had worked on the decor, he met Cocteau in Paris. The two men left to join the ballet troupe in Rome, departing Paris by train on February 17, 1917, and probably arriving in Rome just as carnival was ending, on Ash Wednesday, February 21. Having been in Barcelona during that city's preparations for carnival and arriving in Rome just after the festivities there, Picasso likely had carnival and folk figures on his mind as he designed the theater curtain and the costumes.

Several of the costumes Picasso incorporated into *Parade* were certainly reminiscent of figures from carnival, as one Barcelona critic noticed when the ballet was performed there in November:[25] for example, a Chinese conjurer, a mannequinlike young American girl, and two acrobats. A horse costume (an object of derision when the ballet was performed in Paris) evoked Corpus Christi animals, which, like Picasso's horse, consisted of people whose feet showed beneath their costumes (figure 15).[26] Moreover, a bullfighter, two Harlequins, a female acro-

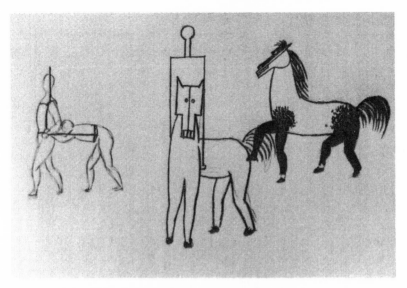

Fig. 15. Pablo Picasso, Design for the costume of the horse
in *Parade*, 1917. Courtesy of the Musée Picasso, Paris. Copy-
right 1991 ARS N.Y. / SPADEM.

bat, and two horses all appear on the drop curtain—which some de-
scribed as flat and colorless.[27] In any event, the American girl (and the
cacophonous music Satie composed for her, which was interspersed
with typewriter sounds) and the two figures of an American and a
French theater manager—presented as cubist monstrosities, though
they bear a certain resemblance to the *nans* or big heads of Corpus
Christi—were simply more than good French taste could bear in May
1917. In the midst of war, French nationalism had reached a crescendo.
The presentation of the Russian Ballet with costumes and sets by a
Spaniard reeked of foreignness, and the xenophobic Parisian audience
hated it. According to legend, the opening performance of *Parade* led
to a riot in which the Parisian audience literally began tearing up the
seats. The war hero Apollinaire, his head wrapped in bandages, alleg-
edly jumped onto the stage to quiet the mob. When the ballet received
its one performance in Barcelona the following November, the crowds
were dubious, but polite.[28]

After *Parade* failed in Paris, the Ballets Russes left for Spain. The
troupe's appearance at Barcelona's Lyceum Theater during the last week
of June was a big event that attracted people of all kinds. An anarcho-
syndicalist character in Victor Serge's novel *The Birth of Our Power*, set

in Barcelona in the summer of 1917, attended a performance and was transfixed: "We left the *Liceo* together: the enchantment of the Russian ballets was totally in keeping with the magic of nights in this city."[29] If only citizens of Barcelona could share power the way they shared leisure activities.

King Alfonso XIII supported Diaghilev, who, always desperate for money and virtually stateless after the overthrow of the tsar in February 1917, appreciated Spanish support and grew to love Spanish culture. Picasso followed Diaghilev to Barcelona in June 1917—though in fact the ballet master may have had very little to do with Picasso's renewed interest in the city. Olga Koklova, a minor ballerina with the troupe, had attracted Picasso's attention during rehearsals in Rome. When the company left for the July and August season in Argentina (to return to Barcelona in the autumn), she and Picasso stayed behind.

It was widely known by this time that Picasso was an important painter, but just what kind of a painter was unclear, even to local artists like Miquel Utrillo, whom he counted among his friends. Picasso's old acquaintance Jaume Brossa, publisher of the *Diluvio,* wrote about Picasso's cubist work in patronizing terms in June 1917. He claimed that Picasso, who was capable of "inspired realism," had succumbed to "the religion of cubism" with its "evangelical message."[30] Rumblings that summer may also have recalled to the artist images antedating cubism. No one in Barcelona could escape the sense that the city was a powderkeg and that revolution could easily explode. After three years of being like World War II Casablanca, Barcelona began to resemble modern Belfast.

Revolutionary Upsurge

As we saw in Chapter 5, desperation had been mounting throughout Spain because of the rapid price increases caused by the war. And while inflation alone would not trigger popular political action, inflation combined with government repression and profiteering could and did fuel an urban social movement of massive proportions. Failing to confront the political reality, the authorities in Madrid had refused since February to summon the Cortes. Provocation and repression had replaced government.

When officials in Barcelona, fearing outbreaks of social disorder, pro-

hibited public celebrations after carnival in the spring of 1917, certain groups fought back. On April 23, traditional ceremonies for the festival of Saint George (Sant Jordi) had been suppressed. It was customary on that day for city dwellers to attend mass at the Saint George Chapel of the provincial government building in the Plaza of Saint James. Usually women sold roses and men sold books all around City Hall, helping to make Sant Jordi one of Barcelona's most elegant holidays. At midday on this particular Saint George's Day, amid the unnatural silence, some youths began singing "Els segadors," the seventeenth-century revolutionary anthem traditionally sung when the Catalans rose up against the Madrid government. Antigovernment demonstrations followed. Police stepped in and attacked the protesters, fearing that Catalanist sentiments could spark more violent insurgency. By the time Corpus Christi arrived on June 6, there was a massive show of troops all along the procession route, making the popular festivities seem like a military parade.[31] Even the democracy of street festivals had disappeared.

Fear of the popular classes hardest hit by inflation led the government and the conservative Catalan nationalists of the Regionalist League to pursue other repressive policies as well. In early 1917, strikers and their organizers were attacked; amnesty struggles ensued, which helped the workers to overcome their isolation and win middle-class supporters. Springtime saw constant benefit performances, sponsored by groups like the Cultural and Artistic Union, to raise money for imprisoned strike leaders. One evening consisted of a performance of Santiago Russinyol's pacifist play *The Hero,* plus readings of original dramas and poetry by workers.[32] But even despite already harsh social conditions, the central government in Madrid chose to resort to further repression.

Three Possible Revolutions That Failed

Three near-revolutions occurred during the summer of 1917. The most threatening to the state was a potential army rebellion. Ever since the nineteenth century, the Spanish army had been top-heavy with officers. In the face of inflation—from which they suffered just like the rest of the population—the younger officers had begun organizing what they called defense committees (really army unions), and Barcelona was the center of their activities. In 1909, when demonstrators had

tried to win conscripts—largely working men—over to their cause, they had failed. Nevertheless, the Spanish government still worried that officers would lead an army insurrection against the monarchy; it therefore folded in June 1917 and effectively bribed officers to remain loyal by agreeing to grant them wage increases.[33]

The next challenge came from the conservative Catalan nationalist party, the Regionalist League, whose members were furious about the king's failure to call the Cortes, participation in which provided one of the few opportunities Catalan nationalists had to influence the state. The longtime party leader Enric Prat de la Riba, as he lay dying in the summer of 1917, outlined proposals for a federal Spain, in which regions like Catalunya would be granted rights similar to those held by an American state. The conservative Catalan banker Francesc Cambó went even further, attempting to formulate a national program, not just one relevant to Catalunya. He traveled to Madrid in June 1917 to convince the prime minister to summon the Cortes or face a constituent congress. The government refused and, at the end of June, imposed martial law in Barcelona, warning that the calling of a congress would be considered a "truly seditious act."[34]

With Barcelona still under martial law on July 5, the Regionalist League nevertheless convened a meeting of all Catalan Cortes delegates; forty-six of the total forty-nine delegates attended.[35] Their goal was to form a constitution to transform the political structure of Spain, giving regions such as Catalunya more power over their local affairs. Rumors circulated that the prime minister planned to send the army to rout an expanded meeting, this one of delegates from all over Spain scheduled to occur in Barcelona on July 19. Representatives, including the philosopher José Ortega y Gasset, did indeed gather on that date in Barcelona for a parliamentary assembly, following circuitous routes to reach the secret meeting place. According to the carefully planned itineraries, the delegates left their hotels, meandered through Barcelona's traffic under the direction of deputies who knew their destination, arrived at a restaurant in Citadel Park, and finally walked the short distance to the meeting place, the auditorium of the Electric Company. All the secrecy was for nought. On the very first day, the civil governor of the province entered the hall and personally ordered the delegates to leave, comically laying hands on several of them but taking care to avoid causing injury.[36] With the convention broken up, the delegates went home. Even so, there had always been limits on how far the sixty-eight national representatives would have gone, since most likely they never did think they would succeed.

The Catalan delegates of the Regionalist League and the party leaders outside the Cortes had supported constitutional reforms as a means of achieving change while preserving social order, as Cambó had tried to convince the king. When reform proved impossible, the league was reluctant to assume leadership of an army putsch, perhaps fearful that it would be unsuccessful. It was certainly unwilling to make common cause with the workers, whose potential power they feared more than the might of the government in Madrid. Those who believed in omens may have taken the death of the Catalan nationalist leader Prat de la Riba on August 1 as a signal that this phase of the political drama was over.

Just what Picasso or any of the local artists knew about the events of the summer we do not know, but the newspapers were filled with accounts. In the midst of the crisis of the parliamentary assembly, on July 12, Miquel Utrillo organized a gathering of local artists to honor Picasso at the Laietana Gallery.[37] Other days, Picasso lunched at the Garriga Canary Restaurant (where he dated some drawings on July 21), attended bullfights, and visited his fiancée at the Ranzini Pension.

All around, a popular social revolution did seem to be developing. First, the anarcho-syndicalist leader José Climent died under mysterious circumstances on July 13. Then the barricades went up in the Parallel at 1:30 A.M. on July 19, the night before Cortes delegates met. One person was killed, and the government dispatched the cavalry to put down a possible insurrection.[38] This could have been the moment of truth for the CNT and their Socialist allies throughout Spain had they been strong enough to supplant the politically bankrupt Spanish monarchy with a popular democracy. Ultimately, however, it became plain that they were not.

Some *cenetistas* in Barcelona were eager to take action at once in hopes of provoking revolutionary changes. As Dario, the Seguí character, says in *The Birth of Our Power:*

The main thing is to begin. Action has its own laws. Once things get started, when it's no longer possible to turn back, they'll do—we'll all do—what must be done. . . . What will it be? I haven't any idea, Comrade. But certainly a whole lot of things we don't even suspect. . . . In 1902 we held the city for seven days. In 1909 we held out for three days, without, moreover, finding anything better to do than burn a few churches. There were no leaders, no plans, no guiding ideas. Now, all we need are a couple of weeks to make us practically invincible.[39]

Since the previous December, local anarcho-syndicalists and Socialist party leaders in Madrid had been considering launching a nationwide general strike in 1917; the one that occurred that August, however,

seems to have been rather spontaneous. A national railroad strike that began in Valencia in July was the catalyst. Even though the grievance was quickly settled, the Northern Railroad Company, angry because it had been forced to recognize the Socialist-backed union, laid off a dozen workers. This provocation lent credence to the view that employers and the government, who could have controlled them, were eager to promote a general strike, which the workers would certainly lose: they lacked arms, had not mobilized support in the army, and were insufficiently coordinated with workers outside Madrid, Valencia, and Barcelona. Nonetheless, once the Valencian workers were dismissed, railroad workers throughout the northern corridor did go on strike. This action sparked a general strike in Barcelona, as the government knew it would, since food and fuel could not come into the province without the trains. Although neither the CNT nor the Socialist party had called the strike, the government declared a state of war throughout Spain, giving free rein to the military.[40]

Captain General Milans del Bosch had assembled twelve thousand soldiers in Barcelona in expectation of an insurrection. Evidently the government had assuaged the military with its response to the defense committee movement of June. Upon declaration of the state of war, soldiers dutifully set up artillery at key locations and began to patrol the city. Spontaneous fighting between workers and the troops took place at the harbor, the Rambla, the Plaza of Catalunya, the university, and in Gracia. Rebel snipers fired on the soldiers with revolvers from windows above the streets; the governor responded by ordering all blinds to be kept closed.

Wherever such attacks occurred, every man and woman in the house was held responsible and subject to arrest. Adolfo Bueso, a CNT printer, for example, was lunching with his wife and sister-in-law when a sergeant and four soldiers entered, claiming that shots had been fired from their building. The officer searched for shells and said, "If I find even one shell, I'm hauling everyone in the building in." He soon left, mercifully unsuccessful, whereupon the woman who owned the bar downstairs invited everyone in for a brandy.[41]

As a way of capturing power in the city, the populace tried to stop the trolleys from running in Saint Martin, Sans, and the Parallel. Adolfo Bueso recalled being part of a plot to distribute T-shaped pieces of iron, meant to derail the trolleys, to neighborhood committees consisting of large numbers of women. Eluding the soldiers who had set up road blocks throughout the city, Bueso was met with laughter when he told

the neighborhood committees that the T's would be delivered in little trucks; but when the little trucks that served as ambulances made their deliveries before going on to the hospitals, the revolutionaries were satisfied.[42]

Six people were killed and numerous others wounded in the first days of struggle. The army rode shotgun on the trolleys. By Saturday, August 18, the five-day strike was over except for occasional shots still being fired in the wealthy area above the Plaza of Catalunya. In the Parallel, numerous people had been arrested. Thirty-five were dead and sixty-two wounded. During the five days of fighting, shops and factories had closed; only soldiers walked the streets in large numbers. By August 19, however, people were once again filling the movie theaters, and farmers began bringing beans and fruit to the markets. But while the vendors were not above a little speculation, the women were in no mood for price gouging: in one marketplace dispute police intervention was required to settle the matter.[43]

Government forces captured Seguí, but Pestaña escaped, only to return to Barcelona several months later and discover he had been pronounced dead. His comments on his participation reveal a great deal about his views of popular struggle and about the way the 1917 general strike had unfolded: "I am neither a brave man nor a coward and I am unable to attack anyone. . . . But [the strike] was a revolutionary movement of the people, and I, who had proposed and defended the idea that they should make one, was duty bound to go into the streets and honor my words."[44]

By mid-August, all of Spain was under martial law, which entailed newspaper censorship and the suspension of rights of assembly. The government closed ten syndicalist centers in Barcelona alone and even detained the republican deputy Marcel.lí Domingo, despite his parliamentary immunity. Thousands of laborers were also arrested and languished in jail.[45]

Picasso's Response to the 1917 General Strike

Skirmishes between the police and the people centered on the Plaza of Catalunya, the Rambla, and the Parallel, the part of town where Picasso had always lived. All through the tempestuous sum-

mer of 1917, Picasso and Olga Koklova stayed in separate dwellings nearby—he at his mother's house on Mercy Street behind the civil governor's palace, she in the Ranzini Pension close to the Columbus Monument.[46]

Picasso made no verbal comment on the political events of the summer, but he left one hard-to-decipher notebook and a painting of the Columbus Monument against the background of the yellow-and-red Catalan flag (figure 16). The notebook consists of pages about seven inches by nine inches (15.5 cm × 23 cm) bearing lead pencil cartoons or caricatures. The predominant images are twenty renditions of horses and bulls in the bullfight, intermixed with studies of Koklova. Like the streets of the August days, Picasso's bullfight drawings are filled with turmoil.

In one drawing (no. 65), the bull occupies center stage as a general audience looks on.[47] The animal turns from the *toreador* toward the *picador*, whose horse rears up, lifting its right foreleg to form a pendant above the bull's head. Drawing no. 67 portrays a moment when the bull, ignoring the *toreador*, lowers his head and meets the pike of the *picador*; simultaneously, the bull's horn penetrates the lower belly of the horse on which the *picador* rides (figure 17). Paul Morand described a similar occasion:

A mare kicking the palisade attracts [the bull]. He moves toward her. She is a pumice-colored wreck, her belly sewn up like a poor woman's petticoats, her legs waver under the weight of the upholstered picador shaking his lance. The bull pauses an instant, and bellows. Caught by the fat glitter of the menacing steel, he advances, his nose grazing the ground. The picador's calves stiffen. The lance goes into the bull's shoulder. The horns sink into the mare's belly with a squish. She seems to jump, and stays there suspended, while the bull blind with the warm blood rummages about in her belly.[48]

Drawings 68, 69, and 70 contain foretastes of later Picasso sketches of horses. The horse's head lifts straight up in the air as if in a shrill shriek. Its right legs splay out, but its left legs bend back on themselves; the hind left leg collapses. It is as if the horse had lost any control over its limbs. On the underbelly, a mass that only slowly becomes discernible as the horse's intestines appears as another appendage. It may not be too farfetched to guess that the anguish and violence in these drawings may partly reflect Picasso's response to the political scene in the city where he drew them.

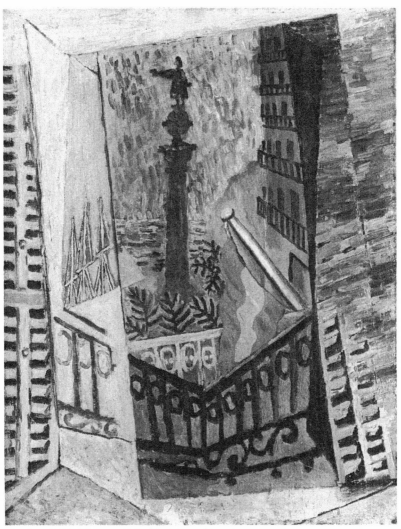

Fig. 16. Pablo Picasso, *Columbus Pass*, 1917. Courtesy of
the Museu Picasso, Barcelona. Copyright 1991 ARS N.Y. /
SPADEM.

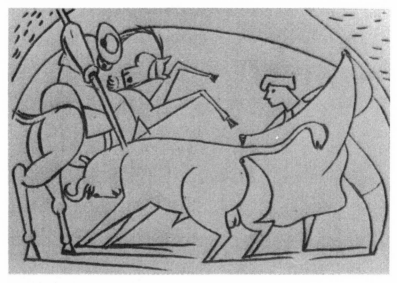

Fig. 17. Pablo Picasso, *Bull, Toreador, Picador,* 1917. Courtesy of the Museu Picasso, Barcelona. Copyright 1991 ARS N.Y. / SPADEM.

Conclusion

The monarchy triumphed over the workers in the 1917 general strike. The only chance the prime minister had of preserving the government was to persuade the middle class to support it against the CNT-led ranks. By provoking a general strike through its support of the railroad layoffs, moreover, the government drew the CNT into an insurrection when it was too weak to prevail. According to historian Gerald H. Meaker,

There is reason to believe that if the August Strike had not been attempted and defeated, the unbroken revolutionary confidence and stored-up energy of the Left would almost certainly have burst out in a revolutionary effort during the post-Armistice period, probably early in 1919. . . . It is difficult to believe that an effort like that of August, better prepared and launched in the post-Armistice context, would not have ended the monarchy and brought the Republic eleven years early.[49]

Still, the CNT, which had organized underground, won new adherents all over Spain in the years after 1917. More than seventy thousand people were said to have attended an open CNT meeting in Sans in late

June and early July 1918. Prior to that time, most Catalan unions were organized along craft lines, according to trade; the Sans conference anticipated the CIO in establishing single industrial unions, which democratically organized entire services or sectors of production regardless of skill.[50] Among such vertical groupings was the Construction, Woodworking, and Metallurgical Workers' Union that Salvador Seguí directed, which so dominated the building trades that officials could not persuade any of its members to work on constructing a new jail. To one official it appeared that "not even a leaf falls from the tree in Barcelona without the permission of the industrial union."[51]

With the establishment of single unions it seemed that the popular community had developed a new democratic institution. Many anarcho-syndicalists now expected to move rapidly toward a social revolution, especially after the events of October 1917 in Russia. The image of the Bolshevik revolution beckoned to them as to revolutionaries throughout Europe. Before anarcho-syndicalists became disillusioned with the Soviet Union, they believed that events there might serve as a model for a revolution in Spain.[52]

The Regionalist League emerged from this period less democratic and more conservative. League members evidently decided that if they had to choose between regional autonomy and social order built on repression, the latter would win, even if it meant defense of the army and the monarchy. When the king invited two League Cortes delegates to join the cabinet, they agreed, thus ending the League's separation from the monarchy. Its members then entered into a period of class resistance against the efforts of the workers and the poor to win some economic relief. As with other movements forged in terms of opposition to an enemy, the League derived strength from its portrayal of the CNT as wild and uncontrollable. Those poor people who had once inclined toward Catalanism now and forever turned away in disgust at the movement's new leadership. In Barcelona, the legacy of this 1917 transformation of the broad-based popular community would be virtual civil war between poor and rich.

Picasso, as much as any other apolitical person in Barcelona that year, must have realized that economic conflicts and social strife both threatened and ensured further political transformations. Revolutions had broken out in Mexico in 1910, Portugal in 1913, and Russia in February 1917. Barcelona, too, seemed ripe for its own revolution. Pablo Picasso, who seldom came home to the city between 1904 and 1917, was caught in a whirlwind when he did. In the civic culture of which he had

been a part at the turn of the century, republicans had spoken with the same voice as anarchists and bohemian artists. Subversive holidays like carnival had provided both an escape valve for social strife and a place to rehearse it. Folk figures like those in the Corpus Christi Day processions could serve as emblems of all Barcelona's citizens, who always liked a parade. In 1917, however, the masses spoke with a new voice. Seguí, Pestaña, and the CNT embraced a new vision of society. The general strikes they pursued could far transcend the civic rituals that Picasso had so loved in his youth.

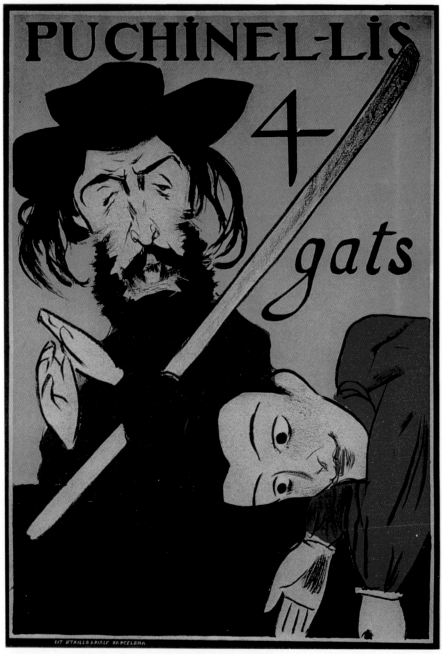

Plate 1. Ramón Casas, *Puchinel.lis 4 gats,* 1898. Courtesy of
the Museu de les Arts de l'Espectacle, Barcelona.

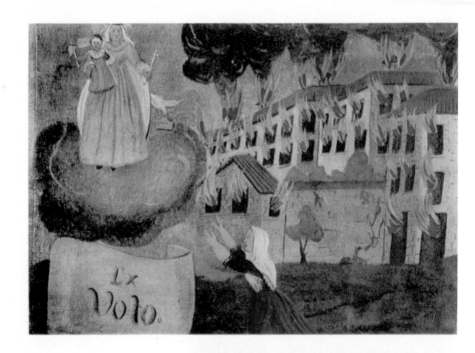

Plate 2. Votive painting dedicated to Our Lady of Bonanova: The burning piano factory. Courtesy of Señora Consol Mallofré and the Arxiu Amades.

Plate 3. Pablo Picasso, *Parody of an Ex-Voto*, 1899–1900. Courtesy of the Museu Picasso, Barcelona. Copyright 1991 ARS N.Y. / SPADEM.

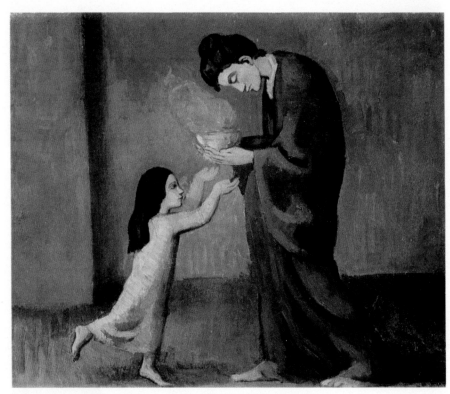

Plate 4. Pablo Picasso, *The Soup (The Offering)*, 1902–1903.
Courtesy of the Art Gallery of Ontario, Toronto. J. H. Crang
Collection. Copyright 1991 ARS N.Y. / SPADEM.

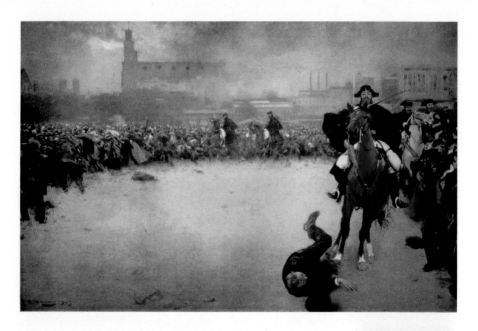

Plate 5. Ramón Casas, *The Charge,* 1899, 1902. Courtesy of the Museu Comarcal de la Garrotxa, Olot.

Plate 6. Pablo Picasso, *Pug Nose,* 1899. Courtesy of the Museu Picasso, Barcelona. Copyright 1991 ARS N.Y. / SPADEM.

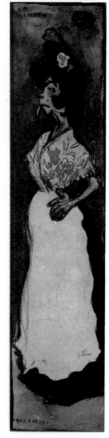

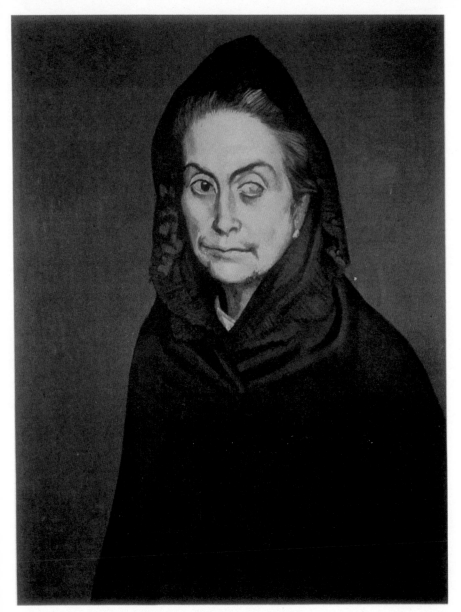

Plate 7. Pablo Picasso, *The Celestina (The Procuress)*, 1904.
Courtesy of the Musée Picasso, Paris. Copyright 1991 ARS
N.Y. / SPADEM.

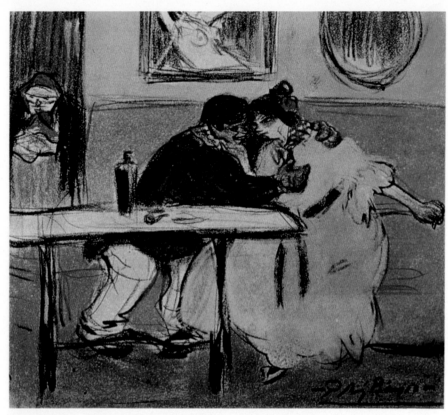

Plate 8. Pablo Picasso, *The Divan*, 1899. Courtesy of the
Museu Picasso, Barcelona. Copyright 1991 ARS N.Y. /
SPADEM.

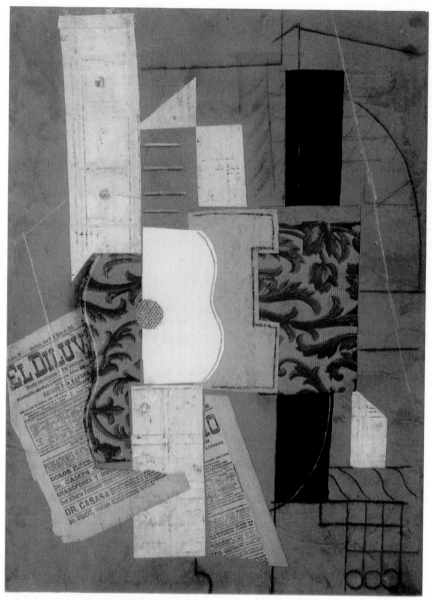

Plate 9. Pablo Picasso, *Guitar*. Spring 1913. Courtesy of the
Museum of Modern Art, New York. Nelson A. Rockefeller
Bequest. Copyright 1991 ARS N.Y. / SPADEM.

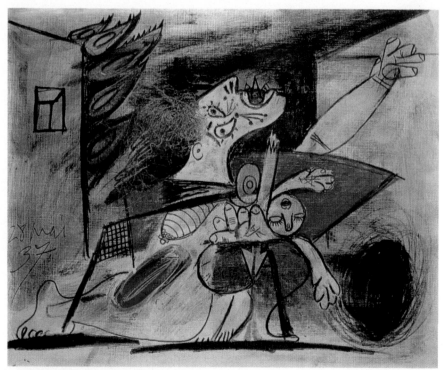

Plate 10. Pablo Picasso, *Third Sketch for Woman in Burning House with Dead Child* for *Guernica,* May 1937. Courtesy of the Prado Museum, Madrid. Copyright 1991 ARS N.Y. / SPADEM.

7

Urban Disorder and Cultural Resistance, 1919–1930

Beginning with the general strike of 1917 and the "women's war" of 1918, social strife prevailed over any unity in Barcelona. As the working population and the Catalan nationalist Regional League drew further and further apart after 1917, a new group of Catalan nationalists began to emerge. Although they promised to unite all Catalans, it took the cultural repression of a military dictatorship between 1923 and 1930 to weld the population of Barcelona together.

A long general strike in the late winter and spring of 1919 brought the city to a standstill, pitting anarcho-syndicalists and the popular community against employers and the captain general. Elsewhere in Spain, revolutionary struggles were equally widespread, so much so that the period from 1917 to 1919 would be called the "Bolshevik trienium." The landless day laborers of Andalusia swept the southwest seizing land. In the north, militant mining and textile strikes were waged. Food riots engulfed Madrid, Valladolid, and Málaga as women demanded an end to high prices. Miners in Huelva and workers in Tortosa walked out. Although in Andalusia, as in Catalunya, the CNT led the workers, the Socialist party held sway in Madrid, the Basque country, and among the coal miners of Asturias. The failure of the 1917 general strike may have chastened the always-timid Spanish Socialists about the possibilities of joint action with the anarcho-syndicalists, making it difficult for them to unite in a common effort.

More than ever before, class conflicts in the immediate postwar period followed the layout of the urban landscape. After Tragic Week of

1909, when mummies had been heaped in front of the palaces of the marquis of Güell and of Comillas, the elite had moved out of the area near the harbor into the Extension and up toward Tibidabo, leaving behind the government buildings amid the cafés and brothels. The Gothic Quarter itself had been divided in half when Laietana Way was cut from the Plaza of Urquinaona to the harbor between 1908 and 1911. Whole neighborhoods around Picasso's old haunt, the Four Cats Café, disappeared. Near the cathedral, in what remained of Madeline Street, a new central police station had been built.[1]

More and more, the Parallel and the northeastern edges of the Rambla became the center of everything conservatives feared, from vice to anarcho-syndicalism. Known as Chinatown (Barrio Chino), with all the racist connotations of exoticism and violence that term evoked, the downtown area assumed a symbolic connection to the popular classes.[2] Slumming continued to bring middle-class and rich men to the area to visit brothels like the Moor's Chalet or Madame Petit's near the harbor.[3] But armed struggle between the captain general and the workers increasingly turned downtown Barcelona into a war zone between 1919 and 1923.

The 1919 General Strike

In February 1919, scarcely three months after the armistice ending the First World War, the workers at Barcelona's Canadian-owned Ebro Irrigation and Power Company went on strike to win recognition of their new industrial union and to fight against wage cuts the company was making in the wake of the war. Lasting through April, the strike ultimately affected all the people of Barcelona because it cut off the electrical power in the city. Now that public life had become dependent on electricity—required to run the city's factories and illuminate its streets—Barcelona's citizens were hostage to disruptions in service, which could easily force everyday life to a standstill. By undermining public services, the general strike threatened civic order. There could be no agnostics: everyone in the city had to choose sides, either to resort to any means necessary to restore services or to meet the demands of those withholding them. Thus the strike welded the working population of men and women into a self-conscious community, even despite differences in language and experiences of immigration.

With the firing of eight union organizers at the Ebro Irrigation and Power Company on February 2, 1919, the Industrial Union of Water, Gas, and Electrical Workers decided to strike. Three days later, 144 electrical workers staged a sit-in, calling on the civil governor to adjudicate the dispute—a moderate act for syndicalists.[4] When workers in the city's other two electric companies went out in solidarity with the employees of the Canadian-owned company, all trolleys stopped and public transportation came to a halt.

By 4:00 P.M. on February 5, abandoned trolleys lined the streets throughout the city. Workers had to walk home, as did women stranded in markets. Those women employed by the textile factories joined the other strikers and demanded union recognition, the eight-hour day, the English week (with a half-day on Saturday), total abolition of piecework, worker's compensation, prohibition of child labor under the age of fourteen, and a full week's wages once employment began, even if the plant had decided to stop or reduce production.[5]

What became the forty-four-day-long "Canadian strike" was only one part of the international revolutionary upsurge in the winter and spring of 1919, though the strike was by far the most dramatic action in Spain. An attempt to carry out a Communist revolution in Germany had been defeated in January, and another revolution had failed in Hungary. Still, it was obvious to both leftists and conservatives in Barcelona that a revolution such as the ones that overthrew the German and Russian autocracies could topple the Spanish monarchy as well.

Whether revolutionary or not, people all over Barcelona joined the ranks of striking electrical workers in staying off the job: after all, there was no electricity to drive the plants. On February 21, troops began to run the trolleys and the electric companies. This action, however, brought on unintended consequences. Even those workers who had not gone on strike were outraged that military force would be used against those who had. Water and gas company workers walked out of their plants. Newspapers refused to publish government threats, imposing what became known as "red censorship." By mid-February, 70 percent of all the factories and shops in the city and its outlying districts had closed.

The captain general of the province, welcoming an opportunity to repress the labor movement before it grew even stronger, drafted all gas, water, and electrical workers between the ages of twenty-one and thirty-one. This move subjected them to military law, which meant they could be court-martialed if they ignored orders to return to work. Three thou-

sand resisted and wound up in Montjuich Prison. From Madrid, the prime minister decided to intervene in the dispute; he sent an aide to Barcelona to negotiate between the union and the employers, thus officially recognizing the union. Representatives of both sides arrived at a proposed settlement: employers reluctantly agreed to grant amnesty to jailed workers and to rehire them with wage increases, strike pay, and the eight-hour day. But the negotiators had yet to win the agreement of their constituents.[6]

Responding to the proposed settlement, some workers met on March 19 and demanded the immediate release of all labor militants who had been arrested since the general strike of 1917. The next day, twenty thousand syndicalists and their supporters gathered in the Arenas bullring, where their leaders urged moderation. Salvador Seguí, at age thirty-two at the height of his powers, made the most difficult speech of his career. An eyewitness described the scene:

It was interesting to listen to the oratory of the worker [Seguí] that night. Free of demagogic vanity, without affectation, his arms moving with natural gestures and a conciliatory air, his head held high, with a strong gaze, and with a spirited voice, he confronted an antagonistic multitude. . . . [They were opposed] to the peaceful solutions the orator was proposing to the huge assembly, the most crucial of which was the immediate return to work instead of fighting to obtain the release of all the strikers held prisoner.[7]

Seguí presented two options to the crowd: they could accept the proposed settlement, or they could march on Montjuich Prison to free the prisoners and begin a revolution to overthrow the state. At the bullring, the audience agreed that since they were not ready to launch a revolution, they would return to their jobs and wait for the remaining prisoners to be freed quickly.

If Seguí and other CNT leaders had wanted to begin a revolution, they would have had to have been better prepared and better armed than they were. Although some revolutionary fliers had circulated among the troops occupying Barcelona, the CNT had failed to carry on any systematic organization among the soldiers. It was unlikely that conscript troops from outside the region would have mutinied and come over to support the masses in Barcelona.[8]

Despite Seguí's skills in negotiating a settlement, the general strike resumed owing to the captain general's intransigence on behalf of the employers. Fearful that a union victory would lead to new demands, the captain general, supported by the employers, rejected the settlement

the prime minister's aide had worked out, refusing to free the three thousand workers still in jail from the 1917 strike and refusing to negotiate further about their release.[9] Thus the general strike resumed on March 24, 1919, and lasted until April 14. One hundred thousand people walked off the job, and everything closed down because the electrical workers went out again. Even banks and shops refused to open.

Repression often works. The strike was defeated when the police and army arrested workers, including the two-hundred-member strike committee. Intimidated by the use of force and faced with the absence of their leaders, the *cenetistas* returned to work on April 7. The metallurgical and construction workers managed to hold out until April 14, the official end of the strike. Thousands were arrested and given long sentences. The prime minister, who had secured a royal decree on April 2 which mandated that the eight-hour-day was to begin on October 1, was forced to resign. His conservative successor lasted from April to July, during which time Barcelona remained under martial law. Between May and August 1919, more than forty-three thousand members of the CNT in Catalunya wound up in jail. Countless other organized workers were fired from their jobs and blacklisted. Most historians seem to agree that the captain general had led the army, with the support of the industrialists, into "a virtual war of extermination designed to liquidate the unions in their formative stages."[10]

The narrative of the strike does not begin to explain what happened to the people in Barcelona who suffered through it. Women again stood in lines as supplies of flour, meat, vegetables, and chickpeas dwindled. No one ever knew when transports would get through to the markets. Bakers periodically struck to end night work; at other times they simply lacked flour to make the bread that was the staple of working-class diets. As a result of women's scuffles with vendors at the Saint Joseph and Saint Anthony markets in downtown Barcelona, occupation troops were brought in to these sites.[11] Trolleys stopped and started. When they were operating under military control it was dangerous to ride them, since crowds along the way threw stones at them.

Normal life ceased for the better part of two and a half months. Women rushed to get their laundering and shopping done at the fountains and markets and then scurried home. Cafés, music halls, and bars shut their doors. Scarcely anyone came out to stroll on the Rambla. Even employees of the municipal government went home early most days, since the light was insufficient for them to work. Corpses accumulated as the funeral workers refused to drive hearses or bury bodies.

Local newspapers could print only sporadically. Rumors spread. When the Congregation of the Sacred Blood, whose chaplains ministered to prisoners condemned to death, flew its flag at half mast, the population was convinced that three strikers had been executed: in fact, the master of the order had died.[12] Barcelona, with its population of eight hundred thousand, had stopped functioning. Losses were estimated at thirty million *pesetas*.

Hoping to seal the defeat of the CNT and streamline business, employers locked out two hundred thousand workers in Barcelona between November 25, 1919, and January 26, 1920. The employers' refusal to compromise provoked the most violent elements within the labor movement. Gang wars broke out between the hired guns (*pistoleros*) of the factory owners and counterterrorists working for the anarcho-syndicalists. Taking matters into his own hands, the new captain general, Severiano Martínez Anido, who had come to Barcelona after the 1919 general strike, attempted to crush the anarcho-syndicalist movement in Barcelona once and for all. He personally ordered many of the seven hundred political assassinations in Catalunya between 1920 and 1922, in a period that resembled the bloody days of the Argentine junta. Industrialists, too, ordered a succession of assassinations. Between 1920 and 1921, more than 230 people were shot in the streets of Barcelona alone. The CNT, although it commanded the support of up to 80 percent of the city's workers, was driven underground. Despite the chaos, public service workers continued to organize unions and carry out strikes, as, for example, the transport workers did in the summer of 1920. But conservative businessmen offset the CNT's power by creating the Free Unions (Sindicatos libres) filled with gangsters who spoke for whomever paid them the highest price.[13] It is always possible, too, that the city was deliberately destabilized to discredit Spain's already weak parliamentary government and to prepare the way for the dictatorship of Primo de Rivera in September 1923.

The Death of Seguí

Following the 1896 bombing of the Corpus Christi procession and the 1905 explosion at the Rambla of Flowers, the people of Barcelona had vented their outrage against mindless attacks in elaborate civic funerals. In 1920 and 1923, as at the turn of the century and as

today, the poor were the most vulnerable when violence became a way of life. Old ritual practices—such as civic funerals—allowed both sides to dramatize their repugnance at the growing brutality in the city.

During political struggles, participants know the risks, and others try to stay out of the cross fire. Until quite recently, however, attacks on places of recreation violated the codes of urban war. When people of the Parallel learned on Monday morning, September 13, 1920, that just after midnight the local Pompey Music Hall and Movie House, at the corner of the Parallel and New Street of the Rambla, had been bombed, a twenty-four-hour strike was ordered in protest.[14]

Three people had died in the bombing, two were critically wounded, and dozens more were injured. Large numbers of women had gathered at the hospital to identify and keen over the bodies. Just as their mothers had followed the caskets of the Rafa sisters in 1905, these local women stood as witnesses over the dead and injured to demand lives free from violence. The funeral of the three victims who were killed in the blast was set for Thursday, September 16, at 3:30 P.M.[15] The planned itinerary of the cortege indicated that the locus of sacred secular spaces had shifted since the early part of the century. The route to the cemetery was scheduled to go from the city hospital west of the Plaza of Catalunya down Provence, Muntaner, Council of One Hundred, Villarroel, and Main streets to the western side of Montjuich in front of the old bullring, and then to the cemetery on the western slopes of Montjuich in Sans.[16] When the procession reached Main Street, though, a group asked that they be allowed to detour back toward the old city.

Granted permission, the long funeral cortege passed the Plaza of the University and moved down Pelayo Street to the Rambla (see map 3). Passing slowly through the central corridor of Barcelona, the procession arrived at the flower market. The women flower vendors threw flowers onto the three coffins. Then the officials, family members, and the crowds following the funeral coaches moved toward New Street of the Rambla and the Parallel. There, lights lit up the Pompey Music Hall. A group came out of the vestibule carrying additional wreaths, which they laid on the coffins. The Pompey's orchestra assembled out front to play a funeral dirge. Once the ceremony was finished, a smaller number of people followed the hearses to the cemetery.[17]

In honor of the three men killed in the blast, almost all the stores in Barcelona, especially in the downtown area, had closed their doors from 3:30 to 5:00. Many factories and shops had shut down at midday so that workers could attend the funeral. On Wednesday, two more work-

ers died from injuries inflicted by the bombs; another funeral with a slightly different political cast was held the following Sunday. Whereas the first ceremony had gathered the municipal police, clergy, the civil governor, acting mayor, a judge, the head of the provincial government, as well as family, friends, and townspeople, the funerals on Sunday included a union demonstration. The burial of Rafael Isquerdo, a union member who worked for the telephone company, drew masses of his companions. Along with union brothers, however, came the civil governor, the acting mayor, the foreman of the telephone company, and the general director of the telephone system.[18]

Officials might pay their respects to the dead, but the police investigation showed that no matter who had bombed the Pompey, as well as setting another bomb at the Theater of the Woods that luckily was discovered in time, the authorities were in fact after the anarcho-syndicalists.[19] Even though the likely attackers were hired killers from the Free Unions engaged in terrorist acts against Barcelona's leftist militants, the police pursued anarcho-syndicalists. On the day of the first funeral, the police invaded the back rooms of a fruit store on New Street of the Rambla. There they allegedly discovered guns, ammunition, explosives, and a sign saying, "Long live the liberators of humanity," in addition to engravings alluding to Tragic Week and the 1917 general strike.[20] As usual, police went on a hunting expedition. They arrested and held five suspects in the case, among them an anarcho-syndicalist who openly disapproved of music halls and collected libertarian books.[21]

Anyone who supported the CNT became a potential target of terrorist attacks in the period 1919–1923. The Catalanist republican Francesc Layret was a labor lawyer who defended CNT members and other workers in court and was attempting to win amnesty for countless CNT members in prison. Severely disabled by infantile paralysis that forced him to move using two canes, the diminutive Layret, ambling along like a spider on stilts, represented the best in Barcelona's citizens. He tried to convince anarcho-syndicalists to form a republican labor party uniting republicans and Socialists. The CNT could then run Seguí, who had been in jail for several months, as a candidate for the Cortes. Once he was elected, parliamentary immunity would secure his release. But Layret's efforts were of no avail. Being a peacemaker, he was doomed. On November 30, just after the wife of his friend Lluís Companys, another liberal lawyer, had stopped by to consult with him about winning Companys's release from jail, Layret was shot in the face outside his house.[22]

Layret's funeral took place on December 3, 1920. Although one observer had called for "a civic gesture that will lift the collective spirit," that was not to be.[23] With the mayor, Layret's father, his two brothers, and the cream of Barcelona's intellectuals in attendance, Layret's body passed in front of a crowd, backed by the Civil Guard gathered at Main Street and Balmes. Some people wanted to move toward the Rambla, while others continued down Balmes, where Layret had been gunned down. The mounted troops of the Civil Guard attacked the crowd, seriously injuring a man and a woman.[24]

The next major community funeral was to be Salvador Seguí's. Between 1920 and 1922, Seguí was periodically detained. In early 1920 he was deported to a prison island along with other anarcho-syndicalists and his cousin Lluís Companys, and from December 1920 to the spring of 1922 he was again in jail. Finally he was permitted to return home and resume his union work. Because he and Pestaña were able to bring syndicalists and federalist republicans together, they represented a special threat to conservatives. Concern was particularly acute regarding Seguí and his attempts to win supporters away from a policy of armed confrontation and toward the construction of big unions.[25] The potentially broad appeal of the moderate peacemaker was far more threatening than the violence of those who wanted to pursue a politics of revenge. Whether or not there were actual contracts out on the two men's lives, Pestaña narrowly avoided an assassination attempt while on an organizing trip to Manresa in August 1922, whereas the *pistoleros* finally succeeded in hunting down and murdering Salvador Seguí in March 1923.[26]

Seguí's daily habits kept him in his own neighborhood, the Parallel. Almost every day he stopped by the Saint Simplicimus Street building that housed four unions and served as a hangout for anarcho-syndicalists; he then usually spent some time at the Tostadero Café on his way home. A few weeks before his assassination, Seguí, his pregnant companion, Dolores Rubinat, and their seven-year-old son had been followed home, and Seguí had narrowly escaped with his life. Yet he refused to change his habits or accept a guard. On March 10, 1923, he and his friend Francisco Comas Pagés had gone to a labor meeting and stopped at the Tostadero, where Seguí played billiards with Companys. Comas and Seguí left together and walked down a street in the old industrial hub of Barcelona. This time the gangsters from the Free Unions hit their mark. As Seguí and Comas stopped for a light, the killers shot at them, killing Seguí and fatally wounding Comas.[27] Outrage swept

the community, not only because Seguí was a beloved figure and a voice of reason among anarcho-syndicalists and republicans, but also because his death was yet another example of how unsafe daily life in the old neighborhoods had become.

The public response to the deaths of Seguí and Comas reflected community fury at the monarchy, which, unable to control the employers and their hired killers, permitted virtual civil war to reign in Barcelona. The anarcho-syndicalists called for a mass protest meeting at the Plaza of Catalunya followed by a march. They also wanted to declare a general strike.[28] The workers proclaimed that the governor had attempted to extinguish "the civic spirit of the citizens of Barcelona, who have not risen up en masse against these brutal attacks on the lives of workers. . . . But our voice, the voice of workers and citizens who repudiate this crime, will be heard."[29]

On the Sunday morning following Seguí's death, a group of women laid flowers on the corner of Saint Rafael and Cadena streets, where he had been shot.[30] Neither they, Seguí's family, nor his union associates knew that the police would the next day secretly carry Seguí's body from the morgue to the storage area of the cemetery without his wife, child, or cousin being present. The CNT protested to Civil Governor Salvador Raventós about both the killing and the removal of the body: the government had stolen Seguí's body as the gangsters had stolen his life.[31]

The demonstration scheduled for 3:00 Monday afternoon at the Plaza of Catalunya had various purposes. It would bring together local citizens of all classes to assert their right to the streets by taking them in a peaceful procession to the offices of the civil governor. There they would protest against the assassination and the body snatching to officials of the state. The demonstrators would then march to the cemetery, the governor's prohibitions notwithstanding.[32]

Militant posturing characterized the behavior of both the anarcho-syndicalists and the infantry as they faced each other at the Plaza of Catalunya. By 4:00 that afternoon, the entire downtown area around the plaza was filled with five to six thousand people who came from all over Barcelona as well as from the surrounding towns to register their opposition to the murder of Seguí. The procession moved to the Angel Gate via the Plaza of Saint Anne and to the civic center at the Plaza of Saint James. From there the crowd proceeded to the governor's office near the harbor. In this march, the people symbolically reclaimed and purified the streets that assassination had profaned.

The issue of whose community had come under attack took on crucial significance now and in the days that followed. As the street demonstration drew to a close at the governor's office, he attempted to present himself as at one with the community, as a fellow victim of the tragedy. He addressed the crowd, saying that he mourned with them for the death of Seguí and the wounding of Comas. Whether out of humanity or fear of social disorder, he permitted Seguí's family and about fifteen other people to hold a secret funeral ceremony late Monday afternoon at the cemetery. Although there was, of course, no Catholic rite, echoes of Catholic hagiography came to surround the event. One commentator claimed that when the casket was opened, the body, like those of saints, showed no signs of decomposition.[33]

When poor Francisco Comas Pagés died as a result of his wounds, he, unlike Seguí, received a public burial. The ceremony was set for Sunday, March 18. By coincidence, this was the date that Barcelona republicans had frequently chosen to commemorate the Paris Commune, although no one recalled this at the time. Thousands flowed downtown from the suburbs inhabited by industrial workers and artisans. The correspondent for the Madrid daily newspaper *Sol* noted that an unusually large number of women, carrying roses and red carnations, waited outside the morgue for Comas' body. Men prepared the hearse by removing the traditional crosses, and they wrapped the coffin in a red flag. Crepe, cut flowers, and wreaths were placed on the bier. At 9:45 A.M., the cortege began to move down the street, past the Civil Guards. Some twenty thousand people lined the route. The procession passed through the Plaza of Spain, where photographers waited. A group of neighborhood people placed bouquets of flowers on the hearse. Then the cortege wended its way slowly through the district of Sans to the cemetery, in the suburb of L'Hospitalet. There, Seguí too received recognition as the crowds burying Comas walked solemnly past his grave.[34]

New Trends in Catalan Nationalism

Seguí's death marked the beginning of the end of the period of internecine strife in Barcelona that had opened with the "women's war" in 1918. As mentioned earlier, the roots of a new kind of Catalanism that would transform Barcelona's political landscape in the period after Seguí's death could be traced to 1918 as well. On Novem-

ber 15 of that year, two days after the end of World War I, Catalan delegate Marcel.lí Domingo had argued in the Cortes that Catalunya needed "integral autonomy." What he meant was that Catalunya should have rights of self-government, to be exercised through regional executive, legislative, and judicial institutions within the Spanish state.[35] Another delegate, Francesc Macià, went even further. He viewed Catalunya as properly a nation with rights of self-determination: "The moment of truth has arrived," he said. "All Catalans are prepared for the struggle and the final victory."[36] A former army officer born to a modest family and married into the Catalan landed elite, Macià was the leading advocate for a new cross-class alliance that would gain the independence of a Catalan state. In believing that independence would lift the dual oppression of workers and Catalans, he stood with other European liberals right after the war who were convinced that national self-determination could solve all social problems.[37]

In late February 1919, as the Canadian strike was spreading, Macià had attempted to promote a popular alliance of Catalans regardless of class. Addressing the Cortes on February 21, he claimed that the problems of both the workers and Catalunya raised fundamental questions about freedom. He chastised the assembly, saying: "You treat Catalunya as a conquered country, and you have imposed a language that is not its own. Catalunya wants liberty from the tyranny of Spain and you have denied it. . . . The working classes are [also] oppressed and persecuted, especially in Barcelona [and they, too, deserve recognition]."[38] A month later, in March 1919, Marcel.lí Domingo wrote: "The reason Barcelona has been driven to the present conditions [of the general strike] is that the government has not been willing to treat Catalunya's two great movements, the autonomists and the syndicalists, with justice."[39]

Moved by communitarian sentiments despite the near civil war that swept Barcelona after 1919, Macià intensified his political activities. He believed it was possible to rescue Catalan nationalism from the conservative Regionalist League and promote a middle-class Catalan nationalist party committed to democracy and republicanism. In 1922, to this end, he launched the Catalan State (Estat Català), a political organization that incorporated a militia of young Catalan nationalist men capable of overthrowing the monarchy through armed struggle.[40]

Catalanism, long led by the conservative Regionalist League, was passing to a new generation. Both the goals and the means that Macià and Domingo espoused were political. They wanted social justice as well as regional autonomy, and they believed that Catalunya's success in

creating and running its own courts, schools, and police force and col-
lecting its own taxes would depend on restructuring the Spanish state
into some form of republic.[41] Just what kind of republic Macià envi-
sioned and whether he wanted an entirely separate Catalan country—
roughly like Ireland or Czechoslovakia—is not clear.[42]

Resistance to the Dictatorship

Had an outside enemy not brought the people of Barce-
lona together, the fortunes of Macià's Estat Català might have been
quite different from what they proved to be—for the dictatorship of
General Miguel Primo de Rivera, which began in 1923 and ended in
January 1930, sparked a movement of resistance against cultural repres-
sion.

For over a century, the Spanish army and generals like Primo de Ri-
vera had viewed themselves as guardians of national order. Of late, with
the king and his ministers apparently incapable of establishing eco-
nomic stability or social harmony, the army had become increasingly
restive. The war in Morocco had flared up again in 1919, and especially
bad losses in 1921, believed to be the fault of the king, had led officers
to seek a military presence at the head of state. The army wanted victory
abroad and order—by which they meant suppression of Socialist and
anarcho-syndicalist unions—at home. On September 13, 1923, Miguel
Primo de Rivera staged a coup in Barcelona and stepped in to carry out
their will.

Primo de Rivera, heir to gigantic sherry vineyards and landed estates
in southwestern Spain, was the captain general of Catalunya in 1923. A
jovial, cultivated man with aristocratic bearing, he socialized with mem-
bers of the Regionalist League and led them to believe he understood
their ideas about Catalan culture. Conservative Catalan nationalists like
the architect and politician Josep Puig i Cadafalch thus regarded Primo
as their friend. Moreover, they presumed that he, like the captains gen-
eral who had preceded him, would support their interests against the
workers. Prat de la Riba, the leader of the Regionalist League for more
than a generation, had believed that Catalanism would prosper under
dictators, who could reduce civil strife and enable Catalan culture to
develop peacefully.[43]

Prat de la Riba had died on August 1, 1917, a little more than six

years before his presumptions were proved untrue. A week after Primo de Rivera seized power, he issued a decree making the use of the Catalan language in public and in print a crime, subject to the jurisdiction of military courts.[44] During the Primo dictatorship, the government censored newspapers, prohibited flying the Catalan flag, and even outlawed dancing the *sardana,* the traditional regional circle dance.[45]

Police roundups of suspected dissidents began as early as January 1924. Leftists and Catalan nationalists (except for certain members of the Socialist party [PSOE], who agreed to serve on mediation boards with employers), fled underground or into exile. By March 1925, those leaders of the small Communist party and the massive anarcho-syndicalist movement who had remained in Barcelona had disappeared behind bars.[46]

Catalan business interests had already demonstrated in the period 1919–1923 that, like feudal lords, they could exercise their own military force by hiring gangsters to act against provincial insurgents. Had Primo and the army been less obsessed with destroying Catalan identity, local businessmen such as the banker Cambó would have been more than happy to carry out a far-ranging policy of repression in Catalunya while gloving the iron hand inside Catalan culture.[47] But the fear of regionalism in Spain is like the fear of communism in the United States, in that reasoned arguments do not begin to address the problem.

Workers, many of whom spoke Catalan, had had no illusions about a community welded by Catalan culture—after all, the police who beat them and the gangsters who attacked them also frequently spoke Catalan. With the gratuitously petty repression of Catalan culture by Primo's forces, however, Catalanism emerged as a culture of resistance for people from all walks of life, workers and businessmen alike.

A common reaction to twentieth-century authoritarianism has been civil disobedience. Under normal circumstances, civic rituals would have provided opportunities for republican Catalan nationalists and anarcho-syndicalists to struggle for civil rights. But the first Saint George's Day of the dictatorship on April 23, 1924, and May Days thereafter, indicated how much control Primo had already gained over civic traditions.

Ordinarily on Saint George's Day, flower vendors from the Rambla would set up shop on Bishop Street, to the right of the Generalitat, where Catalunya's medieval regional government had met. People would congregate there, on the Patio of Oranges just outside the

Chapel of Saint George. Everyone, especially engaged couples and new-lyweds, would buy roses on Bishop Street and carry them to the chapel and patio. Crowds customarily thronged the square in front.

Saint George's Day in 1924 was to be quite a different affair. First of all, rumors circulated that the government had closed the Generalitat to the rites, though no decree appeared. Flower sellers, acting on hearsay, boycotted their usual places in Bishop Street and instead dispersed their stalls throughout the Gothic Quarter. Many people, hoping to avoid trouble, simply stayed away from downtown, and the crowds grew thinner. Those who subscribed to shared civic culture were made uncomfortable.

Repression intensified throughout 1924, and, as was usual in Barcelona, the anarcho-syndicalists bore the brunt of the government attacks. The former captain general of Barcelona Severiano Martínez Anido, who once had gunned down labor activists, became Primo's minister of the interior and thus the chief policeman in Spain. Militants faced stepped-up persecution. In retaliation, anarcho-syndicalists shot the city executioner of Barcelona at the end of May 1924. The government then rounded up hundreds of people they suspected of anarcho-syndicalism, whether or not evidence linked them to the assassination. In November, anarcho-syndicalists marched on the Atarazanas Barracks near the harbor. The effort to seize the barracks failed, and the Spanish authorities executed two anarcho-syndicalists they named as ringleaders.[48]

In May 1925, a month after the peaceful celebration of Saint George's Day, an attack in the Garraf Tunnel south of the city on the train carrying Spain's king and queen toward Barcelona was foiled, thanks to an informer's tip. Authorities traced the plans to four young supporters of Macià, all seventeen to twenty years of age, arrested them, and set their trial for April 30, 1926, a week after Saint George's Day and just before May Day.[49]

Early in 1926, the government provoked local anger by decreeing that the Rosary be performed in Latin, not Catalan. In opposition, Catalan separatists organized massive demonstrations of civil disobedience. It was decided that official Catalan worship of the region's patron saint would take place at the Saint George Chapel of the cathedral, not at the government building. People convened at the cathedral "in the morning and at noon to pray for Catalunya, for prisoners, for exiles, and especially for those the prosecutors had asked to be executed in connection with their attempt on the lives of the king and queen at the Garraf Railroad Station."[50] Secret handbills offered detailed instruction on how

people should proceed. Civic ritual thus gave way to political mobiliza-
tion as people acted on the half-inch–by–quarter-inch tissue-paper mes-
sages that urged them to buy their flowers only in front of the Saint
Lucy entrance to the cathedral and to place the bouquets on the Saint
George altar inside the cathedral. People also took their candles to the
Saint Just Chapel, Barcelona's oldest shrine.[51]

At the trial the next week, the court decreed a death sentence, which
outraged many sections of the population. An attempted coup was
scheduled for Saint John's Day, June 24, 1926—a joint scheme of
anarcho-syndicalists, clergy, monarchists, army officers, separatists, and
even a former prime minister. By choosing another holiday as the date
for the uprising, Macià's supporters assured that most people in the city
would be off from work and available to observe the opposition to
Primo; perhaps they might even be persuaded to take part. Saint John's
Day, of course, honored the saint; it also traditionally celebrated the
summer solstice with huge bonfires, firecrackers, and all-night celebra-
tions the night before, making it a cross between New Year's Eve and
the Fourth of July in the United States—a perfect occasion for an insur-
rection.[52] Police, however, uncovered the plot before the leaders could
try to seize power, arrested suspected dissidents, and held them without
trial. Still, demonstrations did take place on Saint John's Day, and those
angry about the persecution of Catalans continued to look for ways to
show their opposition to the regime.[53]

The success of the civic rite of disobedience on Saint George's Day
followed by the demonstrations on Saint John's Day aroused the dicta-
tor's fears. No sooner did the anarchists Buenaventura Durruti and
Francisco Ascaso arrive in Paris in July 1926 from exile in Argentina
than they were accused of plotting to assassinate the Spanish king dur-
ing his visit to France. Possibly under pressure from Primo, the French
tried them and handed down three-month sentences. Then in August,
an anarchist named Domingo Massach tried to assassinate Primo at the
government center at the Plaza of the Palace in Barcelona. The attempt
cost him eight years in jail.[54] Even the celebration of the Virgin of
Mercy Day on September 23, 1926, only exacerbated the sense that
Barcelona was living in chains. Although the associated religious rites
took place, the carnivalesque parades and costume balls were sup-
pressed.[55]

In November 1926, Macià was arrested with fifty followers of his
Estat Català on the French side of the Pyrenees, just as the group was
about to invade Spain. Twenty alleged supporters in Barcelona were de-

tained and held as well, despite the absence of any evidence that they had conspired to organize an insurrection. Upon his release from jail, Macià left France to raise money from Catalan émigrés to South America. When he returned to France, he gathered together a hundred or so young Catalans for another invasion. Informers denounced them, and they all were tried in France, where they received light sentences.[56]

Although another military plot, known as the Valencia Conspiracy, failed to materialize in 1928, not even the gala opening on May 18, 1929, by Primo de Rivera and the king of the Barcelona International Exposition could win Catalan support for the regime. Unlike previous exhibitions in 1888 and 1902, the 1929 fair was designed to promote Spain rather than Catalunya. Among the most notable of the projects the exposition launched was the Spanish Village, with arts and crafts and replicas of architecture from all over the country. Although building the village and the National Palace (which later became the Museum of Catalan Art) provided employment for forty thousand workers, and the dictatorship paid about one-third of the enormous costs, the financial burden was too great for the city and it went bankrupt, leaving large numbers of workers unemployed once the exposition opened.[57]

By the end of 1929, Primo's chiefs of staff warned him that they could no longer keep him in power.[58] He resigned on January 28, 1930, thirteen days after the exposition closed, and he died within the year. He was succeeded by a caretaker general who ruled for a little over a year.

Conclusion

After 1923, the cultural content, including the civic rituals, that characterized Catalan nationalism enabled it to draw on people from all classes to infuse new political meanings into old ceremonial practices. The government could never be certain about the loyalties of Barcelona's mayors, councillors, and dignitaries. To be sure, labor struggle in the city remained intense. Catalan rulers were willing to use police and hired guns to attack the labor movement, and they did so brutally. From Madrid's perspective, even conservative Catholic businessmen and industrialists were not dependable, especially when it came to cultural matters. The Catalan leaders clearly wanted to rule, at least in

the cities and the province; the army, however, simply would not permit any government to preside over "the dismemberment" of Spain.

Although Catalan nationalism always remained somewhat factionalized and never represented a single political ideology, it was to become a potent force against twentieth-century dictators in Spain. As a 1924 clandestine flier in the form of an anagram asked, "While the Director [the dictator's title] continues to prohibit our flag and language in schools and public centers, while he suppresses publications, can a thousand patriots and community groups not join together and provide an example for the masses of Catalans?"[59] Such nationalistic feelings were frequently expressed in communal rituals that transformed old practices into rites of resistance which acted in new ways.

For more than forty years, rituals had developed, played on one another, and changed their meanings in the civic life of Barcelona. By the time of Primo de Rivera's regime, Catholic holidays celebrating Saint George and Saint John and May Day had all become civic holidays for people of every class. As civic consciousness in Barcelona was formed and reformed, folk elements became political. By 1930, the Madrid government would have had to ban every holiday celebration in Barcelona to remove the risk of public mobilizations. Any collective act for any goal could potentially be turned into a symbol of the city of Barcelona in resistance.

8

Cultural Reactions to the Spanish Republic and the Civil War in Barcelona

Catalan nationalism flowered during the first years of the Second Republic, which lasted from 1931 to 1939. But with the republic there also came political and social disputes that pitted certain portions of the community against others. As in the past, battles were fought physically and symbolically, and images and rituals, whose meanings lay in past political and personal experiences, reemerged, to be interpreted by political leaders and artists.

Pablo Picasso, Miquel Utrillo, and Ramón Casas, having come of age as modern civic culture took shape in turn-of-the-century Barcelona, had developed a sense of community with latent political content.[1] They, like many other bohemian artists who had grown up in Barcelona, assumed an antiauthoritarian stance, if only in their artistic endeavors. Through festivals, puppet theater, and art exhibitions, many of them participated in a larger popular community and developed a strong sense of its cultural forms.

Imagery derived from civic life in Barcelona—bullfights, horses, devotional paintings, and folk figures—permeated the work of Casas, Russinyol, Utrillo, and Picasso throughout their lives. The first three died in the thirties, during the Second Republic. Although Picasso visited Barcelona only twice in the thirties and never returned to Spain thereafter, he remained linked by personal memories and relationships to this town where his mother, sister, and oldest friends continued to live. It is no wonder, then, that in 1937, at a time of horror for the Spanish people, when Barcelona was racked by civil war, Picasso would

once again conjure up images from Barcelona that he had already used over and over again. If his direct involvement in Barcelona during the dramatic events of the thirties was intermittent, it was nevertheless intense, culminating in two etchings each called *The Dreams and Lies of Franco* and in his masterwork, *Guernica*.[2] These works all drew on traditional motifs that Picasso had already employed, while adding political dimensions seldom before seen in his art.

The thirties were a period of great promise and of dashed hopes for both Spain and Barcelona. With the decline of Primo de Rivera and his short-lived successor, General Dámaso Berenguer, the government could not command support. Further indication of the monarchy's powerlessness came on April 12, 1931, when routine municipal elections resulted in Socialist and republican majorities in every major city in the country. When the king, hoping to stay in power by force, polled the army officers on whom he depended to maintain his position, they refused to guarantee that they would support him as they had done during the parliamentary crisis of 1917. Lacking military support, King Alfonso XIII fled the country. Again, as in 1873, Spain became a republic because the king had resigned.

Republican and Socialist journalists and university professors in the Cortes, who for years had dreamed of transforming Spain into a republic, got their wish, and two days after the municipal elections, on April 14, they declared the creation of the Second Spanish Republic. A constitutional congress made up of Cortes delegates elected the following June went into action. Although their major concerns were social relief for victims of the economic depression, land reform, streamlining of the army through a reduction in the number of officers, and separation of church and state, in short order they were faced with the problem of Catalan nationalism.

In July 1931, hoping to head off a militant separatist movement in Catalunya, the constituent Cortes passed a temporary Statute of Autonomy to define Catalunya's rights within the Second Spanish Republic. It authorized elections to the ancient Catalan provincial government, or Generalitat, which would prepare a Statute of Autonomy, hold a plebiscite of Catalan citizens to consider the statute, and then submit the statute to the Cortes. When the elections took place that summer, the republican coalition known as the Republican Left of Catalunya (Esquerra Republicana de Catalunya), a party put together by Lluís Companys in just over three weeks, won a majority.[3] Quickly, Companys was elected head of the provincial government. The results of the referen-

dum, announced on the evening of August 2, 1931, empowered the Generalitat to supervise museums and to use Catalan in all public institutions, including the universities. While it would have authority over all provincial municipalities, it lacked the power to raise taxes, appoint police, or reorganize the school system.

The new Spanish constitution, which took effect in 1932, proclaimed the state a "republic of workers of all categories," yet the republican government was not supportive of the demands of the working classes. Most legislators were troubled by the social revolutionary aims of organized labor and the landless day laborers of the south. The CNT, which had reemerged in 1931, now represented over a million workers and peasants throughout Spain, the vast majority of them in Catalunya. It wanted to create a new government in which workers would share all economic resources equally. Industrial workers in Catalunya, meanwhile, attempting to improve their conditions, were meeting with harsh treatment. Two days after a miners' strike in Llobregat Valley west of Barcelona was put down on January 18, 1932, the Republican government viciously suppressed sympathy strikes among CNT workers in the city. It ordered the army to club and shoot striking workers and then jail their leaders. The CNT was prohibited and, once again, went underground.[4]

Catalan nationalists, a majority of whom now supported the Republican Left, wanted increased power in the region. The Statute of Autonomy as it appeared in the Constitution of September 1932 permitted the belief that Catalunya could finally take control of its own local affairs: it confirmed Catalan as an official language, permitted the creation of a public school system, and gave the Generalitat power over museums, archives, and libraries, local and provincial police, provincial roads, forests, agricultural conditions, health systems, and courts (except for military courts). To finance these activities, money would come from the Spanish government and from provincial taxes on estates, forests, and mines.[5]

Unable to solve the nation's agrarian problem by massive redistribution of land or to ease the economic problems of the working classes, the Republic, governed by a coalition of republicans and Socialists, repressed both groups. When the starving villagers of Casas Viejas in Cádiz Province in southwestern Spain rose up and declared their village a commune, the government burnt the town, killing four people and wounding twenty-five.[6] Outraged, the clandestine CNT stepped up its resistance to the government. In the spring of 1933 it launched strikes

for amnesty, for the right to organize, and for resumed publication of newspapers that had been shut down. By the middle of April, construction and dock workers were striking in Barcelona. As the strikes proceeded during that spring and summer, Spain's jails filled up with some nine thousand CNT prisoners. The effort to free these prisoners developed into an amnesty campaign that drew nearly sixty thousand people to Barcelona's northeastern bullring in September 1933.[7]

The massacre at Casas Viejas had convinced both the left and the right that the government was incapable of governing, and over the first half of 1933 the ruling coalition of republicans and Socialists fell apart. Spaniards outraged by the liberals' use of military force against workers and peasants from 1931 to 1933 and those in Barcelona who were dissatisfied with the pace at which Catalan autonomy was expanding abstained from voting in the parliamentary election of November 19, 1933. As a result, a conservative government representing the interests of the large landowners of the central and southern provinces and the religious middle classes nationwide came to power in Spain—in the same year that Adolf Hitler became chancellor of Germany. This conservative coalition ruled until February 1936.

Cultural Resurgence

The declaration of the Second Republic and the Statute of Autonomy launched a period of euphoria that drew back to Barcelona Spaniards who had left the city for a variety of reasons. One of those who returned in 1931 was the puppeteer Ezequel Vigués, known as "Dido." A native of Terrassa in Catalunya, Vigués had come to Barcelona for the first time as a tourist during the 1888 exposition. Deciding to stay, he lived with cousins who ran a café in the old section of town and worked first in a fancy dry goods store and then in El Siglo department store on the Rambla. In 1907 he left for Paris and then Egypt, where he spent the next twenty years before returning to Paris in 1928. There he opened the Seville Café, producing Catalan plays performed in French. Although the café became a hangout for Spanish and especially Catalan émigrés, their support could not save it from bankruptcy following the 1929 crash. He decided to travel again.[8]

On a ship going to Panama he ran a puppet show and, at age fifty,

decided to change careers and become a puppeteer. Back in Paris in 1930 and 1931, he worked as a clown at Medrano Circus and played in one of Josephine Baker's bands while honing his skills as a puppet master. On June 24, 1931, two months after the Second Republic was declared, he returned to Barcelona and almost immediately got a job at the combined puppet theater, art gallery, and furniture store known as Reig's Furniture (Mobles Reig) on Gracia Pass. The new puppet plays he created became instant hits.

His popularity convinced the directors of the Artistic Circle of Saint Luke's, which occupied the old premises of the Four Cats on Mount Zion Street, to reopen the puppet theater in March 1932 and invite him to perform. One of the plays he launched there dealt with the fall of Rafael Casanova; it ended with Casanova's death on the barricades of Saint Peter Boulevard in 1714. Delivered in Catalan, this play and others like it promoted a historical memory among young Catalans. When Ramón Casas, the painter and former denizen of the Four Cats, died that March, Vigués even had one of the puppets ask the children to observe a minute of silence for him.[9] Like the late-nineteenth-century puppet shows, those of Vigués were filled with social satire and political commentary. For example, it was common for puppets to remark on the similar red capes worn by the Devil and the policeman, both of whom still spoke Castilian when other characters spoke Catalan. Thus, in building on traditional Catalan puppet theater, Vigués attempted during the Second Republic to preserve and transform Catalan culture, inculcating its values in the next generation.

Other, more famous exiles from Barcelona also returned to the city during the early days of the Second Republic. In the summer before the parliamentary elections of 1933, Pablo Picasso brought his wife and twelve-year-old son, Paulo, to the city. Dismissing their chauffeur, they drove into Barcelona in the Hispano-Suiza luxury car of which Picasso was so proud. Once there, Picasso showed his son and nephews Fen and Xavier Vilató the Spanish Village and the National Palace of Art, launched at the 1929 International Exposition. Picasso of course also attended some bullfights, which revitalized his lifelong preoccupation with the sport.

Returning in late August 1934 for what was to be his last trip to Spain, Picasso and his family traveled to San Sebastián, Burgos, Madrid, Toledo, and Zaragoza before arriving in Barcelona for a few weeks' stay. There, in a sweltering Barcelona August, they previewed,

under Miquel Utrillo's direction, the Museum of Catalan Art, scheduled to open at the end of September.[10] After viewing the collection, Picasso commented to a local newspaper that he admired the "strength, intensity, and sureness of vision" he associated with Catalan Romanesque art.[11]

Even during Picasso's early days in Barcelona, as we have seen, he had been close to people who were early admirers of medieval art, among them Utrillo and the artist Isidre Nonell. Catalan Romanesque murals and Gothic paintings had been displayed at the 1888 exposition, and in 1891 they were deposited in the Palace of Fine Arts in Citadel Park, where they were on view during the festival of the Virgin of Mercy in September and October 1902. Between 1915 and 1929, with the help of Italian crews, the provincial government of Barcelona removed murals from abandoned monasteries and churches all over the region, placing the entire collection in the Archeological Museum in Citadel Park.[12]

During Picasso's years abroad, he continued to be exposed to Spanish medieval art in one form or another. Art historian Lydia Gasman has noted that in the late twenties and early thirties, when Picasso visited his friend Max Jacob, now a monk at Saint-Benoit-sur-Loire, he must have noticed the abbey's porch, which was covered with statues deriving from the Spanish medieval manuscript of the *Apocalypse of Beatus of Liebana*.[13] And in 1931, it is likely that Picasso saw the article on Catalan Romanesque manuscript drawings written by his friend Christian Zervos in *Cahier d'art*.[14] Picasso, though out of the country during the crucial early years of the Second Republic, was not entirely out of touch.

Growing Political Turmoil

After the conservatives came to power in Spain in November 1933, the CNT planned a national uprising for December 8. Despite a spectacular Barcelona jail break by CNT prisoners, the insurrection was a failure; indeed, it was used to legitimate government censorship, union repression, and the arrest of labor leaders. When, in October 1934, the Catholic conservative party won three cabinet positions, Socialists and anarcho-syndicalists were galvanized to take action against what they feared would be a right-wing coup, whether in fact or

in name. Within a few days, the CNT and the Socialist General Confederation of Workers (UGT), which since December 1933 had been discussing some kind of working-class alliance, planned a national general strike. It began on October 4, with coal miners in Asturias in northern Spain leading the struggle. If there had been any doubts about the ruthlessness of the new republican government, they were laid to rest by its treatment of the workers. Utterly unsympathetic to the gruesome conditions under which the coal miners worked and without concern for their fears, it called in Colonel Francisco Franco. As commander of the crack Moroccan troops and Foreign Legion mercenaries, Franco showed no mercy as his soldiers quashed the miners and their supporters. From October 10 to October 18, Moroccan troops and Legionnaires were permitted to rape and pillage in the mining towns of Asturias. The maneuver resulted in about one thousand dead and thirty to forty thousand jailed throughout Spain.[15]

The day after the nationwide general strike was called on October 4, 1934, Lluís Companys, now president of the Generalitat, proclaimed the "Republic of Catalunya within the Federal Republic of Spain"—an act that was regarded as treason, since there was no federalist state at the time.[16] Companys was arrested and held for sixteen months, and the Statute of Autonomy was abrogated.

After the strike, forces from among Spain's landowners, its army, and its fascist Falange political party had begun to negotiate with Mussolini and Hitler, from whom they obtained financial commitments and promises of military support for a rebellion to overthrow the legally elected Second Republic. The republicans and the left, increasingly aware of the growing fascist menace throughout Europe and mindful that in 1933 divisions among republicans, Socialists, and leftists had permitted conservatives to come to power in Spain, decided to run a unified slate for the parliamentary elections of February 16, 1936. Their coalition, like other such slates elsewhere in Europe, was known as the Popular Front.[17]

Meanwhile, during the summer of 1935, Jaume Sabartés, a poet turned journalist who had been a close friend of Picasso's some three decades earlier in Barcelona, received a summons from the painter. Now that Picasso had left his wife Olga Koklova, with whom he had been fighting for years, he needed a secretary. He hoped that Sabartés, who had recently returned to the city after twenty years as a journalist in Latin America, would accept this position. Although Sabartés had been

the butt of Picasso's jokes in their youth, he was happy to serve. Persuading his own wife to join him, Sabartés headed for Paris, where, from November 1935 to the winter of 1937, he practically lived with Picasso as his secretary and companion.[18] Presumably, he filled Picasso in on recent events in Barcelona.

In the midst of the Popular Front election campaign, Picasso was contacted by the Catalan Friends of the New Arts (Amics de l'Art Nou, or ADLAN), who wanted to open an exhibit of his work on February 18, 1936, two days after the election was scheduled to take place. Even though Picasso was a celebrity, few in Barcelona were familiar with his art, which had not been seen since he and Ramón Casas exhibited jointly in Barcelona in 1932. Picasso agreed to the retrospective but refused to attend.[19] His mother, María Picasso, Joan Miró, and Salvador Dalí talked on the radio in his place to publicize the show. Picasso's friend, the surrealist poet Paul Éluard, traveled down to Barcelona from Paris for the exhibit and delivered a lecture at the opening. Éluard, standing in for Picasso, received the hearty support of students who chanted, "Picasso, the Marxist," confirming that they saw Picasso as a radical. (In fact, although Picasso did later, in 1944, join the Communist party of France, Éluard, like most of the other surrealists, had become a member in 1926.)[20]

When the Popular Front won the elections in February, the left was jubilant, and the right intensified their plotting. With the support of Catholic landowners and fascists, five generals, including Francisco Franco, organized a barracks uprising for July 18, 1936, that was designed to overthrow the freely elected government and impose one more congenial to themselves. The plotters, however, had not counted on the loyalty of certain officers who supported the Popular Front. Nor did they count on the quick action of the people in cities like Barcelona, Madrid, and Seville, where civilians—many of them acting through their unions—rose up to defend the Republic. Only about half of Spain went over to the rebels. And thus the Spanish Civil War of 1936 to 1939 began.[21]

On the day of the attempted coup in Barcelona, the CNT marched on the army barracks, disarmed the soldiers, and seized their weapons to arm themselves.[22] Having chafed at the bit under nearly five years of republican rule, the CNT now attempted to carry out a social revolution by collectivizing all local economic and social resources. George Orwell, who was in Barcelona shortly afterward, talked about how it felt to be in a city in which the people ruled:

It was the first time I had ever been in a town where the working class was in the saddle. Practically every building of any size had been seized by the workers and was draped with red flags or with the red and black flag of the Anarchists; . . . almost every church had been gutted and its images burnt. Every shop and café had an inscription saying that it had been collectivized; even the bootblacks had been collectivized and their boxes painted red and black. Waiters and shopworkers looked you in the face and treated you as an equal. Servile and even ceremonial forms of speech had temporarily disappeared. Nobody said "Señor" or "Don" or even "Usted"; everyone called everyone else "Comrade" and "Thou." . . . The revolutionary posters were everywhere, flaming the walls in clean reds and blues that made the few remaining advertisements look like daubs of mud. . . . Practically everyone wore rough working-class clothes, or blue overalls, or some variant of the militia uniform. All this was queer and moving. There was much in it that I did not understand, in some ways I did not even like it, but I recognized it immediately as a state of affairs worth fighting for.[23]

The Spanish Republican government continued to carry on its work while it attempted to defend itself against its enemies. The right-wing rebels, among whom General Francisco Franco had become preeminent by November 1936, were willing to empower Hitler and Mussolini to test new military strategies on Spain in their behalf. On October 23, 1936, three months after the Civil War had begun, the Luftwaffe began to bomb Madrid. Over five thousand people were killed in a single night, in the first time systematic bombing was used specifically to terrorize and crush the will of a civilian population. Like later similar attempts, however, this first instance only enhanced the resolve of the people, both in Madrid and in the Spanish nation as a whole. It was at this time that Dolores Ibarruri, a Communist leader known as "La Pasionaria," coined the slogan "No pasarán" (They shall not pass), which became a watchword for democratic forces throughout the world.

Popular Culture and Artistic Resistance

To demonstrate its commitment to art and show the Republic's determination to preserve Spanish culture, the government, well aware that Picasso was an international celebrity in the art world, named him titular director of the Prado Museum in the summer of 1936. And in January 1937, when the Republican government began to prepare a pavilion for the Paris International Exposition of Arts and

Technology to be held that summer, they invited Pablo Picasso to do a mural. He accepted the commission but did not decide on the subject matter for several months.

On January 8 and 9, 1937, Picasso prepared two etchings, both entitled *The Dreams and Lies of Franco* (figures 18 and 19). Each etching was divided into nine boxes in the form of an *auca*, *auques* being a style of Catalan printing that dated back to the seventeenth century. Engravings printed on large paper, divided into forty-eight boxes in eight lines of six rows, *auques* resembled the feature pages of modern newspapers, which began to supplant them in the early twentieth century. A typical *auca* was organized thematically and depicted festivals, stories from mythology, artisans working at their craft, historic events, scenes from literature, and landmarks, with captions appearing below each box. The *auques* were read and reread like classic comics, or they might be hung on walls to decorate the rooms of the poor.[24]

Like street marches, *auques* proved to be a traditional form that could be adapted to comment on modern life. They appeared documenting Barcelona's first May Day and describing the gala events around the Virgin of Mercy celebration in 1902. On at least four occasions before 1937, moreover, Picasso had made *auques* (in Castilian, *Aleluyas*) of his own. On January 13, 1903, during his third trip to Paris, he drew an affectionate comic strip about the life of his French friend Max Jacob.[25] In 1904, following Picasso's fourth trip to Paris, he illustrated a fantasy in comic-strip form portraying himself and a companion riding a train to Paris, getting off, and receiving a huge bag of money from a leading art dealer.[26] The drop curtain Picasso prepared for the ballet *The Three-cornered Hat* in 1919 was another *auca*, this one depicting a bullfight. On July 4, 1931, when Picasso was preparing his illustrations for Honoré de Balzac's *The Unknown Masterpiece*, he once again etched an *auca* depicting a bull and a horse in one frame and the artist in his studio in the other eleven boxes.[27] Like the miracle painting he did in 1899 or 1900 to commemorate Utrillo's safe recovery from an auto accident, Picasso's *auques* both demonstrated his sensitivity to popular culture and incorporated his own preoccupations within a traditional form.

The two *auques* entitled *The Dreams and Lies of Franco* clearly express his views about what was transpiring in Spain during the Civil War. In nine frames, the first version, dated January 8, 1937, demonstrates Picasso's antagonism to Franco, who appears as a polyp with a mustache, wearing military boots and a crown. In one of the first examples of Picasso's use of overt political imagery, the polyp appears as an instrument

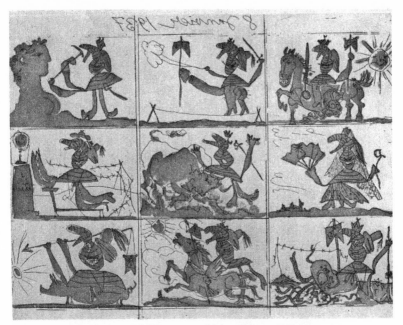

Fig. 18. Pablo Picasso, *The Dreams and Lies of Franco I*, January 8, 1937. Courtesy of the Prado Museum, Madrid. Copyright 1991 ARS N.Y. / SPADEM.

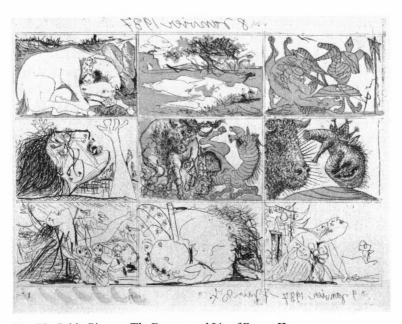

Fig. 19. Pablo Picasso, *The Dreams and Lies of Franco II*, January 9–June 20, 1937. Courtesy of the Prado Museum, Madrid. Copyright 1991 ARS N.Y./ SPADEM.

of the military, religious forces, and the monarchy. An enemy of art, the polyp is portrayed hacking at a classical bust with a pickax. In another frame, the polyp, with a full erection and a hairy, bare bottom, appears to lose his cardinal's hat as he brandishes a sword. Elsewhere, as a malicious-looking sun takes note, the polyp appears as a knight, bearing a sword and mounted on a broken-down horse whose entrails are falling to the ground. Below that box, the polyp is shown in *mantilla,* holding a fan decorated with a Madonna. In another frame, the polyp rides a pig; here he wields a pike at the end of which is the kind of religious flag that appears in four other squares. The triangular figure that appears on the banners could well be the Virgin of Mercy, near whose sanctuary Picasso had lived as a youth. In the center square of this first *auca,* a heroic bull with a beautiful face attacks and overthrows the polyp.

The Dreams and Lies of Franco II, which was begun on January 8 and 9, 1937, taken up again in May, and finished on June 7, reintroduces the polyp in three of the top five frames (completed in January). In the last segments, completed in May and June, Picasso replaced the marauding polyp with dead and crying women and children. Of the five frames done in January, the first square shows a delicate and alluring sleeping mare. That etching is paired with one immediately to its right of an outstretched woman, apparently dead in a field. To the right of that is one of the two most violent drawings in this series. An observer wearing the pointed headgear common both to victims of the Spanish Inquisition and to the Celestina witch figure watches a horse writhing in agony, thrown to its back by the polyp in military boots. The horse, hooves kicking in the air, lies powerless, its teeth bared in apparent suffering rather than in aggression. To the far right in the drawing is a religious banner, like those in the first *auca.*

The center panel of the work is more violent still. A flash of a curly-haired bull, twisted around itself, is identifiable by its horns. A figure, half-polyp, half-horse, with teeth and snout twisted in pain, faces the bull, whose guts spill out on the earth. Imbedded in the offal, as if claiming to triumph over it, is another flag with an image resembling the Virgin of Mercy. Two other flags, that of the Spanish Republic and that of the Francoist forces, also appear.

Originally, Picasso planned to break the blocks of his *auques* apart and sell them as postcards to raise money for Spanish relief, but instead the etchings were ultimately published in a booklet along with an illustrated poem he wrote in June 1937, at the time of the Parisian International Exposition.

The Bombing of Guernica and
the Civil War in Barcelona

Despite Picasso's manifest concern with the Spanish Civil War, most critics agree that he had not decided to make it the subject of his mural for the Spanish Pavilion until the Nazi bombing of the ancient Basque town of Guernica on April 26, 1937, at 4:30 in the afternoon. The world was shocked. Guernica had no strategic importance at all: it simply served as a testing ground for fascist war planes.[28]

For centuries, Guernica had been the symbolic center of the Basque nation, the place where the medieval common laws (called *fueros*) that had governed the four Basque provinces were read out from under a tree that became invested with deep cultural meaning. Now, refugees from the fighting in nearby towns had swelled the population of Guernica from its normal seven thousand to ten thousand.

It was a Monday market day when the Nazi planes flew over. Junker 52S's followed Heinkel 111's every twenty minutes for over three hours, bombing and machine-gunning civilians until some 1,600 people lay dead, with more than 800 wounded. The strafing by up to two hundred planes went on and on in a show of military overkill that has since become commonplace. G. L. Steer, an eyewitness, described the horrors of that day in the *Times* of London:

[The planes] flew at six hundred feet, slowly and steadily shedding their tubes of silver, which settled upon those houses that still stood in pools of intolerable heat; then slipped and dribbled from floor to floor. Gernika was compact as peat to serve as fuel for the German planes. Nobody now bothered to save relatives or possessions; between bombardments they walked out of Gernika in front of the stifling smoke and sat in bewildered hundreds on the roads to Bermeo and Mugika. Mercifully, the fighters had gone. They no longer glanced down to mutilate the population in movement and chase them across the open fields. The people were worn out by noise, heat, and terror; they lay about like dirty bundles of washing, mindless, sprawling, and immobile.[29]

Meanwhile, by late April, civil strife was sweeping Barcelona. The scene must have had a familiar ring to Picasso, who, according to art historian Herschel Chipp, was following the news from Spain in the Parisian newspapers *Ce soir* and *Figaro*.[30] His mother and his sister and her family had already been affected by the war when a convent near their home burned during the first days of fighting in the summer of 1936.[31] The widow of a middle-class doctor, Picasso's sister may have worried about what would happen in the city as the CNT, in the eleven

months from July 1936 to May 1937, proceeded to carry out the revolution of which they had always dreamed.

Nominal power remained with the city and provincial government in the Plaza of Saint James. But as we have seen, it was the CNT who led the working class in neutralizing the army during the military insurrection in July. Under confederation leadership, factories were collectivized, though they frequently remained under the management of the old owners; it was, after all, in everyone's interest for the factories to run smoothly.[32] Despite growing shortages of material, the plants operated well. Nevertheless, republicans, Communists, and Socialists all blamed the CNT for concentrating on making a revolution in Barcelona rather than on winning the war against the fascists in Spain.

The liberal democracies of the United States, France, and Great Britain had effectively quarantined the Spanish Republic out of the misguided view that an arms embargo would shorten the war.[33] Whereas the fascist governments were giving massive aid to Franco's side, the Soviet Union provided only limited help to the Republic; still, being the only major outside source of military support, it exercised considerable power over the government in Madrid. According to Stalin as well as the Spanish republicans and Socialists, defeating the fascists depended on the continued support of the Spanish middle classes, and that required restoring private property that had been collectivized and preventing future appropriation of such property. Pursuing this policy entailed crushing the CNT.[34]

In an atmosphere of mutual antagonism and impending doom, on April 25, the day before Guernica was bombed, a leader of the Stalinist United Socialist Parties of Catalunya (PSUC), Roldán Cortada, was gunned down at Mollís de Llobregat near Barcelona. Public opinion blamed the CNT. Cortada's funeral became a civic ritual, an occasion for a massive show of force by liberals and Communists. Then, on April 26 and 27, a great fear swept the CNT's ranks: the government, it was rumored, planned to disarm the popular militias and consolidate power in the hands of the police and the Republican army. The barricades, which had come down when the city was secured in the summer of 1936, went up again in Barcelona on April 28, two days after Guernica was bombed.[35]

To show their outrage at the bombing of Guernica and at so-called French neutrality, one million Parisians marched on May Day. Barcelona's mayor, however, announced that there would be no May Day celebrations in that city. Since 1890 the workers had used May Day as

their preeminent street spectacle, and in 1931, just after the Second Republic was proclaimed, there had been a massive May Day demonstration in nearby Badalona. The reporter for the *Diluvio* explained at the time: "Today's festival is significant not only for workers. . . . Today's festival is the people's affirmation of its support for the republican cause, a test of the fervor with which it has embraced [the Republic], and a formidable and unequivocal demonstration of the knowledge of what it will take to defend it and what it will take to consolidate it."[36] Six years later, the banning of May Day presaged trouble.

Barcelona's May Days and the Making of *Guernica*

On May Day 1937, five days after the bombing of Guernica and four days after the showdown between the CNT and the government in Barcelona began, Picasso, working in Paris, drew the first six sketches for the overall composition of *Guernica*, as well as the first studies of the principal figures in the mural. The sketches included depictions of a wounded horse, a woman with a lamp at a window, and a bull, which appeared in the final mural; not included in the sketches were a woman in a burning house, the woman with the dead child, the fallen warrior, a magical eye with a light bulb, and an intelligent face on the bull, all of which would figure prominently in the mural as well.[37] The study of the twisted, collapsed horse crying out, one of the May Day drawings (figure 20), is reminiscent of the studies of wounded horses he did in 1917. Evidently, social strife in Spain triggered in Picasso certain images recalled from youth.

On May 2, Picasso prepared three more studies—two drawings and one oil painting—of the horse in agony, as well as two different outlines of the entire composition. All three horses throw back their heads in pain, for the first time revealing not only teeth but also, as in the final mural, tongues like daggers.[38] The increasingly intense images of the horse recall the most grizzly moments in a bullfight, those times when, as the mounted *picador* tries to spear the beast with his pike, the bull, crazed with pain, turns on the horse, the innocent bystander who lacks any heroic role in the fight.

The day after Picasso completed these three studies for *Guernica*,

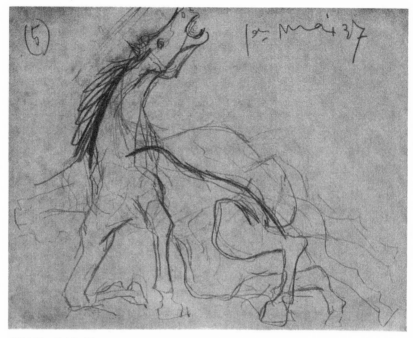

Fig. 20. Pablo Picasso, May Day drawing of a horse for *Guernica*, 1937. Courtesy of the Prado Museum, Madrid. Copyright 1991 ARS N.Y. / SPADEM.

events in Barcelona took a dramatic turn: what became known as the "May days" were triggered when the city government, supported and perhaps instigated by the small but influential Communist party, attempted to retake the telephone and telegraph exchange from the CNT militias. The latter had seized the telephone company at the foot of the Plaza of Catalunya on Fountain Street in July 1936 and had continued to run the exchange during the first year of the war. The telephone system in Barcelona had originally been intended for Montreal but, rejected by that city, had been sold to Barcelona instead and, for one reason or another, had never run efficiently. Callers were frequently cut off, lines were fuzzy, and people were often shifted in and out of one another's calls. It is also possible that, as city officials claimed, the *cenetistas* at the phone company listened in on conversations of representatives of the provincial and municipal government.

On May 3, the Catalan Communist party and the Barcelona police forcibly seized the telephone and telegraph offices. The CNT resisted, and workers from all over Barcelona went out on strike. On Tuesday, May 4, Prime Minister Francisco Llargo Caballero called for a cease-fire. The same day, the Communists succeeded in pressuring Llargo Ca-

ballero to dissolve the CNT militias. On May 5, a Communist delegate to the Cortes was killed, probably in retaliation for the attacks on the telephone company two days earlier. On May 4 and 5, the street lights went out in Barcelona. Bombs and shots were heard throughout the Parallel, Laietana Way, and the Plaza of Spain, and intense gunfire rang out between Canovas and Balmes streets. Women stood in lines in the markets to get what little milk was available for their children.

May 6 saw heavy fighting at the Born Market; ten were killed and thirty wounded. Fighting also broke out near the Saint Anthony Market near Parliament Street. New barricades went up all over the Parallel. That day, the four CNT leaders who, in September 1936, had been drawn into the national government as cabinet members to help unite the country in its resistance to Franco came to Barcelona and tried to save the *cenetistas* and get the city back to order. The appearance of street cleaners at 6:00 A.M. on Friday, May 7, raised hopes that normal life would begin again. But the cease-fire failed, and the CNT cabinet members stood aside as the government called in twelve thousand soldiers, who reached the city on May 8 and established peace by breaking the power of the CNT. By Sunday, May 9, the city was quiet. As the fighting ended, the roundups of CNT members intensified. When it was all over, about five hundred lay dead, with approximately a thousand wounded.[39]

It may have been only a coincidence, but between May 3, when the police and the Communists retook the telephone exchange in Barcelona, and May 8, when the fighting came to an end, Picasso did no work on *Guernica*.[40] When he began again on May 8, the puppetlike woman at the window holding her beacon of light—which, as the art historian Sir Anthony Blunt points out, was a staple of both the early drawings and the final composition—disappeared for the only time from the preliminary drawings. In her place, a woman carrying a dead child appeared.[41] It is hard to resist concluding that for Picasso, the lights of hope had gone out with the repression in Barcelona.

On May 9, Picasso drew what, with some elaborations, would become the composition of the final work. This rendition of *Guernica* suggests a darkened stage out of which the figures emerge, brought into relief by theatrical lighting. The woman with the lamp illuminates her section of the drawing, and on her left, a house on fire lights another section. To our left, stage right, a building that looks like a set with a door makes its first appearance. The stagy design reminds one of miracle paintings, where the disaster represented always appears in tableaux.

The other new element added in the May 9 composition was three

upstretched arms, two on the left and one moving from the window behind the woman with the dead child. At the end of each arm is a fist, the symbol of the Popular Front. The disembodied limbs are reminiscent of the votive limbs and organs often hung in churches as gratitude for cures. The motif of extended arms also derives from posters that were plastered all over Paris in an effort to get the French government to give up its policy of nonintervention.[42]

On May 11, Picasso began work on the painting itself, on a massive canvas twenty-five feet eight inches wide by eleven feet six inches high. Using the canvas as if it were paper, he took the mural through seven different incarnations. Meanwhile, he continued to do studies of individual elements, especially the horse, the bull, and the crying woman in a kerchief holding a dead baby. One new feature, which first appears in a study on May 11, is the woman in the burning house; again, here one thinks of miracle paintings, like one on the altar of the Virgin of Bonanova of a piano factory in flames (plate 10; cf. plate 2).

On May 20, 1937, as mopping-up activities were taking place in Barcelona (Picasso could again communicate with his family by telephone instead of getting his information from the radio and newspapers), he did a sketch of a bull, its face a mask with nostrils flaring in different planes (figure 21). In the background are figures that resemble paramecia;[43] hairlike fila seem to propel them, and at second glance they appear to be eyes surrounded by lashes. As abstract as this drawing seems, it owes a great deal to the Catalan Romanesque art Picasso had been familiar with at least as far back as 1902, when he attended the exhibition of medieval art associated with the Virgin of Mercy celebration.

As a way to promote Catalan culture and the Republican cause, Picasso, Pablo Casals, and others had organized an exhibit of figures from the Museum of Catalan Art, which opened at the Jeu de Paume and a local Parisian gallery in March 1937. Picasso's friend Christian Zervos published a catalogue of the exhibit, *L'art de la Catalogne de la seconde moitié du neuvième siècle à la fin du quinzième siècle*, which amounted to a comprehensive study of medieval Catalan art.[44] Among the representative murals that Zervos reproduced in black and white are images, never fully explained, of disembodied eyes and markings that are frequently echoed in the works of Joan Miró and later Catalan painters such as Manel Cuixart and Antoni Tàpies. For example, the seraphim on a mural from Saint Clement of Tahull, which is still housed in the Museum of Catalan Art, has eyes all over its wings and similar eyes that look like stigmata on its hands (figure 22).[45] Zervos also reproduced an

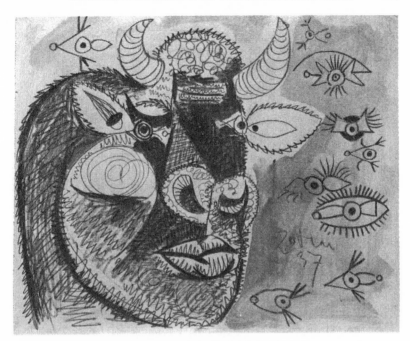

Fig. 21. Pablo Picasso, Drawing of a bull's head for *Guernica,*
May 20, 1937. Courtesy of the Prado Museum, Madrid.
Copyright 1991 ARS N.Y. / SPADEM.

apocryphal animal and a lamb of the Apocalypse, both of which are
covered with eyes that evoke what in the final version of *Guernica* be-
came the sun and the light bulb (figures 23 and 24).[46]

In *Guernica,* Picasso turned to his own previous work, in addition to
earlier Catalan styles. His use of bullfight imagery is one obvious ex-
ample. Another is his use of imagery drawn from newspaper photo-
graphs. During the period 1912–1913 when Picasso first made col-
lages, he frequently inserted newspaper clippings in his compositions.
Nearly a quarter of a century later, in *Guernica,* he once again drew on
the daily press in using black and white for the painting and in imposing
what looks like newsprint on the central part of the mural. Newspapers
had played an increasing role in shaping public opinion as Picasso was
growing up in Barcelona. At the beginning of the twentieth century,
forty-two papers a week were published in Barcelona, of which four
were dailies.[47] Black-and-white photographs had by then replaced
drawings in supplementing the printed texts, and for many the picture
was more important than the words. One of Picasso's close friends from

Fig. 22. Detail of a Catalan
mural: Seraphim with Saint
Luke and his bull. From
Saint Clement of Tahull,
A.D. 1123. Museu d'Art de
Catalunya, Barcelona.
(Originally published in
Christian Zervos, *L'art de la
Catalogne* [Paris, 1937].)

youth, Joan Vidal Ventosa, had been not only a connoisseur of Roman-
esque art but also a master of photogravure, the early method for pro-
ducing pictures in newspapers. Stephen Spender, writing about the mu-
ral in the *New Statesman* on October 15, 1938, when it was on display
at the Burlington Gallery in London, observed persuasively that *Guer-
nica*

is a picture of horror reported in the newspapers, of which [one] has read ac-
counts and perhaps seen photographs. This kind of second-hand experience,
from the newspapers, the news-reel, the wireless, is one of the dominating real-
ities of our time. The many people who are not in direct contact with the disas-
ters falling on civilization live in a waking nightmare of second-hand experi-
ences which in a way are more terrible than real experiences because the person
overtaken by a disaster has at least a more limited vision than the camera's wide,
cold, recording eye, and at least has no opportunity to imagine horrors worse
than what he is seeing and experiencing. The flickering black, white, and grey
lights of Picasso's picture suggest a moving picture stretched across an elon-
gated screen; the flatness of the shapes again suggests the photographic image,
even the reported paper words. The center of this picture is like a painting of a
collage in which strips of newspaper have been pasted across the canvas.[48]

Fig. 23. Detail of a Catalan mural: Apocryphal animal. From Saint Mary of Bohi, early 13th century. Museu d'Art de Catalunya, Barcelona. (Originally published in Christian Zervos, *L'art de la Catalogne* [Paris, 1937].)

Fig. 24. Detail of a Catalan mural: Lamb of the Apocalypse. From Saint Clement of Tahull, A.D. 1123. Museu d'Art de Catalunya, Barcelona. (Originally published in Christian Zervos, *L'art de la Catalogne* [Paris, 1937].)

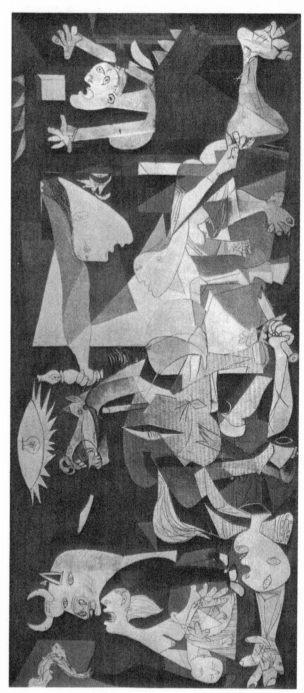

Fig. 25. Pablo Picasso, *Guernica*, May–June 1937. Courtesy of the Prado Museum, Madrid. Copyright 1990 ARS N.Y. / SPADEM.

Guernica has become a twentieth-century icon, a "masterpiece" that transcends its own history and its constituent parts, although an understanding of its political and cultural context surely enhances, if not its power, then our understanding of its power (figure 25). In adapting medieval Catalan renditions of the Apocalypse, Picasso painted one of his own. *Guernica* can be considered to express Picasso's views of good and evil in the modern age through the use of popular Catalan forms and motifs. Thus it is rooted in Barcelona's visual culture, as Picasso experienced it—in *auques,* and the photographs of ancient Catalan murals in Zervos's catalogue, and newspaper photographs; indeed, it portrays aspects of that culture with great profundity. Drawing on the traditions of medieval art and of the bullfight, Picasso confronted modern war with modern art.

Surely it is significant that during a dark period in Barcelona's history and Picasso's life, bullfights, Catalan art, comic-strip *auques,* and miracle paintings reappeared in his art. One way to approach *Guernica* is to note how it blends the images he chose to use—some of whose meanings are embedded in the political history of Barcelona, some of which reside in his own personal experiences—to achieve a masterpiece of universal meaning.

Epilogue:
Cultural Resistance
in the Aftermath

Community consciousness, preserved in cultural life ranging from ordinary interaction in public plazas and cafés, to rituals and festivals, to theater and dance, helped Catalans survive the brutal repression of the Franco years, which began with the Nationalist victory that halted the Civil War in March 1939 and ended with Franco's death in 1975. After the war, in which one million people died, Franco's forces executed tens of thousands of Spaniards, among them about four thousand Catalans.[1] Summary executions of union members and political activists were the order of the day, and exact figures for those massacred will never be available. Under such a reign of terror, mere survival was a triumph. Yet Barcelona did more than survive: it maintained an identity through clandestine organizations and, later, autonomous trade unions.

The citizens of Barcelona shared cultural scripts that, not limited to mere words, described possible scenarios to be enacted when public life was subject to repression. Whatever the overt content of an event like the Saint George's Day celebration, tied up as it was with urban politics, or May Day, with its origin in workers' struggles for the eight-hour day, anyone familiar with the event could practice the rite. The ritual figures, objects of veneration, banners, and other accessories, which had specific meanings in one setting, could be used for entirely new purposes in another. In any event, the use of familiar images often signaled that something political was afoot.

In short, in Barcelona, civic culture provided a familiar vocabulary

for political struggle, as the history I have described here should make clear. First, between 1888 and 1923, contending forces had fought for the hearts and minds of new immigrant groups by appropriating old cultural forms and creating new ones. Then the city's civic culture became a bulwark of resistance against the Primo de Rivera dictatorship. The inability of repressive governments to suppress this culture derived largely from its embeddedness in the everyday life of all citizens.

Following the Civil War, the government would have had to plow under the Rambla and the Plaza of Catalunya, prohibit women from going to market, ban all Catholic holidays, and impose a permanent curfew to suppress civic identity in Barcelona. Although any number of troops would have been insufficient to carry out this plan, the government, undaunted, attempted to assert its might regardless.

On January 26, 1939, the Francoist troops entered the city, which after the CNT defeat had become a republican stronghold, as a conquering imperial power and began their mopping-up activities. As Franco's brother-in-law Ramón Serrano Suñer remarked, "Today we have Catalunya at the point of our bayonets."[2] Franco, recognizing that popular culture in Barcelona, especially after its renewal during the Second Republic, kept resistance to him alive, set out to destroy it. By decree, the use of Catalan in official documents, the publication of books, journals, or newspapers in Catalan, even dancing the *sardana*, again became crimes, as they had been under Primo de Rivera. Speaking Catalan in public was punishable by fines of 1,000 to 5,000 *pesetas*. Students found talking in the language were cited, although they could avoid punishment by informing on their classmates: thus the government gained student spies.[3] Loudspeakers and posters exhorted citizens of Barcelona to "speak the language of the empire." Many Catalan books and pamphlets were gathered up and burned. Schools, theaters, music halls, and libraries of Catalan culture disappeared. Catalan women's rights to divorce and abortion, granted by the Generalitat in 1932, were abolished.

Even the map of the city was touched by the government's anti-Catalan fervor. As we have seen, the old streets, plazas, and boulevards of downtown Barcelona had been central to almost every major demonstration between 1888 and 1939. Religious processions and political marches had attempted to declare or appropriate a civic identity by covering the body of the city with the moving bodies of paraders. Streets had political meanings, less because of the buildings on them than because moving down the streets in large crowds gave visual expression to

civic solidarity. The downtown area became synonymous with Barcelona as a historic and cultural entity: it served as the symbolic representation of the personality of the city.

It is not surprising, then, that one of the conquerors' first acts was to rechristen the Plaza of Catalunya, where marches so frequently began, calling it the Plaza of the Spanish Army. Taking down Catalan street signs, the military also renamed all the major thoroughfares for fascist heroes and generals. In the end, though, the popular outcry against changing the name of the Plaza of Catalunya was so strong that even the triumphant military had to rescind its order.[4]

The fight for a civic Catalan identity went on using familiar symbols and practices. The strength of Catalan nationalism under Franco lay with the people's long historical claim to control of the streets and their identification with folk culture, two elements that added up to civic pride with a political content.

Despite all prohibitions, the people of Barcelona in fact succeeded in keeping Catalan culture alive. Mothers continued to teach Catalan to their children; as a result, most people who grew up in Barcelona during the war years speak Castilian with heavy Catalan accents. People took great pains to save objects of Catalan devotion. The statue of Catalunya's eighteenth-century hero Rafael Casanova, for instance, was dismantled and hidden away until 1977, when it could be resurrected. The experiences of repression under the dictatorship of Primo de Rivera had turned civic culture in Barcelona into a culture of resistance. Francoist terror only solidified it.

The contribution of memory to a sense of communal consciousness can never be measured by recourse to written texts. Children were raised amid the public celebrations in the main thoroughfares and plazas of the city. To the extent that this pageantry held meaning, parents helped define it. But whatever parents taught their children, the city itself, with its repetitive marches and demonstrations, inculcated a certain civic pride in young citizens as they came of age. Commentators frequently remarked that the streets and cafés were Barcelona's living rooms. Much as children learn about family feeling while half-listening to what goes on around them in the adult world, immigrants and citizens of all ages developed a sense of civic consciousness merely by spending time in Barcelona's streets and plazas.

The Catalan Catholic church played a role, too. In 1937, all the bishops of the Spanish church except Bishop Mugica of the Basque country and Cardinal Vidal i Barraquer of Catalunya signed a Collective Epis-

copal Letter legitimating Franco's uprising and declaring him the pro-
tagonist of a crusade against "Masons, Communists, and Jews." Vidal i
Barraquer had already resisted the Primo de Rivera government's pro-
hibition of Catalan for the Rosary, arguing that "in Catalunya, the
teaching of the Divine Word . . . will be in the country's language [Cat-
alan]."[5] Before Vidal i Barraquer died in exile in Geneva in 1943, he
tried to warn Pope Pius XII that the Franco regime was using its notion
of Catholicism as a national religion to promote its own political
agenda. Franco well recognized the importance of Te Deums, proces-
sions, and other pageants. Pitting patroness against patroness, Franco-
ist Catholics tried to promote the Virgin of Pilar, patroness of the re-
gime, against Barcelona's Virgin of Mercy and Catalunya's Virgin of
Montserrat.[6]

Folk culture, including religious images and holiday celebrations,
contributed to Barcelona's civic pride and its political content during
Franco's regime as during earlier ones. May Day demonstrations were,
of course, outlawed under Franco, but the festival of Saint Pons on May
11 provided an occasion for people to come from throughout the city
to occupy the Rambla. For Saint Pons, who had medicinal powers,
women brought herbs and wildflowers from the countryside to sell on
the Rambla and at the markets. One of many traditional spring rites,
Saint Pons Day permitted people to join in a civic rather than a political
gathering. But what happened in conversations on the streets or in the
surrounding cafés was something that police could only partially moni-
tor. Thus, during this festival and others, like the Ascension of Mary,
groups with focused political goals could pass relatively unnoticed in
the crowds of assembled people, and clandestine political meetings
could and did occur, even despite the intense repression that continued
well into the late forties. Franco's secret investigation and information
service was more wary of secular organizations such as the Red Cross,
which they viewed as a magnet for those Barcelona citizens who were
"disaffected or indifferent" to the regime between 1939 and 1941.[7]

The rebirth of leftist resistance during the Franco period in the form
of movements for amnesty and clandestine political parties and trade
unions owed its origins to the underground networks once organized
in Catalan streets and cafés, generated by shared working and living
conditions. The first militant demonstrations in Barcelona after the
Civil War occurred in 1947, when the women of the old sections of the
Parallel and Sans protested against the lack of adequate sewage disposal
and fresh water supplies in their neighborhoods. Because they were act-

ing as mothers, authorities allowed their public gatherings at a time when any assembly of ten or more people was forbidden. Similarly, in 1951, people in the old downtown neighborhoods and in the working-class suburbs, presenting themselves as consumers, organized a bus boycott to protest against the high cost of transportation.[8]

Spain had become an economic backwater during and after the Second World War. Whereas the Axis powers had lavished aid on Franco during the Spanish Civil War, when Spain was a testing ground for air war and saturation bombing strategies, the money dried up once World War II began, five months after the Nationalist victory. Although Franco contributed to the fascist war effort by sending the Blue Division to the eastern front, the Axis nations lost interest in Spain. The oppressed working classes in Barcelona, meanwhile, pinned their hopes on an Allied victory, and when it came in Europe in April 1945 and in Japan that August, they celebrated the victories with illegal strikes at large factories in the city. Yet despite their hopes, when the Marshall Plan to reconstruct certain Western European countries was instituted, Spain was not among them. Unlike Germany, Spain at the time had no political or strategic importance to the United States.

Spain's internal political situation changed somewhat as the cold war intensified. The United States sought air bases in the Mediterranean, and Spain was an obvious choice. The 1953 defense pact between Spain and the United States and the consequent influx of American and European capital underwrote an expansion of Catalan industry. Foreign businesses were attracted by the low wages—about $3.50 a day in 1956. Despite repressive political conditions, which forced all workers into fascist labor syndicates along with their employers and prohibited all strikes, independent, largely Communist, clandestine unions began to take shape. Meeting in bars or at religious festivals, just as their predecessors had done for nearly a century, workers began to organize.[9]

The influx of tourists to the beaches north and south of Barcelona in the sixties gave new cultural shape to movements of opposition to Franco. Tourism influenced the practice of traditional culture, for what the tourists wanted to see in Barcelona was the typical Catalan dances and music that Franco had done so much to repress. The slogan of the Spanish Office of Tourism, "Spain Is Different," was intended to convey the message that all of Spain, including Catalunya, had bullfights, endless beaches, and glorious festivals—not, of course, that the military was everywhere.

The government played cat and mouse, permitting some demonstra-

tions of Catalan identity and repressing others. Festivals like that of Corpus Christi were, of course, continued. The procession had become a *tableau vivant* of conservative Barcelona in which soldiers and children celebrating their first communions and confirmations marched together with the city officials appointed by the Franco government. The same was not true of pre-Lenten festivities. When people of the popular classes reversed hierarchies, as they traditionally did during carnival, they also renewed oppositional elements within the city's civic culture. Such activities, although weak in specific analysis, ideology, and agenda, were strong in expressing resistance. Accordingly, despite Franco's growing need to boost tourism, which by the late sixties accounted for one-third of Spain's gross national product (GNP), some tourist attractions like bullfighting and flamenco dancing were promoted, while others, like carnival celebrations, continued to be repressed.

The Franco government acted ruthlessly when a particular cultural activity seemed to them especially seditious. When Jordi Pujol, now president of the Generalitat, attended a play and led the audience in singing the Catalan anthem "Els segadors" in front of Franco in 1962, he was imprisoned and beaten. His name appeared in the graffiti of Barcelona for years afterward.

Publications of the Catholic church, in contrast, notably *Serra d'or,* which issued from the Monastery of Montserrat, enjoyed a large measure of freedom. Since such writings were subject to church but not government censorship under Franco, they could promote Catholic Catalan identity without fear of political reprisals, as long as they did not challenge doctrine. Catholic clergy were accountable only to their bishops. And when the abbot of Montserrat denounced the regime publicly in the sixties in an article in *Le monde,* the regime could do nothing to punish him without confronting the pope.[10]

During the time of growing general demands for liberalization in the sixties, artists and musicians inside and outside Barcelona stressed the need for cultural freedom. Painter Joan Miró, who had returned to Catalunya in 1940 when the Nazis invaded France, at first withdrew from Barcelona to the small town of Roig. In the sixties, however, he joined other artists and intellectuals in the city to promote the liberation of Catalan culture, which to them was synonymous with democratization. Pablo Casals, who had organized popular concerts in Barcelona during the Second Republic, lived in France during the forties. When the Nazis invaded that country, he confronted them in a typically Catalan, if personal, way, by composing the Christmas oratory *Els pessebres,* named for

Catalan manger figures. He refused to visit Spain as long as Franco ruled, but even after he moved to Puerto Rico, he organized music festivals in Prades on the French side of the Pyrenees in the sixties as a means of keeping alive the hope of Catalan and Spanish freedom. There and in Puerto Rico he composed *sardanas,* which he played to the world as if to say that music contributed to liberation struggles in his homeland.

As the creator of *Guernica,* Picasso was to remain a constant thorn in the side of the Francoist government, which hoped to retrieve the painting commissioned by the Second Republic. *Guernica,* de facto ownership of which had reverted to Picasso with the fall of the Second Republic, moved from Paris to the Burlington Gallery in London and then to the Museum of Modern Art in New York, where it was sheltered during World War II and remained until Spain once again had a democratic government. In 1981, on the centenary of the artist's birth, *Guernica* was installed in the Prado.[11] Picasso himself never again set foot in his native country after he painted his masterpiece. After his mother's death in the late thirties, he remained in contact with his sister, Lola Vilató, and her family. He also had kept up relations with old Catalan friends— Manel Pallarés, Carles and Sebastià Junyer-Vidal, Cinto and Manel Raventós, and Ángel de Soto—who, after the Second World War and thanks to the efforts of Sabartés, visited Picasso's home in the south of France with their families. Alejandro Cirici Pellicer's 1946 publication of *Picasso antes Picasso* further strengthened Barcelona's claims on Picasso by situating the artist's early work in the traditions of Catalunya's cultural awakening. This connection had made some supporters of the regime nervous; one went so far as to attack Picasso as "an enemy of the soul, of good, and of every divine and human value."[12]

The painful amalgam of a repressed language and military occupation, which continued well into the sixties, in a region that accounted for one-third of the Spanish GNP helped make Catalan cultural nationalism a potent force in the anti-Francoist struggle. In March 1966, to demonstrate support for Barcelona students striking to gain a voice in governing the university, which was run from Madrid, thirty Catalan intellectuals and artists, many of them Communists, barricaded themselves for several days in a local Capuchin monastery until they were forcibly removed by police. Supporters outside beeped their horns and caused gridlock in downtown Barcelona (a modern touch) to express their solidarity and to publicize the intellectuals' action. Street demonstrations like these were the only ways to overcome news blackouts,

which otherwise cloaked resistance to the government. When the police broke through after laying siege to the monastery for three days, they found the demonstrators gathered in the auditorium listening to a lecture on urban planning.[13]

The consistent cultural onslaught caused constant slippage in Franco's hammerlock on the country. In the late sixties, dissidents attempted to create a "movement of national reconciliation" bringing together liberals and leftists to form a united opposition to Franco. In 1971, Catalans reintroduced the Floral Games, although the government imposed numerous restrictions as to how they would proceed.[14] Far more serious was the execution by firing squad of five young alleged terrorists in the woods outside Barcelona in October 1975, a month before Franco died. For over a year afterward, political parties remained illegal. Nevertheless, on September 11, 1976, the anniversary of the defeat of Rafael Casanova in the eighteenth century, over a million people gathered at Sant Bou outside Barcelona to celebrate Catalan independence day. And when the parties finally burst forth in the spring of 1977 after being legalized by the Cortes, party meetings in and around Barcelona varied from assemblies of 30,000 to huge gatherings of 150,000. Despite nearly forty years of repression, the audiences knew the city's traditional revolutionary songs and the life histories, including prison sentences, of hundreds of militants who appeared or were mentioned in speeches at the rallies.

A cultural and political revival of enormous proportions followed the thaw after Franco's death. Women's organizations, their pamphlets and posters published in Catalan, demanded amnesty for political prisoners and repeal of antifeminist laws, including the adultery law, which made adultery a criminal offense and defined the "crime" in such a way that only women could be charged. Neighborhood organizations in the Parallel, Sans, and Saint Martin of Provence organized adult education programs in Catalan and demanded control over rising food prices. To publicize these issues, activists painted wall murals citywide; they sang Catalan protest songs that folk singers had written; and once again, they danced the *sardana* in front of the cathedral on Sundays. When the antinuclear movement in Barcelona sought to educate citizens about the dangers of nuclear reactors and the possibilities of solar energy, it appropriated sun figures from carnival and *gegants* from Corpus Christi Day celebrations.

Male and female citizens of Barcelona have over the past century evolved and preserved a sense of solidarity, sometimes referred to as *seny* in Catalan. Like family members who frequently impose the

harshest punishments on one another, people in Barcelona have periodically engaged in internecine struggles. And yet, also like members of a family, citizens speak the same language and know the same patterns of resistance. When threatened from the outside, they have been able to use their urban customs, their religious practices, even their city streets, to symbolize their resistance to oppressive regimes that crushed all forms of democracy and to educate their children about how to fight on for a better day.

The repeated and consistent appearance of the same symbols and practices in demonstrations and in art, fashioned and refashioned in the hands of different groups, was of infinite use to the city's citizens in their political struggles. These symbols were volatile, shifting from place to place, forming new combinations of meanings for women and men, workers and employers, clergy and secularists; yet they formed a common symbolic language to which all citizens of Barcelona had access and which could be manipulated in different ways at different times.

Clearly, culture is not static; it changes even when it appears constant. Nor is it always a stabilizing force. As Raymond Williams and Stuart Hall have repeatedly argued, people do not simply succumb to or blindly accept the culture of dominant political groups.[15] Resistance sometimes entails using the raw material of the culture they know and infusing it with new meanings.

People create and use culture, but it is a process rather than an object. No authority or political group in Barcelona or elsewhere can be powerful and creative enough to control culture entirely, although some groups have been better than others at recognizing the importance of the cultural realm as a forum for political struggles. Anyone who understands how culture functions politically could not conceive of abstracting it, of attempting to impose single meanings on symbols. The kind of civic culture that was formed in the period from 1888 to around 1939 in Barcelona and then employed in the long period of the Franco regime was embedded in the hearts and minds of citizens and in the streets and squares of the city. No proclamations or police forces could do much to obliterate it, though they could periodically repress it. Such a system of meaning made it extremely hard to destroy the city's political culture, despite widespread repression of union activists and clandestine political leaders, all of whom knew the language of community solidarity and the symbols of civic identity. However hard it tried over its thirty-six years, even the Franco regime was powerless to destroy the tenacity of Catalan culture as it was nurtured, taught, and promoted by the men and women of Barcelona.

Appendix

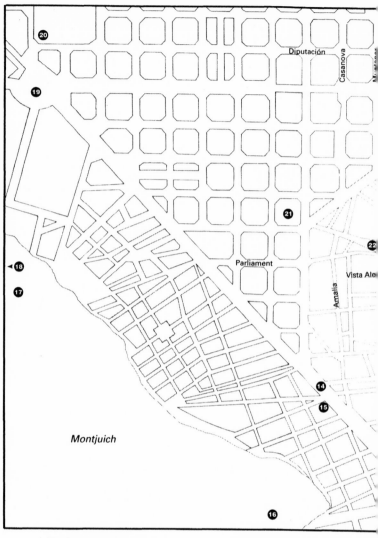

1. The Extension, the area of hexagonal-shaped streets
2. Plaza of the University
3. Pelayo Street
4. Plaza of Catalunya
5. The Rambla
6. The Flower Market
7. Boqueria, Saint Joseph Market
8. Church of Pi, Saint Mary of the Pine Tree
9. The Lyceum
10. New Street of the Rambla
11. Eden Concert
12. Güell Palace
13. Royal Plaza
14. The Parallel, Marquis of Duero A
15. Pompey Music Hall
16. Castle of Montjuich
17. Museum of Catalan Art
18. Spanish Village
19. Plaza of Spain
20. Arenas Bullring

Map 1. Landmarks in Downtown Barcelona, 1808–1937.
(This map reflects the urban reforms of 1859, 1908–1911, and 1926–1929.)

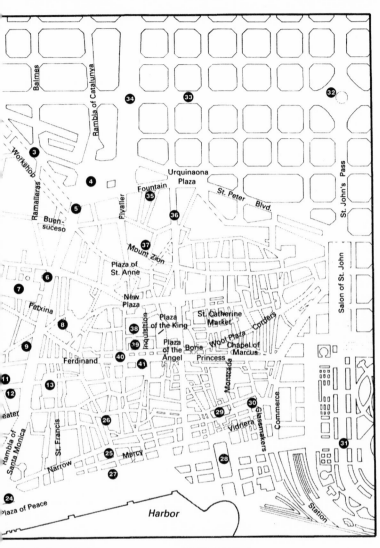

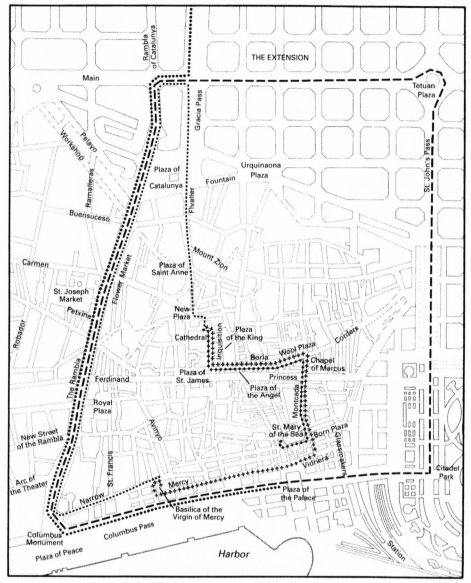

+++++++	1808 Virgin of Mercy demonstration
··········	1888 Coronation procession for the Virgin of Mercy
••••••••	1890 First May Day demonstration (peaceful)
✦✦✦✦✦✦✦	1896 Corpus Christi procession
— — —	1902 Scheduled parade for the Virgin of Mercy

Map 2. Processions, Parades, and Demonstrations, 1808–1902. (This map shows downtown Barcelona before the urban reforms of 1908–1911.)

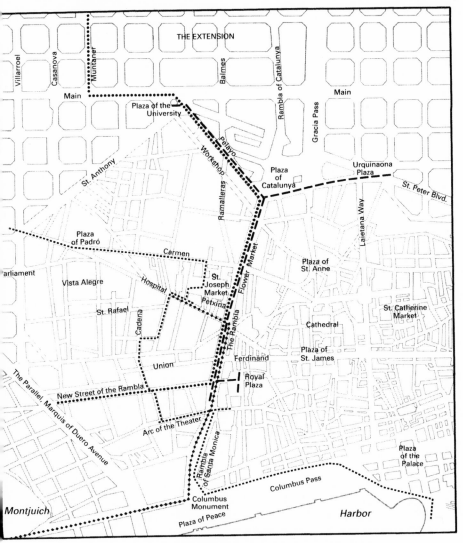

Villarroel · Casanova · Muntaner · Balmes · Rambla of Catalunya · Gracia Pass

THE EXTENSION

Main · Main

Plaza of the University

Pelayo · Workshop · Ramalleras

Plaza of Catalunya

Urquinaona Plaza

St. Peter Blvd.

St. Anthony

Plaza of Padró

Carmen

Laietana Way

Plaza of St. Anne

Parliament

Vista Alegre

Hospital

St. Joseph Market

Petxina

Flower Market

Plaza of St. Anne

St. Rafael

Cadena

The Rambla

Cathedral

St. Catherine Market

Union

Ferdinand

Plaza of St. James

New Street of the Rambla

Royal Plaza

The Parallel, Marquis of Duero Avenue

Arc of the Theater

Rambla of Santa Monica

Plaza of the Palace

Columbus Pass

Montjuich

Columbus Monument

Plaza of Peace

Harbor

•••••• 1905 funeral procession for victims of Rambla of Flowers bombing
– – – 1913 Constancy demonstrations
.......... 1918 women's war (early demonstration)
•••••••• 1920 funeral procession for Pompey Music Hall victims

Map 3. Demonstrations and Funeral Processions, 1905–1920. (This map reflects the urban reforms of 1859, 1908–1911, and 1926–1929.)

Notes

Introduction: The Symbolic Landscape

1. Figures compiled by Joan Connelly Ullman from *Anuario estadístico de la ciudad de Barcelona: 1905*, vol. 4, in *La Semana Trágica. Estudio sobre las causas socioeconómicas del anticlericalismo en España (1898–1912)*, trans. Gonzalo Pontón (Barcelona: Ediciones Ariel, 1972), 127. All writers depend on those who came before them. This study—and most social histories of early-twentieth-century Catalunya—owe a huge debt to Professor Ullman. Unfortunately, because the American edition of her book appeared in 1968, just before women's studies emerged as a discipline in the United States, she has never received the recognition she deserves as a pioneer in women's studies. Although I refer mostly to the vastly expanded 1972 Spanish edition of her book, the American edition, *The Tragic Week: A Study of Anticlericalism in Spain, 1875–1912* (Cambridge, Mass: Harvard University Press, 1968), remains one of the best studies of women's political mobilization and ought to be reissued.

2. Gary Wray McDonogh, in his superb study of the Barcelona middle class in the mid-nineteenth century, *Good Families of Barcelona: A Social History of Power in the Industrial Revolution* (Princeton: Princeton University Press, 1986), 188, portrays the Lyceum theater and concert hall as Barcelona's preeminent elite cultural institution.

3. Luis Cabañas Guevara, *Biografía del Paralelo, 1894–1934. Recuerdos de la vida teatral, mundana y pintoresca del barrio mas jaranero y bullicioso de Barcelona* (Barcelona: Ediciones Memphis, 1945), 7, 16–21.

4. These figures were secured from the local doctors by José Elías de Molins and published in his *La obrera en Cataluña, en la ciudad y en el campo. Orientaciones sociales* (Barcelona: Imprenta Barcelonensa, [1915]), 34.

5. Jaime Alzina Caules, "Investigación analítica sobre la evolución demo-

gráfica de Cataluña," *Cuadernos de información económica y sociológica* (Barcelona) 1, no. 7 (June 1965): 33, cited in Ullman, *Semana Trágica*, 128; McDonogh, *Good Families of Barcelona*, 21; José Reig y Vilardell, *Barcelona en el siglo XIX (Dietario de la ciudad)*, 4 vols. (Barcelona: Imprenta de *La Publicidad*, 1898); Elisa Vives de Fabregas, *Vida femenina barcelonesa en el ochocientos* (Barcelona: Librería Dalmau, 1945), 219.

6. Andre Barey, *Barcelona: De la ciutat pre-industrial al fenomen modernista*, trans. Joaquim Martí (Barcelona: La Gaya Ciencia, n.d.).

7. I learned about how Josep Puig i Cadafalch used medieval Catalan paintings as inspirations for building designs from art historian Judith Rohrer (private communication, June 9, 1989).

8. E. Casanelles, *Antonio Gaudí* (Greenwich, Conn.: New York Graphic Society, 1965), 31–32.

9. For the seventeenth-century uprisings against Castile, see J. H. Elliott, *The Revolt of the Catalans* (New York: Cambridge University Press, 1963). For the Revolution of 1868 and the First Spanish Republic, see Friedrich Engels, "The Bakuninists at Work: Notes on the Spanish Uprising in the Summer of 1873," in Karl Marx and Friedrich Engels, *Revolution in Spain* (New York: International Press, 1939); C.A.M. Hennessy, *The Federal Republic in Spain: Pi y Margall and the Federal Republican Movement, 1868–74* (Oxford: Clarendon Press, 1962); and Miguel González Sugrañes, *La república en Barcelona. Apuntes para una crónica*, 2d ed. (Barcelona: Imprenta de Henrich, 1903).

10. Alzina Caules, "Investigación analítica," 28, chart 4, cited in Ullman, *Semana Trágica*, 128; Molins, *Obrera en Cataluña*, 17.

11. Figures compiled by Ullman from *Anuario estadístico: 1905*, vol. 4, in *Semana Trágica*, 127.

12. Ullman, *Semana Trágica*, 130.

1. Resistance and Ritual, 1888–1896

1. For considerations of the political importance of rituals, see David I. Kertzer, *Ritual, Politics, and Power* (New Haven: Yale University Press, 1988). My thinking about how ritualized patterns of behavior helped workers organize has been influenced by the works of Eric J. Hobsbawm; see especially *Primitive Rebels* (New York: W. W. Norton, 1964); *Labouring Men: Studies in the History of Labour* (New York: Doubleday/Anchor Books, 1967); and "Mass-producing Traditions: Europe, 1870–1914," in *The Invention of Tradition,* ed. Eric J. Hobsbawm and Terence Ranger (New York: Cambridge University Press, 1983), 263. Although I make no direct references to the works of Eric R. Wolf, his insights about how political organization is generated and sustained among rural revolutionaries has influenced the way I have come to understand the formation of a culture of resistance in Barcelona; see especially *Peasants* (Englewood Cliffs, N.J.: Prentice-Hall, 1966); *Peasant Wars of the Twentieth Century*

(New York: Harper & Row, 1969); and *Europe and the People Without History* (Berkeley and Los Angeles: University of California Press, 1982).

2. Surveys of the development of Spanish anarchism can be found in Diego Abad de Santillán [Sinesio Garcia Delgado], *Contribución a la historia del movimiento obrero español. Desde sus orígenes hasta 1905* (Mexico City: Editorial Cajica, 1962); José Álvarez Junco, *La ideología política del anarquismo español* (1868–1910) (Madrid: Siglo Veintiuno Editores, 1976); Manuel Buenacasa, *El movimiento obrero español. Historia y crítica, 1886–1926. Figuras ejemplares que conocí* (Paris, privately printed, 1966); Clara Lida, *Anarquismo y revolución en la España del XIX* (Madrid: Siglo Veintiuno Editores, 1972); Clara Lida, *Antecedentes y desarrollo del movimiento obrero español (1835–1888). Textos y documentos* (Madrid: Siglo Veintiuno Editores, 1973); Max Nettlau, *La première Internationale en Espagne, 1868–1888*, 2 vols., ed. Renée Lamberet (Dordrecht, Neth.: D. Reidel, 1969); Josep Termes, *Anarquismo y sindicalismo en España. La primera International (1864–1881)* (Esplugues de Llobregat: Editorial Ariel, 1973); Jordi Piqué i Padró, *Anarco-col.lectivisme i anarco-comunisme. L'oposició de dues postures en el moviment anarquista català (1881–1891)* (Montserrat: Publicacions de l'Abadia de Montserrat, 1989).

3. Kertzer, *Ritual, Politics, and Power*, 78.

4. Jaume Fabre and Josep M. Huertas, *Barcelona, 1888–1988. La construcció d'una ciutat* (Barcelona: *Diari de Barcelona*, Publicacions de Barcelona, 1988), 21–34; Marilyn McCully, "Introduction," in *Homage to Barcelona: The City and Its Art, 1888–1936* (Barcelona and London: Arts Council of Great Britain, 1985), 16; and Judith Rohrer, "The Universal Exhibition of 1888," in *Homage to Barcelona*, 96–99.

5. For more on this period of history, see Elliott, *Revolt of the Catalans*.

6. See the displays listed in Barcelona, Museo Provincial de Antigüedades, *Catálogo del Museo Provincial de Antigüedades*, ed. Antonio Elías de Molins (Barcelona: Imprenta Barcelonensa, 1888).

7. Marina Warner, *Monuments and Maidens: The Allegory of the Female Form* (New York: Atheneum, 1985).

8. José Sanabre Sanromá, "La ocupación de Barcelona por las tropas Napoleónicas e el templo de Nstra. Sra. de la Merced," *Miscellanea barcinonensia* 4, no. 11 (1965): 8–11.

9. Ibid., 17.

10. Enric Jardí, *Puig i Cadafalch: Arquitecte, polític i historiador de l'art* (Mataró: Ediciones "La Caixa" d'Estalvis Laietana, 1975).

11. Julia Engelhardt, Michael Raeburn and Pilar Sada, "Chronology," in *Homage to Barcelona*, 288–289.

12. Robert Anthony Orsi, *The Madonna of 115th Street: Faith and Community in Italian Harlem, 1880–1950* (New Haven: Yale University Press, 1985), 60.

13. Francesc Carreras Candi, "Les processions de Captius a la Ciutat," in *Llibre de la Mare de Déu de la Mercè*, ed. Marià Manent (Barcelona: Editorial Selecta, 1950), 135–140, Josep Massot i Muntaner, *L'església de Catalunya al segle XX* (Barcelona: Curial Edicions Catalans, 1975), 22.

14. Claudi Ametlla, *Memòries polítiques, 1890–1917* (Barcelona: Editorial Pòrtic, 1963), 96.

15. Carles Cardó, "La obra," in Manent, *Llibre*, 55–127; 126.

16. "Barcelona," *Diario de Barcelona*, October 21, 1888, 13019–13020; ibid., October 22, 1888, 13067.

17. Ibid., October 21, 1888, 13020.

18. Ibid., October 23, 1888, 13083.

19. Jacint Verdaguer, "Coronació de la Verge de la Mercè," in Manent, *Llibre*, 192.

20. Joan Amades, *Gegants, nans i altres entremesos* (Barcelona: Imprenta la Neotipia, 1934), 68–69, 77.

21. Joan Amades, *Custumari català*, vol. 3: *El curs de l'any. Corpus-primavera* (Barcelona: Editorial Salvat, 1952), 78–81.

22. "Barcelona," *Diario de Barcelona*, October 22, 1888, 13066.

23. John Berger, "The Nature of Mass Demonstrations," *New Society*, May 23, 1968, 754–755; for the role of pageantry in an early-twentieth-century American movement, see Linda Nochlin, "The Paterson Strike Pageant of 1913," *Art in America*, May–June, 1974, 64–68.

24. Republicans, who wanted separation of church and state, repeatedly asked that religious pageants take place inside churches behind closed doors rather than in the streets. Although they and leftists took to the streets for their own pageants, they viewed the streets as political arenas, not to be given over to the church by the city. For one republican demand that the city stop subsidizing church ceremonies, see "Cartas de fora," *Campana de Gracia* (Barcelona), June 14, 1902.

25. Records of the cost of religious festivals can be found in the City Registry, Depósito Secre 184-92: Gracia. Expediente referente a la asistencia del Ayuntamiento constitucional de la Villa de Gracia, Gobernación 1892, núm. 987-214; Expediente "Procesión del Corpus de este año." This annex to Institut Municipal d'Història is uncatalogued and rarely open to the public.

26. Fabre and Huertas, "Cronología," in *Barcelona, 1888–1988*, 35.

27. "Barcelona," *Diario de Barcelona*, September 17, 1888, 11478.

28. Ibid.

29. In addition to sources mentioned in note 2 above, see Murray Bookchin, *The Spanish Anarchists: The Heroic Years, 1868–1936* (New York: Harper & Row, 1977); Gerald Brenan, *The Spanish Labyrinth: An Account of the Social and Political Background of the Spanish Civil War* (Cambridge: Cambridge University Press, [1943] 1967), 131–169; Jordi Castellanos, "Aspectes de les relacions entre intel.lectuals i anarquistes a Catalunya al segle XIX (A pròposit de Pere Coromines)," *Els maigs* (Barcelona) 6 (1976): 7–28; Temma Kaplan, *Anarchists of Andalusia, 1868–1903* (Princeton: Princeton University Press, 1977); Joaquín Romero Maura, *"La rosa de fuego." El obrerismo barcelonés de 1899 a 1909* (Barcelona: Editorial Grijalbo, 1975); and Ullman, *Semana Trágica*.

30. P. K., "La manifestació obrera," *Campana de Gracia*, April 26, 1890, 2.

31. "Barcelona," *Diario de Barcelona*, May 2, 1890, 5476.

32. "La manifestación obrera," *Imparcial*, May 2, 1890, 2; Joaquim Ferrer, *El primer "1er de Maig" a Catalunya. Documents a la Recerça* (Barcelona: Edito-

rial Nova Terra, 1972), 85–91. For a discussion of the development of May Day, see Michelle Perrot, "The First of May 1890 in France: The Birth of a Working-Class Ritual," in *The Power of the Past: Essays for Eric Hobsbawm*, ed. Pat Thane, Geoffrey Crossick, and Roderick Floud (Cambridge and Paris: Cambridge University Press and Editions de la Maison des Sciences de l'Homme, 1984), 143–171; *Trabajo* (Sabadell), April 28, 1899, reviews the origins of May Day in Cataluñya, as does Miguel Izard, *Industrialización y obrerismo. Tres clases de vapor, 1869–1913* (Barcelona: Ariel, 1973), 173–183.

33. "Barcelona," *Diario de Barcelona*, May 2, 1890, 5477.

34. Ibid., 5478.

35. Ferrer, *Primer "1er de Maig*," 101; "Barcelona," *Diario de Barcelona* (morning edition), May 3, 1890, 5499.

36. "Barcelona," *Diario de Barcelona* (morning edition), May 3, 1890, 5498–5500.

37. Ibid., May 4, 1890, 5538.

38. Ferrer, *Primer "1er de Maig*," 105.

39. "Barcelona," *Diario de Barcelona* (evening edition), May 5, 1890, 5578.

40. Ibid. (morning edition), May 6, 1890, 5602.

41. Ibid., 5603.

42. Ibid. (afternoon edition), May 7, 1890, 5689–5690; ibid., May 10, 1890, 5786; Piqué i Padró, *Anarco-col.lectivisme i anarco-comunisme*, 122–123.

43. This was also true in Germany, where the Social Democratic party promoted festivals, including May Day celebrations; see Vernon L. Lidtke, *The Alternative Culture: Socialist Labor in Imperial Germany* (New York: Oxford University Press, 1985), 77–84.

44. "Batalladas," *Campana de Gracia*, April 28, 1900, 2.

45. Enric Jardí, *La ciutat de les bombes. El terrorism anarquista a Barcelona* (Barcelona: Librería Dalmau, 1964), 24.

46. Miguel Izard, *El movimiento obrero en Cataluña (1888–1891)* (Barcelona: Editorial Ariel, 1978); Helena Rotes, "Anarquismo y terrorismo en Barcelona, 1888–1902" (mem. lic., University of Barcelona, 1981), chap. 4.

47. *Productor* (Barcelona), May 5, 1892.

48. Quoted in Jardí, *Puig i Cadafalch*, 27.

49. Gaziel [Augustí Calvet i Pasqual], *Tots els camins duen a Roma. Història d'un destí (1893–1914). Memòries*, vol. 1 (Barcelona: Ediciones "La Caixa" d'Estalvis Laietana, 1977), 32–33.

50. Ibid., 37.

51. *Diario de Barcelona* (first of two editions, unmarked), September 25, 1893, 11097–11099.

52. For a detailed description of the violence, see Rafael Núñez Florencio, *El terrorismo anarquista, 1888–1909* (Madrid: Siglo Veintiuno Editores, 1983), 51–60.

53. Less than a month after Pallás's execution, a bomb went off during opening night of the opera at the Lyceum Theater; the police arrested and tortured numerous anarchists before apprehending and executing Santiago Salvador. The best recent account can be found in ibid., 53–57.

54. Descriptions of Corpus Christi can be found in Antonio Aragón Fer-

nández, *La festividad del Corpus Christi en Barcelona* (Barcelona: Librería de la Tipografía Católica Pontificia, 1925); José Aymar y Puig, *Memorias inéditas de la procesión de Corpus* (Barcelona, 1900); and Aurelio Capmany, *Calendari de llegendes, costums i festes tradicionals catalanes. Juny, juliol, agost* (Barcelona: Editorial Laia, 1978). The way celebrations and their folk figures became emblems is dealt with in Jordi Català, "La revetlla de Sant Joan," *Esquella de la Torratxa* (Barcelona), June 21, 1918, 402–403.

55. Amades, *Custumari català* 3:73.

56. Ibid., 93–95.

57. "L'atentat del Carrer de Cambis Nous," *Campana de Gracia,* June 13, 1896, 2; see a drawing of the procession in Amades, *Custumari català* 3:16.

58. A description of the Corpus Christi Day bombing can be found in Núñez Florencio, *El terrorismo anarquista,* 57; see also "Última hora," *Diario de Barcelona,* June 8, 1896, 6879–6883.

59. "Barcelona," *Diario de Barcelona* (morning edition), June 10, 1896, 6939; "L'atentat del Carrer de Cambis Nous," *Campana de Gracia,* June 13, 1896, 2.

60. *Diario de Barcelona* (morning edition), June 10, 1896, 6940.

61. The foreign campaign was largely the work of F. Tárrida del Mármol, a republican activist who was arrested and released; see his *Les inquisiteurs d'Espagne,* 2d ed. (Paris: Stock, 1897). The unfolding of the case the government constructed can be seen in "Del foch a las brasas," *Campana de Gracia,* June 27, 1896, 4; "L'atentat del Carrer de Cambis Nous," *Campana de Gracia,* September 12, 1896, 4. The republican journal *Campana de Gracia,* which at first denounced the terrorists, later proclaimed: "Supporters of modern liberty, lovers of humanity equally abhor bombs and inquisitorial tactics that secure confessions through torture. They are two roads that lead to the same point— barbarism, extinction of liberty, [and the] triumph of brute force" ("Lo procés de Montjuich," *Campana de Gracia,* January 23, 1898, 4).

2. Popular Art and Rituals

1. Anyone investigating the Four Cats and Picasso's early life in Barcelona owes enormous debts to Alejandro Cirici Pellicer, Enric Jardí Casany, Marilyn McCully, Josep Palau i Fabre, and, most recently, John Richardson. The earliest studies of the influence that Barcelona's cultural life had on Picasso are Cirici Pellicer's *Picasso antes Picasso* (Barcelona: Ediciones Iberia, 1946) and its French translation, *Picasso avant Picasso,* trans. Marguerite de Floris y Ventura Gasol (Geneva: P. Cailler, 1950). Anthony Blunt and Phoebe Pool shifted the focus in 1962 to emphasize the French influences on Picasso's work in their study *Picasso: The Formative Years—A Study of His Sources* (Greenwich, Conn.: New York Graphic Society, 1962). The seventies saw a rebirth of interest in Picasso's Barcelona days, owing largely to Enric Jardí Casany's study *Història de els Quatre Gats* (Barcelona: Editorial Aedos, 1972) and Marilyn McCully, whose

exhibits, catalogues, and anthologies made clear for an English-speaking audience how important Catalan friends and their work had been for Picasso; see her catalogue *Els Quatre Gats: Art in Barcelona Around 1900* (Princeton: Princeton University Press, 1978); her collection *A Picasso Anthology: Documents, Criticism, Reminiscences* (Princeton: Princeton University Press, 1982); and her introduction to the catalogue entitled *Homage to Barcelona: The City and Its Art, 1888–1936.* Of the Catalans, no one has done more than Josep Palau i Fabre to trace Picasso's earliest work; see his *Picasso in Catalonia,* trans. Kenneth Lyons (Secaucus, N.J.: Chartwell Books, 1974); *Picasso i els seus amics catalans* (Barcelona: Editorial Aedos, 1971); and *Picasso: The Early Years, 1881–1907* (Barcelona: Ediciones Polígrafa, 1985). John Richardson's *A Life of Picasso,* vol. 1: *1881–1906,* prepared with the collaboration of Marilyn McCully (New York: Random House, 1991), appeared just as my book was going to press. By synthesizing all that has been written about Picasso's early life and dispelling many of the myths to which Picasso happily contributed, Richardson has set a new standard for biographies of Picasso and for studies of the cultural life surrounding him.

2. The monumental show on primitivism at the Museum of Modern Art in New York in 1985 acknowledged the impact of non-Western art on Picasso, Matisse, Derain, and other French artists; see the two-volume catalogue edited by William Rubin, *"Primitivism" in 20th Century Art* (New York: Museum of Modern Art, 1984). One issue that deserves study is the way artists from Ensor and Picasso to Miró and Kandinsky drew on European folk art.

3. For a contemporary account of the 1888 exhibition, with its medieval tiles, paintings, and sculpture, see P. del O., "Excursions per l'Exposició—Palau de Bellas Artes—Secció Arqueológica," *Esquella de la Torratxa,* December 1, 1888, 770–774.

4. Rubén Darío, *España contemporánea* (Paris: Garnier, 1901), 23.

5. For reference to Alberto Russinyol's activities in 1909, see Albert Balcells, "La mujer obrera en la industria catalana durante el primer cuarto del siglo XX," in *Trabajo industrial y organización obrera en la Cataluña contemporánea (1900–1936)* (Barcelona: Editorial Laia, 1974), 62–63.

6. *Diccionari biogràfic* (Barcelona: Editorial Albertí, 1970), 4:172–173.

7. McCully, *Quatre Gats,* 14.

8. P. C. y G., "Luis Labarta's *Hierros Artísticos,* 2 Vols.," *Revista de la Asociación Artístico-Arqueológica-Barcelonesa* (Barcelona) 3 (1901–1902): 506–508.

9. McCully, *Quatre Gats,* 62.

10. M. T. y A., "La Festa Modernista a Sitges," *Veu de Catalunya* (Barcelona), November 11, 1894, 523; P. del O., "Crónica Forastera," *Esquella de la Torratxa,* November 9, 1894, 706.

11. M. T. y A., "Festa Modernista," 522–523; Josep Pla, *Santiago Rusiñol i el seu temps* (Barcelona: Edicions Destino, 1981), 121. There is some confusion about the date of the festival.

12. John Richardson, "Picasso's Apocalyptic Whorehouse," *New York Review of Books* 34, no. 7 (April 23, 1987): 40–47. The bibliography on El Greco is enormous, but it is worth singling out Jonathan Brown et al., *El Greco of Toledo* (Exhibition organized by the Toledo Museum of Art with the Museo del

Prado, the National Gallery of Art, and the Dallas Museum of Fine Arts) (Boston: Little, Brown, 1982).

13. Pla, *Santiago Rusiñol*, 123.

14. *Festa Modernista del Cau Ferrat. Tercer any* (Certamen literari celebrat a Sitges el 4 [9?] de noviembre de 1894) (Barcelona: Tipografía *L'Avenç*, 1895), 8–15.

15. Carles Capdevila, "Santiago Rossinyol," *Revista de Catalunya* 13, no. 70 (June 1931): 490–491.

16. McCully, *Quatre Gats*, 112.

17. My reflections about the importance of darkness and the somnambulant state of the movie viewer derive from Stanley Cavell, *The World Viewed: Reflections on the Ontology of Film* (Cambridge, Mass.: Harvard University Press, 1979).

18. Joan Amades, *Titelles i ombres xineses*, Biblioteca de Tradicions Populars, sér. A, vol. 8 (Barcelona: Imprenta la Neotipia, 1933); the first half of *Titelles* has been translated by H. V. Tozer as "The Catalan Puppets," in *Catalan Puppetry* (Columbus, Ohio: Puppeteers of America, 1944), 1–17. See also Arturo Masriera, "El Senyor Nevas, sombrista," in ibid., 18–20.

19. Masriera, "Senyor Nevas," 18.

20. J. E. Varey, "Los títeres en Cataluña en el siglo XIX," in *Estudios escénicos, Cuadernos del Instituto del Teatro*, no. 5 (Barcelona: Diputación Provincial de Barcelona, 1960), 54.

21. Ibid., 48–51.

22. Ibid., 53, 61.

23. A. Serrano Victori, "De Pedro Romeu al 'Didó,' o la resurreción de 'Els Quatre Gats,'" *Día gráfico*, March 13, 1932, 7.

24. Quoted in Jardí, *Història de els Quatre Gats*, 64.

25. McCully, *Quatre Gats*, 70.

26. Ibid., 32, 40.

27. Quoted in ibid., 20.

28. Paul McPharlin, *The Puppet Theatre in America; with a Supplement: Puppets in America Since 1948, by Marjorie Batchelder McPharlin* (Boston: Plays, [1949] 1969), 288.

29. McCully, *Quatre Gats*, 70, 140; Serrano Victori, "De Pedro Romeu al 'Didó,'" *Día gráfico*, March 13, 1932, 7.

30. See Palau i Fabre, *Picasso i els seus amics catalans*—for Soler: 66, 83, 84, 135, 136, 232; for González: 67, 68, 74, 130; for Juli Pi: 50; for Pi and Bonnin, see McCully, *Quatre Gats*, 22–23 and 44, respectively.

31. McCully, *Quatre Gats*, 20–21.

32. Quoted in Jardí, *Història de els Quatre Gats*, 66.

33. Marilyn McCully (*Quatre Gats*, 16; illus., 19) thinks the scene is an allegory or a "dream sequence" of Romeu's, which may be true. But the presence of stock figures from puppet shows leads me to believe the joke is that once again Romeu himself is being cast as a character.

34. Josephine de Boer, "Rusinyol, the Writer," *Spanish Review* 4, nos. 3–4 (March 1936–April 1937): 16; Amades, *Titelles*, 37–38; Amades, "Catalan Puppets," 16.

35. For shared traditions, see Joan Amades, *El carnestoltes a Barcelona el segle XIX*, Biblioteca de Tradicions Populars, sér. A, vol. 12 (Barcelona: Imprenta la Neotipia, 1934). H. V. Tozer, "El titella catalá vist per un anglés," in M. R. Contractor, *Les grans tradicions populars. Ombres i titelles* (Paris: Arthaud, 1977), 140; Pierre Louis Duchârtre, *The Italian Comedy* (New York: Dover, [1929] 1966), 221.

36. Quote from Tozer, "Titella catalá," 140.

37. Jardí, *Història de els Quatre Gats*, 63.

38. Ibid., 64.

39. Tozer, "Titella catalá," 140; Jardí, *Història de els Quatre Gats*, 64.

40. Amades, "Catalan Puppets," 14–15; Palau i Fabre, *Picasso: The Early Years*, 157.

41. Varey, "Títeres en Cataluña," 73.

42. Tozer, "Titella catalá," 140.

43. Santiago Rusiñol, "El Titella pròdig. Comèdia de Putxinel.lis en un acte i quatre quadros," in *Obres completes. Novel.lis i teatres*, 3d ed., ed. Donald Samuel Abrams (Barcelona: Editorial Selecta, 1973), 1:479–490.

44. Xavier Fàbregas, "Teatre: Titelles i titellaires," *Serra d'or* (Barcelona), 1971, 55.

45. Institut del Teatre, Palau Güell, Barcelona, Puppet belonging to Jaume Anglés from about 1913, reg. no. 26215.

46. Jardí, *Història de els Quatre Gats*, 63.

47. Amades, *Titelles i ombres xineses*, 40; McCully, "Introduction," in *Homage to Barcelona*, 39; Palau i Fabre, *Picasso i els seus amics*, 78–79.

48. Fàbregas, "Teatres," 55.

49. Varey, "Títeres en Cataluña," 69.

50. Ibid., 72; Tozer, "Titella catalá," 143.

51. Tozer, "Titella catalá," 142.

52. Varey, "Títeres en Cataluña," 71.

53. Varey, "Títeres en Cataluña," 74–75.

54. Tozer, "Titella catalá," 140–141.

55. Amades, *Titelles i ombres xineses*, 24.

56. Amades, "Catalan Puppets," 12.

57. McCully, *Quatre Gats*, 70.

58. For consideration of the role of popular devotion in the lives of ordinary people, see William Christian, Jr., *Apparitions in Late Medieval and Renaissance Spain* (Princeton: Princeton University Press, 1981) and *Local Religion in Sixteenth-Century Spain* (Princeton: Princeton University Press, 1981); Robert J. Orsi, *Madonna of 115th Street* and "'He Keeps Me Going': Women's Devotion to Saint Jude Thaddeus and the Dialectics of Gender in American Catholicism, 1926–1965," in *Belief in History: Innovative Approaches to European and American Religion*, ed. Thomas Kaselman (South Bend, Ind.: Notre Dame Press, 1991), 137–169.

59. Santiago Rusiñol, "El pintor de miracles. Sainet en un acte," *Obres completes. Novel.lis i teatres*, 1:757–769.

60. C. Gumá, "Un escultor de sants," in *Fruyta agre-dolsa*, 3d ser. (Barcelona: Llibrería de I. López, [1895?]), 78. Gumá, who wrote his doggerel for

the republican weekly *Campana de Gracia,* also published dozens of pamphlet-sized volumes of his poetry organized more or less topically. His work, though lacking in artistic value, is an excellent source for the study of popular consciousness in late-nineteenth- and early-twentieth-century Barcelona.

61. A superb recent study of votive paintings can be found in Fina Parés i Rigau, *Els ex-vots pintats. Coneguem Catalunya* (Barcelona: Llibres de la Frontera, n.d.).

62. Joan Amades, *Els ex-vots* (Barcelona: Editorial Orbis, 1952), 20.

63. Fortià Solà, *El Santuari de la Mare de Déu del Coll,* 39, cited in ibid., 21.

64. Amades, *Els ex-vots,* 148.

65. Ibid., 147.

66. Ibid., 147–148.

67. Ibid., 151.

3. Community Celebrations and Communal Strikes, 1902

1. This entire book draws on studies about how cultural traditions changed and new traditions developed in the late nineteenth century as classes formed in opposition to one another. A brief cross-section of the works that contribute to this line of thinking include Benedict Andersen, *Invisible Communities: Reflections on the Origin and Spread of Nationalism* (New York: Penguin Books, 1986); Hobsbawm, "Mass-producing Traditions," 263; Lidtke, *Alternative Culture;* Perrot, "First of May 1890 in France." E. P. Thompson's *The Making of the English Working Class* (New York: Vintage Books, 1966) can be considered the progenitor of the line of thought that views culture as a crucible for the formation of classes.

2. Figures from Alzina Caules, "Investigación analítica," 33, in Ullman, *Semana Trágica,* 128; Vives de Fabregas, *Vida femenina barcelonesa,* 219.

3. Bookchin, *Spanish Anarchists,* 139–140; Xavier Cuadrat, *Socialismo y anarquismo en Cataluña (1899–1911). Los orígenes de la CNT* (Madrid: Ediciones de la *Revista de Trabajo,* 1976), 57–68; Romero Maura, *"Rosa de fuego,"* 203–204.

4. Cuadrat, *Socialismo y anarquismo,* 68–77.

5. Reference to the Belgian general strike of 1893 can be found in Ullman, *Semana Trágica,* 132.

6. Considerations of the theory of the general strike can be found in Cuadrat, *Socialismo y anarquismo,* 96–101. Rosa Luxemburg's *The Mass Strike, the Political Party, and the Trade Union,* trans. Patrick Lavin (New York: Harper Torchbooks, [1906] 1971), provides a contemporary analysis of the significance of general and mass strikes.

7. I explored how an alternative, revolutionary society rooted in a tradition of resistance developed through informal neighborhood associations, unions, and cultural groups in southwestern Spain in *Anarchists of Andalusia,* 84–91.

8. Ibid., 166–167.

9. An interview with Federica Montseny about Teresa Claramunt appears in Carmen Alcalde, *La mujer en la guerra civil española* (Madrid: Cambio 16, 1976), 179–180.

10. "La anarquía a Barcelona," *Veu de Catalunya* (Barcelona) (evening edition), February 23, 1902.

11. The daily description comes from an unidentified, moderately conservative eyewitness whose account is in the archives of the Institut Municipal d'Història, Casa de l'Ardiaca; see *La huelga general de Barcelona. Verdadera relación de los sucesos desarrollados con motivo del paro general en Barcelona durante la octava semana de este año por un testigo ocular* (Barcelona: Imprenta de Pedro Toll, 1902), 5; for detailed accounts and analysis of the 1902 strike, see Cuadrat, *Socialismo y anarquismo*, 80–106.

12. *Huelga general*, 8–9.

13. Ibid., 9–15.

14. Ibid., 11, 16, 20.

15. "La anarquía a Barcelona," *Veu de Catalunya* (evening edition), February 23, 1902.

16. P. K., "Durant la huelga general. Impresions," *Campana de Gracia*, February 22, 1902; *Huelga general*, 16; Emili Salut, *Vivers de revolucionaris. Apunts històrics del districte cinquè* (Barcelona: Llibreria Catalònia, 1938), 61. Salut, whose book combines an ethnography of the Parallel at the turn of the century with a biography of the syndicalist leader Salvador Seguí, was rediscovered by Magdalena Fernández Cervantes; see her article "Una nueva fuente histórica sobre la formación de la ideología anarquista barcelonesa: Emili Salut y su obra *Vivers de revolucionaris*," *Convivium. Filosofía, psicología, humanidades* 1–2, nos. 44–45 (1975): 101–122.

17. *Huelga general*, 18–19.

18. Ibid., 21–25.

19. Ibid., 25–27.

20. Cuadrat, *Socialismo y anarquismo*, 88; *Huelga general*, 25–30.

21. Romero Maura (*"Rosa del fuego,"* 216–217) gives low figures on casualties; Cuadrat (*Socialismo y anarquismo*, 82) provides higher figures but settles for lower ones. The best discussion about casualty figures can be found in José Álvarez Junco, *El emperador del paralelo. Lerroux y la demagogia populista* (Madrid: Alianza Editorial, 1990), 270n.11 (which arrived just as my book was going to press). Estimates of the numbers killed and wounded ranged from a low of twelve dead and forty-four wounded to a high of one hundred dead and three hundred wounded; in the end, there is no way to know for sure.

22. Cuadrat, *Socialismo y anarquismo*, 76–77, 86–87; Romero Maura, *"Rosa del fuego,"* 211; Ullman, *Semana Trágica*, 123.

23. Sr. F. Pujola y Vallés, "Contra las festas" (reproduced from *El programa*), in *Veu de Catalunya* (evening edition), September 27, 1902, 4.

24. "Barcelona de festa. Funcions religiosas," *Veu de Catalunya* (evening edition) September 24, 1902, 2.

25. Jardí Casany, *Història de els Quatre Gats*, 122.

26. "La exposició d'art antich," *Veu de Catalunya* (evening edition), Sep-

tember 15, 1902, 1–2; "Programa oficial y detallat de las Festas de la Mercé," ibid., September 16, 1902, 1–2; "La exposició d'art antich," ibid., September 25, 1902, 3.

27. "La exposició d'art antich," *Veu de Catalunya* (morning edition), September 15, 1902, 3.

28. "Festas de la Mercé," *Veu de Catalunya* (evening edition), September 23, 1902, 3.

29. "Barcelona de festa," *Veu de Catalunya* (evening edition), September 24, 1902, 2.

30. "La cabalgata artística industrial," *Liberal* (Barcelona), October 5, 1902, 2.

31. "La cavalcada histórica, artística y industrial," *Veu de Catalunya* (morning edition), October 4, 1902, 4–5; and "Festas de la Mercé: La cavalcada," ibid., October 6, 1902, 2–3.

32. Amades, *Gegants, nans i altres entremesos*, 77; "La festa dels gegants," *Veu de Catalunya* (evening edition), September 27, 1902, 3.

33. "Festa de la Mercé," *Veu de Catalunya* (evening edition), September 22, 1902, 3.

34. "Las festas de la Mercé," *Veu de Catalunya* (morning edition), September 30, 1902, 2–4.

35. "Las festas de la Mercé," *Veu de Catalunya* (evening edition), September 25, 2.

36. Kaplan, *Anarchists of Andalusia*, 201.

37. "L'estat de guerra," *Veu de Catalunya* (evening edition), October 10, 1902, 2.

38. "La cavalcada prohibida," *Veu de Catalunya* (evening edition), October 11, 1902, 2.

39. Domingo Carles, "La obra de Isidro Nonell," in *Memorias de un pintor* (Barcelona: Ediciones Destino), 87–90; Enric Jardí, *Nonell* (Barcelona: Editorial Polígrafa, n.d.), 66, 92, 102, 106, 110, 114; Enric Jardí, *Nonell i altres assaigs* (Barcelona: Editorial Selecta, 1957), 11; Carles Capdevila, "Joaquim Mir," *Art* (Barcelona) 2 (1935): 97; José Pla, *El pintor Joaquín Mir* (Barcelona: Ediciones Destino, 1944), 33.

40. Portraying people only as victims robs them of their potential political autonomy, an issue I explore in "Women and Spanish Anarchism," in *Becoming Visible: Women in European History*, ed. Renate Bridenthal and Claudia Koonz (Boston: Houghton Mifflin, 1977), 400–421.

41. Art historian Patricia Leighten has demonstrated that Picasso was aware of political struggles going on in Barcelona at the turn of the century and that he even signed a letter along with Spaniards living in Paris calling for an amnesty for Spanish political prisoners; see "Manifiesto de la colonia española residencia en Paris," *Publicidad* (Barcelona), December 29, 1900, cited in Leighten's "Picasso's Collages and the Threat of War, 1912–1913," *Art Bulletin* 67 (December 1985): 659n.40. By placing Picasso in a historical and political context among intellectual anarchists in Paris and Barcelona, Leighten has introduced another dimension to the studies of Picasso's work. Her pathbreaking book *Re-Ordering the Universe: Picasso and Anarchism, 1897–1914* (Princeton:

Princeton University Press, 1989) will help shape debate about Picasso's early political ideas for some time to come.

42. Paolo Lecaldano, *La obra pictórica completa de Picasso azul y rosa* (Barcelona: Editorial Noguer, 1980), 89–90.

43. I agree with Patricia Leighten (*Re-Ordering the Universe*, 19–47, especially 38) that insofar as anarchism constituted an antiauthoritarian state of mind shared by many pioneers in art, literature, and philosophy of the time, Picasso was sympathetic, but I am not convinced that Picasso's portrayal of poverty was overtly political.

44. A rare photograph of Claramunt from the twenties can be found in Lola Iturbe, *La mujer en la lucha social y en la guerra civil de España* (Mexico City: Editores Mexicanos Unidos, 1974), 50. A useful debate about how the working class was represented can be found in Eric J. Hobsbawm, "Man and Woman in Socialist Iconography," *History Workshop* 6 (Autumn 1978): 121–138; and in the response by Sally Alexander, Anna Davin, and Eve Hostettler, "Labouring Women: A Reply to Eric Hobsbawm," *History Workshop* 8 (Autumn 1979): 174–182.

4. Women Out of Control

1. N. Bas y Socias, "La dona en el traball," *Campana de Gracia*, October 10, 1908, 3.

2. Although I do not refer directly to Mary Douglas in my analysis of purification rituals in Barcelona, I cannot overemphasize my debt to her; see her *Purity and Danger: An Analysis of the Concepts of Pollution and Taboo* (Boston: Arc, [1966] 1984).

3. "La dinamita en Barcelona," *Imparcial*, September 4, 5, 9, 11, 1905; "Barcelona," *Diario de Barcelona*, September 4–9, 1905; Núñez Florencio, *Terrorismo anarquista*, 76.

4. Joaquín Romero Maura, "Terrorism in Barcelona and Its Impact on Spanish Politics, 1904–1909," *Past and Present* 41 (1968): 130–183; Joaquín Romero Maura, *The Spanish Army and Catalonia: The Cu-Cut! Incident and the Law of Jurisdictions, 1905–1906* (Beverly Hills, Calif.: Sage, 1976). For anarchist charges that police had planted the bombs, see "Mitin Importante," *Tierra y libertad* (Madrid), September 7, 1905, 3.

5. Jordi Solé-Tura, *Catalanismo y revolución burguesa* (Madrid: Editorial Cuadernos para el Diálogo, 1970), 125–127.

6. Ibid., 127–128.

7. Ibid., 266.

8. Ibid., 31.

9. Ibid., 249, 256, 258.

10. For a description of New Cemetery, see A. Gelée-Bertal, *Guide à Barcelone* (Barcelona: Librairie Française, 1896), 184. See also Gary Wray Mc-

Donogh's analysis of the place of the Old Cemetery in the cultural identity of Barcelona in *Good Families of Barcelona,* 172–188.

11. "Después de la explosión," *Imparcial,* September 6, 1905.

12. Teresa Claramunt, "La bomba de Barcelona," *Porvenir del obrero* (Mahón), September 15, 1905.

13. For a discussion of immorality, including the frequency of co-ed nudity on the beach at Barceloneta, see the letter from a friend of Portuguese Prime Minister Hintze-Ribeiro, Barcelona, July 24, 1904 (translated into Spanish by the Spanish embassy in Lisbon), cited in Joaquín Romero Maura, "Rosa de fuego," 263n.189. The figures on prostitution come from Juan de Paulis, *Las obreras de la aguja. Feminismo. Discurso leído en la sesión celebrada el 26 de enero de 1913 en el Ateneo Barcelonés* (Barcelona, 1913), 79, cited in Balcells, "Mujer obrera," 95, 117.

14. Balcells, "Mujer obrera," 95.

15. The life history of one such woman is told in Don Prudencio Sereñana y Partagás, *La prostitución en la ciudad de Barcelona, estudiada como enfermedad social y considerada como origen de otras enfermedades dinámicas, orgánicas y morales de la población barcelonesa* (Barcelona: Imprenta de los Sucesores de Ramierez, 1882), 165–167.

16. Ibid., 136–137.

17. Figures on child labor are compiled from *Anuario estadístico: 1905,* vol. 4, in Ullman, *Semana Trágica,* 127.

18. A. Sartoris, "El problema de la prostitución," *Porvenir del obrero,* July 29, 1903.

19. Francisco Madrid, *Sangre en Atarazanas* (Barcelona: Antonio López, n.d.), 101–117.

20. For one attack on leftist men for their reactionary view about women, see María, "El grito de la mujer esclava," *La cuña. Trabajo, solidaridad, federación. Periódico defensor de los obreros del ramo de elabora madera de España* (Barcelona), February 21, 1907. The account of the life of María Rosa can be found in Salvador Seguí, "Escuela de rebeldía," in J. M. Huertas Clavería, *Salvador Seguí "El noi del sucre." Materiales para una biografía* (Barcelona: Editorial Laia, 1976), 103–132, especially 113–116.

21. *Museu Picasso. Catàleg de pintura i dibuix,* by Jaime Barrachina et al. (Barcelona: Ajuntament de Barcelona Museus, 1984), 426.

22. Guillermo López blames "the decline in marriage and consequently the fall in population and the rise in the incidence of tuberculosis, cancer, syphilis, and alcoholism on the *café cantants*"; see his *Barcelona sucia. Artículos de malas costumbres. Registro de higiene* (Barcelona: Tipográfico Sucesores de F. Sánchez, n.d.), 54–55. A description of the way Chinatown, or the Barrio Chino, developed as a center of the underworld can be found in Dorsey Boatwright and Enric Ucelay Da Cal, "La dona del 'Barrio Chino,'" *L'avenç* (Barcelona), no. 76 (November 1984): 26(870)–34(878). Among the people cited by Boatwright and Ucelay is the republican journalist, Francisco Madrid. Madrid and his colleagues Lluís Capdevila and José Samblancat were grub-street journalists who wrote about prostitution, homosexual life, drug addiction, and conditions of the poor in Barcelona. Although knowledgeable about anarcho-syndicalists and

sympathetic to them, Madrid, who frequently lived in flophouses and even went to jail himself, was more concerned with Barcelona's underworld life than with politics. An excellent view of the relationship between prostitution and the life in the cafés can be found in his *Sangre en Atarazanas*, 18–23, 71–74, 155–172. I am extremely grateful to Susana Tavera of the Universidad Central, Barcelona, for introducing me to the work of Madrid; see her article "La Barcelona obrera 1900–1939" (manuscript copy).

23. See a reproduction of the painting in Palau i Fabre, *Picasso in Catalonia*, 90.

24. Lluís Capdevila, *De la Rambla a la presó* (Barcelona: Edicions la Paraula Viva, 1974), 22–23.

25. R. Cubero, "Prostitución," *Cuña*, August 30, 1906.

26. Sereñana y Partagás, "Prostitución en Barcelona," 184. For additional material on the organization of prostitution, see Madrid, *Sangre en Atarazanas*, 151–153, 156.

27. See a description of appalling conditions of life in the brothels in Justo Sencillo, "Nuestras esclavas," *Porvenir del obrero*, January 11, 1907.

28. Salut, *Vivers de revolucionaris*, 62; Leo Steinberg, "The Philosophical Brothel, Parts 1 and 2," *Art News* 71, no. 5 (September 1972): 20–29; no. 6 (October 1972): 38–47. Steinberg was the first art historian to make the connection between Avinyo Street and *Les demoiselles d'Avignon*.

29. Capdevila, *De la Rambla*, 124.

30. Madrid, *Sangre en Atarazanas*, 84.

31. Reproduced in *Museu Picasso. Catàleg de pintura i dibuix*, 638.

32. The following consideration of Tragic Week and the events leading to it depends on Ullman, *Tragic Week*, and on her substantially revised Spanish edition of the book, *Semana Trágica*. I have also consulted *La época* (Madrid), *El poble català*, *Diario de Barcelona*, *Almanaque del "Diario de Barcelona,"* and *El imparcial* (Madrid) for July 9–August 30, 1909.

33. Ullman, *Semana Trágica*, 274–275.

34. Ibid., 295; *Imparcial*, July 12, 1909.

35. Ullman, *Semana Trágica*, 296.

36. Ibid., 303.

37. "Para las familias de los reservistas," *Imparcial*, July 24, 1909.

38. Ullman, *Semana Trágica*, 319.

39. Ibid., 320; "La campaña de Melilla," *Imparcial*, July 23, 1909, 1.

40. Ullman, *Tragic Week*, 87.

41. Most of the material on women's involvement in Tragic Week in this chapter is from Ullman; see especially *Tragic Week*, 91–92, 136, 151, 170–173, 180–181, 196–197, 208–215, 226–227, 232–236, 241, 244, 247–249, 281, 292–293; and *Semana Trágica*, 130, 159–161, 205, 313, 320–321, 343–344, 347–352, 396, 409–416, 430–431, 437–438, 442, 448–449, 452, 455–458, 519–520.

42. Ullman, *Semana Trágica*, 344.

43. Ibid., 347–348, 351.

44. "Crónica: Los últimos sucesos," *Diario de Barcelona* (evening edition), August 1, 1909, 10421–10426, especially 10422.

45. Ullman, *Tragic Week,* 180–182.

46. Ibid., 187.

47. Ibid., 196–197.

48. A major work of cultural and political history, *El emperador del paralelo* by José Álvarez Junco, appeared just as my book was being typeset. Even cursory reading reveals that this monographic study of Lerroux and the Radical party describes the political phenomena of anticlericalism and late-nineteenth-century republicanism better than any previous work.

49. Alejandro Lerroux, in *La rebeldía,* September 1, 1906, cited in Brenan, *Spanish Labyrinth,* 30.

50. Ullman, *Tragic Week,* 207–208.

51. Ibid., 210–211.

52. The Catholic reformer José Elías de Molins reported in 1915 that the rates paid to women at home were starvation wages. For example, they received 65 *céntimos* for a dozen collars and cuffs, 15 *céntimos* for a dozen embroidered handkerchiefs, 1.50 *pesetas* for a dozen women's underpants, and 2.75 *pesetas* for a dozen men's shirts. See his *Obrera en Cataluña,* 30–31.

53. Ullman, *Tragic Week,* 211.

54. Ibid., 211–212.

55. Ibid., 236.

56. "La sedición en Barcelona," *Imparcial,* August 8, 1909.

57. Ullman, *Tragic Week,* 227.

58. Ullman, *Semana Trágica,* 456.

59. "Los sucesos de Barcelona," *Época,* August 5, 1909, 1; Adolfo Bueso, *Recuerdos de un cenetista. De la Semana Trágica (1909) a la Segunda República (1931)* (Barcelona: Editorial Ariel, 1976), 36.

60. "Los sucesos de Barcelona," *Época,* August 5, 1909, 1.

61. "Barcelona," *Hormiga de oro. Ilustración católica* 26, no. 24 (June 12, 1909): 389. This issue is filled with articles about and pictures of funerals. Republicans were especially scornful of death rituals. In early 1909, a republican journalist had denounced the Catholic church for forbidding cremations even though the Inquisition had burned many live bodies; see El Frare Tacas [Carmelita ben calsat (A well-heeled Carmelite)], "Platicas religiosas," *Campana de Gracia,* January 23, 1909, 2. Another republican scorned Ash Wednesday as the Day of the Good Death and called instead for days and years of good life; see "La professó de la Bona Mort," *Campana de Gracia,* February 27, 1909, 2.

62. Studying carnivals in relation to social movements has become a popular enterprise over the past two decades. Owing largely to the work of Natalie Zemon Davis in "The Reasons of Misrule," in *Culture and Society in Seventeenth-Century France* (Stanford: Stanford University Press, 1975), 97–123; and E. P. Thompson in "'Rough Music': Le charivari anglais," *Annales E.S.C.,* no. 27 (1972): 285–312, Anglo-American historians have become interested in the political impact of folk practices. A more recent study in this tradition appears in Peter Stallybrass and Allon White, *The Politics and Poetics of Transgression* (Ithaca: Cornell University Press, 1986).

Pioneering work on carnival in Barcelona was done by Joan Amades in *El carnestoltes a Barcelona* and *Custumari català,* vol. 2: *Les carnestoltes–la quaresma*

(Barcelona: Editorial Salvat, 1951). For a nostalgic reflection on what carnival was like in nineteenth-century Barcelona, see Santiago Rusiñol, "La muerte de carnaval," in *Obres completes. Novel.lis i teatres*, 2d ed., ed. Donald Samuel Abrams (Barcelona: Editorial Selecta, 1953), 1:1945–1947. For references to the death of Carnestoltes and the burial of the sardine, see Francesc Curet, "Carnestoltes a Barcelona en el segle XIX," *Teatre català* (Barcelona) 4, no. 155 (February 13, 1915): 119–124, especially 121; the whole issue of this journal is dedicated to a discussion of carnival in Barcelona and its history. Theodore Reff, in "Themes of Love and Death in Picasso's Early Work," in *Picasso in Retrospect*, ed. Roland Penrose and John Golding (New York: Harper & Row, 1973), 5–30, shows how Picasso put carnival imagery from Spain and France to work in his art.

63. Ullman, *Semana Trágica*, 517; Bueso, *Recuerdos de un cenetista*, 36.

64. R. Stamm, "On the Carnivalesque," *Wedge* 1 (1982): 47, 55; cited in Stallybrass and White, *Politics and Poetics of Transgression*, 18–19.

65. Ullman, *Tragic Week*, 281; "Los últimos sucesos," *Diario de Barcelona* (evening edition), August 2, 1909, 10454.

66. Ullman, *Tragic Week*, 215.

67. Bueso, *Recuerdos de un cenetista*, 35–36.

68. Ullman, *Tragic Week*, 241.

69. Ibid., 226; "Los últimos sucesos," *Diario de Barcelona* (morning edition), August 7, 1909, 10693–10694; "Datos por la historia," *Hormiga de oro* 26, no. 33 (August 14, 1909): 514; *Almanaque del "Diario de Barcelona"* (1910), 124. A journalist reported in "Aquella reclusa," *Diluvio* (morning edition), September 1, 1910, 8–9, that a girl had escaped from the convent of the Adorers of the Blessed Sacrament and had been returned against her wishes.

70. Ullman, *Semana Trágica*, 140.

71. "Datos por la historia," *Hormiga de oro*, August 14, 1909, 514.

72. Ullman, *Semana Trágica*, 455–456.

73. Josep Benet, *Maragall i la Setmana Trágica* (Barcelona: Edicions 62, 1965), 55.

74. Carmen Karr, "Carta abierta a Mossen Ricardo Aragó," *Diario de Barcelona* (evening edition), August 14, 1909, 11014.

75. The way one working-class community (in Portsmouth, England) viewed attacks on prostitutes as attacks on the entire working class can be seen in Judith M. Walkowitz, *Prostitution and Victorian Society: Women, Class, and the State* (Cambridge: Cambridge University Press, 1980).

76. "Gobierno civil," *Diario de Barcelona* (morning edition), August 11, 1909, 10833.

77. Neil Hertz, "Medusa's Head: Male Hysteria Under Political Pressure," *Representations* 4 (Fall 1983): 27–50. In *God's Bits of Wood* (New York: Doubleday/Anchor Books, 1970), Ousmane Sembene's fictional account of a 1947 railroad strike in Senegal, and in *The Women Incendiaries*, trans. James Starr Atkinson (New York: Braziller, 1966), Edith Thomas's account of the Paris Commune, working-class women mobilize with prostitutes as their leaders.

78. E. Armand, *La prostitution et ses multiples aspects* (Paris: Editions de l'En Dehors, 1933), 16.

79. Stallybrass and White, *Poetics and Politics of Transgression*, 137–138.

80. Drs. Anguera de Sojo and Umberto Verderau y Vellvé, *Bases para la redacción de un reglamento de la prostitución en España. Presentadas á la Academia de Higiene de Cataluña* (Barcelona: Imprenta F. Badia Cantens, 1911).

5. Female Consciousness and Community Struggle, 1910–1918

1. This chapter draws heavily on my article "Female Consciousness and Collective Action: The Case of Barcelona, 1910–1918," *Signs: Journal of Women in Culture and Society* 7, no. 3 (1982): 545–566; I am grateful to the University of Chicago Press for permission to re-incorporate material I used there when I first developed the concept of "female consciousness."

2. Molins, *Obrera en Cataluña*, 6.

3. In 1908, the civil governor of Barcelona founded a Committee for the Protection of Children and the Suppression of Begging to supplement the work done by the church. The problem of abandoned children (known as *trinxerai-res*) remained, however, and was considered a social disease. Molins said poor parents had the impossible choice of abandoning their children or sending them to work at an early age; he also feared that juvenile delinquents "filled the jails and then nurtured anarchism" (*Obrera en Cataluña*, 53).

4. Revelations about the rape, the convent's defense, and the trials of the child and her family begin with "Violación, estrupo y corrupción en un convento de Gracia," *Diluvio* (Barcelona) (morning edition) October 14, 1910, 12–15; and go through "Lo del convento de Gracia," ibid. (afternoon edition), October 31, 1910, 8.

5. "Un convento de Gracia," *Diluvio* (morning edition), October 14, 1910, 14–15.

6. "Lo del convento de Gracia," *Diluvio* (afternoon edition), October 24, 1910, 8.

7. "Lo del convento de Gracia," *Diluvio* (morning edition), October 18, 1910, 8.

8. "Lo del convento de Gracia," *Diluvio* (morning edition), October 30, 1910, 15.

9. "La semana clerical," *Diluvio* (morning edition), October 22, 1910, 20.

10. Quoted in Adolfo Bueso, *Como fundamos la CNT* (Barcelona: Editorial Avance, 1976), 30.

11. See Anselmo Lorenzo, *Las olimpiadas de la paz y el trabajo de mujeres y niños* (Madrid: Imprenta de Antonio Marzo, 1900), for one of his speeches about female and child labor in 1900.

12. Anarchist thought, devoted as it was to human liberation, was always concerned with the need to transform the condition of women. In practice, however, it was far more difficult. The most extensive history of women in the anarchist and anarcho-syndicalist movements can be found in the work of Mary

Nash, especially the following: "La problemática de la mujer y el movimiento obrero en España," in *Teoría y práctica del movimiento obrero en España (1900–1936)*, ed. Albert Balcells (Valencia: Fernando Torres, 1977), 241–279; *Mujer y movimiento obrero en España, 1931–1939* (Barcelona: Editorial Fontamara, 1981); and *Mujer, familia y trabajo en España, 1875–1936* (Barcelona: Anthropos, Editorial del Hombre, 1983). Mary Nash and the Centre d'Investigació Històrica de la Dona, Barcelona, which she directs, have been pivotal in the development of women's history in Spain.

13. Bueso, *Como fundamos la CNT,* 73–75.

14. Balcells, "Mujer obrera," 11–12. The price list was conveyed by a seamstress who testified before the bishop of Barcelona and was reported by Dolors Moncerdà de Macià, a leading Catholic philanthropist. In a March 16, 1910, address to the Catholic group Popular Social Action, she called on Catholics to improve the plight of working women; the lecture was reprinted as a pamphlet, *Conferencia sobre l'Acció Católica social femenina* (Barcelona: L'Acció Católica, 1910); see 13–14. In 1918, Catholic feminists were instrumental in persuading the government to try to regulate home work; see "Preparación de un proyecto de ley sobre el trabajo a domicilio," in *Instituto de Reformas Sociales: Secciones técnicos administrativas* (Madrid: Sobrinos de las Sucesores de los Rios, 1918).

15. Balcells, "Mujer obrera," 12.

16. Molins, *Obrera en Cataluña,* 23; Balcells, "Mujer obrera," 41.

17. Molins, *Obrera en Cataluña,* 17. "Sucesos," *Publicidad* (Barcelona), January 28–30, February 5, and April 21, 1913, provides just a few examples of how common foundlings and dead fetuses were in the streets of working-class neighborhoods. The labor situation was covered in "Vida sindicalista," *Voz del pueblo* (Tarrasa), February 22, 1913; "La vida obrera en Barcelona," *Socialista* (Madrid), April 18, 1913; and "Contra el trabajo nocturno," ibid., July 19, 1913. A. Lopez Baeza, "Acción social: El trabajo nocturno," ibid., November 25, 1913, publicized the statistical unreliability of *Anuari d'estatistica social de Catalunya,* edited by the Museo Social de Barcelona. Most Spanish statistics should be regarded as approximations.

18. There was good reason for female factory workers and women in the community, most of whom earned a living in cottage industry at some time in their lives, to unite as they did in 1913. The most complete consideration of the Constancy strike of 1913 and its social background appears in Balcells, "Mujer obrera," 9–121. For a schematic outline of the strike, see Miguel Sastre, *Huelgas de 1910, 1911, 1912, 1913, 1914* (Barcelona: Establecimento Tipográfico La Hormiga de Oro, 1914), 209–225. See also Molins, *Obrera en Cataluña,* 36–63, on Catholic social services to working women.

19. "Las huelgas," *Socialista,* July 26, 1913; "De la vaga textil. El Seny," *Campana de Gracia,* August 9, 1913.

20. "Las huelgas de Barcelona," *Imparcial,* July 30, August 1, 1913; "El conflicto del arte fabril en Cataluña," *Socialista,* July 31, 1913; quotation appears in "Contra la violencia," *Imparcial,* August 2, 1913.

21. Tomás Caballé y Clos, *Costumbres y usos de Barcelona. Narraciones populares* (Barcelona: Editorial Seguí, 1947), 416; Jacques Valdour, *La vie ouvrière. L'ouvrier espagnol, vol. 1: Catalogne* (Paris: Arthur Rousseau, 1919), 21–22.

22. "Huelgas en el arte fabril," *Diario de Barcelona* (evening edition), August 5, 1913, 10603.

23. "Gobierno civil: Cuestiones obreras," *Publicidad,* April 12, 1913; "Las operarias en seda en Barcelona: Las batallas del proletariado; ecos de la lucha," *Socialista,* April 10, 1913; and "Las obreras triunfan," ibid., August 11, 1913.

24. "De la vaga textil: El Seny," *Campana de Gracia,* August 9, 1911; *Diario de Barcelona* (morning edition), August 4, 1913, 10532–10534; ibid., August 7, 1913, 10653; ibid., August 8, 1913, 10712–10713; ibid., August 9, 1913, 10796.

25. T. Herreros, "Feminismo en actividad," *Almanaque de "Tierra y Libertad" para 1914,* 98–99; *Diario de Barcelona* (morning edition), August 11, 1913, 10837–10838; ibid., August 12, 1913, 10873.

26. *Diario de Barcelona* (evening edition), August 12, 1913, 10904.

27. Ibid., 10905.

28. Ibid., August 20, 1913, 11238.

29. Ibid. (morning edition), August 21, 1913, 11245.

30. *Butlletí de l'Institut d'Investigacions Econòmiques* (Generalitat de Catalunya) 2 (1933): 277, cited in Balcells, "Indice ponderado del precio de las subsistencias en Barcelona entre 1911 y 1933," in *Cataluña contemporánea II (1900–1939)* (Madrid: Siglo Veintiuno Editores, 1979), 88; Jacinto Martin Maestre, *Huelga general de 1917,* Colección Lée y Discute, 15, ser. Roja (Madrid: ZYX, 1966), 48.

31. See my discussion of how women in Russia, Italy, Spain, and Mexico resisted war and speculators in "Women and Communal Strikes in the Crisis of 1917–1922," in *Becoming Visible: Women in European History,* 2d ed., ed. Renate Bridenthal, Claudia Koonz, and Susan Mosher Stuard (Boston: Houghton Mifflin, 1987), 429–449.

32. *Veu de Catalunya,* January 2–12, 1918; *Diario de Barcelona* (evening edition), January 10, 1918, 459. For the pathbreaking discussion of modern food riots and how crowds applied a system of "moral economy" to impose what they considered a "just price," see E. P. Thompson, "The Moral Economy of the English Crowd in the Eighteenth Century," *Past and Present* 50 (February 1971): 76–136.

33. "Aumenta la excitación entre las clases populares," *Sol* (Madrid), January 13, 1918.

34. *Diario de Barcelona* (evening edition), January 11, 1918, 467–468; *Diluvio* (morning edition), January 11, 1918, 7; ibid. (afternoon edition), January 11, 1918, 2; "La región catalana," *Sol,* January 11, 1918; *Veu de Catalunya,* January 12, 1918.

35. Quoted in "La región catalana," *Sol,* January 11, 1918.

36. *Diario de Barcelona* (evening edition), January 12, 1918, 505.

37. "La región Catalana," *Sol,* January 11, 1918; a later article, "La situación en Barcelona," ibid., January 23, 1918, discusses the rift between Alegre and Barrios.

38. *Diluvio* (evening edition), January 13, 1918.

39. Joan Manent i Pesas, *Records d'un sindicalista llibertari català, 1916–1943* (Paris: Edicions Catalanes de París, 1976), 29.

40. "Graves sucesos en Barcelona: Se va el lunes a la huelga general?" *Sol,* January 12, 1918.

41. "La región catalana," *Sol,* January 15, 1918.

42. *Diario de Barcelona* (morning edition), January 14, 1918, 516; ibid. (evening edition), January 14, 1918, 573.

43. Ibid. (evening edition), January 14, 1918, 573–574; ibid. (morning edition), January 15, 1918, 586; ibid. (evening edition), January 15, 1918, 621–622; *Diluvio* (morning edition), January 15, 1918, 7; *Hormiga de oro: Ilustración católica,* January 19, 1918, 31; "La región catalana," *Sol,* January 15, 1918.

44. *Diluvio* (morning edition), January 16, 1918, 7–8.

45. *Diario de Barcelona* (morning edition), January 18, 1918, 769; "Acuerdo de huelga general: La vida en Barcelona," *Sol,* January 16, 1918.

46. *Diluvio* (morning edition), January 18, 1918, 9.

47. "La situación en Barcelona," *Sol,* January 23, 1918.

48. "Nuevos sucesos en Barcelona," *Sol,* January 24, 1918.

49. "Mas información de Cataluña," *Sol,* January 25, 1918.

50. "Después de la suspensión de garantias," *Sol,* January 27, 1918.

51. *Almanaque del "Diario de Barcelona" para el año 1919,* 24–25; *Sol,* February 12, 1918.

52. Bueso, *Recuerdos de un cenetista,* 86.

6. Democratic Promises in 1917

1. Luis Araquistáin, editor of *España,* quoted in Antonio Elorza, Luis Arranz, and Fernando del Rey, "Liberalismo y corporativismo en la crisis de la Restauración," in *La crisis de la Restauración. España entre la primera guerra mundial y la II República,* ed. J. L. García Delgado, Second Segovian Colloquium on the Contemporary History of Spain, dir. M. Tuñón de Lara (Madrid: Siglo Veintiuno Editores, 1986), 9.

2. Ángel Pestaña, *Terrorismo en Barcelona (Memorias inéditas),* ed. Xavier Tusell and Genoveva García Queipo de Llano (Barcelona: Editorial Planeta, 1979), 10–11; "En casa de Ángel Pestaña," *Diluvio* (morning edition), August 27, 1922, 15.

3. Joan del Pí, *Interpretació llibertaría del moviment obrer català* (Paris: Ediciones *Tierra y Libertad,* 1946), 22.

4. In *Vivers de revolucionaris,* Emili Salut describes District V and provides a biography of Seguí. See also Fernández Cervantes, "Nueva fuente histórica." Seguí's rather pedestrian novel *Escuela de rebeldía: Historia de un sindicalista* (Madrid: Rivadeneyra, 1923) provides valuable insights about the daily life of syndicalist workers.

5. Pierre Cabanne, *Pablo Picasso: His Life and Times,* trans. Harold J. Salemson (New York: William Morrow, 1977), 15–20; Mary Mathews Gedo, *Picasso: Art as Autobiography* (Chicago: University of Chicago Press, 1980), 7–19; Pat-

rick O'Brian, *Pablo Ruiz Picasso: A Biography* (London: Colins, 1976); Roland Penrose, *Picasso: His Life and Work* (New York: Harper, 1959), 20; Jaime Sabartés, *Picasso: An Intimate Portrait*, trans. Angel Flores (New York: Prentice-Hall, 1948), 3–12.

6. Balcells, "Indice ponderado del precio de las subsistencias," in *Cataluña contemporánea II*, 87–88; Juan Antonio Lacomba Avellán, *La crisis española de 1917*, Colección "Los Contemporáneos," 19 (Madrid: Editorial Cuenca Nueva, 1970), 28, claims the value of the peseta dropped 50 percent.

7. Pestaña, *Terrorismo en Barcelona*, 13.

8. Bueso, *Recuerdos de un cenetista*, 70.

9. Joaquín Edwards-Ballo, *El nacionalismo continental. Crónicas chilenas* (Madrid: Imprenta Hernández y Gallo Sáez, 1925), 167.

10. Sempronio [Andrés Aveleno Artis], "L'Español, un café unic," *Aquella entremaliada Barcelona* (Barcelona: Editorial Selecta, 1978), 121.

11. Victor Serge, *The Birth of Our Power*, trans. Richard Greenman (London: Writers and Readers Publishing Cooperative, [1931] 1977), 29.

12. Ibid.

13. Balcells, "Introduction," *Cataluña contemporánea II*, 15.

14. Valdour, *La vie ouvrière*, 123, 261.

15. Art historian Patricia Leighten discusses *Guitar* only cursorily, since it was the only collage of Picasso's that used a Spanish newspaper. But her discussion of his use of the French Republican mass-circulation newspaper *Journal* reinforces my own view that Picasso was certainly sympathetic to republican ideas in France and Barcelona. See *Re-Ordering the Universe*, 130, 177, n. 31.

16. Palau i Fabre, *Picasso in Catalonia*, 199.

17. Balcells, "Mujer obrera," 80; Balcells, "Introduction," *Cataluña contemporánea II*, 22, 24.

18. Balcells, "La población catalana en el siglo XX," in *Cataluña contemporánea II*, 61.

19. "Toros," *Diluvio* (morning edition), March 31, 1913, 19–24; ibid., April 28, 1913, 18–22.

20. Serge, *Birth of our Power*, 75; Paul Morand, "Catalan Nights," in *Fancy Goods: Open All Night*, preface and 1st intro. by Marcel Proust, 2d intro. by Breon Mitchell; trans. Ezra Pound (New York: New Directions [1921] 1984), 65–95.

21. "Madrid teatral. Blanquita Suárez," *Liberal* (evening edition), February 6, 1917, 2. Palau i Fabra (*Picasso in Catalonia*, 208) believes that the painting was done when both Picasso and Suárez were back in Barcelona in June. At that time, however, Picasso's somewhat prudish fiancée was with him; it seems unlikely that he would have taken her to see Suárez perform such skits as "The Island of Pleasures," "The Wonder of Damascus," and "The White Kitten." For work on English music halls and their role in shaping views about gender and society, see Judith R. Walkowitz, "Science and the Seance: Transgressions of Gender and Genre in Late Victorian London," *Representations*, no. 22 (Spring 1988): 3–22.

22. The revival of carnival as an important tourist attraction was newsworthy in Barcelona; see "El próximo carnaval," *Liberal* (evening edition), January

20, 1917, 1. Since Picasso's old friend Carles Junyer-Vidal published the *Liberal* and Picasso had done several drawings for it in 1902, he might well have glanced at it when he was in Barcelona. For a fuller discussion of carnival, see chapter 4, note 62.

23. "Fiestas de carnaval: Los bailes de máscaras, el del círculo artístico," *Liberal*, February 14, 1917, 1.

24. For discussions of the place of *Parade* in the development of avant-garde dance and modernism, see Lynn Garafola, *Diaghilev's Ballets Russes* (New York: Oxford University Press, 1989), 76, 93.

25. J. Sacs, "Picasso tuvo ayer un éxito: Sorprendió a todos; tal vez no maravilló a muchos," *Publicidad*, November 1, 1917, 3.

26. Richard Hayden Axom, *"Parade:* Cubism as Theater" (Ph.D. diss., University of Michigan, 1974); Douglas Cooper, *Picasso's Theatre* (New York: Harry N. Abrams, 1968), nos. 91–96; William Rubin, ed., *Picasso: A Retrospective* (Museum of Modern Art, New York) (Boston: New York Graphic Society, 1980), 197–198; P., "El cubismo en escena," *Publicidad*, November 1, 1917, 3; Joan Josep Tharrats, *Picasso i els artistes catalans en el ballet* (Barcelona: Edicions del Cotal, 1982), 38–39.

27. Jaime Brossa, "Pablo Picasso," *Diluvio* (morning edition), June 12, 1917, 9–10.

28. Sacs, "Picasso tuvo ayer un éxito . . . ," *Publicidad*, November 11, 1917, 3.

29. Serge, *Birth of Our Power*, 33.

30. Brossa, "Pablo Picasso," *Diluvio* (morning edition), June 12, 1917, 9.

31. "La fiesta de San Jorge," *Diluvio* (morning edition), April 24, 1917, 7; "Procesión de Corpus," *Diluvio* (morning edition), June 6, 1917, 8; "Procesiones," *Diluvio* (morning edition), June 17, 1917, 7.

32. "Movimiento obrero," *Diluvio* (morning edition), April 25, 1917, 7. The play appears in Santiago Rusiñol, *Teatre,* ed. Carme Arnau (Barcelona: Edicions 62, 1981), 127–201.

33. Gerald Meaker, *The Revolutionary Left in Spain, 1914–1923* (Stanford: Stanford University Press, 1974), 65–70; for detailed accounts of the rumblings in June 1917 by workers and the army defense committees, see "Movimiento obrero," *Diluvio,* June 2, 1917, 9; ibid. (morning edition), June 15, 1917, 10; ibid., June 23, 1917, 2; ibid., June 26, 1917, 10; ibid. (afternoon edition), June 26, 1917, 1.

34. Meaker, *Revolutionary Left,* 71–72.

35. Ametlla, *Memòries polítiques,* 380.

36. For coverage of the parliamentary assembly revolt, see *Imparcial,* July 1–August 4, 1917; "La actitud del gobierno frente a los asambleístas catalanes," ibid., July 10, 1917, 1; "El gobierno y los parlamentarios: La jornada política de ayer," ibid., July 20, 1917, 1; Meaker, *Revolutionary Left,* 73. There is a slight discrepancy between the newspaper accounts and the one Meaker offers, but since he has the benefit of hindsight, I have accepted his narrative of events.

37. A group picture taken at the reunion can be seen in Palau i Fabre, *Picasso in Catalonia,* 202.

38. "Barcelona," *Imparcial,* July 13, 1917, 2; ibid., July 20, 1917, 1.

39. Serge, *Birth of Our Power*, 55–56.

40. "Graves complicaciones: Sin previo aviso se acuerda para hoy la huelga general," *Imparcial*, August 13, 1917, 1.

41. Bueso, *Recuerdos de un cenetista*, 89.

42. Ibid., 80–84.

43. "En Barcelona," *Imparcial*, August 17, 1917, 2; "En provincias: Barcelona," ibid., August 18, 1917, 2; "Después de la huelga general: El día en provincias," ibid., August 19, 1917, 1; "En provincias: Barcelona," ibid., August 24, 1917, 2.

44. Cited in translation in Meaker, *Revolutionary Left*, 88.

45. "Prisión del diputado Marcelino Domingo," *Imparcial*, August 16, 1917, 1–2; Martín Maestre, *Huelga general*, 42.

46. See Luis Almeric [Clovis Eiméric], *La Rambla de Barcelona, su historia urban y sentimental*, Monografías históricas de Barcelona, no. 4 (Barcelona: Ediciones Millá, 1945); and Sempronio [Andrés Aveleno Artis], *Sonata a la Rambla* (Barcelona: Editorial Barna, 1961), for accounts of the downtown neighborhood during 1917.

47. Number designations in the following discussion are to Christian Zervos, "Courses de taureaux, Barcelone, 1917," in *Pablo Picasso: Oeuvres*, vol. 3: *1917–1919* (Paris: Editions *Cahiers d'Art*, 1949), 22–24. The following articles provide extraordinary insights about the place of the bullfight in Picasso's work: M. G., "Picasso taurómaco," *Du. Kulturelle Monatsschrift* (Zurich) 18, no. 8 (August 1958): 11–29; Henry de Montherlant, "Der erste Plan einer von Picasso illustrierten Luxusausgabe der 'Tauromaquia,'" ibid., 34–38, 58–60; and P. F. Allthaus, "Der Stierkampf," ibid., 55–56.

48. Morand, "Catalan Night," 85.

49. Meaker, *Revolutionary Left*, 94.

50. Ibid., 92; Bueso, *Recuerdos de un cenetista*, 101.

51. The statement was made by one of Barcelona's civil governors in a newspaper interview and cited in Joan del Pí, *Interpretació llibertaria*, 27.

52. The best account in English of how Spain responded to the Russian Revolution can be found in Meaker, *Revolutionary Left*, 99–132.

7. Urban Disorder and Cultural Resistance, 1919–1930

1. Sempronio [Andrés Aveleno Artís], "La reforma," in *Aquella entremaliada Barcelona*, 44–51, 49, 50.

2. Sempronio, "Santa Madrona de les drassanes," in ibid., 170–178. Francisco Madrid first gave the name Barrio Chino to the district, which runs roughly from the Rambla to the Parallel, in his collection *Sangre en Atarazanas*.

3. R. Draper Miralles, *Guía de la prostitución femenina en Barcelona* (Barcelona: Editorial Martínez Roca, 1982), 19–21.

4. Meaker, *Revolutionary Left*, 159.

5. Albert Balcells, *El sindicalisme a Barcelona (1916–1923)* (Barcelona: Edi-

torial Nova Terra, 1966), 67–119; Brenan, *Spanish Labyrinth*, 70–75; and Bueso, *Recuerdos de un cenetista*, 109–114.

6. *Correspondencia de España*, March 18, 1919, 4; Meaker, *Revolutionary Left*, 159–160.

7. Salut, *Vivers de revolucionaris*, 130–131.

8. Balcells, *Sindicalisme*, 76–78; *Correspondencia de España*, March 22, 1919, 5–6; Meaker, *Revolutionary Left*, 161–165.

9. Balcells, *Sindicalisme*, 74; Enric Ucelay Da Cal, *La Catalunya populista. Imatge, cultura i política en l'etapa republicana (1931–1939)* (Barcelona: Edicions de la Magrana, 1982), 70, stresses that the conflict was about the degree to which the state could intervene in disputes between workers and employers and whether the government could effectively force employers to recognize the union and its strike committee's right to negotiate for it.

10. Meaker, *Revolutionary Left*, 165–167. Despite this statement, Meaker blames revolutionaries in the CNT for the resumption of the strike, claiming that they were not content with the settlement and therefore decided to resume the work stoppage. Balcells and Brenan, however, disagree with Meaker about the CNT and what its goals were in early 1919. According to them, the CNT was remarkably disciplined and peaceful. See Balcells, *Sindicalisme*, 88–89; and Brenan, *Spanish Labyrinth*, 71.

11. *Correspondencia de España*, March 13, 1919, 4; ibid., March 17, 1919, 5.

12. Ibid., March 25, 1919, 6.

13. Historian Colin M. Winston has done much to dispel the belief that the Free Unions were merely the tools of employers. Many workers, including former CNT members, were genuinely opposed to the revolutionary tack of the CNT and wanted to defend their economic rights. Nevertheless, as Winston admits, the leadership of the Free Unions was always in the hands of right-wing critics of capitalism, if not directly in the employ of conservatives of the Regionalist League. See Winston, "Apuntes para la historia de los sindicatos libres de Barcelona (1919–1923)," *Revista estudios de historia social* 2–3 (1981): 119–139; his arguments are more fully developed in *Workers and the Right in Spain, 1900–1936* (Princeton: Princeton University Press, 1985).

14. "La cuestion social," *Diario de Barcelona* (morning edition), September 13, 1920, 6247; Sempronio, "Intermedí de la bomba del Pompeia," in *Barcelona era una festa* (Barcelona: Editorial Selecta, 1989), 103.

15. *Diario de Barcelona* (morning edition), September 16, 1920, 6256–6257.

16. Ibid. (afternoon edition), September 16, 1920, 6273.

17. "Entierro de las primeras victimas de la bomba," *Diario de Barcelona* (morning edition), September 17, 1920, 6282.

18. "La cuestion social," *Diario de Barcelona*, no. 262 (morning edition), September 19, 1920, 6336.

19. Ibid., September 20, 1920, 6356.

20. Ibid. (afternoon edition), September 16, 1920, 6273.

21. Ibid. (morning edition), September 21, 1920, 6364.

22. Meaker, *Revolutionary Left*, 334–35; "Atentado contra D. Francisco Layret," *Día gráfico*, December 1, 1920, 3.

23. "La ciudad del crimen," *Día gráfico,* December 1, 1920, 3.

24. "Enterrament d'en Layret," *Veu de Catalunya* (morning edition), December 3, 1920, 7.

25. There is no definitive biography of Salvador Seguí, but useful sources can be found in Huertas Clavería, *Salvador Seguí.* See also Salvador Seguí, *Escrits,* ed. Isidre Molas (Barcelona: Edicions 62, 1975).

26. "El atentado contra Ángel Pestaña," *Diluvio,* August 26–29, 1922.

27. Details about Seguí's last days and the response to his death can be found in "Últimos noticias—Atentado—Un muerto y dos heridos," *Diario de Barcelona* (morning edition), March 11, 1923, 1198; "Sigue la tragedia: Salvador Seguí cae muerto a balazos en la calle de la Cadena," *Diluvio,* March 11, 1923, 25–26; "El sábado fué a balazos," *Sol* (Madrid), March 12, 1923, 1; and "La muerte del 'Noy del sucre'," ibid., March 15, 1923, 3.

28. "La cuestion social: Paro general de 24 horas," *Diario de Barcelona* (morning edition), March 14, 1923, 1125–1126; Manent i Pesas, *Records d'un sindicalista,* 100–101.

29. Quoted in "Sigue la tragedia: El cadaver de Salvador Seguí es conducido inesperadamente, en un burgon, al cemeterio . . . ," *Diluvio* (morning edition), March 13, 1923, 15.

30. "Sigue la tragedia," *Diluvio* (morning edition), March 13, 1923, 14.

31. Ibid., 14–15; "Las luchas obreras," *Sol,* March 13, 1923, 1.

32. "La cuestion social," *Diario de Barcelona* (morning edition), March 14, 1923, 1226; Manent i Pesas, *Records d'un sindicalista,* 101–102.

33. "Sigue la tragedia," *Diluvio* (morning edition), March 14, 1923, 12.

34. Manent i Pesas, *Records d'un sindicalista,* 103–104; "Entierro de Francisco Comas (a) Peronas," *Diluvio* (morning edition), March 20, 1923, 11; "Los atentados obreros: Un documento de la Confederación Nacional del Trabajo," *Sol,* March 20, 1923.

35. Josep María Poblet, *El moviment autonomista a Catalunya dels anys 1918–1919* (Barcelona: Llibre de Butxaca, 1977), 21.

36. Ibid., 22.

37. Ibid., 72.

38. Ibid.

39. Ibid., 84.

40. Ferran Mascarell, "Conversa amb Enric Ucelay Da Cal: Macià, un politic sorprenent," *L'avenç,* no. 66 (December 1983): 33. Enric Ucelay Da Cal, the editor of *L'avenç,* Catalunya's leading popular historical journal, completed his doctorate at Columbia University in 1979 with a dissertation on Catalan nationalism in the period 1919–1933; see his "Estat català: The Strategies of Separation and Revolution of Catalan Radical Nationalism (1919–1933)" (Ph.D. diss., Columbia University, 1979), some material of which has been incorporated into the introduction of his *Catalunya populista.*

41. Poblet, *Moviment autonomista,* 84.

42. This is a gloss on the argument Ucelay Da Cal presents in Mascarell, "Conversa," 33.

43. Shlomo Ben-Ami, *The Origins of the Second Republic in Spain* (Oxford: Oxford University Press, 1978), 7–8; Raymond Carr, *Modern Spain, 1875–1980* (Oxford: Oxford University Press, 1980), 107–108. There has always

been the suspicion that many conservative Catalan nationalists, Puig i Cadafalch among them, actually conspired with Primo to seize power; see Melchor Fernández Almagro, *Catalanismo y la república española* (Madrid: Espasa-Calpe, 1932), 116–117.

44. Santiago Alba, *L'Espagne et la dictature. Bilan-prévisions-organisation de l'avenir* (Paris: Libraire Valois, 1930), 73–79; Fernández Almagro, *Catalanismo y la república española*, 118.

45. Carr, *Modern Spain*, 568–569.

46. Bueso, *Recuerdos de un cenetista*, 203.

47. Francesc Cambó was a Catalan with his eye clearly on national rather than regional power. He achieved even greater prominence in the Franco regime for helping bring the regime to power. See his *Memories (1876–1936)* (Barcelona: Editorial Alpha, 1981).

48. Bueso, *Recuerdos de un cenetista*, 213–214.

49. Ibid., 236–239, 244–246. For a summary of the testimonies and sentences in the Garraf trial, see "Vista de la causa por el atentado de las estación Garraf," *Sol*, April 30, 1926.

50. Quote appears in a flyer protesting against the Garraf trial, found in a collection of clandestine materials in the Historical Archive of the City of Barcelona (Institut Municipal d'Història, Casa de l'Ardiaca [hereafter cited as IMH]) in the album labeled *Col.lecció de fulls volanders* (1926).

51. Of the fifty handbills, clippings, and letters from this period that were being catalogued in 1980, most appear in the *Col.lecció de fulls volanders* (1925–1929) at the IMH. The tissue-paper messages, originally in a file labeled "Documentos clandestinos de la dictadura de Primo de Rivera," have been misplaced since 1980, when I saw them.

52. Tanyus, "La nit de Sant Joan," *Esquella de la Torratxa*, June 25, 1926, 426.

53. For further material on the planned uprising for Saint John's Day, see Manent i Pesas, *Records d'un sindicalista*, 106–109; Bookchin, *Spanish Anarchists*, 210–211.

54. *Col.lecció de fulls volanders* (1926); Bueso, *Recuerdos de un cenetista*, 239–40; Diego Abad de Santillán [Sinesio García Delgado], *Alfonso XIII, la II República, Francisco Franco (crónica general de España)* (Madrid: Ediciones Júcar, 1979), 109. For a recent analysis of the anarcho-syndicalist position under the dictator, see Susana Tavera, "Els anarchosindicalistes catalans i la dictadura," *L'avenç*, no. 72 (June 1984): 62–67.

55. Notices about the religious ceremonies associated with the Virgin of Mercy celebration can be found in *Diario de Barcelona* (morning edition), September 23, 1926, 5; and ibid. (morning edition), September 24, 1926, 5.

56. Bueso, *Recuerdos de un cenetista*, 240–241; Mascarell, "Conversa," 34–35.

57. Engelhardt, Raeburn, and Sada, "Chronology," *Homage to Barcelona*, 304. The German Pavilion and the Barcelona chair that Mies van der Rohe designed for it have had a lasting effect on the world of architecture and design.

58. Bookchin, *Spanish Anarchists*, 211–212.

59. The anagram, a typed three-inch-by-two-inch thin sheet of paper, without annotation, appeared in "Documentos clandestinos" in 1980.

8. Cultural Reactions to the Spanish Republic and the Civil War in Barcelona

1. For a discussion of intellectual life among Barcelona's artists at the turn of the century, see Leighten, *Re-Ordering the Universe*, 19–47; and John Richardson's *Life of Picasso*, vol. 1: 1881–1906, which appeared too late to be thoroughly assimilated in this book.

2. An unsurpassed analysis of the mural *Guernica* and Picasso's political views with respect to it can be found in Herschel B. Chipp, *Picasso's "Guernica": History, Transformations, Meanings* (Berkeley and Los Angeles: University of California Press, 1989). Chipp, Leighten, and Richardson, covering different periods of Picasso's work, are sure to establish models for research on Picasso for some time to come.

3. José Antonio González Casanova, *Federalismo y autonomía. Cataluña y el estado español, 1868–1938* (Barcelona: Editorial Crítica, 1979), 258.

4. John Brademas, *Anarco-sindicalismo y revolución en España, 1930–1937*, trans. Joaquín Romero Maura (Barcelona: Editorial Ariel, 1974), 87–91; Bookchin, *Spanish Anarchists*, 244. The two writers disagree about the level of violence used in the repression of the miners.

5. "El estatuto de Cataluña de septiembre de 1932," in Balcells, *Cataluña contemporánea II*, 103–107.

6. For a truly humane and thrilling evocation of a revolutionary time and place, see Jerome R. Mintz, *The Anarchists of Casas Viejas* (Chicago: University of Chicago Press, 1982). The eyewitness accounts of the massacre that overthrew the local commune can be found on pages 213–225.

7. Bookchin, *Spanish Anarchists*, 249–250.

8. Xavier Fàbregas' prologue to Ezequiel Vigués ["Didó"], *Teatre de putxinel.lis*, 61 Monografies de Teatre (Barcelona: Ediciones 62, 1975), 11–15.

9. Serrano Victori, "De Pedro Romeu al 'Didó,'" 7.

10. Joaquín de la Puente, *El "Guernica." Historia de un cuadro* (Madrid: Silex, 1985), 46.

11. Quoted and cited in Chipp, *Picasso's "Guernica,"* 87, 216.

12. Juan Ainaud de Lasarte, "Museu de arte de Cataluña," in *Museos de Barcelona* (Madrid: Patrimonio Nacional, 1972), 17. See drawings and descriptions in the *Liberal*, October 5, 1902, 2–3.

13. Lydia Gasman, "Mystery, Magic, and Love in Picasso, 1925–38: Picasso and the Surrealist Poets" (Ph.D. diss., Columbia University, 1981), 3:1028.

14. Sir Anthony Blunt was one of the first critics to recognize the importance that Romanesque art had for Picasso; see *Picasso's "Guernica"* (Oxford: Oxford University Press, 1969), 29–31. The 1931 article on medieval Catalan manuscripts appeared in Folch i Torres et al., "Les miniatures des commentaires aux apocalypse de Gerona et Seu d'Urgell," *Cahiers d'art* 6 (1931): 330–334, cited in Chipp, *Picasso's "Guernica,"* 216.

15. For discussions about the 1934 uprising, see Gabriel Jackson, *The Span-*

ish Republic and the Civil War, 1931–1939 (Princeton: Princeton University Press, 1967), 153–161; Felix Morrow, *Revolution and Counter-Revolution in Spain* (New York: Pathfinder Press, [1938] 1974), 30–32; José Peirats, *La CNT en la revolución española* (Paris: Ruedo Ibérico, 1974), 1:93–104; Paul Preston, *The Coming of the Spanish Civil War: Reform, Reaction, and Revolution in the Second Republic, 1931–36* (London: Macmillan, 1978), 127–132; Pamela Radcliff, "Community Politics: The Growth of Urban Radicalism in Gijón, 1900–1934" (Ph.D. diss., Columbia University, 1990), 649–670. As with other uprisings in Spain, it is hard to specify the number of those who participated or those who were wounded or died.

16. For assessments of the significance of Companys's declaration, see Fèlix Cucurull, *Catalunya, republicana i autònoma (1931–1936)* (Barcelona: Edicions de la Magrana/Institut Municipal d'Història, 1984), 234–250; Jackson, *Spanish Republic and Civil War*, 149–153; Edward E. Malefakis, *Agrarian Reform and Peasant Revolution in Spain: Origins of the Civil War* (New Haven: Yale University Press, 1970), 341–342; Hugh Thomas, *The Spanish Civil War* (New York: Harper/Colophon Books, 1961), 78–79; Ucelay Da Cal, *Catalunya populista*, 214–219.

17. Jackson, *Spanish Republic and Civil War*, 169–230; Preston, *Coming of the Spanish Civil War*, 169–172; Thomas, *Spanish Civil War*, 86–113.

18. A considerable amount of anecdotal information about Picasso's personal life can be found in the two books by Jaime Sabartés, *Picasso. Documents iconographiques*, trans. Felia Léal and Alfred Rosset (Geneva: Pierre Cailler, 1954), and *Picasso: An Intimate Portrait*. Sabartés's loyalty paid off in art. The secretary, always mindful of Barcelona, donated paintings from his personal collection to the city in 1968. The Picasso Museum, first officially known as the Sabartés Foundation, received the rest of Sabartés's collection at his death later that year; the collection has received additional donations from Picasso's family and collectors in Barcelona.

19. Cabanne, *Pablo Picasso*, 281; Rosa María Subiraná, "ADLAN and the Artists of the Republic," in *Homage to Barcelona*, 211–225.

20. Cabanne, *Pablo Picasso*, 282, 285.

21. Brenan, *Spanish Labyrinth*, 302, 309, 312; Stanley G. Payne, *Falange: A History of Spanish Fascism* (Stanford: Stanford University Press, 1961), 116–119.

22. For the first year of the war, see Ucelay Da Cal, *Catalunya populista*, 289–323.

23. George Orwell, *Homage to Catalonia* (New York: Penguin Books, [1937] 1977), 8–9.

24. Joan Amades, *Auques comentades* (Tárrega: F. Camps Cálmet, 1950); Joan Amades, *El pessebre* (Barcelona: Les Belles Edicions, 1950), 57, 91; R. Violant Simorra, *El arte popular español a través del Museo de Industrias i Artes Populares* (Barcelona: Editorial Aymà, 1953), 129, 133.

25. Sabartés, *Picasso. Documents iconographiques*, no. 83.

26. *Museu Picasso. Catàleg de pintura i dibuix*, 657–658; Sabartés, *Picasso: Documents iconographiques*, no. 83.

27. Georges Bloch, *Pablo Picasso: Catalogue of the Printed Graphic Work,*

1904–1967 (Bern: Kornfeld & Klipstein, 1971), 45; Bernhard Geiser, *Picasso. Peintre graveur* (Bern, privately printed, 1933), no. 135.

28. The definitive study of Guernica and how the press was manipulated by the Nationalists can be found in Herbert Routledge Southworth, *Guernica! Guernica! A Study of Journalism, Diplomacy, Propaganda, and History* (Berkeley and Los Angeles: University of California Press, 1977). Additional material can be found in Chipp, *Picasso's "Guernica,"* 38–43.

29. G. L. Steer, "From the Tree of Gernika," in *And I Remember Spain,* ed. Murray A. Sperber (New York: Macmillan, 1974), 271.

30. Chipp, *Picasso's "Guernica,"* 40.

31. Penrose, *Picasso,* 266.

32. Josep María Brincall, *Política económica de la Generalitat (1936–1939). Evolució i formes de la producció industrial* (Barcelona: Edicions 62, 1970); Ronald Fraser, *Blood of Spain: An Oral History of the Spanish Civil War* (New York: Pantheon Books, 1979), 213–236; Frank Mintz, *L'autogestion dans l'Espagne revolutionnaire* (Paris: Editions Belibaste, 1970), 51–61, 78–91.

33. "International Committee for Application of the Agreement Regarding Non-Intervention in Spain. Resolution Relating to the Scheme of Observations of the Spanish Frontiers by Land and Sea, Adopted at London, March 8, 1937," *American Journal of International Law* (Concord, N.H.) 31 (1937), suppl., 163–179; Douglas Little, *Malevolent Neutrality: The United States, Great Britain, and the Origins of the Spanish Civil War* (Ithaca: Cornell University Press, 1985).

34. Burnett Bolleten, *The Grand Camouflage: The Communist Conspiracy in the Spanish Civil War* (New York: Praeger, 1961), expanded as *The Spanish Revolution: The Left and the Struggle for Power During the Spanish Civil War* (Chapel Hill: University of North Carolina Press, 1979); David Tredwell Cattell, *Communism and the Spanish Civil War* (Berkeley and Los Angeles: University of California Press, 1955); David Tredwell Cattell, *Soviet Diplomacy and the Spanish Civil War* (Berkeley and Los Angeles: University of California Press, 1957); Sam Dolgoff, *The Anarchist Collectives: Workers' Self-Management in the Spanish Revolution, 1936–1939* (New York: Free Life, 1974); Morrow, *Revolution and Counter-Revolution,* 140–164; Bertram David Wolfe, *The Civil War in Spain,* with appendix by Andreas Nin (New York: Workers Age, 1937). A recent fictional account from an anti-Stalinist perspective can be found in Stephen Hunter, *The Spanish Gambit* (New York: Crown, 1985).

35. Manuel Azaña, *Memorias políticas y de guerra,* vol. 2 (Barcelona: Editorial Crítica, 1980), 23; Pierre Broue and Emile Temime, *The Revolution and the Civil War in Spain,* trans. Tony White (Cambridge, Mass.: MIT Press, 1970), 282; Morrow, *Revolution and Counter-Revolution,* 142–159; Juan Augusto Marichal, *La vocación de Manuel Azaña* (Madrid: Alianza, 1982), 238–240, on the May Days; Peirats, *La CNT* 2:137–173.

36. "La Fiesta del Trabajo," *Diluvio,* May 1, 1931, 30.

37. Rudolf Arnheim, *The Genesis of a Painting: Picasso's "Guernica"* (Berkeley and Los Angeles: University of California Press, 1980), 30–41; Blunt, *Picasso's "Guernica,"* 29–31.

38. Arnheim, *Genesis of a Painting,* 42–45. See also Josep Palau i Fabre, *El*

"Guernica" de Picasso (Barcelona: Editorial Blume, 1979); and Chipp, *Picasso's "Guernica,"* for color prints of studies for *Guernica.*

39. For events leading up to the May Days and their aftermath, see Broue and Temime, *Revolution and Civil War,* 285; "Para ganar la guerra y hundir el fascismo," *Día gráfico,* May 6, 1937; Peirats, *La CNT en la revolución española* 2:137–173; and Josep María Solé i Sabaté and J. Villarroya i Font, *La repressió a la reraguardia de Catalunya (1936–1939)* (Barcelona: Publicaciones de l'Abadia de Montserrat, 1989), 1:204–206, 212–216.

40. Since Picasso was reading *Ce soir* and *Figaro* during the spring of 1937 (according to Chipp, *Picasso's "Guernica,"* 40), he may have read in *Figaro* on May 6, 1937, that there had been extraordinary violence throughout the city, followed on May 9 with the information that all the barricades were down in Barcelona and the city was back to normal.

41. Blunt, *Picasso's "Guernica,"* 33.

42. The May 9 sketch of the composition for *Guernica* was filled with clenched fists, which Chipp says Picasso rejected because they were emblematic Communist symbols. The Popular Front, though certainly dominated by Communists, commanded more widespread support. Not all of the people discussed here or those who voted for the Popular Front in France in 1935 or Spain in 1936 were Communists, but they did give the clenched fist as their salute. Even with this more ample view of what the fist stood for, there is reason, as Chipp claims, for Picasso to think that it was far too specific a symbol for his purposes. See *Picasso's "Guernica,"* 96–98.

43. Arnheim, *Genesis of a Painting,* 80.

44. Blunt was the first to notice that the drawing of the bull Picasso did in May evoked images from an eleventh-century Romanesque manuscript of Saint Luke's bull; see *Picasso's "Guernica,"* 54–55; also Chipp, *Picasso's "Guernica,"* 87, 216.

45. Marcel Durliat, *L'art catalan* (Paris: Arthaud, n.d.), opp. 156; Zervos, *Art de la Catalogne,* pl. LXX.

46. See Zervos, *Art de la Catalogne,* pls. LXVI, for an apochryphal animal covered with eyes, and LXXIV, for the lamb with seven eyes.

47. Fernández Almagro, *Catalanismo y la república española,* 21.

48. Stephen Spender, "Guernica," in *And I Remember Spain: A Spanish Civil War Anthology,* ed. Murray A. Sperber (New York: Macmillan, 1974), 151–152.

Epilogue: Cultural Resistance in the Aftermath

1. Estimates of the numbers killed between 1939 and 1945 have varied widely. The most accurate figures appear in Josep M. Solé i Sabaté, *La repressió franquista a Catalunya, 1938–1953* (Barcelona: Edicions 62, 1985), 530–536.

2. Quoted in Josep Benet, *Cataluña bajo el regimen franquista* (Barcelona: Editorial Blume, 1979), 243.

3. For the pall the threat of spying set over student life, see the recollection of Jacint Raventós, son of Picasso's friend Dr. Cinto Raventós, in José Yglesias, *The Franco Years: The Untold Human Story of Life Under Spanish Fascism* (Indianapolis: Bobbs-Merrill, 1977), 225–226.

4. Benet, *Cataluña*, 235–236.

5. Javier Villán and Felix Población, *Culturas en lucha catalana* (Madrid: Editorial Swan, 1980), 37.

6. Ibid., 38.

7. Jordi Borja de Riquer i Permanyer, "Rebuig, passivitat i suport: Actituds polítiques catalanes davant el primer Franquisme (1939–1950)," in *Franquisme. Sobre Resistència i consens a Catalunya (1938–1959)*, Centre de Treball i Documentació, Prologue by Ramon Garrabou, Joaquim Lleixà, and Octavi Pellissa (Barcelona: Editorial Crítica, 1990), 189.

8. Ibid., 192.

9. Nicolás Sartorius, *El resurgir del movimiento obrero*, Colección "Primero de Mayo," no. 2 (Barcelona: Editorial Laia, 1975).

10. Juan Pablo Fusi, "La reaparición de la conflictividad en la España de los sesenta," in *España bajo el Franquismo*, ed. Josep Fontana (Barcelona: Editorial Crítica, 1986), 167.

11. José-Francisco Ivars, "Arte," in *La cultura bajo el Franquismo*, ed. Carlos Castilla del Pino (Barcelona: Ediciones del Bolsillo, 1977), 208.

12. Quoted in Raymond Carr and Juan Pablo Fusi, *Spain: Dictatorship to Democracy* (London: George Allen & Unwin, 1979), 117.

13. Yglesias, *Franco Years*, 235–236.

14. Villán and Población, *Culturas en lucha catalana*, 59.

15. See especially Stuart Hall, "Notes on Deconstructing 'The Popular,'" in *People's History and Socialist Theory*, ed. Raphael Samuel (London: Routledge & Kegan Paul, 1981), 227–240; and Raymond Williams's essays in *Resources of Hope: Culture, Democracy, Socialism*, ed. by Robin Gable (New York: Verso, 1989).

Bibliography

Primary Sources

ARCHIVES

Arxiu Mas, Barcelona
Avery Memorial Architectural Library, Columbia University, New York
Biblioteca Pública, Arús, Barcelona
Biblioteca de Catalunya
Depósito. (City Registry)
 Depósito Secre 184-92: Gracia. Expediente referente a la asistencia del
 Ayuntamiento constitucional de la Villa de Gracia, Gobernación 1892,
 núm. 987-214.
 Expediente "Procesión del Corpus de este año."
Institut del Teatre, C.E.D. A.E.C., Palau Güell, Barcelona
Institute of Fine Arts, New York University
Institut Municipal d'Història, Casa de l'Ardiaca (IMH)
International Institute for Social History, Amsterdam
 Manuel Buenacasa Papers
 Max Nettlau Collection and Correspondence
 Periodicals Collection
Museu Picasso, Barcelona
New York Public Library

NEWSPAPERS AND PERIODICALS

L'avenç (Barcelona)
La campana de Gracia (Barcelona)

237

Ce soir (Paris)
Convivium (Barcelona)
La correspondencia de España (Madrid)
La cuña. Periodico defensor de los obreros del ramo de elabora madera de España (Barcelona)
El día gráfico. Diario republicano (Barcelona)
Diario de Barcelona
El diluvio (Barcelona)
Du. Kulturelle Monatsschrift (Zurich)
La época (Madrid)
L'esquella de la torratxa (Barcelona)
La hormiga de oro. Ilustración católica (Barcelona)
Ilustración catalana (Barcelona)
El imparcial (Madrid)
El liberal (Barcelona)
Miscellanea barcinonensia (Barcelona)
El poble català (Barcelona)
El porvenir del obrero (Mahón)
El productor (Barcelona)
La publicidad (Barcelona)
Revista de la Asociación Artístico-Arqueológica-Barcelonesa (Barcelona)
Revista estudios de historia social (Madrid)
El socialista (Madrid)
El sol (Madrid)
El teatre català (Barcelona)
Tierra y libertad (Madrid)
El trabajo (Sabadell)
La tramontana (Barcelona)
La tribuna (Madrid)
La veu de Catalunya (Barcelona)
La voz del pueblo (Tarrasa)

BOOKS AND ARTICLES

Almanaque del "Diario de Barcelona" para el año 1910. Barcelona: Imprenta Barcelonesa, 1909.
Almanaque del "Diario de Barcelona" para el año 1919. Barcelona: Imprenta del Diario de Barcelona, 1919.
Almanaque de "Tierra y Libertad" para 1914. Barcelona: Imprenta Germinal, 1914.
Ametlla, Claudi. *Memòries polítiques, 1890–1917*. Barcelona: Editorial Portic, 1963.
Anguera de Sojo and Umberto Verderau y Vellvé. *Bases para la redacción de un reglamento de la prostitución en España. Presentadas a la Academia de Higiene de Cataluña*. Barcelona: Imprenta F. Badia Cantens, 1911.

Armand, E. *La prostitution et ses multiples aspects.* Paris: Editions de l'En Dehors, 1933.

Aymar y Puig, José. *Memorias inéditas de la procesión de Corpus.* Barcelona, 1900.

Azaña, Manuel. *Memorias políticas y de guerra.* Vol. 2. Barcelona: Editorial Crítica, 1980.

Barcelona. Museo arqueológico municipal. *Catálogo de la exposición de arte antiguo, publicado por la junta municipal de museos y bellas artes.* Edited by Carlos de Bofarull y Sans. Barcelona: Reproducciones Artísticos Tomás, 1902.

Barcelona. Museo Provincial de Antiguedades. *Catálogo de Museo provincial de antiguedades.* Edited by Antonio Elías de Molins. Barcelona: Imprenta Barcelonesa, 1888.

de Boer, Josephine. "Rusinyol, the Writer." *Spanish Review* 4, nos. 1, 3–4 (March 1936–April 1937): 1–23.

Cabañas Guevara, Luis. *Biografía del Paralelo, 1894–1934. Recuerdos de la vida teatral, mundana y pintoresca del barrio mas jaranero y bullicioso de Barcelona.* Barcelona: Ediciones Memphis, 1945.

Cambó, Francesc. *Memories (1876–1936).* Barcelona: Editorial Alpha, 1981.

Carnaval de Barcelona 1917. La restauración del carnaval barcelonés. El carnaval a través de la historia. Recuerdos del antiguo carnaval de Barcelona. Barcelona: Companía Española de Artes Gráficas, 1917.

Curet, Francesc. "Carnestoltes a Barcelona en el segle XIX." *Teatre català* (Barcelona) 4, no. 155 (February 13, 1915): 119–124.

Darío, Rubén. *España contemporánea.* Paris: Garnier, 1901.

Domenech de Cañellas, María, *Constitución y finaldad de la Federación sindical de obreras.* Barcelona: Protectorado de la Federación Sindical, [1912].

Exposición internacional, Barcelona: Diario oficial 1, nos. 26–32 (September 7–October 12, 1929).

Farnés, Sebastià. *Sebastià Farnés: Articles catalanistes (1888–1891).* Edited by Jordi Llorens i Vila. Barcelona: Edicions 62, 1982.

Fernández Almagro, Melchor. *Catalanismo y la república española.* Madrid: Espasa-Calpe, 1932.

Festa Modernista del Cau Ferrat. Tercer any. Certamen literari celebrat à Sitges el 4 [9?] de noviembre de 1894. Barcelona: Tipografía *L'Avenç*, 1895.

Gelée-Bertal, A. *Guide à Barcelone.* Barcelona: Librairie Française, 1896.

Generalitat de Catalunya. Departament de cultura. Les noves institucions jurídiques i culturals per a la dona. Barcelona: Institut Gráfica Oliva de Vilanova, 1937.

González Castro, José. *El trabajo de la mujer en la industria.* Madrid: Instituto de Reformas Sociales, 1914.

González Sugrañés, Miguel. *La república en Barcelona. Apuntes para una crónica.* 2d ed. Barcelona: Imprenta de Henrich, 1903.

Gual, Adrià. "Els putxinel.lis." *Teatre català* 1, no. 6 (August 24, 1912): 9–10.

Gumá, C. "Un escultor de sants." In *Fruyta agre-dolsa,* 3d ser., 77–79. Barcelona: Llibrería de I. López, [1895?].

La huelga general de Barcelona. Verdadera relación de los sucesos desarrollados con

motivo del paro general en Barcelona durante la octava semana de este año por un testigo ocular. Barcelona: Imprenta de Pedro Toll, 1902.

Instituto de Reformas Sociales. *Informes de los inspectores del trabajo sobre la influencia de la guerra europea en las industrias españolas (1917–1918).* Madrid: IRS, 1919.

"International Committee for Application of the Agreement Regarding Non-Intervention in Spain. Resolution Relating to the Scheme of Observations of the Spanish Frontiers by Land and Sea, Adopted at London, March 8, 1937." *American Journal of International Law* (Concord, N.H.) 31 (1937), suppl., 163–179.

López, Guillermo. *Barcelona sucia. Artículos de malas costumbres. Registro de higiene.* Barcelona: Tipográfico Sucesores de F. Sánchez, n.d.

Lorenzo, Anselmo, *Las olimpiadas de la paz y el trabajo de mujeres y niños.* Madrid: Imprenta de Antonio Marzo, 1900.

Manent i Pesas, Joan. *Records d'un sindicalista llibertari català, 1916–1943.* Paris: Edicions Catalanes de París, 1976.

Memoria de los años 1911 y 1912. Barcelona Junta Provincial de Protección a la Infancia Represión de la Mendicidad, 1913.

Miravittles, Jaume. *Crítica del 6 d'octubre i amb un comentari de Lluís Companys.* Barcelona: Publicacions Aceri, 1935.

Molins, José Elías de. *La obrera en Cataluña, en la ciudad y en el campo. Orientaciones sociales.* Barcelona: Imprenta Barcelonesa, [1915].

Moncerdà de Macià, Dolors. *Conferencia sobre l'Acció Católica social femenina.* Barcelona: L'Acció Católica, 1910.

Pestaña, Ángel. *Terrorismo en Barcelona (Memorias inéditas).* Edited with a prologue by Xavier Tusell and Genoveva García Queipo de Llano. Barcelona: Editorial Planeta, 1979.

———. El terrorismo en Barcelona seguido de principios, medios y fines del sindicalismo comunista (Speech given at conference held in Madrid, October 4, 1919). Palma, Mallorca: Pequeña Biblioteca Calamus Scriptorius, 1978.

Pestaña, Ángel, and Salvador Seguí. *El sindicalismo en Cataluña* (Speech given at conference held in Madrid, October 4, 1919). Palma, Mallorca: Pequeña Biblioteca Calamus Scriptorius, 1978.

"Preparación de un proyecto de ley sobre el trabajo a domicilio." In *Instituto de Reformas Sociales: Secciones técnicas administrativas.* Madrid: Sobrinos de las Sucesores de los Rios, 1918.

"La reforma de Barcelona. La Gran Via A." *Illustración catalana* (Barcelona). March 15, 1908 (special issue).

Reig y Vilardell, José. *Barcelona en el siglo XIX (Dietario de la ciudad).* 4 vols. Barcelona: Imprenta de *La Publicidad,* 1898.

Rusiñol, Santiago. "La muerte de carnaval." In *Obres completes. Novel.les i teatre,* 2d. ed., edited by Donald Samuel Abrams, 1:1945–1947. Barcelona: Editorial Selecta, 1953.

———. "El pintor de miracles. Sainet en un acte." In *Obres completes. Novel.les i teatre,* 3d ed., edited by Donald Samuel Abrams, 1:757–769. Barcelona: Editorial Selecta, 1973.

———. *Santiago Rusiñol per ell mateix*. Edited by Ramón Planes. Barcelona: Edicions 62, 1971.

———. *Teatre*. Edited by Carme Arnau. Barcelona: Edicions 62, 1981.

———. "El Titella pròdig. Comèdia de Putxinel.lis en un acte i quatre quadros." In *Obres completes. Novel.les i teatres*, 3d ed., edited by Donald Samuel Abrams, 1:479–490. Barcelona: Editorial Selecta, 1973.

Salut, Emili. *Vivers de revolucionaris. Apunts històrics del districte cinquè*. Barcelona, Llibreria Catalònia, 1938.

Sastre, Miguel. *Las huelgas en Barcelona y sus resultados durante el año 1905*. Barcelona: Establecimiento Tipográfico *La Hormiga de Oro*, 1906.

———. *Huelgas de 1910, 1911, 1912, 1913, 1914*. Barcelona: Establecimiento Tipográfico *La Hormiga de Oro*, 1914.

Seguí, Salvador. *Escrits*. Edited by Isidre Molas. Barcelona: Edicions 62, 1975.

———. *Escuela de rebeldía. Historia de un sindicalista*. Madrid: Rivadeneyra, 1923.

Sereñana y Partagás, Don Prudencio. *La prostitución en la ciudad de Barcelona, estudiada como enfermedad social y considerada como orígen de otras enfermedades dinámicas, orgánicas y morales de la población barcelonesa*. Barcelona: Imprenta de los Sucesores de Ramierez, 1882.

Tárrida del Mármol, F. *Les inquisiteurs d'Espagne*. 2d ed. Paris: Stock, 1897.

Valdour, Jacques. *La vie ouvrière. L'ouvrier espagnol*. Vol. 1: *Catalogne*. Paris: Arthur Rousseau, 1919.

Vigués, Ezequiel ["Didó"]. *Teatre de putxinel.lis*. Prologue by Xavier Fàbregas. Publicacions de l'Institut del Teatre. Barcelona: Edicions 62, 1975.

Wolfe, Bertram David. *The Civil War in Spain*. Appendix by Andreas Nin. New York: Workers Age, 1937.

Zervos, Christian. *L'art de la Catalogne de la seconde moitié du neuvième siècle à la fin du quinzième siècle*. Paris: Editions *Cahiers d'Art*, 1937.

Secondary Sources

GENERAL

Abad de Santillán, Diego [Sinesio Garcia Delgado]. *Alfonso XIII, la II República, Francisco Franco*. Madrid: Ediciones de Júcar, 1979.

———. *Contribución a la historia del movimiento obrero español. Desde sus orígenes hasta 1905*. Mexico City: Editorial Cajica, 1962.

Ainaud de Lasarte, Juan. "Museu de arte de Cataluña." In *Museos de Barcelona*, 14–31. Madrid: Patrimonio Nacional, 1972.

Alba, Santiago. *L'Espagne et la dictature. Bilan-prévisions-organisation de l'avenir*. Paris: Libraire Valois, 1930.

Albornoz, Alvaro de. *El partido republicano. Las doctrinas republicanas en España y sus hombres. La revolución del 1868 y la república del 73. Los republica-*

nos después de la Restauración. La crisis del republicanismo. Madrid: Biblioteca Nueva, 1918.

Alcalde, Carmen. *La mujer en la guerra civil española.* Madrid: Cambio 16, 1976.

Alexander, Sally, Anna Davin, and Eve Hostettler. "Labouring Women: A Reply to Eric Hobsbawm." *History Workshop* 8 (Autumn 1979): 174–182.

Almeric, Luis [Clovis Eiméric]. *El hostal, la fonda, taberna y el café en la vida Barcelonesa.* Barcelona: Librería Millá, 1945.

———. *La Rambla de Barcelona, su historia urban y sentimental.* Monografías históricas de Barcelona, no. 4. Barcelona: Ediciones Millá, 1945.

Álvarez Junco, José. *El emperador del paralelo. Lerroux y la demagogia populista.* Madrid: Alianza Editorial, 1990.

———. *La ideología política del anarquismo español (1868–1910).* Madrid: Siglo Veintiuno Editores, 1976.

Amades, Joan. *Auques comentades.* 3 vols. Tárrega: F. Camps Cálmet, 1950.

———. *El carnestoltes a Barcelona el segle XIX.* Biblioteca de Tradicions Populars, sér. A, vol. 12. Barcelona: Imprenta la Neotipia, 1934.

———. "The Catalan Puppets." Translated by H. V. Tozer. In *Catalan Puppetry,* 1–17. Columbus, Ohio: Puppeteers of America, 1944.

———. *Custumari català.* Vol. 2: *Les carnestoltes–la quaresma.* Barcelona: Editorial Salvat, 1951.

———. *Custumari català.* Vol. 3: *El curs de l'any. Corpus-primavera.* Barcelona: Editorial Salvat, 1952.

———. *Els ex-vots.* Barcelona: Editorial Orbis, 1952.

———. *Gegants, nans i altres entremesos.* Barcelona: Imprenta la Neotipia, 1934.

———. *El pessebre.* Barcelona: Les Belles Edicions, 1950.

———. *Titelles i ombres xineses.* Biblioteca de Tradicions Populars, sér. A, vol. 8. Barcelona: Imprenta la Neotipia, 1933.

Andersen, Benedict. *Invisible Communities: Reflections on the Origin and Spread of Nationalism.* New York: Penguin Books, 1986.

Aragón Fernández, Antonio. *La festividad del Corpus Christi en Barcelona.* Barcelona: Librería de la Tipografía Católica Pontificia, 1925.

Balcells, Albert. *El arraigo del anarquismo en Cataluña. Textos de 1926–1934.* Crónica General de España. Madrid: Editorial Júcar, 1979.

———. *Cataluña contemporánea II (1900–1939).* Madrid: Siglo Veintiuno Editores, 1979.

———. *Crisis económica y agitación social en Cataluña de 1930 a 1936.* Barcelona: Instituto Católico de Estudios Sociales de Barcelona/Editorial Ariel, 1971.

———. "La mujer obrera en la industria catalana durante el primer cuarto del siglo XX." In *Trabajo industrial y organización obrera en la Cataluña contemporánea (1900–1936),* 7–121. Barcelona: Editorial Laia, 1974.

———. *El sindicalisme a Barcelona (1916–1923).* Barcelona: Editorial Nova Terra, 1966.

————, ed. *Teoría y práctica del movimiento obrero en España (1900–1936)*. Valencia: Fernando Torres, 1977.

Barey, Andre. *Barcelona: De la ciutat pre-industrial al fenomen modernista*. Translated by Joaquim Martí. Barcelona: La Gaya Ciencia, n.d.

Ben-Ami, Shlomo. *Fascism from Above: The Dictatorship of Primo de Rivera in Spain, 1923–1930*. Oxford: Clarendon Press, 1983.

————. *The Origins of the Second Republic in Spain*. Oxford: Oxford University Press, 1978.

Benet, Josep. *Cataluña bajo el regimen franquista*. Barcelona: Editorial Blume, 1979.

————. *Maragall i la Setmana Tràgica*. Barcelona: Edicions 62, 1965.

Berger, John. "The Nature of Mass Demonstrations." *New Society*, May 23, 1968, 754–755.

Boatwright, Dorsey, and Enric Ucelay Da Cal. "La dona del 'Barrio Chino.'" *L'avenç* (Barcelona), no. 76 (November 1984): 26(870)–34(878).

Bolleten, Burnett. *The Grand Camouflage: The Communist Conspiracy in the Spanish Civil War*. New York: Praeger, 1961. Expanded as *The Spanish Revolution: The Left and the Struggle for Power During the Spanish Civil War*. Chapel Hill: University of North Carolina Press, 1979.

Bookchin, Murray. *The Spanish Anarchists: The Heroic Years, 1868–1936*. New York: Harper & Row, 1977.

Borja de Riquer i Permanyer, Jordi. *Lliga regionalista. La burgesia catalana i el nacionalisme (1898–1904)*. Barcelona: Edicions 62, 1977.

————. "Rebuig, passivitat i suport: Actituds polítiques catalanes davant el primer Franquisme (1939–1950)." In *Franquisme. Sobre resistència i consens a Catalunya (1938–1959)*, 179–193. Centre de Treball i Documentació. Prologue by Ramon Garrabou, Joaquim Lleixà, and Octavi Pellissa, Barcelona: Editorial Crítica, 1990.

Brademas, John. *Anarco-sindicalismo y revolución en España, 1930–1937*. Translated by Joaquín Romero Maura. Barcelona: Editorial Ariel, 1974.

Brenan, Gerald. *The Spanish Labyrinth: An Account of the Social and Political Background of the Spanish Civil War*. Cambridge: Cambridge University Press, [1943] 1967.

Bridenthal, Renate, and Claudia Koonz, eds. *Becoming Visible: Women in European History*. Boston: Houghton Mifflin, 1977.

Bridenthal, Renate, Claudia Koonz, and Susan Mosher Stuard, eds. *Becoming Visible: Women in European History*. 2d ed. Boston: Houghton Mifflin, 1987.

Brincall, Josep María. *Política económica de la Generalitat (1936–1939). Evolució i formes de la producció industrial*. Barcelona: Edicions 62, 1970.

Broue, Pierre, and Emile Temime. *The Revolution and the Civil War in Spain*. Translated by Tony White. Cambridge, Mass.: MIT Press, 1970.

Brown, Jonathan, et al. *El Greco of Toledo*. Exhibition organized by the Toledo Museum of Art with the Museo del Prado, the National Gallery of Art, and the Dallas Museum of Fine Arts. Boston: Little, Brown, 1982.

Bueso, Adolfo. *Como fundamos la CNT*. Barcelona: Editorial Avance, 1976.

————. *Recuerdos de un cenetista. De la Semana Trágica (1909) a la Segunda República (1931)*. Barcelona: Editorial Ariel, 1976.

Buenacasa, Manuel. *El movimiento obrero español. Historia y crítica, 1886–1926. Figuras ejemplares que conocí*. Paris (privately printed), 1966.

Caballé y Clos, Tomás. *Costumbres y usos de Barcelona. Narraciones populares*. Barcelona: Editorial Seguí, 1947.

Capdevila, Lluís. *De la Rambla a la presó*. Barcelona: Edicions la Paraula Viva, 1974.

Capdevila, Carles. "Joaquim Mir." *Art* (Barcelona) 2 (1935): 93–98.

————. "Santiago Rossinyol." *Revista de Catalunya* 13, no. 70 (June 1931): 489–492.

Capmany, Aurelio. *Calendari de llegendes, costums i festes tradicionals catalanes. Juny, juliol, agost*. Barcelona: Editorial Laia, 1978.

Cardó, Carles. "La obra." In *Llibre de la Mare de Déu de la Mercè*, edited by Marià Manent, 55–127. Barcelona: Editorial Selecta, 1950.

Carles, Domingo. "La obra de Isidro Nonell." In *Memorias de un pintor*, 87–90. Barcelona: Ediciones Destino, 1944.

Carr, Raymond. *Modern Spain, 1875–1980*. Oxford: Oxford University Press, 1980.

Carr, Raymond, and Juan Pablo Fusi. *Spain: Dictatorship to Democracy*. London: George Allen & Unwin, 1979.

Carreras Candi, Francesc. "Les processions de Captius a la Ciutat." In *Llibre de la Mare de Déu de la Mercè*, edited by Marià Manent, 135–140. Barcelona: Editorial Selecta, 1950.

Casanelles, E. *Antonio Gaudí*. Greenwich, Conn.: New York Graphic Society, 1965.

Castellanos, Jordi. "Aspectes de les relacions entre intel.lectuals i anarquistes a Catalunya al segle XIX (A propòsit de Pere Coromines)." *Els maigs* (Barcelona) 6 (1976): 7–28.

Castells, Joan. "Titelles avui. II Festival de titelles de Barcelona." *Serra d'or* (Barcelona), 1974, 469–471.

Castells, Manuel. *The City and the Grassroots*. Berkeley and Los Angeles: University of California Press, 1983.

————. *Ciudad, democracia y socialismo. La experiencia de las asociaciones de vecinos en Madrid*. Madrid: Siglo Veintiuno Editores, 1977.

Castilla del Pino, Carlos, ed. *La cultura bajo Franquismo*. Barcelona: Ediciones del Bolsillo, 1977.

Castillo, Alberto del. *De la puerta del Angel a la plaza de Lesseps. Ensayo de la biología urbana, 1821–1945*. Barcelona: Dalmau, 1945.

Cattell, David Tredwell. *Communism and the Spanish Civil War*. Berkeley and Los Angeles: University of California Press, 1955.

————. *Soviet Diplomacy and the Spanish Civil War*. Berkeley and Los Angeles: University of California Press, 1957.

Cavell, Stanley. *The World Viewed: Reflections on the Ontology of Film*. Cambridge, Mass.: Harvard University Press, 1979.

Cervera, Joseph Philip. *Modernismo: The Catalan Renaissance of the Arts*. New York: Garland, 1976.

Chaet, Bernard. *Artists at Work*. Cambridge, Mass.: Webb Books, 1960.

Christian, William, Jr. *Apparitions in Late Medieval and Renaissance Spain*. Princeton: Princeton University Press, 1981.

————. *Religion in Sixteenth-Century Spain*. Princeton: Princeton University Press, 1981.

Contractor, M. R., ed. *Les grans tradicions populars. Ombres i titelles*. Paris: Arthaud, 1977.

Cuadrat, Xavier. *Socialismo y anarquismo en Cataluña (1899–1911). Los orígenes de la CNT*. Madrid: Ediciones de la Revista de Trabajo, 1976.

Cucurull, Fèlix. *Catalunya, republicana i autònoma (1931–1936)*. Barcelona: Edicions de la Magrana, Institut Municipal d'Història, 1984.

Dalmau, Antonio R. *El circo en la vida barcelonesa. Crónica anecdótica de cien años circenses*. Barcelona: Librería Millá, 1947.

Davis, Natalie Zemon. "The Reasons of Misrule." In *Culture and Society in Seventeenth-Century France*, 97–123. Stanford: Stanford University Press, 1975.

De Grazia, Victoria. *The Culture of Consent: Mass Organization of Leisure in Fascist Italy*. Cambridge: Cambridge University Press, 1981.

Diccionari biogràfic. 4 vols. Barcelona: Editorial Albertí, 1969–1970.

Dijkstra, Bram. *Idols of Perversity: Fantasies of Feminine Evil in Fin-de-Siècle Culture*. New York: Oxford University Press, 1988.

Dolgoff, Sam. *The Anarchist Collectives: Workers' Self-Management in the Spanish Revolution, 1936–1939*. New York: Free Life, 1974.

Draper Miralles, R. *Guía de la prostitución femenina en Barcelona*. Barcelona: Editorial Martínez Roca, 1982.

Douglas, Mary. *Purity and Danger: An Analysis of the Concepts of Pollution and Taboo*. Boston: Arc, [1966] 1984.

Duarte, Ángel. *El republicanism català a la fi del segle XIX*. Vic: Editorial Eumo, 1987.

Duchârtre, Pierre Louis. *The Italian Comedy*. New York: Dover, [1929] 1966.

Durliat, Marcel. *L'art catalan*. Paris: Arthaud, n.d.

Edwards-Ballo, Joaquín. *El nacionalismo continental. Crónicas chilenas*. Madrid: Imprenta Hernández y Gallo Saez, 1925.

Elliott, J. H. *The Revolt of the Catalans*. New York: Cambridge University Press, 1963.

Elorza, Antonio, Luis Arranz, and Fernando del Rey. "Liberalismo y corporativismo en la crisis de la Restauración." In *La crisis de la Restauración. España entre la primera guerra mundial y la II República*, edited by J. L. García Delgado, 5–50. Second Segovian Colloquium on the Contemporary History of Spain, directed by M. Tuñón de Lara. Madrid: Siglo Veintiuno Editores, 1986.

Engelhardt, Julia, Michael Raeburn, and Pilar Sada. "Chronology." In *Homage to Barcelona: The City and Its Art, 1888–1936*, 287–308. Exhibition organized by the Generalitat de Catalunya, the Ajuntament de Barcelona, and the Arts Council of Great Britain. Barcelona and London: Arts Council of Great Britain, 1985.

Engels, Friedrich. "The Bakuninists at Work: Notes on the Spanish Uprising

in the Summer of 1873." In Karl Marx and Friedrich Engels, *Revolution in Spain*, 208–236. New York: International Press, 1939.

Fabre, Jaume, and Josep M. Huertas. *Barcelona, 1888–1988. La construcció d'una ciutat*. Barcelona: *Diari de Barcelona*, Publicacions de *Diario de Barcelona*, 1988.

Fabrega Grau, Ángel. *Sanctuarios Marianos de Barcelona. Historia-Leyenda-Folklorico*. Barcelona: n.p., 1954.

Fàbregas, Xavier. Prologue to *Teatre de putxinel.lis*, by Ezequiel Vigués ["Didó"]. Publicacions de l'Institut del Teatre. Barcelona: Edicions 62, 1975.

———. "Teatre: Titelles i titellaires." *Serra d'or*, 1971, 53–57.

Fernández Cervantes, Magdalena. "Una nueva fuente histórica sobre la formación de la ideología anarquista barcelonesa: Emili Salut y su obra *Vivers de revolucionaris*." *Convivium. Filosofia, psicologia, humanidades* (Barcelona) 1–2, nos. 44–45 (1975): 101–122.

Ferrer, Joaquim. *El primer "Ier de Maig" a Catalunya. Documents a la recerça*, 10. Barcelona: Editorial Nova Terra, 1972.

Fontana, Josep. *Cambio económico y actitudes políticas en la España del siglo XIX*. Barcelona: Editorial Ariel, 1973.

———. *La fi de l'antic règim i la industrialització (1787–1868)*. Història de Catalunya, vol. 5. Edited by Pierre Vilar, with Josep Termes. Barcelona: Edicions 62, 1988.

———, ed. *España bajo el Franquismo*. Barcelona: Editorial Crítica, 1986.

Fraser, Ronald. *Blood of Spain: An Oral History of the Spanish Civil War*. New York: Pantheon Books, 1979.

Fusi, Juan Pablo. "La reaparición de la conflictividad en la España de los sesenta." In *España bajo el Franquismo*, edited by Josep Fontana, 160–169. Barcelona: Editorial Crítica, 1986.

Garafola, Lynn. *Diaghilev's Ballets Russes*. New York: Oxford University Press, 1989.

García Delgado, J. L., ed. *La crisis de la Restauración. España entre la primera guerra mundial y la II República*. Second Segovian Colloquium on the Contemporary History of Spain. Madrid: Siglo Veintiuno Editores, 1986.

Garrabou, Ramon, Joaquim Lleixà, and Octavi Pellissa. Prologue to *Franquisme. Sobre resistència i consens a Catalunya (1938–1959)*. Centre de Traball i Documentació. Barcelona: Editorial Crítica, 1990.

Garrut Romá, Josep María. *600 anys de Placa Nova*. Barcelona: Editorial Selecta, [1955] 1978.

———. *L'Exposició Universal de Barcelona de 1888*. Barcelona: Ajuntament de Barcelona, Delegació de Cultura, 1976.

———. *Itinerarios de piedad en Barcelona*. Barcelona: Editorial Aymá, 1952.

Gaziel [Augustí Calvet i Pasqual]. *Tots els camins duen a Roma. Història d'un destí (1893–1914). Memòries*. Vol. 1. Barcelona: Ediciones "La Caixa" d'Estalvis Laietana, 1977.

Givanel Mas, Juan. *Publicaciones periòdiques barceloneses escrites en llengua catalana des de 1879 a 1918*. Barcelona: Caritat, 1920.

González Casanova, José Antonio. *Federalismo y autonomía. Cataluña y el estado español, 1868–1938*. Barcelona: Editorial Crítica, 1979.

Gramsci, Antonio. *Selections from the Prison Notebooks*. Edited and translated by Quintin Hoare and Geoffrey Nowell Smith. New York: International Publishers, 1971.

Hall, Stuart. "Notes on Deconstructing 'The Popular.'" In *People's History and Socialist Theory*, edited by Raphael Samuel, 227–240. London: Routledge & Kegan Paul, 1981.

Hansen, Edward C. *Rural Catalonia Under the Franco Regime: The Fate of Regional Culture Since the Spanish Civil War*. Cambridge: Cambridge University Press, 1977.

Hennessy, C. A. M. *The Federal Republic in Spain: Pi y Margall and the Federal Republican Movement, 1868–74*. Oxford: Clarendon Press, 1962.

Hernández-Cros, J. Emili, Gabriel Mora, and Xavier Pouplana. *Arquitectura de Barcelona*. 2d ed. Barcelona: Publicaciones del Colegio Oficial de Arquitectos de Cataluña y Baleares/La Gaya Ciencia, 1973.

Hertz, Neil. "Medusa's Head: Male Hysteria Under Political Pressure." *Representations* 4 (Fall 1983): 27–50.

Hobsbawm, Eric J. *Labouring Men: Studies in the History of Labour*. New York: Doubleday/Anchor Books, 1967.

———. "Man and Woman in Socialist Iconography." *History Workshop* 6 (Autumn 1978): 121–138.

———. "Mass-producing Traditions: Europe, 1870–1914." In *The Invention of Tradition*, edited by Eric Hobsbawm and Terence Ranger, 263–307. New York: Cambridge University Press, 1983.

———. *Primitive Rebels*. New York: W. W. Norton, 1964.

Huertas Clavería, J. M. *Salvador Seguí "El noi de sucre." Materiales para una biografía*. Barcelona: Editorial Laia, 1976.

Hunter, Stephen. *The Spanish Gambit*. New York: Crown, 1985.

Iturbe, Lola. *La mujer en la lucha social y en la guerra civil de España*. Mexico City: Editores Mexicanos Unidos, 1974.

Ivars, José-Francisco. "Arte." In *La cultura bajo el Franquismo*, edited by Carlos Castilla del Pino, 205–218. Barcelona: Ediciones del Bolsillo, 1977.

Izard, Miguel. *Industrialización y obrerismo. Tres clases de vapor, 1869–1913*. Barcelona: Ariel, 1973.

———. *El movimiento obrero en Cataluña (1888–1891)*. Barcelona: Editorial Ariel, 1978.

Jackson, Gabriel. *The Spanish Republic and the Civil War, 1931–1939*. Princeton: Princeton University Press, 1967.

Jardí, Enric. *La ciutat de les bombes. El terrorism anarquista a Barcelona*. Barcelona: Librería Dalmau, 1964.

———. *Nonell*. Barcelona: Editorial Polígrafa, n.d.

———. *Nonell i altres assaigs*. Barcelona: Editorial Selecta, 1957.

———. *Puig i Cadafalch: Arquitecte, politic i historiador de l'art*. Mataró: Ediciones "La Caixa" d'Estalvis Laietana, 1975.

Kaplan, Temma. *Anarchists of Andalusia, 1868–1903*. Princeton: Princeton University Press, 1977.

———. "Civic Rituals and Patterns of Resistance in Barcelona, 1890–1930." In *The Power of the Past: Essays for Eric J. Hobsbawm*, edited by Pat Thane, Geoffrey Crossick, and Roderick Floud, 173–193. Cambridge and Paris:

Cambridge University Press and Editions de la Maison des Sciences de l'Homme, 1984.

———. "Female Consciousness and Collective Action: The Case of Barcelona, 1910–1918." *Signs: Journal of Women in Culture and Society* 7, no. 3 (1982): 545–566.

———. "Women and Spanish Anarchism." In *Becoming Visible: Women in European History*, 1st ed., edited by Renate Bridenthal and Claudia Koonz, 400–421. Boston: Houghton Mifflin, 1977.

———. "Women's Communal Strikes in the Crisis of 1917–22." In *Becoming Visible: Women in European History*, 2d ed., edited by Renate Bridenthal, Claudia Koonz, and Susan Mosher Stuard, 429–449. Boston: Houghton Mifflin, 1987.

Kertzer, David I. *Ritual, Politics, and Power*. New Haven: Yale University Press, 1988.

Lacomba Avellán, Juan Antonio. *La crisis española de 1917*. Colección "Los Contemporáneos," 19. Madrid: Editorial Cuenca Nueva, 1979.

Lida, Clara. *Anarquismo y revolución en la España del XIX*. Madrid: Siglo Veintiuno Editores, 1972.

———. *Antecedentes y desarrollo del movimiento obrero español (1835–1888)*. *Textos y documentos*. Madrid: Siglo Veintiuno Editores, 1973.

Lidtke, Vernon L. *The Alternative Culture: Socialist Labor in Imperial Germany*. New York: Oxford University Press, 1985.

Little, Douglas. *Malevolent Neutrality: The United States, Great Britain, and the Origins of the Spanish Civil War*. Ithaca: Cornell University Press, 1985.

Luxemburg, Rosa. *The Mass Strike, the Political Party, and the Trade Union*. Translated by Patrick Lavin. New York: Harper Torchbooks, [1906] 1971.

McCully, Marilyn. "Introduction." In *Homage to Barcelona: The City and Its Art, 1888–1936*, 15–77. Exhibition organized by the Generalitat de Catalunya, the Ajuntament de Barcelona, and the Arts Council of Great Britain. Barcelona and London: Arts Council of Great Britain, 1985.

McDonogh, Gary Wray. *Good Families of Barcelona: A Social History of Power in the Industrial Revolution*. Princeton: Princeton University Press, 1986.

———, ed. *Conflict in Catalonia: Images of an Urban Society*. University of Florida Monographs, Social Sciences no. 71. Gainesville: University of Florida Press, 1986.

McPharlin, Paul. *The Puppet Theatre in America; with a Supplement: Puppets in America Since 1948, by Marjorie Batchelder McPharlin*. Boston: Plays, [1949] 1969.

Madrid, Francisco. *Sangre en Atarazanas*. Barcelona: Antonio López, n.d.

Malefakis, Edward E. *Agrarian Reform and Peasant Revolution in Spain: Origins of the Civil War*. New Haven: Yale University Press, 1970.

Manent, Marià, ed. *Llibre de la Mare de Déu de la Mercè*. Barcelona: Editorial Selecta, 1950.

Marichal, Juan Augusto. *La vocación de Manuel Azaña*. Madrid: Alianza, 1982.

Martín Maestre, Jacinto. *Huelga general de 1917*. Colección Lée y Discute, 15, ser. Roja. Madrid: ZYX, 1966.

Mascarell, Ferran. "Conversa amb Enric Ucelay Da Cal: Macià, un politic sor-prenent." *L'avenç* (Barcelona), no. 66 (December 1983): 24–38.

Masriera, Arturo. "El Senyor Nevas, sombrista." Translated by H. V. Tozer. In *Catalan Puppetry*. Columbus, Ohio: Puppeteers of America, 1944.

Massot i Muntaner, Josep. *Aproximació a la història religiosa de la Catalunya contemporània*. Barcelona: Publicaciones de l'Abadia de Montserrat, 1973.

———. *L'església de Catalunya al segle XX*. Barcelona: Curial Edicions Catalans, 1975.

Meaker, Gerald H. *The Revolutionary Left in Spain, 1914–1923*. Stanford: Stanford University Press, 1974.

Mintz, Frank. *L'autogestion dans l'Espagne revolutionnaire*. Paris: Editions Belibaste, 1970.

Mintz, Jerome R. *The Anarchists of Casas Viejas*. Chicago: University of Chicago Press, 1982.

Moeller, Robert G. *German Peasants and Agrarian Politics, 1914–1924: The Rhineland and Westphalia*. Chapel Hill: University of North Carolina Press, 1986.

Molas, Isidre. *Lliga catalana: Un estudi d'estasiología*. 2 vols. Barcelona: Edicions 62, 1972.

Morand, Paul. "Catalan Nights." In *Fancy Goods: Open All Night*, 65–95. Preface and first introduction by Marcel Proust, second introduction by Breon Mitchell; translated by Ezra Pound. New York: New Directions, [1921] 1984.

Morrow, Felix. *Revolution and Counter-Revolution in Spain*. New York: Pathfinder Press, [1938] 1974.

Nash, Mary. "Dos intelectuales anarquistas frente al problema de la mujer: Federica Montseny y Lucía Sánchez Saornil." *Convivium. Filosofia, psicología, humanidades* (Barcelona) 1–2, nos. 44–45 (1975): 71–99.

———. *Mujer, familia y trabajo en España, 1875–1936*. Barcelona: Anthropos, Editorial del Hombre, 1983.

———. *Mujer y movimiento obrero en España, 1931–1939*. Barcelona: Editorial Fontamara, 1981.

———. *"Mujeres libres": España, 1936–1939*. Barcelona: Editorial Tusquets, 1975.

———. "La problemática de la mujer y el movimiento obrero en España." In *Teoría y práctica del movimiento obrero en España* (1900–1936), edited by Albert Balcells, 241–279. Valencia: Fernando Torres, 1977.

Nettlau, Max. *La Première Internationale en Espagne, 1868–1888*. 2 vols. Edited by Renée Lamberet. Dordrecht, Neth.: D. Reidel, 1969.

Nochlin, Linda. "The Paterson Strike Pageant of 1913." *Art in America*, May–June 1974, 64–68.

———. *The Politics of Vision: Essays on Nineteenth-Century Art and Society*. New York: Harper & Row, 1989.

———. *Women, Art, and Power and Other Essays*. New York: Harper & Row, 1988.

Núñez Florencio, Rafael. *El terrorismo anarquista, 1888–1909*. Madrid: Siglo Veintiuno Editores, 1983.

Orsi, Robert Anthony. "'He Keeps Me Going': Women's Devotion to Saint Jude Thaddeus and the Dialectics of Gender in American Catholicism, 1926–1965." In *Belief in History: Innovative Approaches to European and American Religion,* edited by Thomas Kaselman, 137–169. South Bend, Ind.: Notre Dame Press, 1991.

———. *The Madonna of 115th Street: Faith and Community in Italian Harlem, 1880–1950.* New Haven: Yale University Press, 1985.

Orwell, George. *Homage to Catalonia.* New York: Penguin Books, [1937] 1977.

Parés i Rigau, Fina. *El ex vots pintats.* Coneguem Catalunya, 20. Barcelona: Llibres de la Frontera, n.d.

Payne, Stanley G. *Falange: A History of Spanish Fascism.* Stanford: Stanford University Press, 1961.

Peirats, José. *La CNT en la revolución española.* 3 vols. Paris: Ruedo Ibérico, 1971.

Pèrez Baró, Albert. *Els "Feliços" anys vint. Memòries d'un militant obrer, 1918–1926.* Palma de Mallorca: Editorial Moll, 1974.

Perrot, Michelle. "The First of May 1890 in France: The Birth of a Working-Class Ritual." In *The Power of the Past: Essays for Eric Hobsbawm,* edited by Pat Thane, Geoffrey Crossick, and Roderick Floud, 143–171. Cambridge and Paris: Cambridge University Press and Editions de la Maison des Sciences de l'Homme, 1984.

Pí, Joan del. *Interpretació llibertaria del moviment obrer català.* Paris: Ediciones Tierra y Libertad, 1946.

Piqué i Padró, Jordi. *Anarco-col.lectivisme i anarco-comunisme. L'oposició de dues postures en el moviment anarquista catalá (1881–1891).* Montserrat: Publicacions de l'Abadia de Montserrat, 1989.

Pla, José. *El pintor Joaquín Mir.* Barcelona: Ediciones Destino, 1944.

Pla, Josep. *Santiago Rusiñol i el seu temps.* Barcelona: Edicions Destino, 1981.

Poblet, Josep María. *El moviment autonomista a Catalunya dels anys 1918–1919.* Barcelona: Llibre de Butxaca, 1977.

Prat, Joan, and Jesús Contreras. *Conèixer Catalunya: Les festes populars.* Barcelona: DOPESA, 1979.

Prat, José. *La burguesía y el proletariado (Apuntes sobre la lucha sindical).* Barcelona: Ediciones Tierra y Libertad, 1937.

Prats, Llorenç, Dolors Llopart, and Joan Prat. *La cultura popular a Catalunya. Estudiosos i institucions, 1853–1981.* Barcelona: Serveis de Cultura Popular, 1982.

Preston, Paul. *The Coming of the Spanish Civil War: Reform, Reaction, and Revolution in the Second Republic, 1931–36.* London: Macmillan, 1978.

Radcliff, Pamela. "Community Politics: The Growth of Urban Radicalism in Gijón, 1900–1934." Ph.D. diss., Columbia University, 1990.

Rohrer, Judith. "The Universal Exhibition of 1888." In *Homage to Barcelona: The City and Its Art, 1888–1936,* 96–99. Exhibition organized by the Generalitat de Catalunya, the Ajuntament de Barcelona, and the Arts Council of Great Britain. Barcelona and London: Arts Council of Great Britain, 1985.

Romero Maura, Joaquín. *"La rosa de fuego." El obrerismo barcelonés de 1899 a 1909*. Barcelona: Editorial Grijalbo, 1975.

——. *The Spanish Army and Catalonia: The Cu-Cut! Incident and the Law of Jurisdictions, 1905–1906*. Beverly Hills, Calif.: Sage, 1976.

——. "Terrorism in Barcelona and Its Impact on Spanish Politics, 1904–1909." *Past and Present* 41 (1968): 130–183.

Ross, Ellen. "Fierce Questions and Taunts: Married Life in Working-Class London, 1870–1914." *Feminist Studies* 8, no. 3 (Fall 1982): 575–601.

——. *Love and Labor in Outcast London: Motherhood, 1870–1918*. New York: Oxford University Press, forthcoming.

——. "Survival Networks: Women's Neighborhood Sharing in London Before World War I." *History Workshop* (London), no. 15 (Spring 1983): 4–27.

Rotes, Helena. "Anarquismo y terrorismo en Barcelona, 1888–1902." Mem. lic., University of Barcelona, 1981.

Ryan, Mary. "The American Parade: Representations of the Nineteenth-Century Social Order." In *The New Cultural History*, edited by Lynn Hunt, 131–153. Berkeley and Los Angeles: University of California Press, 1989.

Sabater, Jordi. *Anarquisme i catalanisme. La CNT i el fet nacional català durant la guerra civil*. Barcelona: Edicions 62, 1986.

Sanabre Sanromá, José. "La ocupación de Barcelona por las tropas Napoleónicas e el templo de Nstra. Sra. de la Merced." *Miscellanea barcinonensia* 4, no. 11 (1965): 7–23.

Sartorius, Nicolás. *El resurgir del movimiento obrero*. Colección "Primero de Mayo," no. 2. Barcelona: Editorial Laia, 1975.

Schorske, Carl E. *Fin-de-Siècle Vienna: Politics and Culture*. New York: Alfred A. Knopf, 1980.

——. *German Social Democracy, 1905–1917: The Development of the Great Schism*. New York: John Wiley, 1965.

Scott, Joan W. *Gender and the Politics of History*. New York: Columbia University Press, 1988.

Sembene, Ousmane. *God's Bits of Wood*. New York: Doubleday/Anchor Books, 1970.

Sempronio [Andrés Aveleno Artís]. *Aquella entremaliada Barcelona*. Barcelona: Editorial Selecta, 1978.

——. *Barcelona era una festa*. Barcelona: Editorial Selecta, 1989.

——. *Sonata a la Rambla*. Barcelona: Editorial Barna, 1961.

Serge, Victor. *The Birth of Our Power*. Translated by Richard Greenman. London: Writers and Readers Publishing Cooperative, [1931] 1977.

Serrano Victori, A. "De Pedro Romeu al 'Didó,' o la resurección de 'Els Quatre Gats.'" *Día gráfico*, March 13, 1932, 7.

Silverman, Debora L. *Art Nouveau in Fin-de-Siècle France: Politics, Psychology, and Style*. Berkeley and Los Angeles: University of California Press, 1989.

Solé i Sabaté, Josep María. *La repressió franquista a Catalunya, 1938–1953*. Barcelona: Edicions 62, 1985.

Solé i Sabaté, Josep María, and J. Villarroya i Font. *La repressió a la reraguar-*

dia de Catalunya (1936–1939). Vol. 1. Barcelona: Publicaciones de l'Abadia de Montserrat, 1989.

Solé-Tura, Jordi. *Catalanismo y revolución burguesa*. Madrid: Editorial Cuadernos para el Diálogo, 1970.

Southworth, Herbert Routledge. *Guernica! Guernica! A Study of Journalism, Diplomacy, Propaganda, and History*. Berkeley and Los Angeles: University of California Press, 1977.

Spender, Stephen. "Guernica." In *And I Remember Spain: A Spanish Civil War Anthology*, edited by Murray A. Sperber, 151–152. New York: Macmillan, 1974.

Sperber, Murray A., ed. *And I Remember Spain: A Spanish Civil War Anthology*. New York: Macmillan, 1974.

Stallybrass, Peter, and Allon White. *The Poetics and Politics of Transgression*. Ithaca: Cornell University Press, 1986.

Steer, G. L. "From the Tree of Gernika." In *And I Remember Spain: A Spanish Civil War Anthology*, edited by Murray A. Sperber, 267–272. New York: Macmillan, 1974.

Tàpies, Antoni. *Memòria personal. Fragment per una autobiografia*. Barcelona: Editorial Crítica, 1977.

Tárrida del Mármol, F. *Les inquisiteurs d'Espagne*. 2d ed. Paris: Stock, 1897.

Tavera, Susana. "Els anarchosindicalistes catalans i la dictadura." *L'avenç*, no. 72 (June 1984): 62–67.

———. "La Barcelona obrera, 1900–1909." Manuscript copy.

Termes, Josep. *Anarquismo y sindicalismo en España. La primera International (1864–1881)*. Esplugues de Llobregat: Editorial Ariel, 1973.

Thane, Pat, Geoffrey Crossick, and Roderick Floud, eds. *The Power of the Past: Essays for Eric J. Hobsbawm*. Cambridge and Paris: Cambridge University Press and Editions de la Maison des Sciences de l'Homme, 1984.

Thomas, Edith. *The Women Incendiaries*. Translated by James Starr Atkinson. New York: Braziller, 1966.

Thomas, Hugh. *The Spanish Civil War*. New York: Harper/Colophon Books, 1961.

Thompson, Dorothy. *The Chartists: Popular Politics in the Industrial Revolution*. New York: Pantheon Books, 1984.

———. *Over Our Dead Bodies*. London: Virago, 1983.

———. *Queen Victoria: Gender and Power*. London: Virago, 1990.

Thompson, E. P. *The Making of the English Working Class*. New York: Vintage Books, 1966.

———. "The Moral Economy of the English Crowd in the Eighteenth Century." *Past and Present* 50 (February 1971): 76–136.

———. "'Rough Music': Le charivari anglais," *Annales, E.S.C.* 27 (1972): 285–312.

Tisa, John, ed. *The Palette and the Flame: Posters of the Spanish Civil War*. New York: International Publishers, 1979.

Tozer, H. V. "El titella català vist per un anglés." In *Les grans tradicions populars. Ombres i titelles*, edited by M. R. Contractor, 139–143. Paris: Arthaud, 1977.

Tusell, Javier. *La dictadura de Franco*. Madrid: Alianza Editorial, 1988.

Ucelay Da Cal, Enric. *La Catalunya populista. Imatge, cultura i política en l'etapa republicana (1931–1939)*. Barcelona: Edicions de la Magrana, 1982.
———. "Estat Català: The Strategies of Separation and Revolution of Catalan Radical Nationalism (1919–1933)." 2 vols. Ph.D. diss., Columbia University, 1979.
Ullman, Joan Connelly. *La Semana Trágica. Estudio sobre las causas socioeconómicas del anticlericalismo en España (1898–1912)*. Translated by Gonzalo Pontón. Barcelona: Ediciones Ariel, 1972.
———. *The Tragic Week: A Study of Anticlericalism in Spain, 1875–1912*. Cambridge, Mass.: Harvard University Press, 1968.
Varey, J. E. "Los títeres en Cataluña en el siglo XIX." In *Estudios escénicos*, 45–78. Cuadernos del Instituto del Teatro, no. 5. Barcelona: Diputación Provincial de Barcelona, 1960.
Vila, Pau. "Orígenes i evolució de la Rambla." *Miscellanea barcinonensia* 4, no. 11 (1965): 59–74.
Villán, Javier, and Felix Población. *Culturas en lucha catalana*. Madrid: Editorial Swan, 1980.
Violant Simorra, Ramón. *El arte popular español a través del Museo de Industrias y Artes Populares*. Barcelona: Editorial Aymà, 1953.
Vives de Fabregas, Elisa. *Vida femenina barcelonesa en el ochocientos*. Barcelona: Librería Dalmau, 1945.
Walkowitz, Judith M. *Prostitution and Victorian Society: Women, Class, and the State*. Cambridge: Cambridge University Press, 1980.
———. "Science and the Seance: Transgressions of Gender and Genre in Late Victorian London." *Representations*, no. 22 (Spring 1988): 3–22.
Warner, Marina. *Alone of All Her Sex: The Myth and Cult of the Virgin Mary*. New York: Wallaby Pocket Books, 1975.
———. *Monuments and Maidens: The Allegory of the Female Form*. New York: Atheneum, 1985.
Williams, Raymond. "The Importance of Community." In *Resources of Hope: Culture, Democracy, Socialism*, edited by Robin Gable, 111–119. New York: Verso, 1989.
Winston, Colin M. "Apuntes para la historia de los sindicatos libres de Barcelona (1919–1923)." *Revista estudios de historia social* 2–3 (1981): 119–139.
———. *Workers and the Right in Spain, 1900–1936*. Princeton: Princeton University Press, 1985.
Wolf, Eric R. *Peasants*. Englewood Cliffs, N.J.: Prentice-Hall, 1966.
———. *Peasant Wars of the Twentieth Century*. New York: Harper & Row, 1969.
———. *Europe and the People Without History*. Berkeley and Los Angeles: University of California Press, 1982.
Yglesias, José. *The Franco Years: The Untold Human Story of Life Under Spanish Fascism*. Indianapolis: Bobbs-Merrill, 1977.

PICASSO STUDIES

Allthaus, P. F. "Der Stierkampf." *Du. Kulturelle Monatsschrift* (Zurich) 18, no. 8 (August 1958): 55–56.

Arnheim, Rudolf. *The Genesis of a Painting: Picasso's "Guernica."* Berkeley and Los Angeles: University of California Press, 1980.

Axom, Richard Hayden. *"Parade:* Cubism as Theater." Ph.D. diss., University of Michigan, 1974.

Bloch, Georges. *Pablo Picasso: Catalogue of the Printed Graphic Work, 1904–1967.* Bern: Kornfeld & Klipstein, 1971.

Blunt, Anthony. *Picasso's "Guernica."* Oxford: Oxford University Press, 1969.

Blunt, Anthony, and Phoebe Pool. *Picasso: The Formative Years—A Study of His Sources.* Greenwich, Conn.: New York Graphic Society, 1962.

Cabanne, Pierre. *Pablo Picasso: His Life and Times.* Translated by Harold J. Salemson. New York: William Morrow, 1977.

Chipp, Herschel B. *Picasso's "Guernica": History, Transformations, Meanings.* Berkeley and Los Angeles: University of California Press, 1989.

Cirici Pellicer, Alejandro. *Picasso antes Picasso.* Barcelona: Ediciones Iberia, 1946. Translated by Marguerite de Floris y Ventura Gasol as *Picasso avant Picasso.* Geneva: P. Cailler, 1950.

Cooper, Douglas. *Picasso's Theatre.* New York: Harry N. Abrams, 1968.

Daix, Pierre, and Georges Boudaille. *Picasso: The Blue and Rose Periods—A Catalogue Raisonné of the Paintings, 1900–1906.* Compiled with the collaboration of Joan Rosselet. Translated by Phoebe Pool. Greenwich, Conn.: New York Graphic Society, 1967.

Gasman, Lydia. "Mystery, Magic, and Love in Picasso, 1925–38: Picasso and the Surrealist Poets." Ph.D. diss., Columbia University, 1981.

Gedo, Mary Mathews. *Picasso: Art as Autobiography.* Chicago: University of Chicago Press, 1980.

Geiser, Bernhard. *Picasso. Peintre graveur.* Bern (privately printed), 1933.

Jardí Casany, Enric. *Història de els Quatre Gats.* Barcelona: Editorial Aedos, 1972.

Krauss, Rosalind E. *The Originality of the Avant-Garde and Other Modernist Myths.* Cambridge, Mass.: MIT Press, 1985.

Lecaldano, Paolo. *La obra pictórica completa de Picasso azul y rosa.* Barcelona: Editorial Noguer, 1980.

Leighten, Patricia. "Picasso's Collages and the Threat of War, 1912–1913." *Art Bulletin* 67 (December 1985): 653–672.

———. *Re-Ordering the Universe: Picasso and Anarchism, 1897–1914.* Princeton: Princeton University Press, 1989.

Leja, Michael. "'Le vieux marcheur' and 'Les deux risques': Picasso, Prostitution, Venereal Disease, and Maternity, 1899–1907." *Art History* 8 (March 1985): 66–81.

Lipton, Eunice. *Picasso Criticism, 1901–1939: The Making of an Artist Hero.* New York: Garland, 1976.

M. G. "Picasso taurómaco." *Du. Kulturelle Monatsschrift* 18, no. 8 (August 1958): 11–29.

McCully, Marilyn. *Els Quatre Gats: Art in Barcelona Around 1900.* Princeton: Princeton University Press, 1978.

———. *A Picasso Anthology: Documents, Criticism, Reminiscences.* Princeton: Princeton University Press, 1982.

Montherlant, Henry de. "Der erste Plan einer von Picasso illustrierten Luxus-ausgabe der 'Tauromaquia.'" *Du. Kulturelle Monatsschrift* 18, no. 8 (August 1958): 34–38, 58–60.

Musée Picasso. Catalogue des collections. Catalogue by Marie-Laure Besnard-Bernadac, Michèle Richet, and Hélène Seckel. Paris: Ministry of Culture, Editions de la Réunion des Musées Nationaux, 1985.

Museu Picasso. Catàleg de pintura i dibuix. Catalogue by Jaime Barrachina, Magdalena Gual, M. Teresa Llorens, M. Teresa Ocaña, Núria Rivero, Pilar Vélez, and Cecilia Vidal. Barcelona: Ajuntament de Barcelona Museus, 1984.

O'Brian, Patrick. *Pablo Ruiz Picasso: A Biography.* London: Collins, 1976.

Palau i Fabre, Josep. *El "Guernica" de Picasso.* Barcelona: Editorial Blume, 1979.

———. *Picasso: The Early Years, 1881–1907.* Barcelona: Ediciones Polígrafa, 1985.

———. *Picasso in Catalonia.* Translated by Kenneth Lyons. Secaucus, N.J.: Chartwell Books, 1975.

———. *Picasso i els seus amics catalans.* Barcelona: Editorial Aedos, 1971.

Penrose, Roland. *Picasso: His Life and Work.* New York: Harper, 1959.

Picasso: Collected Writings. Preface by Michel Leiris; edited with an introduction by Marie-Laure Bernadac and Christine Piot; translated by Carol Volk and Albert Bensoussan. New York: Abbeville Press, 1989.

Picasso on Art: A Selection of Views. Edited by Dore Ashton. New York: Da Capo, 1972.

de la Puente, Joaquín. *El "Guernica." Historia de un cuadro.* Madrid: Silex, 1985.

Raventos i Conti, Jacint. *Picasso i els Raventos.* Barcelona: Editorial Gilit, 1974.

Reff, Theodore. "Harlequins, Saltimbanques, Clowns, and Fools." *Art Forum* 10, no. 2 (October 1971): 30–43.

———. "Picasso's Three Musicians: Maskers, Artists, and Friends." *Art in America* (special issue), December 1980, 125–142.

———. "Themes of Love and Death in Picasso's Early Work." In *Picasso in Retrospect.* Edited by Roland Penrose and John Golding, 5–30. New York: Harper & Row, 1973.

Richardson, John, with Marilyn McCully. *A Life of Picasso.* Vol. 1: *1881–1906.* New York: Random House, 1991.

———. "Picasso's Apocalyptic Whorehouse." *New York Review of Books* 34, no. 7 (April 23, 1987): 40–47.

Rubin, William, ed. *Picasso: A Retrospective* (Museum of Modern Art, New York). Boston: New York Graphic Society, 1980.

———, ed. *"Primitivism" in Twentieth Century Art: Affinity of the Tribal and the Modern.* 2 vols. New York: Museum of Modern Art, 1984.

Sabartés, Jaime. *Picasso. Documents iconographiques.* Translated into French by Felia Léal and Alfred Rosset. Geneva: Pierre Cailler, 1954.

———. *Picasso: An Intimate Portrait.* Translated by Angel Flores. New York: Prentice-Hall, 1948.

Steinberg, Leo, "The Philosophical Brothel, Parts 1 and 2." *Art News* 71, no. 5 (September 1972): 20–29; no. 6 (October 1972): 38–47.

Subiraná, Rosa María. "ADLAN and the Artists of the Republic." In *Homage to Barcelona: The City and Its Art, 1888–1936,* 211–225. Exhibition organized by the Generalitat de Catalunya, the Ajuntament de Barcelona, and the Arts Council of Great Britain. Barcelona and London: Arts Council of Great Britain, 1985.

Tharrats, Joan Josep. *Picasso i els artistes catalans en el ballet.* Barcelona: Edicions del Cotal, 1982.

Withers, Josephine. "The Artistic Collaboration of Pablo Picasso and Juli González." *Art Journal* 30, no. 2 (Winter 1975–1976): 107–114.

Zervos, Christian, ed. *Pablo Picasso. Oeuvres.* Vol. 1: *1895–1906.* Edited by *Cahiers d'Art* (Paris). New York: E. Weyhe, 1932.

———. *Pablo Picasso. Oeuvres.* Vol. 2.2: *1912–1917.* Paris: Editions *Cahiers d'Art,* 1942.

———. *Pablo Picasso. Oeuvres.* Vol. 3: *1917–1919.* Paris: Editions *Cahiers d'Art,* 1949.

———. *Pablo Picasso. Oeuvres (Supplement: 1914–1919).* Paris: Editions *Cahiers d'Art,* 1975.

Index

257

Compositor: Graphic Composition, Inc.
 Text: 10/13 Galliard
 Display: Galliard